Words at an Exhibition
열 장의 이야기와 다섯 편의 시
an exhibition in ten chapters and five poems

이 책은 2020부산비엔날레《열 장의 이야기와 다섯 편의 시》의 일환으로 제작되었습니다.
The anthology is published as a part of Busan Biennale 2020 *Words at an Exhibition*
《열 장의 이야기와 다섯 편의 시》 *an exhibition in ten chapters and five poems.*

Words at an Exhibition

열 장의 이야기와 다섯 편의 시

an exhibition

ı ten chapters and five poems

목차

Contents

서문

열 장의 짧은 이야기와 다섯 편의 시를 수록한 이 책은 2020부산비엔날레《열 장의 이야기와 다섯 편의 시》를 위해 제작되었다. 책에 소개되는 열한 명의 저자는 광범위한 장르, 세대, 문체를 보여준다. 탐정, 스릴러, 공상과학, 역사가 가미된 가상의 이야기들과 더불어 혁명, 젠더, 음식, 사랑에 관한 이야기들이 있다. 부산에 대한 짧은 이야기를 쓰기 위해 초대된 저자들은 도시를 둘러싼, 그리고 도시에 관한 가상의 층을 창조했다. 몇몇 저자는 부산을 직접적으로 참고한 이야기를, 다른 저자들은 간접적인 도시 이야기를 썼다. 이 원고들이 70인 이상의 시각 예술가와 음악가들에게 주어졌고, 이들은 전시를 위해 기존 작업 중의 일부를 선택하거나 새로운 작업을 제작했다.

전시《열 장의 이야기와 다섯 편의 시》에서 도시 부산은 문학, 사운드, 시각 예술이라는 만화경을 통해 보여진다. 전시의 뼈대나 다름없는 열한 명의 저자들이 집필한 텍스트가 각 장으로 나뉘어 도시의 곳곳으로 퍼져나갔다. 배수아, 김혜순, 김숨, 편혜영, 마크 본 슐레겔, 아말리에 스미스, 이상우의 이야기를 담은 일곱 개의 장은 부산현대미술관에 자리한다. 다음 세 개의 장에 담긴 박솔뫼, 김금희, 안드레스 솔라노의 이야기는 부산의 원도심 일대의 다양한 장소들을, 마지막 장인 김언수의 이야기는 영도 항구에 있는 한 창고를 차지한다. 전시장으로 선정된 공간은 부산의 중요한 역사적 장소들을 대표해주며, 이야기들의 일부가 이 장소에서 전개되기도 한다. 이야기들과 전시는 관람객들이 부산의 탐정이 되도록, 그리고 이 도시의 다양한 지역과 공간, 거리, 건축물을 탐험하고 재발견할 수 있게 해준다.

Introduction

This collection of ten short stories and five poems were commissioned for the Busan Biennale 2020, *Words at an Exhibition* 《열 장의 이야기 와 다섯 편의 시》 *an exhibition in ten chapters and five poems*. The eleven authors featured in this publication represent a broad range of genres, generations, and styles of writing. The selection not only includes detective tales, thrillers, science-fiction, but also the stories about history, revolt, gender, food, and love. The authors were invited to visit Busan, South Korea, to write short stories or poems about the city. Some stories have direct references to Busan and others are indirect. The texts were given to more than 70 visual artists and musicians and they either responded with their existing works or produced new works for the exhibition.

In *Words at an Exhibition* 《열 장의 이야기와 다섯 편의 시》 *an exhibition in ten chapters and five poems*, the city is seen through a kaleidoscopic view of literature, sound, and visual art. The eleven authors function as the skeleton of the exhibition, and their texts, which are divided into eleven chapters, are spread across the city in several exhibition venues. Seven chapters by BAE Suah, KIM Hyesoon, KIM Soom, PYUN Hye-young, Mark von SCHLEGELL, Amalie SMITH, and YI SangWoo are situated at the Museum of Contemporary Art Busan (MOCA Busan) on Eulsukdo Island; three chapters by BAK Solmay, KIM Keum Hee, and Andrés Felipe SOLANO are placed in various spaces in Busan's Old Town area; and the last chapter by KIM Un-su occupies a warehouse at the harbor on the island called Yeongdo. The selected neighborhoods represent significant locations

서문

전시의 제목《열 장의 이야기와 다섯 편의 시》는 러시아 작곡가 모데스트 무소르그스키(1839-1881)의 피아노 모음곡 '전람회의 그림'(1874)에서 파생되었다. 이 곡은 무소르그스키의 친구이자 건축 예술가인 빅토르 하르트만(1834-1873)의 작품에 대한 오마주이자 해석이다. 무소르그스키는 2차원의 작업물인 하르트만의 예술적 표현을 다른 매체 즉, 소리로 변형했던 것이다. 이렇게 열 점의 드로잉과 회화를 음악으로 번역하는 접근법을 빌려 온 2020부산비엔날레는 도시를 짧은 이야기와 시로, 예술 작업과 사운드로 변형하려 한다.

2020부산비엔날레는 열 편의 의뢰된 글과 다섯 편의 시로 정의할 수 있다. 전시에서 이 짧은 이야기들은 책의 구조를 모방하여 '장'(chapter)으로 설명된다. 무소르그스키가 그의 작품을 열 점의 피아노곡과 "프롬나드"(Promenade, 산책)라고 지칭하며 다섯 개의 "인터메조"(sound intermezzos, 간주곡)로 나눈 방식과 비슷하다. 각 장에는 하나의 짧은 이야기가 있고, 한 명에서 열 명에 이르는 예술가들에게 작품을 통해 특정 글이나 시에 응답할 수 있도록 했다. 이 글과 시가 예술가들에게 작업의 출발점이긴 하지만 창작 표현물에 있어서 영감의 원천으로 활용할 수 있도록 요청했다.

이야기, 시, 사운드와 예술 작품을 통해 2020부산비엔날레는 관람객이 역사와 도시 경관을 보는 또 다른 관점을 제공한다.

이 책과 전시를 위해 특별하고도 훌륭한 작품을 제작해준 저자들, 음악가들, 그리고 시각 예술가들에게 진심 어린 감사를 표한다.

전시감독 야콥 파브리시우스,
2020년 4월 1일

in the history of Busan, where some of these stories take place. The exhibition and its stories invite the audience to become detectives in Busan and discover or rediscover different areas, spaces, streets, and buildings in the city.

The title *Words at an Exhibition*《열 장의 이야기와 다섯 편의 시》 *an exhibition in ten chapters and five poems* is derived from the Russian composer Modest Mussorgsky's (1839–1881) piano composition, *Pictures at an Exhibition* (1874), which is a sonic interpretation of ten artworks made by his friend Viktor Hartmann (1834–1873). Mussorgsky transformed Hartmann's two-dimensional works into another medium, sound. By borrowing this approach of interpreting and translating the Busan Biennale 2020 attempts to transform the city into short stories and poems and into artworks and sound.

The Busan Biennale 2020 is defined by the ten commissioned texts and five poems. In this exhibition, each text is described as a chapter similar to how Mussorgsky divided his works into ten compositions and five recurring, varied sound intermezzos. Between one and ten artists were invited to respond to each chapter. The artists were not asked to illustrate them but rather use them as a starting point or as an inspiration for their own expressions.

Through short stories, poems, sounds, and visual arts, the Busan Biennale 2020 offers the visitor a chance to explore the history and the urban landscape of Busan through its fictional layers.

I would like to express my most sincere and heartfelt gratitude to the authors, musicians, and visual artists, who all believed in this idea and produced unique and thought-provoking works for this anthology and exhibition.

<div style="text-align: right">

Jacob FABRICIUS, Artistic Director,
April 1, 2020

</div>

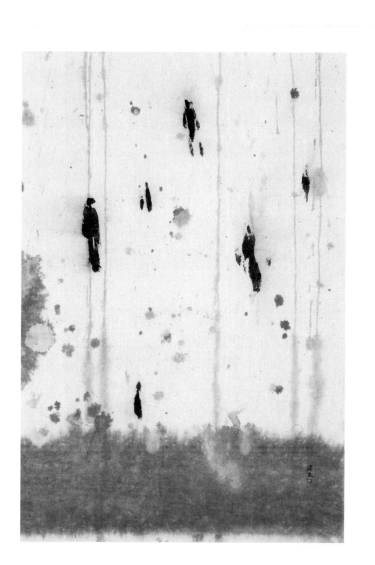

나는 하나의 노래를 가졌다

배수아

무대 위에는 나와 그, 그리고 제3의 목소리가 존재한다. 나와 그, 우리 두 사람은 객석에 등을 돌린 채 멀리 펼쳐진 바다를 바라보며 나란히 바닥에 요가의 연꽃자세로 앉아있다. 우리의 머리와 등은 꼿꼿하고 양 손은 양 무릎 위에 놓였다. 살짝 가벼운 바람이 불어오는 것 같다. 바다 위에는 거대하고 둥근 흰 섬광이 떠 있다. 그것은 예외적인 구름이거나, 공중을 나는 흰 배이거나, 조용하게 정지한 폭발이거나, 비정상적으로 큰 새이거나, 시각적인 불안이거나, 지금 막 열린 어떤 미지의 문처럼 보인다. 우리는 정면을 향한 시선을 돌리지 않은 채 말하기 시작한다. 나는 그를 보지 않으면서 말하고, 그는 내 말을 들으면서 동시에, 입을 움직이지 않고 말한다. 그렇게 우리의 말은 서로 겹치고 뒤섞이며 구별되지 않는다. 그렇게 평행하며 혼재하는 우리의 기이한 이중창의 대화 도중, 간혹 바람이 불어와 우리의 머리카락과 옷자락이 움직이고, 그때마다 제3의 목소리가 간혹 불규칙적으로 끼어든다.

가장 먼저 할 일은, 새를 보지 않는 것이다. 보지 않고, 말하지 않기. 그것에 대해서 말하지 않기. 그것을 향해서, 그것 안으로, 그것의 심장에게

I Had a Single Song

BAE Suah

On the stage, I and he and a third voice exist. I and he, the two of us are sat side by side on the floor in the lotus position, our backs to the audience, gazing at the distant sea. Our heads and backs are held straight and our hands rest on our knees. A light breeze seems to be blowing in. On the sea, a huge, round, white flash of light is floating. It looks like an odd cloud, or a flying ship, a quietly static explosion, an abnormally large bird, visual unease, or some form of strange door that has just opened. Without turning our gazes toward each other, we begin to speak. I speak without seeing him, and he speaks without moving his mouth, at the same time as listening to my words. Like this, our words overlap each other, mixing with each other, indistinguishable. In the course of our odd conversational duet, both parallel and intermixed, the breeze now and then moves our hair and clothes, and at these irregular intervals the third voice comes in.

The first thing to do, is not to look at the bird. Not to look, and not to speak. Not to speak about it. Not to speak towards it or into it, not to address words to its heart. Not to call its name. And not to look inside it, however, disinterestedly. To avert the head. To pretend

13

말을 걸지 않기. 그것의 이름을 부르지 않기. 그리고 그 내부를 무심코라도 들여다보지 않기. 고개를 돌리기. 모른척 하기. 대신 노래를 부른다. 노래하기. 떨어져 있기. 해변의 새가 달아나버리지 않을 정도의 거리를 유지하면서, 노래와 함께 가만히 서성이기. 등을 보이기. 민들레 먹기. 바람에게 길을 내어주기. 의미를 알 수 없는 시로 말하기. 맨발로 걷기. 선율이 소거된 노래 부르기. 내면의 언어로 속삭이기. 몸짓의 언어로. 그러면서 새를 외면하기. 그것은 흰 새일까. 몸을 구부리고 길 위의 것을 줍기. 그게 무엇이든. 발자국이나 그림자, 죽은 뱀, 말(word)의 깃털을. 그리고 그것을 먹기. 그게 무엇이든. 내 입에서 나온 말은 의도적으로 주변의 허공을 너울거리고, 실수로 튀어나오는 은유의 파편들을, 나는 말없이 손으로 잡는다. 그리고 피부 아래로 숨긴다. 망토 아래로 아이의 영혼을 숨기는 사람처럼. 가슴 아래서 희미한 습기를 뿜어내는 여린 숨소리와 체온을 느낀다. 냄새. 나는 잠시 소스라친다. 새를 외면하기를 멈추지 않으면서, 나는 기다린다. 약간의 초조함이 섞인 능동적인 기다림이다. 능동적인 회피, 일월의 잠이다. 그것은 겨울, 일생은 겨울과 같으니. 어느새 나는 새가 날아가버렸음을 느끼지만, 크게 개의치 않는다. 모든 것은 짧다. 나는 원래 새를 보지 않고 있었으므로, 단지 새가 보이지 않는 상태에 대해서는 신경쓰지 않을 수 있다. 나는 불행한가? 그럴지도 모른다. 하지만 내가 한번도 보지 않은 것이, 보이지 않는 것 뿐이다. 시간이 갈수록 나는 새를 안다고 느낀다. (그것은 새일까?) 묘사할 수 없는 것을 품에 안은 채로, 나는 기다리는데, 사실상 나는 기다릴 필요가 없는 것을 기다리는 셈이다. 그 이유는 내가 그것을 이미 전부, 전부 이상으로, 그것이 나타내게 될 형체와 성격 효과 이상으로 이미 알고 있다고 믿기 때문이다. 나는 믿고, 점점 더 믿기 시작한다. 믿음이 아이처럼 내 피부 아래에서 자란다. 그것이 시작이다. 나는 그것을, 아니 우리는 그것을 기다린다. 왜냐하면 나는 어느새 혼자가 아니라고 느끼므로. 그건 외롭지 않다거나 별개의 다른 존재

not to know. To sing instead. To be distant, apart. Maintaining the necessary distance for the seabird not to fly away, to stroll calmly with the song. To turn my back. To eat dandelions. To make a path for the wind. To speak in poetry whose meaning cannot be grasped. To walk barefoot. To sing a song from which the melody has been eliminated. To whisper in an inner language. Through the language of the body's movements. To ignore the bird all the while. Is it a white bird? To bend down and pick up what is lying on the path. Whatever it is. Footprint or shadow, dead snake, the feathers of words. And to eat it. Whatever it is. The words that came out of my mouth flutter automatically in the air around me, and wordlessly I grasp fragments of metaphor blurted out mistakenly. And hide them beneath my skin. Like a person hiding the soul of a child beneath a cape. Beneath my chest I can feel body heat, and soft breathing giving off faint moisture. Smell. I am briefly alarmed. Without ceasing to ignore the bird, I wait. It is an active waiting mixed with slight impatience. It is active avoidance, January sleep. Since it is a winter, life is a winter. At some point, I sense that the bird has flown away, but I'm not too bothered. Everything is brief. As I was never looking at the bird in the first place, I can not care about a situation in which it is not visible. Am I unlucky? Perhaps. But it is only that a thing I have never seen, is not there to be seen. The more time goes by, I feel I know the bird. (Is it a bird?) Embracing something indescribable, I wait; in fact, I wait for something that does not need waiting for. The reason is that I already believe I know everything about it, more than everything, more than the physical form it will reveal and the effect of its personality. I believe, and I gradually begin to believe more. Belief is growing up like a child beneath my skin. It is a beginning. I, no, we, wait for it. Because of feeling at some point that I am not alone. Rather than meaning that I am not lonely, or am conscious of some particular other beings, it is as though I feel the presentiment of a voice that will arrive. I am with the voice that

를 의식한다는 의미가 아니라, 도래할 어떤 목소리의 예감을 느낀다는 뜻이다. 나는 아직 말해지지 않은 목소리와 함께 있다. 목소리는 무형의 성대로 거기 있다. 이제 세계는 오직 목소리가 소리내어질 구조로서 존재한다. 쓴다는 것은 듣는다는 것이다. 쓴다는 것은 본다는 것이다. 쓴다는 것은 느낀다는 것이다. 쓴다는 것은 내부의 감각기관을 이용하여 비로소 외부의 자극을, 도래할 자극을 창조한다는 것이다. 외부는 바로 삶이다. 거기에는 언어가 있다. 내가 이해하지 못하는 언어. 그러나 나로 인해서 번역되기를 기다리는 미래의 언어. 나는 그것을 번역하려고 시도하지만, 내 번역이 틀린 것임을 안다. 옳은 번역이란 존재하지 않는다 번역이 옳다면 그것은 이미 더이상 번역이 아닐 것이므로. 나는 이미 날아가버린 새를 귀기울여 들으며 틀리게 번역하기를 멈추지 않는다. 틀림은 곧 내 길이고 내 동굴이다. 나는 웃는다. 소리내어 웃는다. 동굴에서 메아리치는 홀로인 웃음. 그리고 다시, 말하지 않는다. 보이지 않는 새를, 보지 않는다.

나는 하나의 노래를 가졌다. 나는 하나의 춤을 가졌다. 나는 하나의 바다를 가졌다.

목소리가 말한다, 나는 네가 모르는 네 이름을 알아, 네가 모르는 네가 태어난 곳을 알아. 그건 바닷가 도시의 먼 변두리 언덕 위인데, 집은 이미 사라졌고, 풀들은 짓밟히고 나체야. 집은 이미 사라졌고, 사람은 그보다 더 먼저. 소녀는 그보다 더 먼저.

오래전, 여행을 떠난 나는 세상의 가장 먼 곳에 도달했다고 믿었다. 춥고, 스산하고, 황량하고, 날카롭게 찌르고, 건조하고, 차갑게 붉고, 암석투성이에, 멀고, 또 멀었는데, 태양도 길도 없었다. 대륙의 한가운데. 커다란 검은 까마귀, 참매, 맹금류들, 말들의 피부를 태우며 옆구리에 박힌 거무스름한 낙인. 먼지가 구름을 일으키고, 우리는 갔다. 평원 한가운데서 하

has not yet been spoken. The voice is there as immaterial vocal cords. Now the world exists as a structure in which only the voice will get to sound out loud. Writing is listening. Writing is seeing. Writing is feeling. Writing is using an internal sensory organ to create an external stimulus, a stimulus yet to come. The external is life. Language is there. The language I cannot understand. And yet, a future language waiting to be translated thanks to me. I try to translate it, but I know that my translation is awry. Since there is no such thing as a correct translation, and if a translation is called correct, then that thing is no longer translation. Listening to the bird that has already flown away, I do not cease incorrectly translating. Mistakenness is my path and my cave. I laugh. I laugh out loud. Solo laughter echoing in the cave. And again, I do not speak. And do not see the bird that is not there to be seen.

I had a single song. I had a single dance. I had a single sea.

The voice says, I know your name that you are ignorant of, I know your birthplace that you are ignorant of. It is on the hill of the distant suburbs of a coastal town; the house is gone already, and the grasses are trampled and naked. The house is gone already, and the people were gone before that. The girl earlier still.

A long time ago, while travelling, I believed I had arrived at the most distant place in the world. It was chilly, deserted, bleak, sharply cutting, dry, a cold red, rocky, distant, more distant still; even the sun had no path there. It was the dead centre of the continent. A huge black crow, a goshawk, falcons, a sooty branding iron that burns the skin of words, pressed into my side. A cloud of dust blew up as we went. In the centre of the plain, we met a family. It was a large family, close to twenty people, made up solely of women, and had perhaps been crossing the wastes for several days, as the bodies of each

나의 가족을 만났다. 오직 여자들로만 이루어진, 스무명 가까운 대가족은 며칠째 황무지를 걷고 있었는지 모두 몸에서 짜디짠 가죽냄새를 풍겼다. 머릿수건과 충혈된 눈동자와 메마른 입술. 낡은 가방을 머리에 이고, 붉은 꾸러미를 안고, 포대기에 싸인 갓난아기, 어머니나 아주머니의 치맛자락에 매달린 어린 소녀들의 머리카락은 윤기없는 갈색이었다. 그중에서 나이든 한 여인이 물었다. 우리가 탄 버스에 혹시 빈자리가 있다면 죽은 아이를 태워줄 수 있느냐고. 검은 선글라스로 표정을 감춘 운전수는 입에 담배를 문 채로 고개를 저었다. 타이어 타는 냄새를 풍기며 버스는 돌투성이 길을 느리게 달렸다. 저들은 고향 땅을 찾아가는 거라고, 차창 밖으로 침을 뱉으며 운전수가 설명했다. 어린 딸이 죽었다고 했다. 그들은 죽은 딸을 먼 고향 땅으로 데려가는 거라고. 단지 그곳에 딸을 묻어 주기 위해서. 그리고 다시 차창 밖으로 침을 뱉었다. 우리가 탄 버스는 그들 가족을 지나쳐 먼지를 내뿜으며 앞으로 달려갔다. 버스 안에서 우리는 암말의 젖으로 담근 술을 나누어 마셨다. 술잔을 비우기 전에는 차창 밖으로 한두 방울의 술을 하늘과 대지에 바치는 의례를 잊지 않았다. 그곳은 샤머니즘의 땅이었다. 작고 무표정한 어린 소녀들이 친척 여자의 다리에 매달려 걸어갔다. 서로 구별할 수 없이 놀랄만큼 비슷비슷한 소녀들, 나는 소녀들의 눈을 들여다보지 않으려고 애썼는데, 그건 우연히도 그 안에서 나자신의 눈을 발견하게 될 것이 두려웠기 때문이다. 저 소녀들 중에서 누가 죽은 아이일까, 하고 나는 생각했다. 한없이 늙은 얼굴을 한, 작고, 무표정하고, 스텝 황야처럼 돌투성이의 메마른 소녀들.

나는 하나의 노래를 가졌다. 나는 하나의 춤을 가졌다. 나는 하나의 바다를 가졌다.

목소리가 말한다, 나는 네가 모르는 네 이름을 알아. 네가 모르는 네가 태어난 곳을 알아. 네가 태어났었어야만 하는 곳을 알아. 넌 항상 멀리 있었어. 그런데 지금, 넌 지금 버스에 앉아, 그곳으로 가고 있는 거지.

bore the salty scent of leather. Headscarves and bloodshot eyes and dried lips. Carrying a bag on the head, holding a red bundle, a baby wrapped up in a blanket, the hair of young girls clinging to the skirts of their mothers or aunts was a dull brown. The oldest woman among them asked, providing there was a spare place on our bus, whether we would be able to take a dead baby with us. The driver nodded with his cigarette between his lips. Black sunglasses obscuring his expression. The bus went slowly along the stony road, giving off the smell of burning tires. Spitting out of the window, the driver explained that they were searching for their home. That their young daughter had died, and they were taking the dead girl to their distant home. Only so as to bury her there. And he spat out of the window again. Our bus overtook the family and went on ahead, throwing up dust. Those of us inside the bus shared out alcohol made with mare's milk. Before emptying a glass, we did not forget the custom of offering one or two drops of alcohol to the sky and to the earth, out of the window. We were in the land of shamanism. Small, impassive young girls walked clinging to the legs of their female relatives. Girls so startlingly similar it was impossible to tell them apart, I made an effort not to peer into their eyes; because I was afraid that by chance I would discover my own eyes inside them. Which of those girls is the dead one, I wondered. Girls with endlessly old faces, small, impassive, barren and stony as steppe waste.

I had a single song. I had a single dance. I had a single sea.

The voice says, I know your name that you are ignorant of. I know your birthplace that you are ignorant of. I know the place where you had to have been born. You were always far away. But now, now you are sitting on the bus, going to that place.

… He calls what he is writing a love poem.

… In that case, I ask, does home seem like the childhood house inside the lightning, where you have never lived.

나는 하나의 노래를 가졌다

…… 그는, 자신이 쓰고 있는 글을 사랑의 시라고 부른다.

…… 그렇다면 고향은, 한번도 살았던 적이 없는, 번갯불 속 어린 시절의 집 같은 거냐고 내가 묻는다.

저 멀리 고향 하늘 번개가 번쩍이며,

아버지도 어머니도 오래전에 죽었다.

…… 고향이란, 이름이 태어난 곳, 풀들이 짓밟히고 나체인 곳이라고, 그가 말한다.

그러자 하나의 이름이 문득 내 입에서 저절로 흘러나온다. 나는 그 이름을 아는가? 오래전 소나무 향기가 풍겨오는 바닷가, 젊은 친척 여자들이 바람에 흰 종아리를 드러내고 산책 중이었다. 나는 그중 한 여자의 등에 업혀 있었다. 포근하고 달콤한 어깨의 살 냄새. 물에서 갓 건져올린 미역처럼 싱싱한 머리카락. 그 여자는 물보라처럼 싱그러운 웃음이 떠나지 않는 처녀였고, 가슴은 파도처럼 높이 뛰었으며, 아직 죽기 전이다. 아직 죽기 전이다. 그녀는 나를 소나무 향기가 스민 붉은 포대기로 감싼다. 그래서 나는 알았다. 오, 나는 그곳에서 왔어!

나는 꿈꾼다. 만약 내가 머나먼 땅 스무명의 여자들로만 이루어진 어느 가족의 막내딸로 태어나 이른 나이에 죽었더라면, 그들은 내 몸을 아기용 붉은 포대기에 싸서 안고, 몇 주일 동안이나 황량한 스텝 사막을 걸어 마침내 대륙의 가장자리로, 땅의 끄트머리로, 바다로, 고향으로 갔으리라. 나는 포대기 속에서 달콤한 바다의 살냄새, 바다의 하얀 종아리를 꿈꾸리라.

하지만, 그것에 대해서 말하지 않기. 그것을 향해서, 그것 안으로, 그것의 심장에게 말을 걸지 않기.

…… 자신은 나를 알고 있다고, 이미 오래전부터 알고 있었다고, 왜냐하면, 자신도 한 여자아이를 안고 고향으로 데려다 준 적이 있기 때문이

In the skies above that distant home, lightning glitters,
Father and mother both died a long time ago.

… home, is the place where one's name is born, where grasses are trampled, a naked place, he said.

At that, a name suddenly flowed out of my mouth of its own accord. Did I know that name? A long-ago sea bearing the scent of pine, young female relatives were walking along, baring their white calves to the wind. I was being carried on the back of one of them. The cozy, sweetish scent of her shoulders. Hair fresh like seaweed only just plucked from the water. She was a young woman who still had her smile, refreshing as sea-spray, and this was when her chest was prominent as waves, before she died. It was before she died. She bundled me in a red blanket permeated with the scent of pine. And so I knew. Oh, I came from that place!

I dream. Had I been born in a distant land, the last daughter of some family 20-strong, made up only of women, and died at a young age, would they have wrapped my body in a red baby's blanket and walked across the desolate steppe desert for several weeks, taking me ultimately to the furthest corner of the continent, to the edge of the land, to the sea, to the home. I dream of the sea's sweet skin-scent inside the blanket of its white calves.

But, to not speak about that. To not address words in its direction, to its inside, to its heart.

… "I know you, I already knew you a long time ago, because I too carried a girl child home once," he says suddenly. "Of course, the situation was somewhat different, but due to some chance event, in order to bury a child in a red blanket, no, a being that had at one time been a dead child, I went very far, a very long way. At that time, I almost didn't know her, but if I look back on it now, I can't say that I didn't know, since she had exactly the same name as you, the home where the

라고, 그가 불쑥 말한다. 물론 상황은 조금 다르지만, 어떤 우연한 사고에 의해, 붉은 포대기에 안은 아이를, 아니 한때 죽은 아이였던 존재를 묻어주기 위해 먼 길을, 아주 먼 길을 떠난 적이 있다는 것이다. 당시 그 자신은 그녀를 거의 몰랐지만, 지금 돌이켜 생각해보면 반드시 모른다고만은 할 수 없는 것이, 그녀는 바로 나와 똑같은 이름을 가졌으므로, 이름이 나온 고향. "나는 알지 못하는 당신의 고향으로 갔던 걸까? 당신을 멀리 앞서서, 당신의 앞선 이름을, 당신의 앞선 죽음을 안고 갔던 걸까?" 하고 그가 묻는다. 그건 자신이 갔던 그 어떤 길보다 멀고 어두웠다고 그는 말한다. 해질녘 새들이 날아다니는 하늘의 길. 그건 마치 꿈과 같았다고 그는 말한다. 그건 마치

…… 민들레 먹기. 그게 무엇이든. 그러면서 새를 외면하기.

연극 배우인 그가 마지막으로 섰던 무대, 버려진 낡은 학교에서 열린 바타유의 2인극 공연중에 작은 사고가 있었다. 그와 함께 공연하던 상대 여자배우가 갑작스럽게 발작을 일으켰다.

여자배우의 사지가 비틀리고 입에서 거품이 흘러나왔으나 관객들은 그것을 당연히 연기의 일부로 받아들였다. 그녀는 잠시동안 경련을 일으키다가, 입가에 살짝 침을 흘리며, 정말로 자연스럽게 죽었다! 함께 공연중이던 그 말고는 아무도 그녀의 죽음을 알아차리지 못했을 정도였다. 공교롭게도 그날 그녀가 맡은 역할은 네크로필리아(necrophilia)인 연인을 위해 시체인 척 흉내내는 여자였기 때문이다. 무대 한가운데서 죽은 배우를 두고 공연은 계속되었다. 여자배우는 죽은 다음에도 간헐적으로 사지를 수축하듯이 떨었다. 한번은, 분명히 죽은 다음인데도, 두 눈을 번쩍 뜨고 의자 위에서 왼쪽 팔을 뻗어 머리 위로 들어올리면서 왼쪽 다리를 높이 쳐들어 오른쪽 다리위로 꼬았다. 마치 춤을 추듯이, 정말로 자연스럽게. 그녀의 왼쪽 발에서 구두가 벗겨졌다. 하지만 마침 그때 격정적인 클라이

name came out. Could I have gone to your home that I am ignorant of? Could I have gone far in advance of you, carrying your earlier name, your earlier death?" he asks. "That would have been further and darker than any route I had gone before," he says. The sky road, where birds fly at sunset. It was like a dream, he says. It was like

… to eat dandelions. Whatever they are. And to ignore the bird all the while.

On the stage on which he, a theatre actor, had stood last, there was a small incident during a performance of Bataille's 2-person play, which was put on at an old, abandoned school. The female actor who was playing opposite him had a sudden fit.

Though the actress' limbs writhed and she foamed at the mouth, the audience all took this to be part of the performance. She had spasms for a while, the saliva gushed from her mouth, what a convincingly natural death! So natural, that no one was aware of her death aside from the one on stage with her. Because it just so happened that the role she was entrusted with that day was that of a woman pretending to be a corpse for her necrophiliac lover. The performance went on, leaving the dead actor in the middle of the stage. Even after she had died, she trembled intermittently as though contracting her limbs. One time, even though this was clearly after she had died, her eyes started open, she stretched her left arm out above the chair, raised her head, lifted her left leg high and crossed it over her right. As though she was dancing, quite naturally. The shoe fell off her left foot. But as that precise moment was when the play reached its explosive climax, the audience applauded, which gave him time to shunt the fallen shoe away to the side with his foot. Without anyone becoming aware of anything. The actress slumped right down and didn't move again. He saw the blood-flecked saliva at her mouth. It was blood with bubbles in it. Pretending to gesture with his arm while he spoke his

막스 낭독이 터져 나오는 순간이었기에 관객들은 박수를 쳤고, 그 틈을 타 그는 바닥에 떨어진 구두를 발로 옆으로 밀어버릴 수 있었다. 아무도 알아차리지 못했다. 그리고 여배우는 축 처졌고, 두 번 다시 움직이지 않았다. 그는 그녀의 입가에서 침과 함께 흘러나온 핏방울을 보았다. 거품이 섞인 피였다. 그는 대사를 말하면서 팔을 크게 움직이는 척 하며 소매로 그녀의 입가를 닦았다. 아무도 알아차리지 못했다. 막이 내린 후 그는 죽은 여배우의 몸 위에 공연장 구석에 굴러다니던 붉은 담요를 덮어두고, 그녀가 피곤해서 잠이 든 거라고, 그래서 커튼콜을 할 수 없다고 둘러댔다. 최후의 한 사람까지 모두 돌아가고 공연장이 텅 비게 되자, 그는 아무도 몰래 그녀의 몸을 옮기기로 했다. 공연장에 시신을 그대로 둘 수는 없었고, 게다가 그와 단 둘이 공연 중에 죽었다는게 밝혀지면 어쩌면 그가 범인으로 몰릴 수도 있었기 때문이다. 다행히도 그는 그녀가 근처에 산다는 것을 알고 있었다. 그날 공연시작 전 대화 중에 그녀는 자신의 집이 근처 바닷가 언덕 위 텅 빈 공터 가운데에 홀로 서 있는 녹색 건물 2층에 있다고, 그 집은 작고 방이 하나밖에 없지만 방세를 내지 않아도 되며 창으로는 바다가 보인다고 지나가듯 말했던 것이다. '아마도 그녀는 그 집을 말한걸거야.' 그는 공연장에서 똑바로 바라다보이는 언덕 위의 초록색 작은 집이 바로 그녀가 말한 집일거라고 짐작했다. 그런데 그녀는 정말로 그 집에 사는 것일까? 그는 의심과 불안을 떨쳐버리기 위해 고개를 세차게 흔들었다. '만약 아니라면, 이제 앞으로 살면 되겠지.'

그녀는 몸집이 작은 편이었기에, 마치 어린 소녀처럼, 그가 양팔에 간단히 안고 갈수 있을것 같았다. 하지만 시신은 놀랄만큼 뻣뻣하고 무거웠으므로 생각보다 훨씬 힘들었고 게다가 언덕 위로 오르막을 한참이나 올라가야만 했다. 인적이라고는 없는 언덕 위의 공터는 거의 키 높이까지 자란 무성한 잡초 사이로 쓰레기가 흩어졌고 내다버린 가구와 녹슨 캐비넷이 을신년스럽게 서 있었다. 고장나서 완전히 닫히지 않는 캐비넷 문이

lines, he wiped her mouth with his sleeve. And no one was aware of anything. After the curtain came down, he covered the dead actress' body with a red blanket that had been rolled up in the corner of the performance space, and covered up the lack of a curtain call by saying that the actress was taking a nap. Once the very last audience member had left and the theatre was empty, he decided to move her body without anyone knowing. Because he could not leave a corpse just lying in the theatre, and on top of that, if it got out that she had died during a performance by the two of them, he might be fingered as the culprit. Luckily, he knew that she lived in the area. Before that day's performance had begun, she had said as though in passing that her apartment was on the first floor of a green building standing alone in an empty plot of land on a hill by the sea, that though it was small, only a single room, she didn't have to pay any rent and the sea was visible from the window. "That's probably the one she was talking of." He guessed that the small green house on the hill overlooking the sea, directly opposite the theatre, was the one she had spoken of. But did she really live there? He shook his head vigorously to dispel his doubt and unease. "Even if she didn't before, she can live there from now on."

As she was on the small side, like a young girl, it seemed I would be able to go carrying her simply by both arms. But as her dead body had stiffened and become surprisingly heavy, it was much more difficult than I'd thought, and on top of that was having to go uphill. In the empty lot on top of the hill, where there was no sign of anyone else around, rubbish lay strewn between sparse clumps of weeds that had grown almost to a person's height, and discarded furniture and a rusted cabinet stood sadly. The cabinet's doors didn't close all the way and kept screeching on their runners, and behind it, someone had put up an empty tent for some unknowable purpose. The tent's torn canvas fluttered in the wind. His forehead was all sweaty. Several other shabby old houses that had originally been there had been destroyed after

25

연신 삐걱이는 소리를 냈고 그 뒤에는 누군가가 무슨 용도인지 알 수 없는 빈 천막을 쳐 놓았다. 천막의 찢어진 천이 바람에 펄럭였다. 그의 이마는 땀으로 흥건히 젖었다. 그곳에 원래 있던 다른 몇몇 허름하고 낡은 집들은 사람이 떠나버린 뒤 아무도 돌보지 않아 무너져내렸고, 여배우가 산다는, 적어도 그가 짐작한 그녀의 집만이 폐허와 잔해 사이에 유일하게 온전한 건물로 덩그러니 서 있었다. 집 건물은 3층이었는데 모두 불이 꺼져있었다. 건물 앞에는 자동차가 한대 있었으나 가까이 가보니 그것은 유리창도 모조리 깨지고 타이어와 핸들이 뽑혀나간 채 방치된 버려진 차였다. 마침내 건물 입구의 현관을 통과한 그는 기운이 하나도 남지 않아 마지막에는 죽은 여자의 다리를 잡고 계단 위로 질질끌면서 운반해야만 했다. 그런데 이건 정말로 그녀의 집일까? 집세를 낼 여유가 없는 그녀가 철거 예정 지역의 빈 집을 무단으로 점유하고 사는게 아닐까? 문득 이런 의심이 들었다. 그는 그녀에 대해서 아무것도 모르고 있었고, 그녀가 죽어버린 지금은 더더욱 알 길이 없었다. 그녀는 열쇠를 어디에 두었을까? 이렇게 생각하기가 무섭게 그의 손이 자신도 모르게 빈 집의 현관 문 위쪽을 더듬었다. 정말로 거기 열쇠가 있었다. 그는 최후의 안간힘을 내어 시신을 집 안으로 끌고 들어갔다. 커튼이 없는 창으로 흐릿한 불빛이 스며들어 전등을 켜지 않고도 어느 정도 사물을 분간할 수 있었다. 마침내 그는 패브릭이 찢어져 속 내용물이 튀어나온 낡은 소파에 온기가 채 사라지지 않은 시신을 앉혀두는데 성공했다. 그런 다음에도 당장 그곳을 떠나지는 않았다. 숨을 고르고 기운을 회복하기 위해 소파 곁 바닥에 주저앉아 잠시 쉬어야만 했기 때문이다. 빈 집에는 한동안 그의 거친 숨소리가 울렸다. 죽은 여자는 고개를 옆으로 기울인 자세로 눈을 반쯤 감고 있었다. 살짝 부풀어 튀어나온 눈동자는 어둠 속에서 노르스름한 왁스처럼 움직임이 없었고 입가에는 피를 흘린 자국이 있었다. 문득 연민의 마음이 솟구친 그는 여자를 위해 무엇인가 해 주고 싶은 마음이 들었고, 손수건에 수돗물을 적

the inhabitants left and no one else looked after them, and only the building where the actress lived, at least that he guessed had been hers, loomed among the ruins. It was a three-storey building; the lights were off on all floors. Though there was a car in front of the building, on a closer look, it had been abandoned, each window broken and its tires and handles removed. By the time he passed through the building's entrance, he had no strength left and was forced to drag the dead woman up the stairs by the legs. So was this really her place? Unable to pay rent, had she been illegally occupying an empty house in an area scheduled for demolition? This doubt came to him suddenly. He knew nothing about her, and now that she was dead there was no longer any way for him to find anything out. Where might she have put the key? No sooner had he thought this than, of its own accord, his hand was groping above the door frame. And found the key there. With the last of his strength, he dragged the body into the apartment. A dim light leached in through the curtainless window, so even though the lights were off, he was able at least to make out objects. Eventually, he succeeded in sitting the corpse, from which the heat had not yet gone, on an old sofa whose insides were sticking out through the torn fabric. Even after that, he did not leave immediately. To gather his breath and recover his strength he had to rest for a bit sitting on the floor by the sofa. His rough breathing echoed in the empty house. The dead woman's eyes were half-closed, her neck crooked to one side. Her slightly protruding eyes were unmoving, like yellowish wax in the darkness, and at her mouth there were traces of blood. Pity abruptly gushing up inside him, he wanted to do something for the woman, and wetting a hand towel at the tap he wiped her mouth. As soon as the wet towel touched them, it seemed the woman's lips twitched slightly. If it were given water, could a freshly-dead life revive again? At this superstitious thought, he brought a soaked towel to her lips and cried out without realising, "Drink, drink this!" There was no answer, and instead, the

27

셔 여자의 입가를 닦았다. 젖은 수건이 닿자 여자의 입술이 조금 달싹이는 것 같았다. 물을 마시면 살짝 죽어있던 생명이 다시 돌아오는 건 아닐까? 문득 이런 미신적인 생각이 든 그는 물을 흠뻑 적신 손수건을 여자의 입술에 대고 자신도 모르게 외쳤다. "마셔, 이것을 빨아 마셔!" 대답은 없었고, 대신 입술 사이로 검게 변한 혀끝이 조금 튀어나왔다. 혀는 배가 통통한 작고 검은 뱀처럼 보였다. 그는 손수건의 물을 짜서 여자의 혀에 떨어뜨렸다. 혀는 아무런 반응이 없었고, 대신 여자의 머리가 갑자기 앞으로 푹 꺾였다. 여자는 턱이 가슴이 닿을 정도로 고개를 깊이 떨구었고, 앞으로 쏟아진 머리카락이 여자의 얼굴을 완전히 덮었다. 창으로 스며든 흐릿한 빛이 그가 팔걸이에 올려둔 시신의 양손을 비추고 있었다. 확연히 구부러진 왼손 가운데 손가락 끝이 가만히 떨리는 것 같았다. 하지만 그것은 생명의 몸짓은 아니었고, 도리어 그 반대인 경직의 과정에 가까웠다. 그는 떠나야 했다, 아니 정확히 말하자면 달아나야 했다. 땀이 어느정도 식고 호흡도 진정되자 그는 집을 나와 문을 잠그었고, 열쇠를 원래 있던 자리에 올려놓았다. 그는 자신이 지나온 자리의 짓밟힌 풀들을 따라 더듬거리며 갔다.

　그: 나는 당신의 미래를 알아.

　나: (입술을 조금도 움직이지 않으면서 묻는다) 그렇다면 말해줘, 나는 어디로 가게 될까?

　그: 당신은 향하는 곳은 당신 이름의 고향이야. 당신은 일생동안 그곳으로 가고 있는 거야.

　나: 그렇다면 나는, 어머니와 아주머니와 자매들과 여자 사촌들로 이루어진 가족의 무리를 따르고 있는 걸까? 지금 보이지 않는 친척 여자들의 무리가 나를 이끌고 있는 걸까?

　그: 아니 그렇지않아, 당신은 어느날 불현듯 바타유 공연 도중에, 아무

blackened tip of the woman's tongue poked out from between her lips. The tongue looked like a small, black, fat-bellied snake. He wrung out the towel, so the droplets fell onto the woman's tongue. The tongue made no response, and instead the woman's head suddenly snapped forwards. Her neck dropped so deeply that her jaw rested on her chest, and the hair that fell forwards completely covered her face. The dim light that came in through the window lit both hands of the corpse that he had arranged resting on the armrests. The middle fingertip of the contorted left hand seemed to be trembling quietly. But it was not a movement of the living, in fact close to the spasms of the opposite process. He had to leave, no, to be exact, he had to flee. As soon as his sweat had dried somewhat and his breathing grown regular, he left the apartment and locked the door, and put the key back where he had found it. He stumbled away, following the grasses he had trampled on his way there.

HE: I know your future.

I: (asking without moving lips at all) Then tell me, where will I end up going?

HE: The place you are heading to is the home of your name. You will spend your whole life going there.

I: In that case, will I be going there in a family group made up of my mother and aunts and sisters and female cousins? Are they pulling me along even now, this invisible group of female relatives?

HE: No, that's not it, one day out of nowhere in the middle of a Bataille performance, without anyone being aware of it you will die, and even after you are dead, the performance continues on the stage, then the actor playing opposite you, with whom you at one time happened to have had some kind of relationship, something private between you that no one else knew about, for a very brief time and a long time ago, yet you were soon ashamed of each other, ashamed of

도 알아차리지 못하는 사이 죽을 것이며, 죽은 이후에도 무대 위에서 공연을 계속하다가, 공교롭게도 한때 모종의 관계에 있던 상대 남자배우에 의해, 오래전 아주 짧은 기간 아무도 모르게 은밀한 사이였으나, 곧 서로를 수치스러워하면서, 서로의 경솔함을 즐긴 것을 수치스러워하면서, 오직 후회 만을 남기고 만 그런 관계에 있던 남자배우에 의해서 고향으로 운반될거야. 나는 그것을 알아, 나는 당신의 미래를 알아 (잠시 침묵) 왜냐하면 그녀는 당신과 똑같은 이름을 가졌으니까.

　　목소리: 나는 네가 태어난 곳을 알아. 그건 바닷가 도시의 먼 변두리 언덕 위인데, 집은 이미 사라졌고, 풀들은 짓밟히고 나체야. 집은 이미 사라졌고, 사람은 그보다 더 먼저. 소녀는 그보다 더 먼저.

　　파도가 밀려와 우리의 몸을 적시기 시작하지만 우리는 알아차리지 못한다.

　　파도가 점점 밀려와 앉아 있는 우리의 몸 위로, 가슴 위로, 마침내는 목까지 물이 차오르지만, 우리는 알아차리지 못한다.

　　파도가 점점 밀려와 마침내 우리의 머리가 물 속으로 잠기기 시작한다.

　　파도가 점점 밀려와 마침내 우리의 형체를 완전히 집어삼킨다. 우리는 알아차리지 못한다. 단지, 나는 하나의 노래를 가졌다. 나는 하나의 춤을 가졌다. 나는 하나의 바다를 가졌다. 빛이 산산이 부숴지는 수면 위로 흰 새의 형태를 가진 목소리가 날아간다. 그날 바닷가에서, 죽기 전의 싱그러운 젊은 처녀인 친척 여자에게, 나는 입맞추었던가. 구부러진 가운데 손가락을 가졌으며, 파도처럼 부서지는 웃음소리와 함께 집을 나갔던 내 최초의 여인, 그녀는 나를 알아차리지 못한다. 대신 웃음을 멈추지 않으면서, 해변의 새들을 향해서 발길을 돌린다. 그러나 새를 보고 있는 건 아니다. 그녀는 아무것도 보고 있지 않다. 엄마. 내 입에서는 생애 최초의 말이 흘러나오지만, 나와 그녀, 둘다 그것을 알아차리지 못한다.

having enjoyed each other's thoughtlessness, the kind of relationship where now only regret remains, this actor will carry you to your home. I know it, I know your future (brief silence) because she had the exact same name as you.

Voice: I know the place where you were born. It's on the hill in the far suburbs of a town by the sea, and the house is gone already, the grasses are trampled and naked. The house is gone already, and the people were gone before that. The girl earlier still.

The waves wash in and begin to wet our bodies, but we are not aware of it.

The waves gradually wash in and over our seated bodies, up to our chests, eventually the water rises to our throats, but we are not aware of it.

The waves gradually wash in and eventually, our heads begin to sink beneath the water.

The waves gradually wash in and eventually, our forms are completely swallowed up. We are not aware of it. Only, I had a single song. I had a single dance. I had a single sea. Over the water onto which the light is smashing itself, a voice with the form of a white bird flies. That day by the sea I had kissed her, my female relative, a young woman with the freshness of the not yet dead. My first love, who had left home with her laughter smashing like the waves, she was not aware of me. Instead, while not ceasing to laugh, she turns her steps towards the sea birds. But she is not looking at the bird. She is not looking at anything. Mother. From my mouth the first word of my whole life flows out, but I and she, neither of us are aware of it.

Translated from Korean
by Debora SMITH

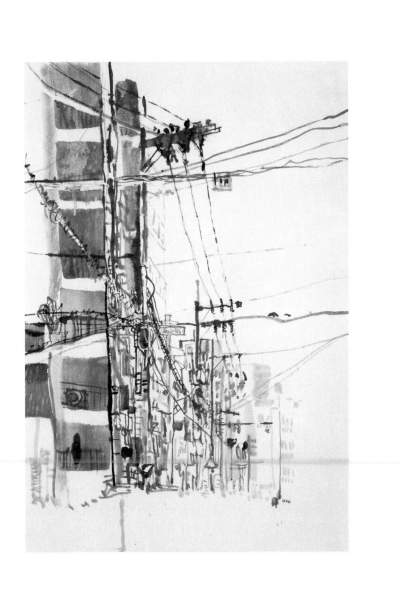

매일 산책 연습

박솔뫼

용두산 아파트 안에 들어가 보고 싶다는 생각이 들었다. 부원맨션을 정면에서 바라보면 아파트 중간에 목욕탕이라고 쓰여 있었다. 아파트 안에 대중목욕탕이 있는 것일까 생각하다가 그러나 가장 들어가 보고 싶은 부산의 아파트는 부산데파트인데 부산데파트의 내부는 최동훈의 영화에서 자세히 보았으니 안 봐도 괜찮지 않을까 생각하다가. 부동산에 연락해 매물로 나온 용두산 아파트에 관해 물었을 때 그는 방금 그 곳은 나갔다고 말했다. 그래도 나중에 비슷한 곳 나오면 보고 싶어서 그런데 한 번 볼 수 없나요? 묻고 그는 내부를 보여주는 것을 허락해주었다. 부산역에서 차이나타운을 지나 중앙동을 걷다 광복동 남포동을 향하면 국제시장 근처에 용두산 아파트는 있었다. 옛날 아파트들은 몇 세대 되지 않는 한 두 동의 건물이 도심에, 왜 여기 있는거지? 그런데 아파트라고 쓰여 있어 라는 느낌을 지나가는 사람들에게 주었고 용두산 아파트는 1층 대부분이 옷가게여서 아파트라는 간판을 보지 않으면 그 곳이 아파트인지 알아차리기 힘들었다. 용두산 아파트를 향해 가며 옛날 유나백화점 건물이었던 곳을 지나고 이 건물 6층 남자화장실에서 1982년 한 대학생이 유인물을 뿌렸다는 것을 떠올렸다. 거기서는 미문화원 전경이 보였을 것이다. 왜 젊은 사

Daily Walking Rehearsals

BAK Solmay

I wanted to take a look inside Yongdoosan Apartments. From Buwon Mansions, I could see 'BATH' written halfway across the building's facade, which made me wonder if there was a public bath on the premises; but really, the apartments I wanted to see the most in Busan were the apartments inside the Busan Department Store, though having already seen their interior up close in Choi Dong-hoon's film, I thought perhaps there was no need to go and take a look after all. When I called the real estate agent to ask about an apartment for sale in Yongdoosan Apartments, he told me the property had just been sold. "Still, could I go and have a look, in case something like it comes up later?" I asked, and he agreed to take me on a viewing. From Busan Station, I had to walk past Chinatown, go on through Jungang-dong, then head towards Gwangbok-dong and Nampo-dong to reach Yongdoosan Apartments, which was near Gukje Market. Comprising, as it did, a mere handful of units, housed within a single building and located in the middle of the city, the old Apartments bemused passersby: 'What is this building doing here?—but the sign says they're apartments?' At street-level, Yongdoosan Apartments was mostly clothing stores, which meant that, unless they read the sign, hardly anyone could tell

람이 이렇게 큰 곳에서 살려고 하냐고 더 작은 곳은 필요 없냐고 묻고 더 작은 곳도 좋다고 좋은 곳 나오면 연락 달라고 말하고 그런데 작업실로도 쓸지 몰라서 큰 곳을 보고 있다고 생각지도 않았지만 자연스럽게 대답하고 그런데 뭐하는 사람이냐는 질문에는 개인 작업을 한다고 말했다. 그 외에도 몇 개의 질문이 따라왔지만 못들은 것처럼 시끄러워서 안 들리는 것처럼 아 네 네 라고 대답하며 집에 온 정신을 집중하려고 했다. 가죽 소파와 금붕어가 노는 수족관이 거실에 있는 40평대의 집을 구석구석 열심히 보았다. 부엌에는 매실장아찌를 담근 유리병이 4개나 있었다. 용두산 아파트 내부를 구경하고 창 너머 보이는 지금은 근대역사관이 된 부산 미문화원 건물을 보았다. 어디에서는 무엇이 보이고 또 그 곳에서는 다른 것이 보이고 무언가를 보기 위해 높은 곳으로 오르고 숨기 위해 창문을 닫는다. 그런데 어떤 장면은 아무 것도 남지 않는다. 그런 것은 찍을 수도 찍힐 수도 없었다. 보는 사람은 있었을까 그것조차 알 수 없다.

백화점 건물 6층에서 미국의 80년 5월 광주에 관한 책임을 묻는 유인물을 뿌리던 남자는 자신의 동료들이 건물 1층으로 들어가고 이후 계획대로 불길이 치솟고 연기가 건물을 에워싸는 것을 보았을 것이다. 바람이 많이 부는 날이었고 무엇을 얼마나 뿌렸을 때 어느 정도의 결과가 발생하는지 그들은 몰랐고 그것을 대체 어디서 어떻게 배우겠는지. 그러므로 그것으로 이후 누군가 죽는 것을 그들은 예상하지 못했다. 아직 그 사실을 알지 못하는 6층 남자화장실의 남자는 그 곳에서 보이는 것을 떨리는 마음으로 지켜보았을 것이다. 실제로 인화물질을 들고 건물 1층으로 들어갔던 이들은 스무살 안팎의 젊은 여성 4명이었고 불을 붙인 사람들도 그 4명이었다. 불이 붙던 순간은 그 네 명만이 어쩌면 네 명 중 한 두 명만이 보았을 것이다. 백화점 6층에서 남자는 그 모습을 지켜보며 유인물을 뿌렸고 그는 후에 주동자로 지목되어 사형을 선고 받는다. 국도극장에서는 당

it was, in fact, an apartment building. On the way, I passed what was formerly the Youna Department Store and thought of how, in 1982, a university student had scattered mimeographed leaflets from the window of a men's bathroom on the sixth floor of the building. From there, he'd have had a panoramic view of the Busan American Cultural Center. "For someone so young, why are you trying to live in such a big apartment? Aren't you interested in anything smaller?" asked the agent. "A smaller place would be great," I said. "If anything comes up, please let me know." Then, with an ease that surprised me, considering I hadn't really thought about it before, I added, "I might use it as a workspace. That's why I'm looking at bigger apartments." The agent asked me what I did for a living, and I said I was a freelancer. Other questions followed, but pretending I hadn't heard him—that I couldn't hear him because of the noise—I muttered, "Yes, yes," and turned my attention to the home. Surveying the 130 square meter apartment from corner to corner, I discovered, in the living room, a leather sofa and an aquarium with goldfish; in the kitchen, there were no fewer than four glass jars of homemade pickled plums. I toured the apartment, and beyond the window, I could see a building that was now the Modern History Museum, formerly the Busan American Cultural Center. Certain things are visible from a certain location— and from that same place, other things also become visible; a person climbs higher to see something and closes the window in order to hide. But some views leave nothing behind. They can neither capture nor be captured. It's impossible to know whether anyone was even looking.

From the department store's sixth-floor window, as he scattered leaflets demanding that the U.S. be brought to account for events in Gwangju in May 1980, the student must have seen his colleagues enter the cultural center through the first floor, and then, as planned, a surging of flames and smoke enfolding the building. A strong wind

시 의대생이던 또 다른 남자가 같은 내용의 유인물을 뿌렸다. 그는 이후 부산에서 빈민들을 위한 치료를 하는 의사가 된다.

최명환 씨를 만나게 된 것은 친구의 소개였다. 친구는 최근 몇 년간 부산 사람들하고만 연애를 계속 했는데 부산의 여자들에게 부산의 남자들에게 구애를 받고 그들의 집에서 살고 그들과 데이트를 하고 부산의 거리를 걷고 또 걸었다. 야 너는 나중에 부산 시장에 나가야 되겠다 친구를 놀리고 그러나 마치 부산의 모든 거리를 아는 사람 같은 친구와 부산의 거리를 걷고 또 걷다가 부동산에 들른 이야기를 하자 아는 사람 중에 중구의 오래된 아파트를 몇 채 가지고 있는 사람이 있다고 하였다. 대체 부산에서 뭘 하고 다니면 그런 사람을 알게 되는 거지? 놀리고 싶었지만 궁금해서 일단 소개해달라고 부탁했다. 뭔가를 기대한 것은 아니었다. 단지 나는 어딘가에 들어가 보고 싶었다. 아파트를 몇 채 가지고 있다면 나이가 많을 수도 있겠다고 생각했지만 친구의 친구라는 설명을 듣고 갔을 때 나타난 사람이 60을 넘은 사람일 것이라고 생각지는 못했고 최명환이라는 이름이 여자일 것이라 생각지도 못했다. 최명환 씨라 부르지 못할 이유는 없으나 이후 나는 그를 선생님이라 불렀으므로 편의상 최선생 혹은 선생님 가끔은 최명환 이라고 부르겠다. 최선생은 내게 아직 내부수리를 한 번도 하지 않은, 그러니까 시공당시의 모습에 가까운 부산 데파트 하나와 여러 번의 내부 수리를 거치고 최근 다시 한 번 수리를 마친 부산 데파트 하나와 비슷하게 두세 번의 수리를 거친 부원맨션 내부를 보여주었다. 그는 미문화원 근처 무역회사에서 19살부터 경리로 일을 하며 돈을 모았다고 하였다. 물론 그것만으로 돈을 모았을 리는 없을 것이다. 어디서 돈을 빌리고 발 빠르게 건물을 사고 빚을 지고 또 사고 팔고 하는 과정이 있었겠지 짐작만 하였다. 친구는 최선생과 같이 책 이야기를 하고 가끔 아파트 청소와 관리를 맡아서 하고 돈을 받았다고 하였다. 친구가 일을 잘

was blowing that day, and none of them knew how much of a result they'd see when they scattered this, by that amount; how—where— could they have learned such a thing? Therefore they did not expect that somebody would die from the fire. Not yet aware of this fact, the student must have watched, with pounding heart, whatever it was that he could see from the sixth-floor men's bathroom. In truth, it had been four young women, all of them aged twenty or so, who'd entered the cultural center with inflammatory materials; they were also respon- sible for starting the fire. Of the four women, only one or two must have witnessed the moment the fire ignited. From the sixth floor of the department store, the student watched these events unfold while he scattered the leaflets; afterwards, he was suspected of leading the group and sentenced to death. Over by Gukdo Theatre, another man, a medical student, had been distributing the same leaflets. Later, as a doctor, he treated low-income and indigent patients in Busan.

I met Choi Myeong-hwan through a friend. For several years now, this friend had exclusively dated Busan natives, receiving love from the men and women of Busan, living in their homes, going out with them; and all the while he'd walked the streets of the city. "You should run for mayor of Busan someday," I'd quipped, but as I walked around Busan with this friend of mine, who seemed to know each and every street, I told him about my visit to the estate agent's office, and he said he knew someone who owned several old apartments in the Jung-gu district. I felt like teasing him—'What do you have to go around do- ing in Busan to get to know someone like that?'—but also intrigued, I merely asked to be introduced. Not that I was expecting anything in particular: all I wanted was to go inside an apartment and take a look. It occurred to me that a person who owned several apartments might be of a certain age, but as this individual was a friend of my friend, I didn't expect to meet someone over sixty; nor did I expect

한 것인지 아니면 정말로 부산의 사람들에게 도움과 사랑을 받는 운명인지는 알 수 없으나 친구의 소개로 알게 된 나에게도 최선생은 꼭 필요한 도움을 주었다. 나는 실제로 부산으로 거처를 옮길 생각이 없지는 않았고 그 이야기를 하자 게스트하우스에서 묵고 있던 내게 최선생은 몇 개월째 안 나가고 있는 부원맨션 매물을 당분간이라는 조건이지만 싼 가격에 빌릴 수 있게 해주었다. 이 집이 왜 안 나간 것일까. 원래 얼마에 내놓은 것일까. 일단은 나는 세입자가 되고 그는 집주인이 되고 원래도 집주인이었지만. 기본적으로는 최선생을 친구의 이모 정도의 느낌으로 편하게 대하다가도 집주인 어른인데 편한 마음을 가져도 되는 것인가 그런 생각이 들다가 말았다. 생각해보면 친구의 이모도 뭐 그렇게 편한 관계일 수가 없는데 말이다.

어느 날인가 친구와 친구의 예전 여자친구와 그 둘이 함께 가던 바의 주인과 최선생의 집에서 술을 마셨다. 새벽에 일을 마친 바의 주인은 잠을 자다 오후에 최선생의 집으로 왔고 가게는 안 여시나요? 그는 달력을 보라고 하였다. 월요일에 쉬는 건가요? 그는 고개를 끄덕였다. 다음 날인 월요일은 휴일이었는데 그래서 나는 바가 월요일이라 쉬는 건지 휴일이라 쉬는 건지 알 수 없었지만 더 묻지는 않았다. 친구의 예전 여자친구 미혜 씨는 술을 마시다 울고 우리는 잠시 달래주었지만 놀라거나 호들갑 떨지 않았는데 그럴 만한 일도 아니었고 미혜 씨도 곧 눈물을 닦고 술을 계속 마시고. 서로 웃다가 순간적으로 우리가 껴안아도 될 것처럼 느껴지는 때. 콧물을 푸는 미혜 씨의 등을 감싸고 아직 눈물이 맺힌 눈을 한 미혜 씨는 몸을 돌려 나를 껴안았다. 친구는 막 웃고 바 주인은 위스키를 마시고 있었다. 우리는 문어를 간장과 초장에 찍어 먹었다. 이렇게 좋은 건 어디서 난 거예요? 최선생은 아는 사람에게 받았다고 하였다. 바의 주인이 가져온 꽃게는 삶아서 먹고 라면에도 넣어 먹었다. 근처에 사는 미혜 씨는

anyone by the name of Choi Myeong-hwan to be a woman. (There's no reason not to refer to her by name, but seeing as I've addressed her as 'seonsaeng-nim' since the day we first met, I'll—for the sake of convenience—call her Choi seonsaeng, seonsaeng-nim, or occasionally Choi Myeong-hwan.) Choi seonsaeng took me around several properties: an apartment in Busan Department Store that had never been renovated, which meant it looked more or less the way it had at the time of construction; another unit in the same building that had been fixed up a number of times, including once recently; and a Buwon Mansions apartment that had likewise been renovated two or three times. She said she'd saved up money by working from the age of nineteen as an accounting clerk at a trading company near the American Cultural Center. It was unlikely, of course, that she'd saved up by that means alone; there must have been some kind of scheme that involved borrowing money, buying up property, acquiring debt, then buying and selling again. My friend said he and Choi seonsaeng discussed books with each other, and that on a number of occasions, he'd cleaned and managed her properties and been paid for the work. Whether it was because my friend had done a good job of it, or because he was destined to receive love and support from the people of Busan, I'll never know; but after my friend introduced me to Choi seonsaeng, even I ended up receiving her indispensable support. As it happened, I was thinking quite seriously about moving to Busan (I'd been staying at a guesthouse), and when Choi seonsaeng learned of this, she said there was an apartment for sale at Buwon Mansions that had remained unsold for several months, and that I could rent it from her temporarily, at a reduced rate. Why hadn't it been sold? How much had it been placed on the market for? In any case, I became a tenant and she became the landlord (though she'd always been a landlord). Mainly, I regarded her as an aunt of a friend, but she was also my older landlord; and for a while I wondered if it was all right to be on

너무 늦지 않게 걸어서 돌아가겠다고 말하고 친구는 머리가 아프다며 산책을 하고 오겠다고 하였다. 당연히 술에 취하지도 흐트러지지도 않은 바의 주인은 마시던 위스키를 설명해주고 나 역시 어른이지만 이 어른들 사이에서 순간 내가 아닌 부산에서 태어나고 자란 모 씨 부산에서 대학을 나오고 직장을 다니는 모 씨 내일이 휴일이라 아는 동네 어른들과 술을 마시는 모 씨 부산이 고향이지만 회와 돼지국밥을 좋아하지 않는 모 씨가 된 기분이 들었다. 나는 회와 돼지국밥이 좋지만. 그렇게 어느 순간 서로의 오래된 역사를 잘 알고 있는 모 씨가 되어 둘에게 더욱 깊은 친근감을 느끼며 술을 마시며 담배를 피웠다. 아직 돌아가지 않은 미혜 씨의 친구가 오고 미혜 씨의 친구는 빠르게 위스키를 두 잔 마신 후 미혜 씨와 함께 일어나고 나와 바의 주인은 서서히 자리를 정리하였다. 꽃게 껍질을 봉투에 담고 병들을 치웠다.

술을 마시면 잠이 들어버리는 사람 또 다른 어떤 사람은 술을 마시고 잠들면 금세 잠에서 깨어버리는 사람. 바의 주인은 끝까지 점잖게 자리를 정리하고 선물로 꼬냑을 한 병 두고 갔다. 꼬냑에 대한 설명과 함께 그는 쓰레기를 손에 들고 나갔다. 나는 최선생의 거실에서 자겠다고 하였다. 이를 닦고 나와 최선생과 나란히 소파에 앉았다. 우리는 보리차를 마시며 텔레비전에서 나오는 영화를 보았다. 영화와 영화 사이 광고는 길고 나는 저 감독의 다른 영화를 본 적이 있다고 말하며 영화 줄거리를 설명하려 하였지만 이미 본 영화의 내용을 정확히 설명하는 것이 생각보다 어렵다는 것을 나는 그 때 알게 되었다. 내가 설명을 시작한 영화는 자주 막히고 이야기는 틈을 들이고 주인공들은 무엇을 할지 몰라 멈췄다가 어색하게 움직였다가 그런 식으로 덜컹거렸다. 이야기를 얼버무리다 영화는 다시 시작하였고 나는 다음 광고쯤 잠이 들었다. 그런데 가끔 내가 그 영화를 지어냈다면, 그 여자는 그래서 어떻게 했냐면…… 내가 보았던 것과 상

such familiar terms with her. If you think about it, a friend's aunt isn't exactly someone you can be familiar with, either.

One day, my friend, his ex-girlfriend, the owner of a bar that the former couple used to frequent together, and I were drinking with Choi seonsaeng at her home. The bar owner had closed up in the early hours of the morning and joined us after a day's sleep. "Don't you have to go and open your bar?" He told me to look at the calendar. "So you rest on Monday?" He nodded. As it was not only a Monday but also a public holiday, I couldn't tell whether the bar was taking the next day off because it was a Monday or because it was a public holiday, but I didn't ask further. My friend's ex-girlfriend, Mi-hye, who'd been drinking, started to cry, and for a while we tried to console her. We weren't startled or disturbed by her weeping—it was in fact nothing to be surprised by or make a fuss over—and soon Mi-hye had wiped away her tears and resumed drinking. We smiled at each other, laughing a little, and for a moment it seemed all right to hold each other. As Mi-hye blew her nose, I embraced her from behind; still looking teary-eyed, she turned around and hugged me. My friend burst out laughing, and the bar owner drank his whisky. We ate octopus, which we dipped in soy sauce or gochujang mixed with vinegar. "Where did you find such a good one?" Choi seonsaeng said that the octopus had been given to her by someone she knew. The bar owner had brought some blue crabs, which we ate boiled; we added a few to ramen and ate that too. Mi-hye, who lived nearby, said she'd walk home before it got too late, and my friend said his head hurt and he was going for a walk. The bar owner, who was, of course, neither drunk nor tipsy, began to explain the whisky he'd been drinking; and in that moment, in the presence of the two older adults (though I too was obviously an adult), I felt myself turning into different person, someone who was born and bred in Busan, who'd gone to university in Busan and was now work-

관없는 이야기를 이어나갔다면 생각한다. 최선생은 언제쯤 나의 거짓말을 알아차리게 될까. 다음 날 사과를 깎아 먹으며 최선생은 내가 자느라 못 본 영화가 어떻게 진행되었는지 설명해주었다. 여자는 추운 곳에서 돌아와 다시 사업을 하는 남자를 만나고 그의 집에서 머문다. 그것은 사랑이라고 할 수 있다. 여자는 남자를 따라 다시 일본으로 가지만 그를 다시 만날 수는 없었다. 그의 설명은 정확하고 매끄러웠다. 그러한 시간은 몇 번인가 반복되었고 그 때 마다 최선생은 영화의 뒷이야기를 해주었고 나는 몇 시간 전까지 보던 영화가 왜인지 처음 보는 영화처럼 느껴지기도 하였다. 자기 전 보던 것들은 꿈처럼 허물어지고 녹아가는 것 같다. 그런 아침에는 사과를 먹고 영화 속 사람들의 이야기를 듣고 이미 준비를 마친 최선생은 커피를 마시고 있었고 나는 그제야 나갈 준비를 하였다. 극장은 아니지만 극장을 나설 때처럼 방금 들은 이야기를 가지고 밖으로 나서면 이곳이 어디인지 자꾸만 생각하였다. 소금이 물에 녹는 것처럼 이야기는 곧 흩어졌지만 바람이 불거나 막다른 골목에서나 누군가의 얼굴에서 어제 본 영화는 겹쳐졌다. 이곳은 아직 눈은 오지 않지만 겨울이 되어도 눈은 드물지만 어제 여자는 눈길을 뛰고 눈을 베어 물었다. 당신은 그 여자가 아니지만 여기는 부산이지만 나는 당신과 눈이 마주치고 나는 잠이 들기 전 본 세계와 눈을 뜨고 들은 이야기만을 가지고 길을 걸었다.

부산에서 지내던 몇 개월간 평소의 나는 산책을 하고 싼 곳에서 밥을 사먹거나 간단히 만들어 먹고 도서관에 가서 책을 보았다. 그리고 글을 쓰고 최선생이 청소나 간단한 일을 맡기면 성실히 해내고 돈을 받았다. 부산에서 직장을 다니는 생각도 해보았고 직장을 다니며 대학원을 다니는 생각도 했다. 몇 년간은 쉬지 않았으니 당분간 쉬겠다는 생각도 하다가 밤이면 근처 고등학교 운동장을 뛰었다. 가끔 바닷가를 뛰어볼까 하는 생각도 하였지만 실제로 하지는 않았다.

ing in Busan, who was drinking with the older locals because it was a public holiday tomorrow, and who, despite being from Busan, didn't like raw fish or pork rice soup—which I, in fact, like. Having become this person, who'd known the two other adults for years—adults with whom I now felt a deeper sense of closeness—I drank and smoked cigarettes. A friend of Mi-hye's arrived (the latter hadn't left yet) and quickly downed two glasses of whisky before getting up to leave with her. Gradually, the bar owner and I began to clean up; we placed the crab shells in a plastic bag and cleared the bottles away.

Some people fall asleep when they drink; others, if they fall asleep, wake up in no time at all. Soberly, the bar owner stayed behind until everything had been cleared away. As a gift, he left behind a bottle of cognac, which he took care to explain to us before departing with a bag of trash in his hand. I said I'd sleep in the living room. After brushing my teeth, I sat down next to Choi seonsaeng on the sofa, where we sipped barley tea and watched a film that was showing on television. At some point during a long commercial break, I mentioned that I'd seen another film by the same director and began to describe the plot; but I realised only then how difficult it was to accurately recount a film one had already seen. The plot was jerky and slow-paced, featuring characters who would pause, bewildered, before awkwardly moving around again, and it kept lurching about in this way. As I floundered with the storytelling, the film resumed on television, and by the next commercial break, I was fast asleep. Sometimes, I wonder what might have happened if I'd simply made up the plot: "So what the woman did next was..." What if I'd said something irrelevant to what I'd seen? How long would it have taken Choi seonsaeng to discover that I'd lied? The next day, as she peeled and ate apples, she filled me in on what I'd missed by falling asleep: "The woman returns from the cold country, reunites with the businessman, and stays at

최선생은 가톨릭 신자였고 그러고 보니 친구도 가톨릭 신자였는데 어릴 때 교회에 다니던 나는 개신교 신자에게 아무런 친밀감을 가지지 않으나 가톨릭 신자들은 서로 친밀감과 유대감을 가지는 걸까? 그래서 친구와 최선생은 쉽게 친해진 걸까 하는 생각도 들었다. 최선생은 영도에 있는 봉래성당을 다녔다. 그는 20년 넘게 미문화원 옆 무역회사에서 일하였고 미문화원 옆에는 한국전쟁 직후 건립된 중앙성당도 있었는데 왜 굳이 버스를 타고 영도까지 가서 성당을 다녔는지 물었다. 모르겠네. 왜 그랬는가. 최선생은 한동안 성당에 다니지 않았다고 했다. 삼사십대의 이십년 가량은 성당에 다니지 않고 주말에도 일을 하고 등산을 다니고 사람들을 만났다고 하였다. 의례처럼 국제시장 주변을 한 번 돌고 최선생이 다니지 않았던 중앙성당 앞에 섰을 때 문득 한 번 들어가 보고 싶어졌고 선생님께 전화를 걸었다.

"성당에 그냥 들어가도 돼요?"
"그럼 들어가도 돼지. 근데 조용히. 뭐 조용히 앉아있으면 됩니다."

스테인드글라스를 통과한 빛들은 바닥에 붉고 노란 그림자를 만들었고 동으로 된 피에타 상은 나와 눈을 마주치지 않았고 녹음된 오르간 소리는 끊어지다 이어졌다. 조용히 들어온 두 사람은 손을 모아 기도를 하고 나는 나를 위해서도 기도하고 싶지 않다는 것을 느끼고 그러나 잠시 다른 사람이 된다면 며칠 전 나 대신 술을 마셨던 모 씨라면 여기서 기도를 할 것이라는 생각 그는 가족과 이웃의 건강과 평안을 바랄 것이라는 생각 그것은 진실되고 거짓이 없는 마음일 것이라고. 나는 그가 이제는 볼 수 없는 친구처럼 그리웠고 그러니 나도 누군가를 위해 기도를 하게 될지도 모른다는 생각을 했다. 조용히 문을 닫고 나왔을 때 오후의 태양은 선명했고 아래로 내려가는 엘리베이터 안에서 선생에게 감사 인사를 보내고 그

his home. You could call that love. The woman follows the man back to Japan, but is unable to meet him again." It was a fluent and exact description. There were several more such evenings; in the following morning, Choi seonsaeng would recount the rest of the film, and even though we'd been watching it only a few hours earlier, I'd feel as if I was hearing about it for the first time—as if everything I'd seen before falling asleep had crumbled and melted away like a dream. On such mornings, I'd listen to the story about the characters in the film as I ate slices of apple, while Choi seonsaeng, already set to leave, drank her coffee; only afterwards would I start getting ready for the day. And when I finally headed out, my thoughts would be full of the story I'd just heard as if I'd stumbled out of a theater (and my apartment was no theater), and I'd keep wondering where I was. Soon enough, the story would dissolve like salt in water; but a blowing wind, a blind alley, a passing face would overlap with the film from the night before. It isn't snowing here, not yet; even in winter it doesn't often snow—but the woman last night was running along streets capped with snow, taking mouthfuls of it. You're not that woman, of course, and this is Busan; but your eyes met mine—and accompanied only by the world I'd seen before falling asleep and by the story I'd heard with open eyes, I walked the streets.

During the months I spent in Busan, I went for walks, ate at cheap restaurants or prepared simple meals at home, and read books at the library; I also did some writing. At Choi seonsaeng's request, I ran errands and did house cleaning, which I carried out diligently and for which I was paid. I considered finding a job in Busan, and even attending graduate school part-time; as I'd worked for several years without a break, I also thought about taking some time off. Meanwhile, at night, I'd jog in the sports field of a nearby high school. Sometimes, I thought about going for a run by the sea, but in fact I never did.

런데 세례명이 뭐예요 묻자 그는 마르타라고 하였다. 음식을 차려주는 성
녀라고. 나는 내가 먹은 문어와 위스키를 떠올렸고 그 전에 얻어먹은 갈
치조림과 칼국수를 떠올렸다. 다음에 선생님을 만날 때 빵을 사갈 것이다.
여전히 눈이 부시다는 생각을 하며 길을 나섰고 큰 건물과 넓은 도로 저
너머에 바다가 있음과 수없이 쌓이고 옮겨지는 컨테이너가 있음을 길을
걸으며 왜인지 실감하며 어디로 향하는지도 모르게 길을 걸었다.

 부산근대역사관 건물 계단을 내려갈 때면 작은 창으로 옆에 서 있는
건물의 간판이 보였다. 2층에서 1층으로 내려갈 때 점집이 보였고 그 너
머로 인삼가게 간판이 보였다. 오래된 건물이었지만 잘 관리된 곳이었고
이 곳이 이전에는 도서관과 상영관과 또 어떤 시기에는 대사관 업무를 겸
한 곳이었구나 잘 그려지지는 않았지만 이곳을 오갔을 미국이라는 곳을
새로운 세계를 꿈꾸었을 학생들을 떠올리고 그들이 어디로 흩어졌을까
생각하고 그러다 그 곳에 불을 붙인 이들을 떠올렸다. 그 중 한 명은 후에
작가가 되고 몇 권의 책도 번역하였다. 나는 그가 번역한 밥 딜런 평전을
도서관에서 빌려왔다. 밥 딜런에게 아무런 관심도 없었고 옮긴이의 말을
보기 위해 빌린 것이었으나 읽다보니 의외로 흥미로워서 끝까지 읽게 되
었다. 밥 딜런은 1962년 초봄 「바람만이 아닌 대답」(Blowin' in the Wind)
을 썼고 그는 초연을 하기 전 "지금 부를 이 곡은 저항곡이 아니며 그런 식
의 무엇도 아니다 왜냐하면 나는 저항곡을 쓰지 않기 때문이다…… 그저
누군가를 위해서, 누군가에게 전해들은 것을 쓸 뿐이다"라고 소개했다.[1]
이후 딜런은 쿠바 미사일 위기에 대응하여 「폭우가 쏟아지네」(A Hard
Rain's a-Gonna Fall)를 쓴다. 이후 해당 곡의 초연을 듣기 위해 카네기
홀에 모인 청중 모두 「폭우가 쏟아지네」가 쿠바 미사일 위기에 관한 노래
라고 생각했다. 카네기 홀의 청중은 딜런의 새 노래에 감동받았고, 몇 주

1 마이크 마퀴스, 『밥 딜런 평전』, 김백리 옮김(서울: 실천문학사, 2004), 74쪽.

Choi seonsaeng was Catholic—and come to think of it, so was my friend. As a child, I'd attended a Protestant church, but had never felt particularly close to any of the congregation. Do Catholics feel an affinity or a sense of closeness with each other? Was this why my friend and Choi seonsaeng had grown close so easily? The latter went to the Bonglae Catholic Church in Yeongdo. I wanted to know why she insisted on taking the bus all the way to Yeongdo for church, despite the fact that Jungang Cathedral, built immediately after the war, was right next to the American Cultural Center and the office building where she'd worked for more than twenty years. "I'm not sure," she replied. "I wonder why." There was a time when she hadn't gone to church at all, she said; for about twenty years in her thirties and forties, she'd worked, gone hiking, and met up with people instead. One day, after a courtesy stroll around Gukje Market, I found myself standing in front of Jungang Cathedral—the church that Choi seonsaeng wouldn't attend—and, seized by a sudden desire to take a look inside, I called seonsaeng-nim on the phone.

"Can I just go inside?"
"Of course you can. But quietly. It'll be fine if you sit there quietly."

Light entered through the stained glass, dappling the floor with red and yellow shadows. A copper Virgin Mary, seated in a pietà, wouldn't meet my eyes, and a recording of organ music kept stopping and starting. Two people entered quietly and began to pray, hands held up in front of them. I didn't feel like praying, even for my own sake; but what if I became someone else for a while? If I were that person from Busan who'd been drinking instead of me a few days ago, I'd be praying in this place, praying for the peace and health of family and neighbours, and it would be heartfelt and not at all insincere. I yearned for this person like a friend I'd never see again, and I realised that I, too,

후 실제로 미사일이 발견되자 그들은 경악했다.[2] 이 부분을 읽다가 현재와 미래를 생각하는 사람들 와야 할 것들을 끊임없이 생각하고 지금에서 그것을 지치지 않고 찾아내는 사람들은 이미 미래를 살고 있다고 생각했다. 시간을 끊임없이 바라보고 와야 할 것들에 몰두하고 사람들의 얼굴에서 무언가를 찾아내고자 하는 이들은 와야 할 것이라 믿는 것들을 이미 연습을 통해 살고 있을 것이라고. 어떤 시간들은 뭉쳐지고 합해지고 늘어나고 누워있고 미래는 꼭 다음에 일어날 것이 아니고 과거는 꼭 지난 시간은 아니에요. 나는 이 책의 번역자는 광주라는 사건을 끊임없이 자신에게 묻고 그 이후 시간의 의미를 묻고 답하였을 것이라고 생각하기 시작하였다. 동시에 1980년 5월에 그들 자신이 광주에 있었다면 이라는 가정을 반복하고 또 반복하였음을 역시 알 수 있었다. 그러다 문득 그것이 아닐 것이라는 생각이 들었다. 그들이 반복한 것은 그 때 그들이 그곳에 있었다면이 아니라 그 때 그곳에 누군가 있었다는 사실일 것이다. 그러나 나는 그가 미국이 자신들의 책임을 인정하는 미래를 연습하였을지는 알 수 없었다. 불을 붙인 이후의 시간을 미래라 생각하였을지도 알 수 없었다. 아마도 그들은 그런 미래를 생각 하지 않았을 것이다. 그럼에도 왜인지 그가 새로운 세계를 스스로 믿고 살아내어 미래를 현재로 끌어당겨 반복하여 왔음은 이해할 수 있었다.

미문화원을 방화한 이들이 그 날 부산 시내에 뿌린 성명서의 시작은 다음과 같다.

"미국은 더 이상 한국을 속국으로 만들지 말고 이 땅에서 물러가라.
우리의 역사를 돌이켜보건대, 해방 후 지금까지 한국에 대한
미국의 정책은 경제수탈을 위한 것으로 일관되어 왔음을 알 수

2 같은 책, 79쪽.

might one day find myself praying for someone. By the time I got up and quietly closed the door behind me, the afternoon sun had turned luminous. In the elevator, I texted seonsaeng-nim to thank her. 'By the way, what name were you christened?' I wrote. 'Martha,' she replied. 'The saint who serves food.' I thought of the octopus and whisky I'd had, and a meal of braised beltfish and kal-guksu soup that she'd once bought for me. I should buy some sweet bread before I visit her next time, I told myself. It was still dazzlingly bright as I stepped into the street, and somehow I could sense, beyond the tall buildings and the wide road, the presence of the sea and the countless containers that were being stacked and moved—and without knowing where I was heading, I began to walk.

Descending the stairs of the Busan Modern History Museum, I could see, through a small window, the signboards on nearby build-ings. On the steps that led down from the second floor to the first, I could see a fortune-teller's shop, and beyond that, a sign for a gin-seng store. The museum building was old but well-maintained; it had once been a library and a cinema, and had also served at one point as a center for embassy services—and though I couldn't really picture it, I tried to imagine the students that must have walked through its doors, dreaming of America, a new world. I wondered where they were all now, and I thought of the students who'd started the fire. One of them became a writer and had even translated several books. From the library, I took home a book translated by the former student; it was a critical biography of Bob Dylan. I had no interest in Bob Dylan and had only borrowed the book to read the translator's note, but it turned out to be more interesting than I'd expected and I read it to the end. In early spring of 1962, Bob Dylan wrote the song "Blowin' in the Wind," on which he later remarked, just as he was about to perform it live for the first time, "This here ain't no protest song or anything like that,

있다. 소위 우방이라는 명목하에 국내독점자본과 결탁하여 매판
문화를 형성함으로써, 우리 민족으로 하여금 그들의 지배논리에
순응하도록 강요해왔다. 우리 민중의 염원인 민주화, 사회개혁,
통일을 실질적으로 거부하는 파쇼 군부정권을 지원하여 민족분단을
고정화시켰다. 이제 우리 민족의 장래는 우리 스스로 결단해야
한다는 신념을 가지고, 이 땅에 판치는 미국세력의 완전한 배제를
위한 반미투쟁을 끊임없이 전개하자. 먼저 미국문화의 상징인 부산
미국문화원을 불태움으로써 반미투쟁의 횃불을 들어 부산시민에게
민족적 자각을 호소한다……"[3]

사건 직후 불을 붙인 학생 몇몇의 출신 학교인 고신대학교는 다음과
같은 문장이 포함된 성명을 발표하였다.

"금번 '미문화원 방화사건'에 우리 학생 몇몇이 관련되었다는 보도는
가슴을 찢는 듯한 통증을 안겨다 주었읍니다. 그러나 우리 모두는 이
일에 전혀 관계가 없으며 우리의 떳떳한 입장을 분명히 하여야 겠읍니다.
　　이 시점에 있어서 우리 고신인들은 겸손한 마음과 담대함으로
하나님 앞에 무릎을 꿇어야 겠으며 이번 교훈을 통하여 조금의 동요도
없이 학문과 신앙에 더욱 매진하여야 겠읍니다."

　　　　　　　　　　　　　　　—1982년 3월 30일, 고신대학 총학생회장[4]

우리 민족의 장래는 우리 스스로 결단하기 위해 사람들이 반복한 미
래는, 겸손한 마음과 담대함으로 반복하는 천국의 미래와 기도의 시간

3　김은숙, 『불타는 미국』(서울: 아카페, 1988).
4　부산 미문화원 방화사건에 관한 고신대측의 성명서. <https://archives.kdemo.or.kr/
　　isad/view/00711516>

'cause I don't write no protest songs… I'm just writing it as something to be said, for somebody, by somebody."[1] Subsequently, he wrote "A Hard Rain's a-Gonna Fall" in response to the Cuban Missile Crisis; everyone who attended the song's premiere at Carnegie Hall believed it was about the Cuban Missile Crisis. At Carnegie Hall, the audience was moved by Dylan's new song, and they were astonished when, a few weeks later, actual missiles were discovered in Cuba.[2] As I read this passage, it occurred to me that those who reflect on the present and the future—those who think unceasingly of what must come to be, and tirelessly search for it in the present—are already living in the future; that such individuals—who gaze at time, devote themselves to what must be, and attempt to find whatever it is they are looking for in people's faces—are rehearsing a life that they believe must come to pass. 'Certain moments in time clump together, merge, expand, and recline; the future isn't necessarily what will occur next, nor is the past simply things that have already happened.' I began to think that, for the book's translator, the incident that was Gwangju, and the meaning of time after Gwangju, had posed a question that had to be asked, and answered, and asked again. At the same time, I could tell that they'd repeatedly asked themselves: 'What if *I'd* been in Gwangju in May, 1980…?' Then it struck me that this might not be true—that actually, it hadn't been a question of 'what if' that they'd posed repeatedly to themselves, but the very fact that anyone had been there in Gwangju at the time, at all. But whether they'd rehearsed a future in which the U.S. admitted responsibility, it was impossible for me to say. Nor could I tell whether the time after the arson incident was their idea of the future; in all likelihood, they hadn't thought of the future on such terms. Nevertheless, I somehow understood that this person

1 *Bob Dylan: A Critical Biography* [Pyeongjeon] (Mike Marqusee, *Chimes of Freedom: The Politics of Bob Dylan's Art*), Seoul: Silcheon Munhak Press, 2004, p. 74.
2 Ibid, p. 79.

은. 두 미래는 다른 곳에 존재하며 사람들은 두 세계를 오갈 수 없다. 하지만 천국의 미래를 그리는 자들이기에 민족의 장래를 그렸을지도 모르겠다. 종교를 가진다는 것은 미래를 연습하는 훈련을 거치겠다는 것과 아주 다르지 않을 것이라는 생각을 했다. 그들이 손으로 만지고 반복한 미래는 어떤 것이었을지 다시 생각하다가 그것을 묻고 되묻고 답하고 다시 묻는다면 끌어온 미래도 이미 일어난 과거로 혹은 지금 살아가는 현재로 믿을 수 있는가.

성당을 다녀온 최선생이 도넛을 들고 집에 들렀다. 내가 살고 있으니 나의 집이지만 최선생의 집인 그 곳에서 거기에는 소파도 없고 텔레비전도 없었고 테이블과 의자만 두 개 있었다. 나는 바닥에서 잠을 자고 바닥에서 책을 읽었다. 바닥에는 요와 얇은 이불이 있었다. 자기 위해 이불을 덮으며 일어나기 위해 이불에서 빠져나올 때 마다 부산에 있다는 것이 새삼스럽게 느껴졌다. 뭔가를 마음먹고 해야 할 때는 밥을 먹는 테이블에 앉았다. 거기서 최선생이 맡긴 일을 하고 집중해서 읽고 싶은 것을 읽고 글을 쓰고 노트북을 올려놓고 부산의 일자리와 대학원과 집값을 알아보았다. 최선생이 영도에서 사온 도넛을 테이블에 앉아 인스턴트 커피와 함께 먹었다. 이거 유명한 거야. 1970년대부터 영업을 했다는 이모 도나스에서 사온 도넛을 먹으며 비가 내리고 있는데 비는 안맞으셨어요 묻고 최선생이 묻히고 온 물냄새 비냄새를 맡았다. 커트머리에 안경을 쓰고 있는 최선생, 집주인은 내게 갑자기 집을 나가라고 말하지 않을까 최선생이 아무 말도 안했는데 갑자기 그런 가정을 하고 최선생은 성당 사람들에게 내가 뭘 하는 사람인지 모르겠다고 말하는 것 아닐까 그래도 덤덤하게 받아들여야지. 뭐하긴요 놀아요 라고 말하고 웃어야지 일어나지 않은 일을 순간 순간 가정하고 표정을 읽으려 들고 읽을 수 있을 리가 없는데 읽는대도 내가 뭘 할 수 있을까. 일단 항의라든가 거부나 교섭이라든가 그런건

had believed in, and lived, a new world of their own, in a repeated attempt to bring the future into the present.

The manifesto—copies of which the arsonists scattered in the center of Busan on the same day they set fire to the American Cultural Center—begins:

"The U.S. should no longer treat Korea as a subject state, and must leave this land at once.

Looking back at our national history, we can see how, from the date of our independence to the present day, U.S. policy towards Korea has been consistent with economic exploitation. Under the pretext of being an ally, the U.S. has colluded with domestic monopolistic capitalists and created a comprador bourgeoisie, forcing our people to accept their logic of domination. By backing the fascist military government, which has more or less denied the people's wish for democratisation, social reform, and reunification, the U.S. has reinforced the division of our people. Now, armed with the belief that we, the people, must determine our future for ourselves, let us ceaselessly advance the anti-U.S. struggle so that total removal of U.S. power and influence from this land is achieved. First, we set fire to the Busan American Cultural Center, a symbol of American culture, and thus lift up the torch of the anti-U.S. struggle and appeal to the citizens of Busan for national self-awakening…"[3]

Soon after the incident, Kosin University, to which several of the student arsonists were affiliated, issued the following public statement.

3 Kim Eun-suk, *America on Fire* [in Korean], Seoul: Agape Press, p. 41.

별로 하고 싶은 마음이 들지 않았다. 그런 어디서부터 시작한 건지 알 수 없는 생각을 하며 커피를 마시다 얼마 전에 미문화원 건물에 들어가 보았다고 말했다. 선생은 1982년 미문화원에 불이 나던 그 날이 기억난다고 말했는데 아직 쌀쌀한 봄이었고 바람이 많이 부는 날이었고 연기가 주변 건물 열어놓은 창에 들어올 정도로 엄청나서 문을 닫고 일을 하다가 몇몇은 먼저 집으로 돌아가고 일이 남은 최선생은 기침을 하며 일을 하다 밤이 되어 돌아가는데 지하도 계단을 내려가다 구두를 신은 채로 넘어졌고 위로 올라간 치마를 보고 지나가던 세 명의 남자는 휘파람을 불었고 그 중 한 명은 최선생에게 맞으라는 듯이 겨냥하여 바닥에 침을 뱉었다. 그리고 그 중 한 명은 지나가다 다시 돌아와 치마 안으로 손을 넣어 다리 사이를 만졌다. 10초 정도의 아주 짧은 시간이었고 최명환은 아무렇지 않은 것처럼 얼른 치마를 내리고 밝은 곳으로 밝은 곳으로 뛰듯이 걸었다. 이후 최명환은 성당에 다녀오면 도넛을 사서 나의 집으로 아니 그의 또 다른 집으로 왔고 우리는 도넛을 먹으며 이야기를 한다. 방화사건 며칠 뒤 최명환은 지하도를 지나기 싫어 길을 돌아가다가 어느 병원 앞에서 사람들이 이야기 하는 것을 들었는데 40대 남자 둘은 빨갱이들은 죽어도 괜찮다는 이야기를 하고 있었다. 나는 최명환의 옆얼굴을 보면서 이야기를 들었다. 도넛은 맛있고 최명환은 커피를 마시며 이야기를 이어나갔다. 오후에 멈춘 비는 갑자기 쏟아지기 시작했고 지금도 나는 누군가 죽어도 좋다는 이야기 / 어떤 사람들은 나라에서 쓸어버려도 좋다는 이야기 / 모자라 보이는 사람들은 흐름에 탈락되어 죽어버려도 좋다는 이야기를 자주 듣는다. 커피를 다 마신 그는 불을 붙인 학생 중 한 명과 같은 성당에 다녔다는 이야기를 하였다.

"김은숙 씨인가요?"
최선생은 대답 없이 커피를 마시고 있었다.

"The recent news that several of our students were involved in the American Cultural Center arson incident has pained us greatly. But the incident bears no relation to us in any way whatsoever, and we must openly clarify our position on the issue.

At this point in time, we, the student body of Kosin University, must kneel before God with humility and courage and take instruction from this incident to strive all the harder for faith and knowledge without wavering in the slightest."

—President of Kosin University Student Union, March 30, 1982[4]

A future rehearsed so that we, the people, can determine our fate for ourselves; and a future that is the kingdom of heaven and a time of prayer, repeated with humility and courage—these two futures exist in separate dimensions that cannot be crossed from one to the other. But for these students, could it be that, because they imagined a kingdom of heaven, they also imagined a future of the people? Having a religion, it seemed to me, was not so different from deciding to undergo training in rehearsing a future. Again, I wondered what kind of future they'd rehearsed and touched with clasped hands. And then I thought: if this sort of thing is questioned, answered, and questioned again, would anyone believe that a future has been brought into the past or the present in which we all now live?

After church, Choi seonsaeng came over to my place with some doughnuts. The place was mine because I lived there, but it was also hers; there was no sofa or television, only a table and two chairs. I slept or read books on the floor, where there was a sleeping mat and a thin blanket. When I went to sleep, I'd cover myself with the blanket; every time I woke up and slipped out from underneath, I'd realize

4 Statement from Kosin University on the arson incident at the Busan American Cultural Center, <https://archives.kdemo.or.kr/isad/view/00711516>.

어느 날은 나도 버스를 타고 영도 봉래 성당에 가보았다. 성당 앞에는 그늘이 있는 벤치가 있었고 나는 뭐가 있는지도 모른 채 자리에 단지 앉으려고 하였는데 검은 덩어리는 소리를 내며 움직여 사라졌다. 저거 표범이야 흑표범. 나는 내 옆에 누가 있는 것처럼 혼잣말로 검은 고양이를 가리키며 말했다. 고양이는 문 앞에 누워 있었다. 조용히 계단을 올라 문을 열고 안으로 들어가 뒷자리에 앉았다. 어느 성당이건 스테인드글라스는 아름다운 그림자를 만들었고 노란색 붉은색 그림자는 흐린 테두리를 만들며 흔들렸고 나는 최선생은 누구를 위해 무엇을 위해 기도하나 잠시 생각했고 또다시 조용히 자리를 잡고 기도하는 사람들을 의식하며 조용히 눈을 감았다. 나는 겸손한 마음으로 천국의 시간을 반복해보고 그 시간은 미래임에도 미래처럼 여겨지지 않았고 마치 슬픈 과거 같았다. 부산근대역사관의 계단은 옛날 건물의 계단이었고 작은 창에서 보이는 먼지와 간판과 작은 흔들림을 반복하여 생각하였다. 성당을 나와 이모 도나스를 향해 걷고 걷고 골목에는 작고 오래된 술집들이 문 앞에 쳐진 발을 달고 있었다. 도넛을 두 개 사서 먹으며 버스 정류장으로 향했고 최선생에게 다른 곳에 가보자고 커피를 마셔요 나가서 밥을 먹어요 말해 보아야겠다고 생각했다. 만두가 먹고 싶어졌다. 걷다보니 말하자면 영도는 섬이니 당연히 바다를 의식할 수밖에 없지만 그럼에도 눈앞에서 다가오는 바다를 보며 바다를 다시 의식하고 손목서가에 들러 조용히 책을 구경하다가 오랜만에 커피를 한 잔 사 마시고 아 커피를 사 마시는 것이 오랜만이라고 생각하다가 서점을 나왔다. 책을 한 권 샀는데 로제 마르탱 뒤가르의 『회색노트』였다.

영도에서 버스를 타고 영주동 거북탕 앞에서 내렸다. 뜨거운 물 안에 몸을 담근 채 미문화원 건물의 계단과 작은 창과 이십대 후반의 블라우스와 치마를 입은 최명환이 검게 그을은 창 앞에 서 있는 것을 보았다. 그는

all over again that I was in Busan. If there was something I had to do, I'd sit at the table, where I also ate my meals: I'd do the work that Choi seonsaeng had set me, or I might concentrate on some reading that I wanted to do, or I'd write, or open my laptop to look up jobs, graduate schools, house prices in Busan. It was at this same table that Choi seonsaeng and I were now sitting, having instant coffee and the doughnuts she'd bought in Yeongdo. "These doughnuts are famous, you know"—the shop, Aunt Donuts, had been open since the seventies. It was raining outside; "You didn't get rained on?" I asked, and I could smell the damp of the rainwater that had fallen on her. Suddenly, I began to worry that Choi seonsaeng, with her glasses and short hair—my landlord—would evict me without warning. She hadn't said anything of the sort, but suppose she was really planning on doing it; had she told her fellow parishioners she had no idea what I did or what kind of person I was? If so, I thought, I'd have to take it in my stride; I'll say to them, "What do you mean, what do I do? I have fun," and smile. I kept up this imaginary scenario in my head and tried to read her expression. Of course, I can't read people's faces; but even if I could, was there anything I could do about the situation? I could protest her decision, reject it, or negotiate, but none of these options appealed to me. For a while, as I drank my coffee, I pursued these thoughts—where they'd come from, I had no idea—and then I said I'd recently visited the American Cultural Center. "I remember the day of the fire in 1982," said seonsaeng-nim. It'd been a cold, blustery spring day, and the smoke, billowing into nearby buildings through open windows, had been so powerful that they'd worked with all the doors and windows shut, and some people went home early. She had work to finish so she'd stayed on, coughing as she worked. On her way home that night, she tripped in her heels and fell over the subway stairs, and three men passing by whistled at the sight of her upturned skirt. One of them spat in her direction, aiming for her with

거의 미친 여자 취급을 받았는데 결혼을 하지 않았고 혼자 살았고 가족에게 돈을 다 주지 않고 자기 돈을 모았기 때문이었다. 왜 불이 났을까 흔들리는 바람과 불안하게 흔들리는 나뭇잎과 간판을 보는 그는 어두운 거리를 뛰면서 집으로 향하고 책을 빌리러 향했던 미문화원 도서관을 떠올리고 책들은 금방 타버릴 것이라고 생각하고 잿더미가 된 책들 이미 책이 아닌 잿더미를 생각하고 밤이 되면 집에서 일본어를 공부했다. 탄 냄새가 나는 블라우스와 치마를 화장실에 걸어놓고 따뜻한 물로 몸을 씻고 나면 화장실을 채운 더운 김이 더러운 것을 사라지게 할 것이다. 나는 온탕에 몸을 담근 채 최명환의 화장실을 채운 김과 밤의 남포동을 뛰어가는 최명환의 뒷모습을 보았다.

지난 달 일한 월급이 뒤늦게 들어온 것을 확인하고 선생에게 밥을 먹자고 연락하였다. 일품향에서 깐풍새우와 오향장육을 시키고 선생은 중국술을 작은 병으로 시켰다. 조금 걸어도 되요? 배부른 우리는 한참을 걷고 또 걷고 어디선가 음악 소리가 들려 잠시 걸음을 멈추었다. 한복희라는 이름과 Thank you라는 인사가 모금함 앞에 쓰여 있었고 선생보다 조금 어려보이는 50대 정도로 보이는 여성은 에디트 피아프의 「아뇨, 난 아무것도 후회하지 않아요」(Non, Je Ne Regrette Rien)를 부르고 있었다. 한복희는 후회 없는 후련한 표정으로 노래를 부르고 있었고 선생은 한복희 씨를 안다고 하였다. 이전에 보수동 인앤빈에서 같이 커피를 마신 적도 있다고 하였다. 우리는 나란히 서서 한복희의 노래를 듣다가 나도 별로 후회가 없다 나는 기억력이 나쁜 것 같다고 말하는 선생에게 마르타, 마르타는 후회 안하는 거예요? 묻고 선생은 크게 소리내어 웃었다. 만원을 모금함에 넣고 한복희 씨와 눈인사를 하고 우리는 길을 걷다 커피를 마시고 나는 선생과 함께 선생의 집으로 돌아갔다. 나의 집으로 돌아가도 그것은 선생의 집이었지만 말이다. 겨울이 막 시작되려 하는 부산은 아직 춥

his spittle, as if he meant for it to land on her; another returned to place his hand under her skirt and touch her between the legs. It lasted a short time, about ten seconds. Swiftly rearranging her skirts as if nothing had happened, Choi Myeong-hwan walked, almost ran, to a spot that was brighter, had more light. Soon it became a routine; after church, she'd buy doughnuts, drop by my home (no—another one of her homes), and we'd talk while we ate them. A few days after the arson incident, Choi Myeong-hwan was walking along a street, taking the long way around—she was reluctant to use the underground passageway—when she overheard some people talking in front of a hospital: two men in their forties were saying that Communists deserved to die. As she spoke, I watched her profile. The doughnuts were delicious, and Choi Myeong-hwan sipped her coffee. The rain had stopped earlier in the afternoon, but suddenly it began to pour again, and to this day I keep hearing people say it's okay if some people die / it's okay to wipe out certain people from this country / it's okay if less able people don't make it and die out. Having finished her cup of coffee, she told me she used to attend the same church as one of the students who'd started the fire.

"Was it Kim Eun-suk?"
Choi seonsaeng drank her coffee without replying.

One day, following her example, I took a bus to Yeongdo and went to Bonglae Church. In front of the building there was a shadowy bench; as I went over to sit down, a black lump gave a yowl and leapt out of sight. "It's a panther—a black panther," I said aloud, pointing as if somebody was standing beside me. The cat was lying in front of the church doors. Quietly, I climbed the steps, opened the door, and sat in the back. As in any church, the stained glass made lovely shadows of red and yellow that trembled within indistinct frames of their own

지는 않았지만 바람이 거셌고 나는 이미 다 자라고 다닐 수 있는 학교들을 다니고 회사를 다니고 돈을 벌고 세금을 내고 할 것들을 다 한 내가 어딘가 어느 순간을 눌러놓고 빼먹은 것처럼 아직 덜 자란 사람처럼 느껴졌고 최선생의 옆얼굴은 빛과 어둠의 경계를 뭉개는 선처럼 흐릿했다. 우리가 그 날 함께 보다 내가 먼저 잠이 든 영화는 이후에도 뒷내용을 알 수 없었는데 드물게 최선생도 영화를 보다 잠이 들었기 때문이었다. 한시쯤 깨어나 이를 닦고 여전히 어두운 무엇이 밝아지거나 변한 것 없는 거실을 둘러보다 소파 위의 선생의 어깨를 흔들고 우리는 텔레비전을 끄고 영화가 어떻게 되었는지 모르겠네 금세 잠이 들어버렸네 잠꼬대처럼 중얼거리다 나는 봉래 성당에 갔다는 이야기를 하고 성당은 생각보다 작지만 좋았고 검은 고양이들이 있었다고 말했다. 흑표범 같아.

최명환은 그 때 가끔 마주치는 흰색과 검은색이 섞인 얼룩 고양이에게 우유를 주었는데 우유를 고양이에게 주다니 아깝다고 사람들은 말했고. 미문화원이 불타고 며칠 뒤 회사 뒤 골목에서 연기 때문에 흰색털이 회색이 된 고양이를 보았다. 고양이는 자기 털을 핥고 또 핥고 그런데 아직 원래 색으로 돌아오지 못했다. 고생하는 고양이를 보며 우유를 주고 그런데 말야 요즘 안건데 고양이한테 사람이 먹는 우유 주면 안좋다고 하던데? 나는 아 맞아요 고양이 우유가 있어요 대답하고 성당의 흑표범들은 우유 같은 것은 안 먹을 것 같았다. 쥐를 잡아먹을 것 같았는데 그게 아니라 성당의 누군가가 챙겨주는 것이겠지. 명절에는 깡통시장에서 일제 담배를 한 보루 사서 가끔 집에서 피웠다. 담배와 같이 산 커피를 마시며 책을 읽고 회색털의 고양이를 생각하다가 고양이는 여기저기 도망을 잘 가고 잘 피하는데 어디로 여기저기로 피해도 연기가 따라왔을까. 참 무섭고 이상하다고 얼마나 놀랐을까 생각하다가 누가 그런 말을 했다. 자갈치 시장의 고양이들은 진짜 통통해. 쥐를 잡지 시장 고양이들은. 쥐를 잡고 생선을

making. Briefly, I wondered for whom and for what Choi seonsaeng said her prayers; then, becoming aware once more of other people quietly seated in prayer, I closed my eyes. With humility, I tried to rehearse a kingdom of heaven; it pertained to a future, but to me it seemed less like a future than a tragic past. The stairs of the Busan Modern History Museum belonged to a building from the past—again, and again, I recalled the dust and the signboards, visible from the small window, and the slight trembling. After leaving the church, I walked—and walked some more—in the direction of Aunt Donuts; the old, cramped bars in the alleyways had drooping bamboo blinds hanging over their doors. I bought two doughnuts, which I ate on the way to the bus stop, and I decided to ask Choi seonsaeng if she felt like going somewhere different: "Let's grab a coffee; let's go out for dinner..." I felt like having dumplings. As I walked along—well, since Yeongdo is an island, one can't help but notice the sea; but even so, as the waves loomed closer and closer before my eyes, I grew conscious of the sea all over again. I went inside a bookstore called Sonmok Bookshelf, where I browsed quietly for a while before buying a cup of coffee, which was something I hadn't done in a while ('It's the first time in a long while that I'm buying a cup of coffee,' I thought to myself), then I left the shop. I'd bought a book; it was Martin du Gard's *The Gray Notebook*.

From Yeongdo, I took a bus to Yeongju and got off in front of the Turtle Bathhouse. Immersed in scalding hot water, I thought of the stairs and the small window inside the American Cultural Center; I pictured a young Choi Myeong-hwan in her late twenties, dressed in a blouse and skirt, standing before a smoke-stained window. Everyone had thought her crazy for living alone and not marrying, and for saving up her money instead of giving it away to support her family. 'What started the fire?' she'd wondered, watching the tree leaves and the signboards trembling in the wind; as she ran home that night along the darkened streets, she'd thought of the library in the Amer-

훔쳐 먹거나 가끔 얻어먹는 진짜 크고 통통한 고양이들. 최명환은 고양이를 크게 키워 호랑이처럼 키워 타고 다니고 집까지 타고 다니면. 귀에서 맴도는 불안하게 뛰어다니는 구두굽 소리를 생각하다가 소리를 거의 내지 않고 다다 다다닷 다니는 고양이를 생각했다.

연말이 되었다. 마지막으로 만난 사람과 길거리에서 소리 지르며 싸우고 안 좋게 헤어진 후 한동안 부산에 오지 않던 친구를 부산으로 불렀고 바의 주인과 미혜 씨와 미혜 씨의 남동생과 최선생의 집에서 술을 마셨다. 미혜 씨는 크리스마스가 가까우니까 라고 말하며 케익을 사왔고 선생이 사온 소고기를 먹고 케익을 먹고 모든 먹고 마시는 것에 예민하고 까다로우며 그리하여 잘 갖추어 내오는 바주인이 내려준 커피를 마셨다. 저는 내년에…… 모두 조금은 들뜬 표정으로 내년을 말하지만 왜인지 시간이 지나자 무엇을 말했는지 각자의 소망은 기억이 나지 않고 어쩌면 다들 속으로 방문을 열고 눕고 울고 씻고 싶다고 생각하고 있을 것 같다고 생각했다. 미혜 씨와 남동생은 웃으며 손을 흔들며 자정이 되기 전 돌아가고 한시가 넘어 바의 주인은 새해에 마시라며 기억나지 않는 좋은 술을 선물로 남기고 나는 침대에서 키가 큰 최선생에게 고개를 기대고 불편한 듯 편안한 자세로 잠이 들었다. 다섯 시쯤 잠에서 깨어나 물을 마시려 나왔을 때 최선생은 소파에 앉아 있었고 나는 그 옆에 나란히 앉아 서서히 어디선가 새어 들어오는 찬바람에 잠이 깨는 것을 느꼈다. 최명환은 창가를 바라보다가 바쁜 하루 정신없이 일을 하며 잠시 커피를 마시며 창가로 밖을 내려다보았을 때 그런데 왜 같이 성당을 다니는 그 아이가 지나가는 것일까 생각을 하였다고 말했다. 누구에게도 물을 수 없지만 어떤 순간들이 접혀져 땜질을 한 것처럼 어떤 사람이랑 어떤 사람이랑 접붙인 것처럼 이음새가 느껴지는 부분이 있고 그래서 덜 자란 것처럼 느껴진다는 것을 왜 최명환의 앞에서 느끼는지 나는 가끔 왜 그것이 명백하게 드러나는지 생각하고.

ican Cultural Center where she often went to borrow books, and of the books that would soon catch fire—books turned to ash, piles of ash that were no longer books—and later that evening, she had come home and studied Japanese, like she did every night. 'If I hang up my skirt and blouse in the bathroom while I wash myself in warm water, the hot steam will remove all the grime and smoke.' Soaking in the hot water, I saw the steam that filled Choi Myeong-hwan's bathroom, and her retreating figure, running along the darkened streets of Nampo-dong.

Having belatedly received my last month's wages, I called seonsaeng-nim to ask if she was free for a meal. We went to a restaurant called Ilpumhyang, where we ordered Chinese deep-fried spicy shrimp and braised o-hyang pork; seonsaeng-nim ordered a small bottle of Chinese liquor. "Shall we walk for a bit?" Feeling full, we set out and wandered around for a while; then, hearing music, we came to a stop. In front of a collection box and a sign that read out a name—Han Bok-hui—and 'Thank You', a woman who appeared to be a little younger than seonsaeng-nim, in her fifties perhaps, was singing Edith Piaf's "Non, je ne regrette rien." Han Bok-hui looked gratified and not in the least regretful. Seonsaeng-nim said she knew her; they'd even once had coffee together at the In And Bean café in Bosu-dong. We stood side-by-side, listening to her singing. "I don't really have any regrets, either. I must have a bad memory," said seonsaeng-nim. "Martha," I said, "Martha has no regrets?" She burst into laughter. We placed a ten-thousand won note in the box and exchanged nods with Han Bok-hui; afterwards, we walked some more, had some coffee, then returned at last to seonsaeng-nim's place. (Had we returned to my place, it'd still have been her place that we were returning to.) Winter was coming; though it was not yet cold in Busan, it was very windy—and though I was a full-grown adult and had attended all the schools I

"회사가 그렇게 가까운 곳에 있었던 거예요?"

"그리로 들어가는 것을 본 게 아니라 회사 앞을 지나는 걸 본 거지."

나는 소파에 나란히 앉아 창 앞에 서 있는 블라우스를 입고 긴 치마를 입은 최명환의 뒷모습을 보고 그는 영도의 성당을 다니고 영도의 성당에는 야학을 다니러 한진의 공장에 다니는 사람들이 오갔고 성당에서 보던 대학생은 왜인지 회사 앞을 지나가고 신학교 학생이라고 했었는데 버스에서 만났을 때 그가 무언가를 읽고 있던 것을 생각하고 불이 났을 때 연기가 가득했을 때 모욕을 당하고 그러나 그것이 모욕이 아니라고 나에게는 아무 것도 일어나지 않았다고 생각하고 뛰어갔을 때. 나는 최명환에게 그런데 김은숙 씨는 어떤 사람이었냐고 물었고. 창 앞에 서서 아래를 내려다보던 최명환은 나의 목소리가 안 들리는 것처럼 눈을 찡그리고 키가 크고 돈을 벌고 혼자 사는 최명환은 잘 웃지 않고 그런데 지금은 내 옆에 나와 나란히 소파에 앉아 나의 질문에 그는 물었다.

"너는 그 사람이 어떤 사람인지 들을 수 있어?"

나는 고개를 끄덕였고.

"네가 준비가 되면 나는 말할 수 있어."

나의 대답을 들은 최명환은 어떻게 김은숙을 알게 되었는지 이야기하기 시작했다.

최명환의 이야기를 다 듣고 다시 잠을 자려 침대에 누웠다. 가끔 잠이 오지 않을 때 눈을 감고 길을 걷는 생각을 했고 이것을 가상산책이라고 부

could have attended, had worked at a company, earned a salary, paid my taxes, and done everything I could have done, I still felt as if I'd wedged away and missed out on a period of my life: as a person, I felt incomplete. The profile of Choi seonsaeng's face was indistinct, like a line mashing the border between light and darkness. That night, we started watching a film, but I never found out how it ended because, rather unusually, Choi seonsaeng fell asleep as well. At around one in the morning, I woke up and brushed my teeth. I gazed around the unchanged living room, which was still dark and unlit; then I shook seonsaeng-nim by the shoulder, and we turned off the television and had a mumbled conversation, like two people talking in their sleep. "I don't know how the film ended; I fell asleep in the middle..." I told her I'd gone to Bonglae Church, which was smaller than I'd expected, but I'd liked it; there had been a black cat. "It looked like a black panther."

Occasionally, near her workplace, Choi Myeong-hwan had come across a black and white piebald cat. She'd offer it milk, though others said it was a waste, giving milk to a cat like that. A few days after the fire, she saw the cat again in an alley behind her office building. Its white fur had turned gray from the smoke, and though it licked and licked away at itself, the fur wouldn't return to its original shade. "I gave that poor thing milk; but what do you know? I hear it's not good for cats to drink milk that humans drink." "No," I said. "There's milk for cats." I doubted the black panthers at church drank milk; they'd catch mice, though it was more likely that someone from the church was feeding them. On Chuseok, she went to the imported goods market and bought herself a pack of ten of Japanese cigarettes, which she'd smoke at home every now and then. She also bought some coffee, which she'd drink while reading books; and then she'd think of the cat with gray fur, and how cats are quite good at evading things and running off every which way—but wherever this gray cat hid, the

르고 있으며 그 날도 눈을 감고 산책을 했다. 중앙동을 걷다가 남포동에 진입할 즈음 멀리서 대교와 바다가 보이고 나는 오른편에 있는 부산데파트에 이르고 거주민처럼 터덜터덜 문을 열고 들어간다. 계단은 미문화원처럼 오래된 계단 오래되고 잘 닦인 계단을 올라 복도를 지나고 아래를 내려다보면 아래층과 대각선 아래층이 보이고 가끔 집 앞의 화분과 복도에 널어놓은 이불이 보이고 열쇠로 문을 열어 대부분 번호키로 바뀌었지만 내가 여는 집은 여전히 열쇠를 사용하여 그 열쇠로 문을 열어 손잡이를 잡고 방문을 열고 언젠가 내가 살았던 집 같은 공간의 구조를 그려본다. 초여름의 오후이고 창에서 들어오는 햇볕 아래 나는 누워 있고 내가 가보고 싶었던 곳에 내가 살고 있고 나는 그 옆에 정답게 눕는다. 그러면 어느샌가 잠이 들었다.

smoke had followed. How strange, frightening, and upsetting it must have been for the cat; but then I recalled that someone had once said, "The cats of Jagalchi Market are really fat. They catch mice—they're big and fat from stealing fish and catching mice; people even feed them, too, sometimes." What if Choi Myeong-hwan had raised a cat until it was the size of a tiger and ridden it home from work? I thought of the sound, ringing in one's ears, of heels running anxiously this way and that; then I thought of cats, and the way they scamper and dart around almost noiselessly.

The year was coming to an end. My friend, whose most recent relationship had ended badly, with fighting and screaming in the street, hadn't been back in Busan for some time; but I summoned him for drinks with the bar owner, Mi-hye, her younger brother, and Choi seonsaeng, at her home. Mi-hye brought a Christmas cake—"Because it's Christmas soon!"—and seonsaeng-nim had bought some beef, so we had that, and Mi-hye's cake; the bar owner, who would prepare the most excellent foods and drinks because he was so fussy and selective about anything digestible, brewed us coffee. "Next year, I'll..." Everyone discussed their future plans in high spirits, but as the hours passed each person seemed to forget what they'd said of their hopes for the new year, and if anything, seemed privately to want to return to their own rooms and lie down, weep, or take a bath. Mi-hye and her younger brother smiled and waved as they left for home before midnight; it was past one in the morning when the bar owner took his leave, imparting an expensive bottle of liquor (I forget which kind) as a gift, which he said we should drink in the new year. I leaned my head against Choi seonsaeng's tall frame, and in that seemingly awkward but comfortable position, I fell asleep in bed. At around five in the morning, I stirred awake and left the room in search of some water. Choi seonsaeng was sitting on the sofa, and I sat down beside her. A

chilly draft blew in from somewhere, and slowly I felt myself wake up.
"It was a busy day at work," said Choi Myeong-hwan, gazing out the
window, "and I was just taking a coffee break, when I looked outside
and thought to myself, 'That's the girl from church; why did she just
walk by?'" Of course, there's no one I can ask such questions, but why
am I able to sense the seams in things?—like those moments in time
that overlap, as in a piece of mending; or the kind of welding that joins
one person to another? It was because I could sense such things that
I felt incomplete as a person. Why did I feel this way in front of Choi
Myeong-hwan, and why did this fact make itself so obvious at times?

"Your office building was that close to the cultural center?"
"I didn't see her go inside; I saw her walk past the building."

As I sat beside her on the sofa, I saw Choi Myeong-hwan standing
before a window, facing away from me, dressed in a blouse and a long
skirt. She attended a church in Yeongdo that factory workers at Hanjin
went to for night school—and for some reason, a university student
she'd seen at church had just walked past her workplace; she recalled
that the student went to a theological college, and when they'd met on
the bus, the student had been reading something. When the fire start-
ed; when the place was full of smoke; when she'd suffered an affront to
her dignity but kept telling herself as she ran away that it hadn't been
an affront, that nothing had happened to her at all—"So what was Kim
Eun-suk like?" I asked Choi Myeong-hwan. The woman standing by
the window, looking down into the street, appeared not to have heard
and frowned; the woman sitting beside me now—who was tall, had
worked for a living, lived alone, and didn't smile often—replied with
a question of her own.

"Are you willing to listen to what kind of person she was?"

71

I nodded.

"I'll tell you if you're ready."

At my reply, Choi Myeong-hwan began to explain how she came to know Kim Eun-suk.

When she finished, I went back to bed. Sometimes, when I have trouble going to sleep, I picture myself walking along a road. I call this a 'virtual walk', and that morning, as usual, I closed my eyes and went for a walk. I walk through Jungang-dong, and as I reach Nampo-dong I can see, from afar, the bridge and the sea; to my right stands the Busan Department Store. I open the entrance door to the building and trudge inside like someone who lives there. The stairs are worn, like the stairs of the American Cultural Center; I climb those worn but well-cleaned steps and pass through the open corridors. As I look down, I can see the floors below, which criss-cross diagonally with the floors below them, and here and there I make out a potted plant by a front door and bedding hung out to dry. Standing before the door to my apartment, I take out my keys—though most have switched to electronic keypad locks, my door still opens with a key—and grasping the handle, I pull it open. Inside, I imagine a space that is like a home where I once lived. It is early summer afternoon, and I lie down by the window in a pool of sunlight; I live in a place I've wanted to visit, and tenderly I lie down beside it. By now, I've fallen asleep.

Translated from Korean
by Sarah LYO

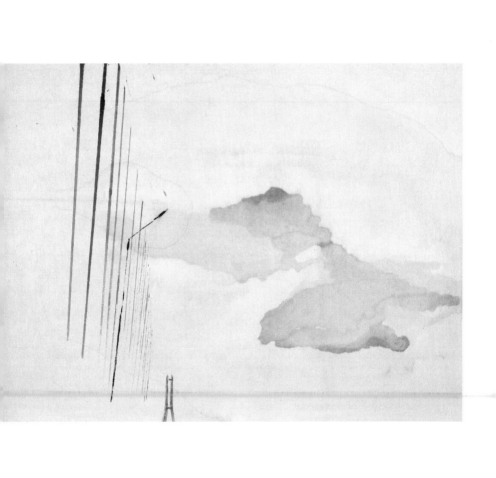

오션 뷰

김혜순

일 년 열두 달
광안대교가 찾아와서 창문을 두드렸다

비가 와도 예외는 없었다
이 슬픔을 해결해야 해 생각했지만
생각을 끝내기도 전에 또 찾아왔다

집안엔 흘려보내지 못한 눈물이 늘
고여 있었다

매일 이 시간
광안대교는 다리를 늘어뜨려
창문을 부수려고 했다

Ocean View

KIM Hyesoon

For twelve months, one year
Gwangan Bridge came over and knocked on the windows

There were no exceptions, even when it rained
I need to get over this sadness, I thought
But it came again even before I finished that thought

In the house, the tears that could not stream away
Was always pooling

Every day at this hour
Gwangan Bridge spread out its legs[1]
And tried to break the windows

1 In Korean, "leg" and "bridge" are homonyms and are both called "dari."

오션 뷰

집안의 가구들이 물속에서 스크럼을 짰다
그러면 나는 눈을 감고 옷을 벗고 물속으로 들어설 준비를 했다

눈을 뜨면 어느새 광안대교의 우람한 다리들이
집안에 들어와 있었다

광안대교가 내 목덜미를 움켜쥐었다
내 몸이 지구 저 건너편으로 떨어지는 것 같았다

밤이 지나 등불이 꺼지면
광안대교는 어느새 창밖에 서 있었다
물속에 전화벨이 울리고
저녁에 다시 돌아오겠다고 했다

Ocean View

Furniture inside the house formed a scrum
Then, I'd close my eyes, take off my clothes, and prepare to enter
 the water

Then, when I opened my eyes, the vast legs of the Bridge
Would already be inside the house

Gwangan Bridge gripped my neck
I felt like I was being thrown across Earth

When the night passed and the lights went out
Gwangan Bridge was already standing outside the window
In the water, the phone rang
It said, I will be back in the evening

고니

고향으로 돌아가는 대열에서 낙오한 흰 고니가
부산야생동물치료센터에 왔다
얼굴에 흰 천을 씌우고
상한 날개를 잘라야 했다
날개를 자르자 흰 고니는 더 이상 먹지 않았다
하는 수 없이 눈을 가리고 주둥이를 묶고
그 사이로 미음을 집어넣었다

나는 새 속에 깃들어 살고 있었는데
깃털의 회랑을 지나
눈동자의 동굴 속으로 기차를 몰았었는데

여름에 깃털은 부채처럼 시원하고
겨울에 깃털은 구름처럼 포근하고

그런 일들이 있다

Tundra Swan

A white tundra swan that failed to join the flock flying home
Came to the Busan Wildlife Rehabilitation Center
They had to cover her face with white cloth
And cut away at the damaged wings
With her wings clipped, the white swan stopped eating
Reluctantly, they had to cover her eyes, tie up her beak
And push gruel through the slit

How I used to dwell among clusters of birds
How I, past the cloisters of feathers
Used to drive a train into the caverns of eyes

Feathers of summer are as cool as fans
Feathers of winter are as soft as clouds

Things like this happen:

고니

'이제 다시는 걸을 수 없습니다'
선고를 받은 엄마가 침대 위에 올려졌다
엄마는 그 침대를 벗어나 집으로 영영 돌아가지 못했다

어느 밤 엄마의 침대를 들추자
주둥이가 묶인 흰 고니가 누워 있었다
말도 못하면서 눈길로 애원했다
'집으로 데려다 달라'고

내가 엄마를 안아줄 때
마치 백년 뒤에서 안는 느낌
고니의 날개를 자른 뭉툭한 곳이 내 늑골과 부딪혔다

내가 새의 깃털에서 멀리 쫓겨났다
기차가 눈동자의 동굴을 애타게 부르며 달렸다

'더 이상 날 수 없습니다'
'더 이상 만날 수 없습니다'
그런 말을 듣는 순간이 온다면
어떻게 해야 할 수도 없는 순간이 온다면

흰 고니는 4년 동안 병원에 있었다
그리고 지금은 저수지에 있다
깃털의 방에 깃든 나를 태우고 북극에서 남극으로
1만 미터 까만 상공을 하룻밤만에 오가던
흰 고니가 저 물가에 있다

Tundra Swan

You cannot walk ever again
Sentenced to this, Mother was placed on a bed
She could not unfetter from that bed and return home ever again

One night when I uncovered her bed
A white swan with a tied beak was lying there
She could not even speak, but pleaded with her eyes:
Please take me home

When I held my mother
It felt like I was embracing her from a time a hundred years later
The blunt place of the swan's clipped wing hit my rib

I was expelled far away from feathers
The train mournfully called out for the eye-cavern as it ran

You cannot soar again
You cannot see her again
When the moment for those words arrives
When the moment when there's nothing to be done arrives

The white tundra swan was in the hospital for four years
And now she is in a reservoir
The white tundra swan that took me on her back
From the chamber of feathers and sailed the black heavens
For ten thousand meters, from the North Pole to the South overnight,

고니

고니의 날개는 이제 바람에 흩어지는
저 물결처럼 접을 수 없다

치료센터의 CCTV 화면을 통해
우리는 하루 종일 마주 보았다

Tundra Swan

Is now by those waters
Now, the swan's wings cannot fold
Like those waves fluttering into the wind

Through the CCTV screen in the rehab center
We faced each other every day, she and I

자갈치 하늘

하늘에서 줄이 내려오면
몸에 해롭다

줄의 인도를 따라
도착한 곳

'숨이 끊어지기 전
환한 유리에 담기게 된다'고

'여기가 마지막 승차장'이라고
'마지막 수심은 이리 얕다'고
엄마 아빠 형제 자매에게
전할 수 있다면 좋으련만

Jagalchi[1] Sky

When a line drops from the sky,
It's bad for one's health

The destination
Following the guidance of the line

You'll be laid inside shining glass
Before your final breath

This is the final destination
The final water level is this low
If only I could tell these things
To my mother father brother sister

1 The biggest fish market in Korea, located in Busan.

자갈치 하늘

꿈속에라도 소식을 넣을 수만 있다면
인편을 마련할 수만 있다면

내가 그만 나를 그만둘 수조차 없다면

'하늘에서 내려온 것을
멀리 하라'

소나기처럼 내리는 칼날 밑에서
심해로 편지를 썼다

Jagalchi Sky

If only I could send this message even in dream
If only I could send a messenger

If I cannot even just quit myself

Stay away from things
That fall from the sky

Under the knife blades falling like sudden rain
I wrote a letter to the deep sea

해운대 텍사스¹ 퀸콩²

모두 잠든 밤이면 나는 빌딩들을 들고 옵니다

청소부들이 초록 울타리를 치고
쓰레기 하치장 팻말을 세우고
빌딩들을 기다립니다

해변의 모래 위에
엎어진 동상처럼 빌딩들이 누워 있습니다
붕대가 너덜거리는 빌딩, 혀가 아픈 빌딩, 머리에 피를 흘리는 빌딩,
　　하이힐을 신은 빌딩
들여다보면 다 사연이 아픈 빌딩
낮에는 빌딩들에게도 물이 졸졸 오르내리고 피가 윙윙 돌고 굽이굽이
　　얼굴도 있었는데

1　빔 벤더스의 영화 〈파리 텍사스〉(Paris, Texas, 1984)를 차용.
2　킹콩(King Kong)의 여성명사형 Queen Kong.

Haeundae[1] Texas[2] Queen Kong[3]

When everyone is asleep at night, I carry over the buildings

Cleaners set up green fences
Put up signs for the garbage dump
And await the buildings

On the sands of the beach,
Buildings lie like toppled statues
A building with frayed bandages, a building with a sore tongue,
 a building with a bleeding head, a building wearing high heels
Upon closer look, all buildings have painful stories
During the day, the buildings too had water trickling up and down,
 blood whizzing around, and faces at every turn

1 The most scenic beach in Busan. The area is the center for international conventions
 as well as a special tourist zone, lined with large high-rise apartment buildings.
2 Reference to Wim Wenders' film, *Paris, Texas* (1984).
3 Feminine equivalent to the proper noun King Kong.

그리하여 시선도 있었는데
내가 바라보기 전에 먼저 나를 바라보았었는데

파도는 깊은 물속에서 올라온 줄에 손목이 묶인
수억만 개의 손가락입니다

해변으로 밀려와 나가고 싶다!
나가고 싶다! 울다가 사라지고
그러면 또 다른 손가락들이 몰려옵니다
파도는 이미 사라져서 벌써 사라집니다

나는 빌딩들이 가득히 쌓인 해변을 걷습니다

깊은 밤 장막속의 깊은 밤 장막속의 깊은 밤 장막속에서는
큰 것은 작아지고
작은 것은 커집니다

창문 안에는 환한 빛 따뜻한 침대
식탁에서 기다리는 우리 엄마 우리 아빠
하지만 내가 죽는 날 함께 할 식사
나는 우리 집이 너무 작아
철대문을 책처럼 옆에 끼고 걷습니다

나는 이제 빌딩들이 떠나버려
망각만이 즐비한 밤의 황무지에 들어섭니다
나는 버드나무 가지로 엮은 귀신처럼

Haeundae Texas Queen Kong

And thus held gazes
They looked at me before I looked at them

Ocean waves are hundreds of millions of fingers
Of wrists bound by ropes rising from the depths

I want to be thrusted out to shore!
I want to get out! They cry, and disappear
Then whole new fingers swarm in
Waves are already gone, and go already

I walk along the beach strewn with mounds of buildings

Inside the curtains of deep night inside the curtains of deep night
 inside the curtains of deep night
Large things grow small
Small things grow large

Inside the window, bright light and a warm bed
My mother, my father waiting at the table
But the meal is for the day I die
Because our home is too small
I tuck the iron gates under my side like books

Now I am stepping into the wasteland of night, lined with oblivion
For the buildings have left

새 소리, 공룡 소리, 온갖 여자짐승 우는 소리를 내며
뛰어갑니다 가끔은 날아갑니다

Haeundae Texas Queen Kong

Like a ghost woven out of willow branches,
Making crying sounds of birds, dinosaurs, all kinds of female beasts,
 I run
And at times, I fly

피난

집이 산을 기어올랐다. 전쟁에서 쫓겨 온 집들이었다. 산에 말뚝을 박고. 하늘에서 내려온 줄에 창문을 매달았다. 집들은 고향을 떠나왔고, 산은 하늘이 고향이었다. 집들은 산을 기어오르려 하고, 산은 하늘로 떠오르려 했다. 그래서 매일 골목이 미끄러웠다. 산에 집이 가득 찼다. 덩달아 미로도 가득 찼다. 여자들이 산 밑에서 물을 길어 산꼭대기까지 날랐다. 오줌은 내려가고, 마실 물은 올라왔다. 70년이 지나 한밤중에 내가 그 미로에서 길을 잃었다. 들쑥날쑥한 담벼락 안에 두런두런 사람이 있었고, 흠칫흠칫 고양이가 있었다. 나는 내 머릿속으로 다시 끌려들어갈까 무서웠다. 달이 떠 있는데 한 할아버지가 나타나 길을 가르쳐 주었다. 그는 나에게 '내려가지 말고, 머리 쪽으로 더 올라가라' 했다. 이 산의 이름이 천마라고 가르쳐 주었다. 그 때 누군가 내 머리 안쪽을 더듬는 느낌이 있었다. 밤의 입안에 칫솔을 넣고 양치를 하고 싶었다. 캄캄한 산을 오르자 피난민으로 바글거리는 도시가 다 내려다 보였다. 새벽까지 골목을 헤매다 다시 그 할아버지를 만났다. '밤새도록 겨우 세 걸음 몸을 옮겼다'고 했다. '천마도 하늘 쪽으로 세 걸음 떠올랐다'고 했다. 할아버지는 '첫 버스를 타러 가는 길이니 자신을 따르라'고 했다. '원주민들이 다 떠나고, 이제 딱 두 집 사람

96

Refuge

Houses climbed the Mountain. They were Houses driven in by war. They drove stakes into the Mountain. They hung windows on the ropes coming down from the sky. The Houses left their homeland, and the sky was the Mountain's homeland. The Houses tried to climb the Mountain, and the Mountain tried to float up to the sky. So the alleys were slippery every day. Houses filled the Mountain. Then the Mountain was filled with mazes. Women fetched water from the bottom of the Mountain and carried it to the top. Pee dribbled down and drinking water was brought up. 70 years later, in the middle of the night, I got lost in the maze. Inside rugged walls were murmurs of people and flinches of cats. I was afraid that I would be dragged into my head again. The moon was out and an old man emerged to tell me the way. He said, *Do not go down, go up toward the head*. He said the name of this mountain is Pegasus. Then, it felt like someone was fumbling the inside of my head. I wanted to stick a toothbrush inside the night's mouth and scrub its teeth. When I climbed the mountain, I could see the whole city swarming with refugees. Wandering the alleys until dawn, I met the old man again. *The whole night, I could barely move three steps*, I said. *The Pegasus floated three steps toward the sky, too*, I said. *I am on*

들만 남았다'고 했다. '이제 외지사람들이 들어오고, 심지어 외국인 관광
객도 많이 와 시끄러워서 잠에 들 수 없다'고 했다.

Refuge

my way to take the first bus, so follow me, the old man replied. *The natives are all gone, except for just two households*, he said. *Now that outsiders are moving in and even foreign tourists are pouring in, the noise keeps me up at night*, he said.

<div align="right">

Translated from Korean
by Emily Jungmin YOON

</div>

크리스마스에는

김금희

견과류

누구나 헤어진 옛 연인이 잘 먹고 잘 살기를 원하지는 않는다. 오직 박애주의자에 버금가는 인격자들만이 그렇게 한다. 그래서 내가 지금 인터뷰를 위해 부산역에 서 있는 것이고.

SNS에서 맛집 알파고 얘기가 퍼진 건 지난여름부터였다. 맛집 알파고의 활동을 요약하면 이렇다. 사람들이 트위터 멘션이나 댓글로 음식 사진을 보내면 상호를 맞힌다. 물론 보낸 사람은 사진에 대한 힌트를 전혀 주지 않는다. 예를 들면 다를 것 없는 떡볶이 떡과 다를 것 없는 어묵, 평범하기 그지없는 고추장 양념의 색과 그릇을 보고도 M대학 인근의 엄마손 떡볶이입니다, 하고 답하는 것이다. 정확도는 놀랍게도 99.9퍼센트였다.

당연히 회사에서는 맛집 알파고가 핫한 섭외 대상으로 떠올랐다. 우리가 하는 "능력자"라는 케이블 프로그램은 일상의 숨은 실력자들을 발굴하자는 취지였고 주로 SNS나 유튜브상에서 화제를 모으는 인물들이 출연했다. 총 세 팀이 번갈아 가며 촬영을 맡지만 콘텐츠는 먼저 섭외하는 사람이 잡는 것이었다. 대놓고 경쟁하지는 않아도 시청률이 신경 쓰이긴

102

At Christmas…

KIM Keum Hee

A Handful of Nuts

No one wants their ex lovers to be living and eating well. Only the super upstanding, philanthropists and the like, would ever wish for such a thing. And so I'm standing in Busan Station, here to film an interview.

Talk of Matjip AlphaGo had started spreading on social media in the summer. People would post pictures of food from eateries that were considered special and so were called "matjips" as Twitter mentions or comments to Matjip AlphaGo, and the account replied with the name of the place. Of course, the people posting photos never gave any hints at all. For instance, with nothing more to go on than the plate and colour of an utterly ordinary gochujang sauce with tteokbokki tteok and nothing-special eomuk, Matjip AlphaGo would respond: *This is Made by Mom Tteokbokki near M University*. And amazingly enough, the accuracy rate was 99.9 percent.

Naturally, Matjip AlphaGo came up at work as an ideal casting to film a feature with. The basic premise of our cable program "Unbelievable Talent" was to uncover people with amazing talents hidden in everyday life, and it usually featured people who had become sensations on social media or YouTube. Three teams took it in turns to go

했다. 회사에서는 대체 이 계정주는 사람이 맞는가, 맞는다면 음식평론가인가 셰프인가 이 많은 음식들을 다 먹어봤다면 돈이 들었을 텐데 재벌인가 추측이 난무했다. 하지만 나는 이미 정체를 알고 있었다. 옛 연인 현우의 아이디였으니까.

현우를 섭외할까 말까 하룻 동안 고민했다. 소주와 와인 각 1병씩을 두고 한 치열한 고민이었다. 나는 알코올들을—눈으로 다 마셔버릴 듯이—무섭게 노려보면서 생각이 다른 국면으로 전환될 때마다 술 한 잔과 너트 한 줌을 먹었다. 견과류에는 뇌에 좋은 성분들이 있으니까 이성적인 판단을 가능하게 할 것이고, 술은 생에서 제할 수 없는 파토스 영역에 관한 고려를 놓지 않게 할 것이다.

이런 것이야말로 균형 감각이지, 균형 감각.

듣는 사람은 없었지만 나는 그렇게 말하고는 물티슈로 식탁의 얼룩을 좀 닦았다. 무섭도록 외롭고 상념이 휘몰아치는 밤이었다. 어느 순간에는 대학 시절 연애란 이제 머리를 짜내야 겨우 몇 장면 떠오르는 옛 이야기 아닌가 호쾌하게 괜찮다고 생각하다가도 유리창에 비친 내 얼굴을 보면 그렇지는 않구나 싶어 얼굴이 굳었다. 아직 끝내지 못한 복수가 있어 어떤 극한의 트레이닝도 견디고자 하는 결기의 은둔자 하나가 거기에는 있었다.

병을 다 비워갈 즈음, 간신히 내린 결론은 이런 일종의 조커를 인생에서 사용하지 않는다면 내 손해 아닌가였다. 오래전 대학에서의 그 연애를 끝내며 입은 상처 때문에 인생 자체가 골로 가는 느낌이었는데, 더는 내가 손해 볼 필요는 없잖아, 하는. 누구는 섭외를 위해서라면 유산 문제로 인연을 끊은 동기간도 다시 찾아가 재회하는 판인데—옆팀에서 일어난 일이었다—그깟 연애가 뭐라고, 그거 적당히 만나 서로에 대해 알아가다가 섹스하고 여행하고 외식하고 다시 섹스하고 갈등하고 서운해하고 더 서운해하다가 끝장나는 것 아닌가. 요즘에는 그런 과정에서도 형사 및 민

out and film features, but it was the team who succeeded in securing the best casting that got the airtime. We weren't in open competition, but still, we all kept tabs on the ratings. Speculation was rife in the office as to whether this account owner was a real person, and if they were, could they be a food critic, or a chef, or since they would have to spend a lot to try all those foods, were they the child of one of the big chaebol families? But I already knew who was behind Matjip AlphaGo. Because it happened to be my ex-boyfriend Hyunwoo's screenname.

For an entire day I agonized over whether or not to make contact with Hyunwoo. It was an intense deliberation, executed with a bottle of soju and a bottle of wine on the table in front of me. Glaring at the alcohol—as though I would devour it with my eyes—every time my thoughts threatened to wander, I would drink another cup and eat a handful of nuts. Nuts are full of nutrients good for the brain, so they would facilitate rational judgement, and the alcohol would make sure I didn't forget to consider the domain of pathos that can never truly be detached from life.

"This is exactly the kind of thing that demands a sense of balance. Balance," I said to no one, and then scrubbed at some of the smudges on the table with a wet wipe.

It was a frighteningly lonely night where my thoughts raged. At one point I heroically thought it was no big deal: wasn't a college relationship now no more than an old story that I would have to wrack my brains to recall? But then, seeing my face reflected in the dark window, I knew, *That's not really true is it*, and my expression hardened. There was a determined recluse in that expression, one who was ready to endure whatever extreme training the revenge that still hadn't been meted out might require.

The conclusion I just about came to, around the time when the bottles were completely emptied, was that I would lose out in life if I didn't play this kind of trump card. I already felt like my whole life

사 건에 해당하는 패악을 저지르는 것들이 있어서 끝나고 나서도 손절을 위한 확실한 방어가 필요할 때가 많지만 아무튼 그렇지 않은가, 그러니까 그저 그런 것 아닌가.

사실 그렇지만은 않다고, 그런 것만이 아니라는 사실은 이미 욱신대는 상처의 기억이 경고하고 있었지만 나는 그런 우려의 목소리쯤은 견과류와 함께 아득한 내장기관으로 씹어 삼켜버렸다. 그리고 다음 날 출근하자마자 내가 아는 현우의 정확한 이메일 주소로 편지를 쓰기 시작했다.

안녕, 나 이지민. 그때 영등포에서 그렇게 헤어지고, 12년
만인가, 오랜만이지? 졸업하고 대학원 갔다가 S사에 들어갔다는
소식까지는 들었어. 굼벵이도 구르는 재주가 있다고 신기하다고
생각했다. 나 MTN교양예능국 피디로 일해. 네가 최근 트위터에서
하고 있는 활동에 대해 알고 있어. 한번 출연해볼 생각 있어?
네게도 꽤 좋은 일. 촬영까지 내가 나갈지는 알 수 없고, 나는
원래 자연 다큐 담당이지 이런 류는 아닌데 회사에서 쪼아서
연락해본다. 근데 그거 어떻게 맞히는 거야? 대기업 연봉, 맛집에
쏟아부은 거니? 네가 먹는 데 집착이기는 했지. 근데 먹으면서
흘리는 버릇은 고쳤니? 난 네 입 어딘가에 구멍 난 줄 알았잖아.
하긴 연봉이 높으니까 구멍이 있었더라도 고치긴 고쳤겠지…….

전투적으로 손가락을 내리치던 나는 어딘가 잘못되어간다 싶어 순간 멈췄다. 그리고 건, 조, 하, 게, 라고 중얼거렸다. 한겨울 바싹 마른 북어포처럼 건조하게, 국을 하려고 잡아 뜯으면 수분 하나 없이 보드라운 살결들이 다 뜯기는 북어포처럼 건조하게. 이번에는 삭막하다 싶을 정도로 인터뷰 제안만 적힌, 심지어 내가 네가 아는 그 이지민이라는 사실조차 암시하지 않은, 일련번호만 매기면 공기관 송신용으로 써도 무방할 내용으

was in freefall because of the wounds I'd received when that relationship ended years ago in college, and I thought to myself, there's no need for you to lose out any more. There were people who had gone to track down and reconcile with siblings estranged over inheritance disputes just to secure a casting—this was something that had happened in the team beside mine—so what was such a relationship anyway? Surely it was no more than meeting up an appropriate number of times, getting to know each other and then having sex, going on holiday, eating out and having sex again, getting into conflict and being hurt, getting even more hurt, and then it was over. These days there are those who commit such depravity in the process that a criminal case or civil case can be brought against them, so there are plenty of instances when you need a sure-fire defence to cut your losses even after its over. But anyway, it was no more than that, and so wasn't it just, you know, that kind of thing…

Still, the memory of a wound that was already smarting was warning me, actually, that's not all there was to it, it wasn't only that kind of thing. But I chewed up the voice of worry with a handful of nuts and swallowed it down into the depths of my gut. And the next day, as soon as I got to work, I began to write an email to what I knew was Hyunwoo's email address.

Hey, it's me, Lee Jimin. Has it really been 12 years since we parted ways like that in Yeongdeungpo? Sure is a long time. I heard that you went on to graduate school and then scored a job at S company. Well, they do say that even cicada larvae have a talent for crawling, but I still couldn't believe it. I work as a producer at MTN Refinement Entertainment Broadcasting. I know about what you've been up to on Twitter lately. Would you consider appearing in a show? It's a great opportunity for you too. There's no way of knowing if I'd actually be sent out to do the filming, I mainly work on nature documentaries, not this kind of thing, but my boss keeps pestering

로 채워졌다. 어차피 기억상실에 걸리지 않은 이상 내 이메일 주소를 모르
지는 않을 테니까. 일주일쯤 지나 현우에게서는 반갑네, 하는 답장이 왔
다. 나는 지금 부산에 와서 살아, 하는.

**

　현우와 나는 대학의 문학 동아리에서 처음 만났고 예술적 재능이 딱
히 없다는 이유로 급격히 친해졌다. 지금 생각하면 둘 다 예술을 하기에
는 너무 천진하고 내면이 단순했는데, 왜 그런 동아리에 가입했는지 모를
일이었다. 하지만 어떻게 생각하면 또 자연스러웠다. 둘 다 옥주 언니에게
끌렸으니까.

　언니를 처음 본 건 동아리 홍보 시간이었다. 교양강의 쉬는 시간이 되
자 옥주 언니가 다른 선배들과 함께 우르르 들어왔고 각자의 동아리를 소
개하기 시작했다. 봉사와 종교 같은 판에 박힌 타입의 동아리에서, 경제
지 읽기나 주식투자, 벤처 같은 밀레니얼 세대의 구미에 맞는 활동까지
다양했다. 소개하는 선배들도 대기업 사원들처럼 언변이 좋고 자신감 넘
쳤다. 옥주 언니는 "문학"이라고 쓰인 작은 팻말을 들고 있다가 자기 차례
가 되자 한발 걸어나왔다. 큰 키에 발목까지 오는 웨스턴 부츠를 신고 있
어 인상적이었다.

　언니는 앞을 가만히 건너보고 있다가 갑자기 "너희들은!" 하고 손가락
을 뻗어 우리를 가리켰다. 너희라는 반말도 반말이거니와 그렇게 외치고
아무 말이 없자, 홍보를 하든 말든 자기 할 일을 하던 애들까지 언니를 주
목했다. 그 뒷말은 더 경악스러웠는데 "개돼지다!"라고 했기 때문이었다.
우리는 황당해서 화조차 낼 수 없었다. 어색한 침묵이 흐르고, 강의실 한
편에서 늘 고요히 노트 필기에 집중하는, 그래서 사실 있는지도 없는지도
몰랐던 남자애가 손을 들고, 감정이라고는 깃들지 않은 무미건조한 목소

me, so I'm getting in touch. But anyway, how do you know where the pictures are from? Are you spending all that corporate salary on eating out? I guess you always were obsessed with eating. That reminds me, did you fix your bad habit of spilling when you eat? I used to think there must be a hole somewhere in your mouth. Then again, even if there was a hole in your mouth, with that big salary you would have had it fixed by now…

I was hammering down on the keyboard as if in battle when I stopped for a moment because I realized that I had gone wrong somewhere. And then I mumbled to myself "Keep, it, dry." Dry like pollack hung out in the freezing winter sunshine, dry like porous dried pollack that flakes easily when you pick it apart to make soup. This time I just wrote the proposal for an interview in a way that could even be read as bleak: I didn't hint at the fact that I was the Lee Jimin he knew; the email was made up of content that would be fine to use for a communication template at a government office, all that was missing was an official serial number. As long as he hadn't gotten amnesia, he would recognise my email address anyway. About a week later, "It's nice to hear from you," Hyunwoon's reply came, and he explained that he had moved down to Busan and lived there now.

**

Hyunwoo and I first met at the literature club at our university, and we got friendly fast because neither of us had any particular creative talent. Thinking about it now, we were both so naïve, with internal worlds too simple to really be creative. Why we signed up for that kind of club was anyone's guess. But at the same time, it was only natural, since both of us were drawn to Okju.

The first time I saw her was in the time set aside for clubs to promote their activities to new students. In the break during our intro-

리로 "그건 왜 그러죠?" 하고 물었다. 그것이야말로 우리가 물을 수밖에 없는 말이었다. 그러자 언니는 그 남자애, 현우 쪽을 힐끔 보더니 "궁금하면 우리 동아리에 들어와." 하고는 강의실을 저벅저벅 나가버렸다.

모두들 우리가 사랑받을 가치가 있다고, 심지어 스티브 잡스나 워렌 버핏 같은 기업가가 될 수 있다며 희망을 불어넣는 판에 개돼지라니. 하지만 그 말은 분명 새롭고 불온했으며 흥미를 자극했다. 문학 동아리에는 스무 명 넘는 애들이 가입했다. 선배들은 문사철에 관한 오랜 명저들을 중심으로 세미나 커리큘럼을 짠 다음, 배부른 돼지보다는 배고픈 소크라테스가 되자고 했다.

우리는 옥주 언니를 좋아했다. 언니가 동아리 소개 때 한 그 말이, 한 유명한 문학교수가 새학기마다 신입생들에게 하는 "지성의 철퇴"였고, 언니는 따라한 것에 불과하다는 사실을 알고도 그랬다. 그리고 좋아하는 만큼 옥주 언니를 닮고 싶어 했다. 옥주 언니가 어느 날 만년필로 필기를 하면 만년필 바람이 불었고 기형도를 읽으면 당연히 도서관에서 대출 중이었다.

언니가 다프트 펑크 팬클럽 회원이라는 사실이 알려지자 동아리에는 일렉트로닉과 하우스 음악이 유행했다. 다들 원래 그 뮤지션을 알고 있었고 변명했지만 실제로 그들을 "다펑"이라는 애칭으로 자연스럽게 부를 줄 아는 사람은 옥주 언니뿐이었다. 우리는 홍대의 펑키펑키라는 클럽에 가서, 다프트 펑크가 각본을 쓰고 주연까지 맡은 〈일렉트로마〉(Electroma)라는 영화를 보기도 했다. 인간의 존재론적 회의와, 자기파괴를 통한 역설적 자기구원을 다룬 그 영화는 대사 한마디 없이 음울하고 어두운 세기말적 음악들로 구성되어 있었다. 평소에도 자신들이 안드로이드라고 주장하며 헬멧을 쓰고 다니는 다프트 펑크는 영화에서도 그것을 벗지 않았다. 실제 얼굴로 하는 열연을 기대했던 우리는 점점 지루해져 나중에는 병맥주를 소진하는 데만 열중했다. 온몸이 불타고 망하고 쫓기다 종료되는 그 안드로이드 예술가의 삶을 형형한 눈빛으로 지켜보는 사람은 옥주 언니뿐이었다.

duction to liberal arts lecture, Okju filed into the lecture hall with a bunch of other senior students and they each started introducing their extracurricular clubs. They were varied, from the usual suspects of clubs for volunteering and religion, to clubs with activities matched to the interests of the millennial generation, such as reading economic magazines, investing in stocks, or starting enterprises. And the older students introducing them were as versed in public speaking and brimming with confidence as employees of large corporations. Okju stood there holding a sign that said "Literature" and when it was her turn, she took a step forward. Her height and the ankle-high cowboy boots she wore made her stand out.

She stood still, looking out ahead, and then suddenly stuck out her arm, pointed at us and yelled "You lot!" Not only was "you lot" too informal for the situation, having shouted out like that, she'd just stopped, and so even the students who were getting on with their own work, not interested in the session at all, paid attention. And what came next was even more dumbfounding, because she announced "Are nothing but animals!" It was so absurd we couldn't even get angry about it. There was an awkward silence, and from a corner of the lecture hall a student who was always silently taking down notes, and so no one actually noticed whether he was there or not, raised his hand, and with a flat tone that didn't betray any kind of emotion asked, "Why's that then?" The question couldn't help but be asked. And with that, Okju glimpsed over at him, at Hyunwoo, and said "If you want to find out, join our club" and plodded straight out of the lecture hall.

The speakers who came before had inflated our hopes, telling us we were all worthy of love, that we could even become entrepreneurs like Steve Jobs or Warren Buffett, and then she'd called us animals. But that idea was undoubtedly refreshing and subversive, and it aroused our interest. More than twenty students joined the literature club. Once our seniors had put together a seminar curriculum focused around

"정말 신들린 연기지?"

영화를 보고나서 언니가 우리에게 물었다. 우리는 좀 애매하게 네……
하고 답했다.

"정말 슬프지 않았니?"

옥주 언니는 다시 한 번 우리에게 동의를 구했다.

"네……."

"그럼 어디가 슬펐는지 말해볼까?"

옥주 언니는 정기적인 학생회 회의와 토론, 세미나 등을 진행해본 관
록으로 우리에게 좀 더 구체적인 설명을 요구했다. 슬픈 것은 뭐라고 설
명할 수는 없지만 여기까지 와서 이런 영상을 긴 시간 보아야 하는 상황과
그러느라 늦어진 저녁식사 정도였지만 예의상 그렇게 말할 수 없어 망설
였는데, 현우가 "일종의 숭고미랄까" 하고 정리했다.

현우는 옥주 언니를 따랐다. 현우에게 언니는 램프 속 요정 같은 능력
자이자 어려운 일을 마음 놓고 상의할 수 있는 '통곡의 벽'이었으니까 그
럴 만하다고 여겼다. 하지만 그렇게 해서 이동하고 확장되어갔을 현우의
마음, 혹은 옥주 언니의 상태에 대해 나는 미련하게도 예상하지 못했다.
깨달았을 때는 내 첫 연애가 예정된 결말을 향해 가고 있었다. 종료 버튼
이외에 별다른 선택권이 없었다.

나는 대체 언제부터 옥주 언니를 좋아하게 되었냐고, 어느 순간, 어느
타이밍이었냐고 계속 물었다. 감정이 깊다면 얼마나 깊은지, 수습 가능한
지, 내게 주었던 마음과는 다른지 등은 묻지 않았다. 나는 그냥 그 감정의
시발점, 그렇게 해서 현우가 나를 기만한 것이 언제부터였는지를 확인하
는 일에 몰두했다. 현우는 최근이라고 했다. 그러니까 함께 '문학의 밤'을
준비하면서. 하지만 나는 그 대답은 믿지 않았고 우리 연애가 시작된 그
때부터 이미 그에게 나는 차선이었으리라고 결론 내렸다. 비참함에 완전
히 절여지는 기분이었다. 내 사랑과 정성과 마음은 모욕감 속에 완전히 밀

old classics of literature, history, and philosophy, we vowed to become hungry Socrates rather than well-fed pigs.

We all liked Okju. Even after we found out that the stunt she had pulled during the club presentations was the same "withdrawal of intelligence" that a famous literature professor repeated to his new students at the start of every semester, and she had merely copied it. And as much as we liked her, we wanted to be like her. When one day Okju took notes with a fountain pen, a trend for writing with fountain pens started, and when she was seen reading the poet Gi Hyeong-do all of his books had soon been checked out of the library.

When people found out she was a member of the Daft Punk fan club, electronic and house music became all the rage with everyone in the club. We all pretended as though we were already familiar with them, but the only person who could actually call them by the nickname "Dapung" and have it sound natural was Okju. We even all went to Club FunkyFunky in Hongdae, to watch the film *Electroma*, written by Daft Punk and starring them in the leading roles. The film, which dealt with human existential skepticism and depicted paradoxical self-redemption through self-destruction, was made up of melancholy and dark fin-de-siècle music, without a single line of dialogue. Daft Punk, who claimed they were androids and always wore helmets wherever they went, didn't take them off for the film either. Having anticipated enthusiastic performances with their real faces, we gradually became more and more bored, and later on we were purely absorbed in exhausting the bar's supply of bottled beer. The only one of us who watched the lives of those android artists—burning up and going wrong and being chased out of town and coming to an end—intently and with gleaming eyes was Okju.

"Wasn't it really inspired acting?" Okju gushed after watching the film.

We responded with a slightly non-committal, "Yeah..." and Okju sought our agreement again with, "Wasn't it really sad?"

폐돼 형질이 달라진 듯했다. 말하자면, 있긴 있는데 목적도, 쓰임도 없는 악취 같은 것. 사람이 어떻게 사람을 버릴까, 나는 생각했다. 모든 사랑과 연애가 엔딩 없이 계속되리라고 믿지는 않았지만 그래도 어떻게 네가 날 버릴까.

"처음부터 날 속인 거잖아."

"아니야!"

현우는 파렴치한 인간이 되고 싶지 않은지, 정말 그런 오해가 자신을 고통스럽게 하는지 격렬하게 부인했다.

"처음부터 그랬던 게 아니야."

"아니긴 뭐가 아니야, 이 나쁜 새끼야, 나가 뒈져버릴 개새끼야."

내가 소리 지르자 영등포역 앞을 지나던 행인들이 돌아보았는데, 이미 분노감에 단단히 사로잡힌 나는 그런 시선쯤은 상관이 없었다.

"믿어 줘, 아니야."

현우의 눈에는 눈물까지 차올라 있었지만 한겨울 꽝꽝 얼어버린 스테인리스 양동이처럼 차가워진 내 마음은 변화가 없었다.

"쇼를 해라, 이 새끼야, 쇼를."

기억하기에 그것이 내가 현우에게 한 마지막 말이었다.

초량동

서울에서 내려온 우리 팀은 셋이었다. 신입으로 들어와 섭외를 담당하는 소봄 씨와 촬영을 맡은 재형이었다. 인터뷰어가 섭외된다고 촬영부터 하는 것은 아니고 정말 방송으로 만들 만한가를 알아봐야 했다. 출연자 중에는 막상 만나보면 심신이 미약해 촬영 당일이나 이후 문제를 일으킬 만한 사람들이 흔했는데, 그런 이들을 걸러내는 것이었다. 우리 프로그램은 자기 능력을 과신하는 일종의 망상에 붙들린 사람들이 흥미를 가질 콘셉

"Yeah…"

"So, why don't we talk about what was sad about it?" Okju tried to eke a more specific explanation out of us with the commanding presence of someone who had led periodic students' union meetings, discussions and seminars.

I couldn't explain it, but the whole situation, having come all this way to watch that kind of footage for over an hour, and the fact that dinner had gotten late because of it, was the saddest part, but saying so wouldn't be polite, so everyone was hesitating, when Hyunwoo summed it up for us. "I guess you could call it a kind of sublime beauty." Hyunwoo was fond of Okju. In Hyunwoo's eyes she was a truly talented person, like the genie in the lamp, the Wailing Wall with whom he could discuss any difficulty without restraint, and that seemed reasonable to me. But foolishly enough, I didn't foresee Hyunwoo's feelings moving and expanding from there, or consider Okju's side of things. When I realised it, my first relationship was already moving towards a pre-appointed conclusion. There was no other real choice aside from hitting the brakes.

I kept asking things like, When did you start liking her? From what moment? How long had it been? I didn't ask if the feelings were deep, or how deep they were. Whether he could deal with them or if they were different to the feelings he had for me. I was just absorbed in trying to ascertain the starting point of those feelings, from what point Hyunwoo had begun deceiving me. Hyunwoo said it was recent. More precisely, it began while they were preparing the Night of Literature event. But I didn't believe him and decided for myself that I had already been second best to her when our relationship began. I felt pickled in misery. Like my heart and love and sincerity had been completely sealed off by shame and their fundamental makeup had changed. That part of me was now something like a foul smell: present, but without use or objective. I thought, *How can a person discard another*

트이기 때문에 더 조심해야 했다. 방송의 핵심 콘텐츠인 '그 능력'을 검증하는 건 물론이었다.

그러니까 맛집 알파고의 경우에는 정말 맛집을 귀신처럼 잡아내는 능력이 있는가, 있다면 어떻게 가능한가, 혹시 트위터의 허위계정을 여럿 만들어 자문자답하는 게 아닌가. 재형을 비롯한 회사 사람들이 추측하는 가장 확률 높은 진실이 바로 자문자답이었다.

하지만 소봄은 그럴 리가 없다고 했다. 사진을 의뢰하는 계정을 살펴보면 오랫동안 SNS활동을 해온 '진짜' 유저라는 얘기였다. 둘은 어차피 만나보면 알게 될 진실을 두고, 내려오는 KTX에서까지 말싸움을 했다. 그렇지 않아도 부담스러운 재회에 시름시름 곯아가던 나는 그냥 잠이나 좀 자, 밤샘 때 졸지 말고, 하며 짜증을 왈칵 냈다. 현우도 나도 섭외 과정에서 우리가 '그런 사이'라는 사실은 언급하지 않아서 둘은 모르고 있었다.

"맞은편에 차이나타운이 있어. 거기 맛집에서 밥 먹으면 되겠어."

재형이 역 밖으로 나갔다 들어오며 알렸다. 곧 정문을 밀고 들어올 현우에게 신경이 곤두 선 나는 메뉴 따위에는 관심이 없었다.

"소봄 씨 어때?"

내가 반응하지 않자 재형이 소봄에게 물었다.

"싫은데요, 저는 부산 맛집 가고 싶은데."

"부산 맛집 어디? 뭐?"

"밀면이나,"

"밀면?"

재형이 그런 선택은 정말이지 한심하다는 듯 푸- 하고 웃었다.

"그거 맵고 조미료 치고 뭐가 맛있다고."

"중국집도 조미료 쓰는데, 아주 한국자씩 쓴다던데요?"

"밀면에 쓰는 거랑 짜장면에 쓰는 거랑 같니?"

person? It's not that I believed all love and relationships lasted forever without end, but still… *How could you just toss me aside?*

"You tricked me from the very start."

"No!" Hyunwoo vehemently denied it, perhaps because he didn't want to be marked as shameless, or maybe such a misunderstanding really was agonizing for him, "It wasn't like that from the start."

"What do you mean it wasn't? You bastard. You can just fuck right off. You son of a bitch."

The people walking by outside Yeongdeungpo Station turned to look as I shouted, but gripped as I was by indignation, I didn't care at all.

"You have to believe me. It wasn't like that."

There were tears in Hyunwoo's eyes, but my heart had gone cold like a steel bucket frozen hard in winter, and there was no changing it.

"You really know how to put on a show, you bastard, just a show."

As far as I can remember, that was the last thing I said to Hyunwoo.

Choryang-dong

There were three of us in the team that had come down from Seoul. Sobom was a new hire, in charge of liaison, and Jaehyung was there to take care of filming. When we cast someone for the show, we didn't go straight into filming, first we had to figure out whether they were actually viable for making into a broadcast. There were plenty among the people we wanted to feature who, when you actually met them, you could tell just wouldn't make the cut and could cause problems on the day of filming or afterwards. So we did preliminary screen tests to filter out people like that. Because the concept of our show was particularly appealing to those caught up in overconfident delusions of their capability, we had to be even more careful. And of course, we had to verify the "special talent" which was the core content of our show.

"달라요?"

"아, 다르지, 소봄 씨는 엄마는 짜장면이 싫다고 하셨어도 모르니?"

소봄은 재형이 그렇게 자기 멋대로 우기기 시작하자 입을 아예 다물어버렸다. 띠동갑인 둘은 12간지가 돌고 돌면 저렇게 상극이 되나 싶을 정도로 맞지 않았다. 재형은 소봄이 애 같다고 했고 소봄은 재형이 꼰대라고 불평했다. 꼰대라니, 예술학교에서 영화를 전공한 재형으로서는 상상도 못하고 인정할 수도 없는 말일 것이다.

드디어 세 시가 되고 나는 유리문 쪽을 뚫어져라 바라보았다. 마치 그렇게 하면 현우의 등장으로 내가 입을 충격이 덜해지기라도 하는 것처럼. 하지만 여행가방을 들고 끝없이 밀려드는 사람들 가운데 현우로 보이는 이는 없었다. 10분쯤 지났을까. 소봄에게 일이 있어 좀 늦는다는 현우의 전화가 걸려왔다.

"뭐야? 왜 늦어?"

내가 표정을 굳히자 소봄이 얼른 스피커폰을 켜서 현우의 목소리를 들려주었다. 기억 속 그 목소리로 현우는 "집에 환자가 있습니다"라고 설명하고 있었다. 오늘 컨디션이 좋지 않아서 돌보다 나가야 할 것 같아요.

"거짓말 아냐?"

전화를 끊자 재형이 물었다. 여기까지 왔는데 허탕 치고 올라가는 거 아니냐며, 뭔가 진상 냄새가 난다고.

"아닐 거야."

나는 가방에서 머플러를 꺼내 둘렀다가 여기는 부산이지, 싶어 다시 풀었고 나가서 밥이나 먹고 있자고 했다. 재형은 인터넷 블로그평을 꼼꼼히 읽어가며 식당을 골랐다. 이윽고 점찍은 식당은 블로그 게시물이 그중 가장 없는, 부산 현지인들의 오랜 맛집이라는 중국집이었다. 재형은 이런 곳이야말로 진짜라고 했다.

긴가민가하면서도 길을 건너는데 '초량 아쿠아'라는 간판을 단 5층짜

So in the case of Matjip AlphaGo, whether he really had the ability to identify matjips like magic, and if he did, how it was possible. We had to check that he hadn't made a whole bunch of fake Twitter accounts and was posting the questions as well as answering them himself. That was what people in the office, including Jaehyung, had decided was the most likely method: self-question and self-answer.

But Sobom said that wouldn't be it. She protested that, going through the accounts that had posted pictures she had found "real" users who had been active on social media for a long time. Even in the KTX as we travelled down, the two of them argued over something that would be clear enough as soon as we met him. Already souring with the drawn-out worry of an uncomfortable reunion, I told them off in a burst of anger, saying, "Just get some sleep, and don't start nodding off when he have to film through the night." In the casting process neither I nor Hyunwoo had mentioned the fact that we knew each other "like that" so the two of them had no idea.

"Chinatown is just over the road. We can get something to eat at a matjip there," Jaehyung announced on returning from a look around outside the station.

With my nerves out on feelers towards the main door that Hyunwoo would soon step through, I had absolutely no interest in deciding what to eat.

When I gave no response, Jaehyung asked Sobom, "What do you say Sobom?"

"I don't want to. Can't we go for something you can only get in Busan?"

"What kind of thing? What is there?"

"I don't know, milmyeon or something like that…"

Jaehyung let out a huff. "Milmyeon?" he laughed, as if to say such a choice was utterly pathetic. "That's just regular noodles with too-spicy sauce that's artificially flavored. What's even tasty about it?"

리 건물이 보였다. 생각해보니, 현우와 부산에 내려왔을 때 묵었던 찜질방이었다. 그날 우리는 밤차를 타고 새벽 두 시 넘어서 도착했다. 크리스마스이브에 만났다가 서울 밖으로 가고 싶다는 내 말에 기차를 탄 것이었다. 날이 밝을 때까지 잠깐이라도 쉴 장소가 필요해서, 지하도를 건넜더니 싸고 규모가 작은 여관들이 있었다. 하지만 한결같이 간판불이 꺼져 있었다. 간판불이 켜져 있지 않으면 만실이라고 현우가 말했다.

"너 그런 것도 알아?"

구두 신은 발이 천천히 얼어가는 것을 느끼며 내가 물었다.

"나 여관에서 한동안 살았었잖아."

아빠의 실직으로 갑자기 어려워진 현우네 가족은 한동안 여관 달셋방에서 지냈고 현우는 고등학생이 되면서 서울로 올라왔다. 자기 집에 관한 이야기는 그것이 다였다. 강추위가 밀려와 행인도 없고 가로수 사이에 설치한 색색의 알전구만 빛나는 거리를 오래 헤매도 적당한 곳을 찾지는 못했다. 한곳이 가능했지만 객실 어딘가에서 싸움이 났는지 누군가가 고래고래 화를 내고 있었다. 그런 장면들이 모조리 떠오르자 나는 기분이 아주 착잡했다. 그만큼 풍경의 힘이란 대단한 것이었다.

결국 초량동 일대를 뱅뱅 돌던 우리는 찜질방에 가기로 했다. 들어가기 전에 최대한 여러 번 포옹하면서 아쉬움을 달랬다. 날이 밝으면 바다가 보이는 가장 좋은 모텔을 빌리자고 서로를 위로했다. 이제 그만하고 들어가려다가 다시 한 번, 또다시 한 번. 얼굴이 얼얼하게 얼어갈 때가 되어서야 우리는 심야입장권을 끊었다. 여탕으로 가서 몸을 씻는데, 타일들이 몇 장씩 떨어져 나간 낡은 열탕에 청색바가지들이 동동 떠 있었다. 탕으로 들어가 하나를 손바닥으로 텅- 밀었더니 출렁이며 밀쳐졌다가 흔들흔들 균형을 잡았다.

하지만 곤란은 그치지 않았다. 수면실로 올라가보니 방 하나에 남자와 여자가 분리되어 양편에서 자고 있었다. 적어도 같이 누울 수는 있을

"They use artificial flavoring at Chinese places too! I heard they add it in by the ladleful."

"You think the stuff they use in milmyeon and the stuff they use in jjajangmyeon is the same?"

"How are they different?"

"Ah, of course they're different. I know you said your mother never liked jjajangmyeon, but you should know that much at least."

When Jaehyung kept persisting, Sobom just completely stopped engaging. Born under the same Chinese zodiac sign, they were always in so much conflict that it made you wonder how such incompatibility could arise from a 12-year cycle coming around again. Jaehyung said that Sobom was like a kid, and Sobom complained that Jaehyung was a ggon-dae, one of those grumpy old men who think they're always right. Having gone to art school and majored in film, Jaehyung would never have even imagined he could be called a ggondae, let alone accept the diagnosis.

When three o'clock came around I stared over at the glass doors as if to burn a hole through them. As though this would somehow lessen the shock I would suffer when Hyunwoo showed up. But among the endless stream of people with suitcases, there was no one who looked as though they could be Hyunwoo. At around ten minutes past, a call came through to Sobom from Hyunwoo saying that he would be a little late, something had come up.

When I frowned "What is it? Why's he late?" Sobom put on speakerphone so we could all hear Hyunwoo's voice. In that voice from my memory, Hyunwoo was explaining, "Someone at home is sick. Their condition isn't good today, so I think I'll have to look after them a little longer before I head out."

"Do you think he's lying?" Jaehyung asked as soon as the call ended.

He was worried that we would end up going back to Seoul with nothing to show for coming all this way, he said that something didn't seem right, we might be being taken for a ride.

줄 알았던 우리는 당황했다. 그렇다고 둘이 있겠다고 통로에서 밤을 샐수도 없고 이미 씻어서 노곤했으므로 우리는 아쉽지만 적당한 자리를 찾아보기로 했다. 이 시간 찜질방이란 몸을 닦는 사람보다는 우리처럼 어떻게든 그 밤을 나야 하는 사람들이 대부분이라 만석이었다. 그래도 몸을 들이밀자, 이미 자고 있던 사람들이 조금씩 몸을 옮겨 자리를 만들어주었다.

기억에서 가장 강렬한 장면은 방 한켠에 관리자인 듯싶은 여자가 홀로 앉아서 경비를 서고 있는 것이었다. 스마트폰이 없던 시절이라 그랬겠지만 여자는 초량 아쿠아라는 명칭이 아치형태로 쓰인 티셔츠를 입고, 그방에 어울리지 않게 책을 읽고 있었다. 제목을 읽어보려 해도 어두워 볼수가 없었다. 책을 말듯이 쥐고 기우뚱한 머리를 한 손으로 괸 채 골몰해있는 여자의 모습은 내내 지켜야 할 그 밤이 그렇듯 피로하면서도 나른하고 또한 어딘가 불온해 보였다.

부산에 대한 현우의 감정은 양가적이었다. 고향이기 때문에 그리웠지만 불우했던 유년 때문에 떠올리고 싶지 않은 공간이기도 했다. 그러니까 현우가 스물세 살 크리스마스에 나와 함께 부산으로 내려간 건 특별한 일이었다. 적어도 그해의 크리스마스에 나는 그렇게 믿었다. 그 순진성은 문제였을까.

그 시절 현우는 자기는 절대 부산에 와서 살지 않을 거라고 했다. "왜, 부산 좋은데 따뜻하고 먹을 것도 많고 크고." 내가 말하면 "아냐, 싫어." 하던 현우의 완강한 표정.

재형이 안내한 중국집은 그렇게 숨은 맛집 느낌은 아니었다. 이미 벽면 가득 유명인들의 사인과 어디어디 방송에 출연했다는 사진들이 붙어있었으니까. 재형이 세어보더니 3억, 대략 3억 썼구먼, 하고 결론을 내렸다. 맛집 소개 프로그램들이 제작비를 받고 방송을 짜주니까 한 건당 3천만원쯤으로 계산한 것이었다.

"뭐하는 분들이세요?"

"It'll be alright," I said, taking out my woolen scarf and starting to wrap it around my neck. Then I remembered, *Oh yeah, we're in Busan*, took it off again, and said, "Let's go and have something to eat." Jaehyung picked out a place by scouring through reviews on internet blogs. The place he'd finally decided on was the one with the least blog posts: a Chinese restaurant that was supposed to be an old favourite among people who actually lived in Busan. Jaehyung said that this kind of place was the real deal.

I wasn't particularly convinced, but we set out anyway, and as we crossed the road, I noticed a five-story building with a sign that said "Choryang Aqua." Thinking about it, it was the jjimjilbang Hyunwoo and I had slept in when we came down to Busan together. We took a night train and had arrived well after two in the morning. We had met up on Christmas Eve and I said I wanted to get out of Seoul, so we got on a train. We needed somewhere to rest for a while until it got light, so we crossed through the underpass to where there were a bunch of small cheap motels. But every one of them had the light in their sign switched off. Hyunwoo said that if the light was off it meant they were full.

"How do you know that kind of thing?" I asked, feeling my feet gradually freezing solid in my nice shoes.

"I told you before, I lived in a motel for a while."

After his father was laid off, their situation became difficult, so Hyunwoo's family spent some time living in a motel room on monthly lease, and when it was time for Hyunwoo to go to high school he left them and moved to Seoul. That was all he had ever told me about his home life. No matter how long we roamed the street, emptied of people by the onset of freezing cold and with no lights but the multicolored bulbs strung up between the roadside trees, we couldn't find a suitable place. There was one possibility, but there seemed to be a fight going on; in one of the guest rooms someone was shouting

여자 사장이 엽차를 가져다주다가 그 말을 듣고 물었다.

"에이, 사장님, 저희가 방송국 사람들이에요."

재형이 포장을 찢어 물티슈로 손을 닦으면서 너무 발끈하지 말라는 듯 웃었다.

"어디 방송국인데 그런 말을 해요?"

"이 친구가 농담을 한 거예요. 저희는 맛집 이런 거 안 해요. 저희는 자연 다큐 찍는 사람들이에요."

나는 문제가 커져봤자 우리만 피곤하니까 팔을 허위허위 저으면서 분위기를 무마했다.

"그럼 손님은 피디님이신가?"

여자가 호리병처럼 눈을 흘기며 재형에게 질문했다.

"찍사예요."

재형이 그렇게 답하는 순간 소봄이 엽차를 콸콸 부어 재형 앞에 탁 내려놓았다. 우리는 군만두와 탕수육은 기본으로 하고, 짜장면과 사천짬뽕을 시켰다.

"매운 거 잘 드세요? 우리 사천은 매븐데?"

주문을 받아가며 사장이 확인했고, 재형은 제 성이 매울 신, 입니다, 매울 신, 하고 답했다.

"오리지널 그대로 주세요."

그리고 각자 휴대전화를 들여다보며 음식을 기다렸다. 한참 있다 소봄이 "눈 올 확률 60퍼센트래요. 화이트 크리스마스 오랜만이다." 하고 기대에 차서 알렸다. 나는 눈이 오는 건 정말 싫었다. 눈이 와서 그 희고 차고 가볍고 빛나는 것이 와서 부산을 덮는 것이 싫었다. 나는 그냥 오늘도 어제와 다르지 않은 날이라서 아주 건조하고 건조하게 본촬영에 참고할 내용만 "잘 뽑아서" 여기를 뜨고 싶었다.

"소봄 씨는 눈 오는 크리스마스 왜 기다려?"

non-stop, venting their rage. I couldn't help picturing what must be unfolding in there in detail, and it made me feel ill at ease. That's the formidable power of scenery.

In the end, having circled around the whole area of Choryang-dong, we agreed to go to a jjimjilbang. We hugged as many times as we could before going in, trying to soothe the sense of disappointment. We comforted each other, saying that as soon as it was light we would go and get a room at the nicest motel with a sea view. Just when we were about to go in, we stopped and hugged again, and then again once more. Only when our faces were numb with cold did we buy our late-night entrance tickets and go in. I went into the women's baths and showered. There were blue plastic basins bobbing on the surface of the water in the big communal tub that had tiles missing here and there. I eased myself into the warm water and pushed one of the basins with my palm. It sped away with a splosh and after wobbling for a while regained its balance.

But our difficulties that night didn't stop there. When I put on the shorts and t-shirt they gave us at the entrance and went out to the sleeping room, I found it was one big room for both men and women, but the men and women were separated to opposite sides of the room. Having thought we would at least be able to lay side by side, we were at a loss. But we couldn't stay up all night in the chilly corridor just to be together, and we were already bathed and sleepy, so despite the disappointment we each tried to find a spot on the floor to lay down. Since most of the people in the jjimjilbang at this time of night weren't there to wash and scrub but to get through the night one way or another just like us, the room was full. Still, when I pushed my body in amongst the line of women, even though they were already sleeping, everyone moved a little and made space for me.

The most vivid memory I have of that night was of the woman who looked like a caretaker, keeping watch alone in one corner of the

"왜냐구요?"

소봄은 그런 말이 어디 있냐는 듯 눈을 둥그렇게 뜨며 황당해했다. 그러고는 "피디님은 그럼 안 기다려요?" 하고 확인했다.

"응, 싫어."

"아이고, 우리 피디님 피곤하신가 보다."

소봄의 말투는 마치 달래듯 했는데, 정말이지 피곤하긴 했다. 디졸브 촬영이라고 우리가 자조해서 부르는 밤샘 촬영을 하다보면 비몽사몽간에 이게 대체 뭐 하는 짓인가 싶은 생각이 들었다. 이 많은 인간들과 장비와 말들은 다 무엇인가. 졸업하고 방송계를 어슬렁거리며 늘 자연 다큐를 찍고 싶었지만 그쪽으로 일할 수 있었던 적은 없었다. 내게는 그저 인간, 좀 더 나은 인간, 어떤 면에서 좀 특이한 인간, 좀 다른 인간, 하지만 그러고 보면 뭐 그리 특출 난 게 아니라 갖가지 어리석음과 인간적 한계로 뒤틀리고 비뚤어진 인간들의 연속일 뿐이었다.

재형은 내가 그런 말을 하면 감상적이라며 자주 비웃었다. 독립 피디로 일하고 있는 자기 친구는 자연 다큐가 좋아서 유학까지 하고 돌아왔는데, 혼자 섭외하고 촬영하고 드론을 띄우고 일인다역을 해가며 일하다 사고까지 당했다고. 해외에서 환자를 이송해와야 하는데 그 돈을 방송사도, 프로덕션도 주지 않아 동문들이 모금을 다 했다고.

"렌즈가 자연을 향해 있으면 뭘 하니 우리가 인간인데. 그래도 우린 외주는 아니잖아."

중국집에는 이상하게도 손님이 별로 없었다. 원탁 한곳에만 두툼한 메뉴첩이 올라가 있고 젓가락과 숟가락이 각 자리에 맞게 준비되어 있었다. 예약 손님이 있는 모양이었다. 하지만 손님들은 아직 오지 않았고 거기에는 손님들이 올 것을 암시하는 젓가락과 숟가락만 놓여 있다. 올 거라는 약속, 채워지리라는 표지, 추후를 예비하는 노력 같은 것.

이윽고 음식이 나왔고, 소봄은 탁자 사진을 찍더니 나중에 맛집 알파

sleeping room. It wouldn't happen now in the smartphone era, but wearing a t-shirt with Choryang Aqua printed on it in an arch shape, she was reading a book: something which seemed very out of place in the dark room. Try as I might to decipher the title, it was too dark to see. Gripping the book as if to roll it up, with her tilted head held in one hand, engrossed, she looked exhausted and listless, just like the night that she would have to sit through. But there was also something subversive-looking about her.

Hyunwoo had mixed feelings about Busan. He missed it because it was his hometown, but because of his deprived childhood, it was also a place he didn't want to be reminded of. So it was something special for Hyunwoo to go down to Busan with me at Christmas when he was twenty three. Or at least I believed as much then. Perhaps that naivety of mine was part of the problem.

Back then Hyunwoo had said that he would never come back to live in Busan. When I said, "Why? Busan's great, it's warm and there are great things to eat, and it's a big city," he was resolute when he said, "No. I don't like it."

The Chinese place Jaehyung took us to didn't have the feel of a hidden gem matjip at all. There were already celebrity autographs and photos commemorating appearances on this and that television show plastered all over the walls. Jaehyung counted them and came up with the figure of "300 million, they must have spent about 300 million won for all that." Since shows introducing matjips covered their production costs with contributions from the businesses they featured, he must have accounted for around 30 million won for each appearance.

Hearing this as she brought over a pot of tea, they lady owner asked, "What line of work are you in then?"

"Ah, can you tell? We work in broadcasting."

As he unfolded his hand wipe and scrubbed his hands, Jaehyung laughed as if to say, *Don't fly into a rage.*

고를 만나면 우리가 어디서 뭘 먹었는지 맞히는 과제를 주겠다고 했다. 웬일로 재형이, 좋은 생각인데, 하고 칭찬했다. 탕수육은 바삭했고 군만두는 고소했으며 짜장면에서는 적당하게 감칠맛이 났다. 그렇게 말없이 먹다가 짬뽕을 먹는 재형을 봤는데 표정이 심상치 않았다. 땀을 흘리며 단무지 그릇에 연신 고추를 덜어내고 있었다. 하나를 덜어내고 또 하나를, 어디서 그렇게 매운 것들이 나오는지 모르게.

"사장님, 아니 사장님, 이거 조리하다가 쏟은 거 아녜요?"

재형이 조리실로 들어가버린 사장을 찾았다. 안이 꽤 넓은지 "뭐라고요……" 하고 사장이 좀 먼데서 묻는 소리가 들렸다.

"왜 뭐가…… 이상해요?"

"아닙니다. 이상한 건 아니고요."

"괜찮아?"

나는 저렇게 땀을 흘리다가 무슨 일이 생기는 게 아닌가 싶어 물었다.

"매우면 먹지 마."

"괜찮아, 괜찮은데,"

"괜찮으셔야죠. 매울 신인데."

소봄이 끼어들어 얄밉게 말을 보탰다. 나는 경고의 의미로 소봄의 어깨를 툭 쳤다. 그래도 매울 신이 맞기는 맞는지 재형은 짬뽕을 거의 비웠다. 계산을 하러 나온 사장은 플라스틱 접시에 냉동 리치를 담아 탁자에 올려놓았다. 냉동 리치는 까기만 힘들 뿐 맛은 없었다. 그래도 재형은 사탕을 받은 아이처럼 잘 까서 흐뭇하게 물었다.

밥을 다 먹을 때까지 현우에게서는 답이 없었다. 혹시 오지 않으려는 걸까? 만날 수가 없는 걸까? 그렇다면 그 또한 당연하다는 생각도 들었다. 그래, 그런 상처를 나에게 주고 최소한 인간으로서의 예의가 있지 얼굴을 들고는 나오지 못하겠지. 하지만 그렇게 해서 만날 수 없는 것이 정말 내 바람인지는 알 수 없었다. 현우가 오지 않는다. 이 만남은 공백 혹은 결락,

"Which company are you from to be talking like that?"

It would end up being exhausting for us if the situation escalated, so I stirred the air with my arms and tried to calm the mood, "This guy's just trying to be funny. We don't do matjip features. We just film nature documentaries."

Giving a sidelong scowl, the woman asked Jaehyung, "So, are you the producer then?"

"Not me, I'm just the cameraman."

As soon as Jaehyung gave his reply, Sobom poured out a cup of the hot tea and hit it down on the table in front of him. We ordered crunchy fried dumplings and crispy sweet and sour pork to share, with jjajangmyeon and Sichuan-style jjamppong for mains.

"Are you good with spicy food? Our Sichuan-style broth is very hot," the owner checked as she took the order.

Jaehyung responded that the Chinese character for his surname was spicy Shin, spicy Shin, "Just give it to me as it comes."

And then we each looked at our phones while we waited for the food. A while later, full of anticipation, Sobom informed us, "Apparently there's a sixty percent chance of snow! It's been a while since we've had a white Christmas." I really didn't want it to snow. I didn't want the white and cold and light and shining of snow to come down and cover Busan. I wanted today to be just like any other day, so that we could utterly dryly "extract" only the content we would need to reference for the proper filming and then be out of here.

"Why are you so excited by the prospect of a snowing Christmas, Sobom?"

With her eyes bulging as if to say, *Who would ever ask such a thing?* Sobom was taken aback, "Why?" And then she checked, "Do you mean to say that you're not?"

"Right. I don't like it."

"Oh dear, you must be really exhausted."

있으리라 했던 것의 불발 상태가 된다. 그러자 긴장감을 동반한 감정들이 밀려왔고, 그것은 기분에서 더 나아가 통증에 가깝다고 생각하는 순간, 현우에게서 도착했다는 연락이 왔다.

복수

현우는 우리가 예약한 스튜디오에서 촬영하기를 원하지 않았다. 영도에 있는 특정 카페를 고집했다. 초등학교 동창이 하는 그 카페에서만 집중할 수 있고 능력을 발휘할 수 있다는 거였다. 무엇보다 집중력이 필요한 일 아니겠습니까, 네? 현우는 내가 만났던 시절보다는 당연히 늙어 있었지만 그때보다 더 말쑥한 차림새였다. 캐시미어 함량이 높아 보이는 고급 겨울 외투에 도톰한 밤색 스웨터 셔츠를 입고 있었다. 우리는 또다시 부산역 맞은편 길가에 서서 어디로 가야 할지 갈피를 잡지 못했다. 그러다 소봄과 재형의 반대에도 불구하고 "갑시다, 영도." 하고 내가 결론 내렸다. 등장할 때부터 현우는 나를 전혀 알은체 하지 않았고 그 자연스러운 연기력이란 오스카도 울고 갈 판이었다.

　택시는 부두 주변의 숱한 선박 관련 부품가게와 수리점들을 지나 영도다리를 달려 흰여울마을 언덕에 우리를 내려주었다. 햇빛이 눈부시게 내린 광활한 바다에 대형선박들이 떠있었다. 영도 앞바다는 급유나 수리가 필요한 원양어선들이 닻을 내리고 머무는 묘박지라고 철제 안내판에 쓰여 있었다. 현우의 능력이 발휘 가능하다는 카페까지는 층층의 계단과 한 사람이 겨우 지날 만한 골목을 지나야 했다. 그리고 마침내 '부산 교향곡'이라는 이름의 카페가 나타났다. 이층집을 개조한 형태였고 마당에는 고양이 네댓 마리가 뛰어놀고 있었다. 카페에 도착하자마자 재형이 화장실을 찾더니 사라졌다. 소봄도 주문하러 가고 둘만 마당 벤치에 남자 현우는 "이렇게 먼 길을 와서 어떻게 해." 하고 차분하게 말을 건넸다. 이럴 땐 초

Sobom spoke almost as if to comfort me, but I really was exhausted. Doing what we mockingly referred to as "dissolve transition filming," where we had to stay up all night for a shoot, half awake and half asleep, I would think to myself, *What is all this for anyway? What's the meaning of all this equipment, all these people and words?* Loitering around in the broadcasting world since graduation, I had always wanted to work on nature documentaries, but no opportunities had ever come up. For me it was nothing but a continuous stream of humans, humans who were a little better, humans who were a little special in one way or another, humans who were a little peculiar, but all just humans who weren't all that exceptional at close range, and were actually twisted and warped, each by their own foolishness and limitations.

Jaehyung would make fun of me when I said things like that, saying that I was too sentimental. He told me about his friend who was working as an independent producer; he was so set on doing nature documentaries that he'd even gone overseas to study for it, and he had to take care of everything like a one-man-band, scouting locations and filming and flying drones all on his own. And then he got injured on the job. Jaehyung said that, even though he needed to be transported back from overseas for treatment, neither the broadcasting company nor the production company would pay for it, so their alumni society had to do a fundraiser to get him home.

"It's no use pointing the lens at nature, we're humans. And look on the bright side, at least we're not subcontractors."

There were strangely few customers in the Chinese restaurant. On one of the big round tables there was a thick menu, and chopsticks and spoons had been placed at each table setting. As though there was a reservation. But the customers hadn't arrived yet and all that was there were spoons and chopsticks which implied that they might be on their way. Something like a promise to come, a sign that the seats would be filled, an effort in preparation for the future.

장의 답변이 중요한데 어떻게 받아쳐야 할까 고민스러웠다. 네 알 바 아니잖아,에서, 인두겁을 쓰고 어떻게 내 앞에 나타나,를 거쳐, 이거 우리 비즈니스야,까지. 그러다 나는 "오늘 잘 부탁해." 하고 짧게 대답했고 스스로 그 간결함이 마음에 들었다.

차를 내온 카페 주인은 덩치가 크고 머리를 어깨까지 길러 굵게 펌한 남자였다. 남자는 현우를 우야, 우야, 하며 끝자만 따서 불렀는데 큰 체격과 달리 살가워 보였다. 숨을 좀 밭게 쉬어서 알레르기 같은 게 있나 싶었다. 소봄과 매장에서부터 대화하고 있었던 듯, 얘기를 이어나갔는데 부산 교향곡이라는 카페 이름은 다름 아닌 이 앞의 묘박지에서 12월 31일 밤이 되면 모든 배들이 뱃고동을 울려 새해를 축하하는 데서 왔다고 했다. 일주일 후가 바로 디데이인데 왜 이렇게 일찍 왔냐고, 그때 또 촬영하러 와서 여기 마당에서 그 거대한 바리톤의 소리를 들으며 뱅쇼를 한잔하자고, '쬐매한' 악기랑은 차원이 다르다고, 아주 우주적 선율이라고 열을 올렸다.

"우야, 니는 들어봤제? 한번 설명을 좍 해야 방송 나가고 우리 카페도 입소문을 타고 안 하겠나. 다음 주에 오이소, 한해 마지막에 가슴 뻐근해지고, 없던 인류애도 생겨나고 희망도 생기고."

"다음에는 저희가 또 다음 촬영이 있으니까요."

"다음에는 그래 어떤 능력자가 나오능교?"

카페 주인은 정말 궁금한지 아니면 그냥 해보는 말인지 그렇게 물었다.

"물고기랑 대화하는 사람이 나와요."

"물괴기요?"

"네."

다음 주부터 진행해야 할 촬영이야말로 한심하기 그지없었다. 나는 일몰을 준비하는 바다와 겨울이라고는 믿기지 않게 온난한 미풍 그리고 햇볕에 노곤해져, 알릴 필요도 없는 근황을 쏟아냈다. 카페가 자리한 흰여울 마을 꼭대기 어딘가에 마음과 몸이 완전히 눌어붙는 기분이었다.

When the food came out at last, Sobom took a picture of the table and said that when we met Matjip AlphaGo later she would show it to him and see if he could identify what we ate and where. For some reason Jaehyung commended her with, "What a great idea!" The pork was crispy, the dumplings were tasty, and the jjajangmyeon had just the right depth of flavor. Having eaten for a while in silence, I looked over at Jaehyung who was eating his Sichuan-style jjamppong and his expression was extraordinary. He was dripping with sweat and endlessly picking out big slices of dried chili from the soup and piling them onto the side plate of yellow radish. He picked out one after another, so many it was hard to know where all those spicy things were appearing from.

"Excuse me, uh, over here," Jaehyung tried to get the attention of the owner who had disappeared into the kitchen. "Did all these get poured in by mistake?"

As though it was vast inside, "What was that...?" the owner's voice sounded from a long way off, "Is something... strange?"

"No no. Nothing's strange, it's just that..."

"Are you alright?" I asked, worried that sweating so much might make him ill. "If it's too spicy don't eat it."

"I'm alright, I'm fine, it's just,"

Sobom cut him off, "You'd better be alright. You're a spicy Shin."

I gave Sobom a firm tap on the shoulder as a warning. But perhaps he really was a spicy Shin, because Jaehyung emptied the bowl almost completely. The owner who came out of the kitchen to settle up put a plastic plate with frozen lychees on it on our table. The frozen lychees were hard to peel and there was no taste to them. Even so, Jaehyung peeled one and put it in his mouth with glee, like a child who'd been given a sweet.

There was no further word from Hyunwoo, even once we had finished eating. Maybe he was never planning to show up in the first

"뭐라 카는데 물고기가?"

"철학을 한다더라고요, 그래서 이름도 철학 잉어."

우리는 여기까지 말하고 나서 웃기 시작했는데, 그건 지금 빨대로 빨아들이고 있는 이 차고 맹맹한 아이스커피만큼이나 한심한 일이었다.

"아니 잉어가 철학을 하면 뭐라 카는가. 실존은 본질에 앞선다 이런 기가. 배부른 가물치보다는 배고픈 도다리가 되겠다 이카는가?"

사장이 현우의 어깨를 툭툭 치면서 자꾸 웃었는데, 소봄이 왜 하필이면 가물치냐고 물었다.

"가물치는 바닷고기가 아니에요, 민물이지. 고기가 망망대해에서 버티려면 얼마나 막막하겠능교."

카메라를 설치하자 현우는 좀 긴장하는 것 같았다. 세월이 흘렀는데도 그 미세한 표정 변화를 바로 알 수가 있었다. 나는 그렇다면 현우도 내 얼굴에서 뭔가를 읽을 거라고 생각하고 또 혼자 건, 조, 하, 게, 라고 중얼거렸다. 가장 먼저 현우에게 보여준 사진은 아까 중국집에서 찍은 것이었다. 현우는 그 특별할 것 없는 짬뽕과 탕수육, 번들거리는 춘장과 기름에 벅범이 된 짜장면 사진을 들여다보더니 한동안 고개를 들지 않았다. 중간에 잠시 고개를 들고 사실 알아내자면 시간이 좀 걸립니다, 하더니 시선을 내렸다. 나는 망한 걸까, 하고 생각했다. 하지만 트위터에서 백발백중 맞혔던 일은 어떻게 된 것인가. 정말 의뢰인과 답신자 모두 자기 자신인가. 유령 계정을 사들였나. 카페에서 틀어놓은 90년대 록발라드들이 다 돌고 난 뒤 이윽고 현우는 "이건 데이터 밖인데." 하고 답변했다.

"데이터 밖이라니요?" 소봄이 물었다.

"정상적인 사진이 아니란 말이죠. 각 식당은 더구나 오래된 맛집들에는 아주 정확한 매뉴얼이 존재하잖아요? 플레이팅과 재료의 써는 각도, 대파와 고추 같은 양념의 사용으로 인한 빛깔, 고기의 익힘 정도와 고명 종류.

place. Or was he unable to meet us? If that was the case, well, I thought it was actually quite reasonable. Of course, having hurt me like that, out of human courtesy, at the very least he wouldn't be able to actually come out and face me. But I couldn't tell if that wasn't just what I was hoping for. *Hyunwoo never turns up. This meeting is left as a vacuum or deficit, a non-event that might have been.* And with that thought, the emotions that came along with my trepidation rushed in, and just as I could feel that they had progressed from stifling emotions to physical pain, Hyunwoo got in touch to say he had arrived.

Revenge

Hyunwoo didn't want to do the filming in the studio we had booked. He insisted on a particular café in Yeongdo. Apparently, he could only concentrate and exhibit his talent at this café run by his old elementary school classmate. "You see," he said, "it's something that needs concentration more than anything else." Hyunwoo had aged since the time when I knew him, of course, but his grooming and dress sense were better than back then. He wore a well-made winter coat that looked like it had a high percentage of cashmere and a thick chestnut brown sweater with a shirt collar showing at the neck. We found ourselves stood again on the pavement across the road from Busan Station, unable to work out where to go. After a while, despite Sobom and Jaehyung being against it, I took the lead and said, "Alright, let's go to Yeongdo." Hyunwoo hadn't given away any hint of knowing me since he'd shown up; even Oscar winners would have to acknowledge such an ability to act perfectly natural.

The taxi we took drove past rows of boat mechanics around the quayside and stores selling parts for boats, then raced across Yeongdo Bridge and dropped us off on the hillside of Huinnyeoul Village. There were huge boats floating on the wide open sea below, that dazzled reflecting the sunshine. A steel information board explained that the

마치 공장에서 생산하는 것처럼 아주 고정되어 있는데 이건 내가 아무리 굴려봐도 없어, 아니야."

나는 이건 또 무슨 궤변인가 하고 있는데, 방금 전에도 화장실을 다녀온 재형이 "그렇지, 그렇지." 하고 맞장구치며 갑자기 나섰다.

"그렇죠? 이거 빛깔이랑 이런 거 어디서도 못 봤죠? 고추도 이게 뭐야 이건 고추탕이지. 고추탕. 와씨, 그 아줌마 나한테 일부러 그랬네."

재형은 잦은 설사에 하얘진 얼굴로 분통을 터뜨렸다. 그렇게 흥분하고 화를 내는 재형은 처음이었다.

"재형, 사장이 왜 일부러 그랬단 말이야? 진정해."

"왜 그런지 이 피디 너 정말 몰라서 묻는 거야?"

재형은 흥분했는지 언제나 지키고 있던 카메라 뒤에서 나와, 앵글에다 잡히도록 서서, 복수한 거잖아, 하고 확신에 차서 말했다.

"내가 자존심을 긁었더니 복수를 한 거야."

"그런 복수를 왜 해? 서로 곤란해질 일을."

"그렇게 곤란해지기를 무릅쓰는 게 복수지."

"그러니까 그 곤란을 왜 무릅쓰냐고?"

"무릅쓰고 싶으니까."

나는 어쩐지 이 대화가 부담스러워져 잠깐 쉬자, 하고 볼펜을 탁자 위로 던졌다. 카페 안에서는 주인이 테이블을 돌아다니며 작은 촛불들에 불을 붙이고 있었다. 평대에 진열된 오래된 카메라와 사진들을 보는데, 주인이 다가와 자신의 할아버지가 부산 최초의 사진사라고 자랑했다. 큰 예식장도 운영했는데, 그 당시에는 예식장 비용보다 사진값이 더 비쌌기 때문에 예식 비용은 공짜였다고.

"예식장 오너요? 대대로 부자셨네요."

"내 대에 와서 이렇게 짜부라졌죠, 뭐."

"사장님이 어때서요? 이런 데 사장도 사장은 사장이죠."

sea just off Yeongdo was an anchorage where deep-sea fishing boats that needed to refuel or have repairs could put down their anchors and stay for a while. We had to go up endless stairs and walk along an alleyway that was just wide enough for one person to pass through to get to the café where Hyunwoo could demonstrate his talent. At last, a café called "Busan Symphony" appeared. It was a repurposed two-story house and in the yard outside a few cats were jumping and playing about. As soon as we got to the café Jaehyung disappeared in search of the toilet. When Sobom went in to order our drinks and just the two of us were left on the bench in the yard, Hyunwoo addressed me calmly, "This is a long way to travel for work."

At times like this the first response sets the tone, so I had to think carefully about what to say back. I went from *It's none of your business,* past, *How dare you show your face before me?* all the way to, *It's just the nature of the work we do.* And then I gave the short reply, "We're counting on you today," and was pleased with myself for its concision.

The café owner who brought out our drinks was a heavy-set man with hair down to his shoulders that was loosely permed. The man called Hyunwoo by the last syllable of his name, "Hey Woo," "Woo!" so, unbefitting to his bulk, he seemed affectionate. His breathing was a little wheezy, so I wondered if he might have an allergy or something like that. As though he had already been in mid-conversation with Sobom inside the café, he continued explaining that the name "Busan Symphony," came from none other than the New Year celebration that took place in the anchorage down the hill, where on the night of December 31st all the boats would sound their foghorns together at midnight. He got all heated, saying that exactly a week from now would be D-day, so why had we come so early? We should come back again to film then and have a glass of mulled wine here in the yard and hear that boundless baritone. He said it was on a completely different level to "teeny tiny" instruments, a truly cosmic melody.

내 대답에 주인은 말을 뚝 끊더니 "우야가 좋은 사람이라 카더마는, 뭐 이래 삐딱하노." 하며 자기 일로 돌아갔다.

현우는 소봄이 내민 사진 중 두 장을 맞혔다. 대왕왕곱창구이라는 서울의 식당과, 영지면옥이라는 진천 어딘가에 있는 식당이었다. 그런데 문제는 시간이 너무 오래 걸린다는 점이었다. 하나를 맞히는데 적어도 한 시간 반이 걸렸다. 하지만 맞히긴 맞혔으니까 아예 없는 능력이라고 하기에도 애매했다. 어떻게 할 것인가? 나는 하는 수 없이 국장에게 전화를 걸었다. 국장은 맞히긴 하던가? 물었고 내가 그렇다고 하자 그러면 나중에 다 까내더라도 일단은 좋게 좋게 해서 촬영하라고 했다. 통편집을 하더라도 우선은 진행하라는 것이었다. 해는 져서 볕은 사라지고 바다에는 아주 짙고 푸른 수면이 깔려 있었다.

다시 자리로 돌아와 우리는 또다른 음식사진을 내밀었다. 현우는 그것을 스캔이라도 하려는 듯 눈으로 힘주어 내려다보며 또 시간을 보냈다. 고양이들이 마당 한켠에 있는 자전거 바퀴를 발톱으로 긁다가 우다다를 하다가 자기들끼리 엉겨 놀다 야옹야옹거릴 만한 시간을, 술기운이 거나한 사람들이 들어와 아이스음료로 속을 풀려다 자기들끼리 말싸움이 붙어 어색하게 헤어질 만한 시간을, 하늘을 비추던 등대 불빛이 구름의 두툼한 두께를 여러 번 매만지다 사라지는 시간을, 그리고 재형이 전화를 걸어 중국집과 한판 싸움을 벌일 만큼의 시간을. 사장은 음식이 평소 같지 않았다는 현지인의 증언을 확보했다는 말에 아니 우리가 무슨 기계예요? 음식이란 주방장 컨디션에 따라 그때그때 다르고 그게 사람이지, 하고 웃었다고 했다. 자기를 도리어 가르쳤다며 재형은 분을 삭이지 못했다.

나는 재형이 한심했다. 다른 불의에는 관심도 없으면서, 심지어 지난 정권 때 다들 나가는 광장 한 번을 안 나가놓고는 지금 저렇게 흥분하는 건 뭔가. 그 피해가 뭐라고, 그건 그냥 남들 보기 민망하게 자꾸 화장실을 들락거리고 설사 좀 하는 일에 불과하지 않은가. 물론 매운 음식을 먹어

"You've heard it, haven't you, Woo? Describe it to them really well so they'll want to come back and put it in their program and then people from all over will start coming to the café." Then he turned to me, "Make sure you come back next week. It'll get your heart all pumped up at the end of the year, give you a love for humanity and a feeling of hope."

"Next week we'll be on our next assignment."

"What talented person is appearing next then?" The café owner asked, perhaps because he really was curious, or maybe just because.

"We're going to feature someone who can communicate with a fish."

"With a fish?"

"Yes."

The filming we had to begin the following week really was hopelessly pathetic. Feeling more relaxed with the mild breeze and sunshine that made it hard to believe we were by the sea in winter and the sun was about to set, I said more than I needed to. It felt as though my mind and body were completely stuck in place, somewhere in Huinnyeoul Village where the café sat atop the hill.

"What does it have to say, this fish?"

"Apparently, it's very philosophical, so they call it the Philosophizing Carp."

Once I said that we all started laughing, but it really was as pathetic as the cold and tasteless iced coffee that was coming up through my straw.

"But what does this Philosophizing Carp say? Things like, *Existence comes before essence?* Or *I'd rather be a hungry sole than a well-fed mullet?*"

While the owner kept laughing away, hitting Hyunwoo's shoulder, Sobom asked why he'd singled out mullet.

"Mullet aren't sea fish; they live in freshwater. Sea fish surviving out in the big open sea must be way more lonesome."

Once we had the camera set up it seemed as though Hyunwoo was a little anxious. So many years had passed, but I could tell that kind

서 하는 설사란 통증도 어느 정도 있겠지만 그게 뭐 대수인가. 그 정도 통증 없이 사는 사람도 있어? 그게 항문 통증이라 그렇게 문제가 되는 거야, 뭐야. 우리가 촬영과는 상관도 없는 그 문제에 대해 얘기하는 동안 현우가 카페로 들어가 와인 한 병을 들고 왔다.

"음주 촬영 안 되세요."

소봄이 제지하자 현우는 저 말고 여기 선생님들 드시면서 좀 진정하세요, 라고 했다. 내가 말릴 틈도 없이 재형이 잔에 가득 따라서 들이켰고 소봄도 현우가 따라주는 잔을 받아 자기 자리 앞에 내려놓았다. 그리고 현우가 다시 잔에 따라 내게 내밀었을 때 나는 그 손이 흔들리는 것을 느꼈다. 양 입가에 힘을 주어 밝은 표정을 유지하고는 있지만 손은 완전히 그 표정과 달리, 아래위로 흔들리고 있었다. 나는 현우에게 엉망이지? 하고 묻고 싶은 충동을 느꼈다. 엉망이잖아, 결국 그렇게 되었잖아, 하는. 하지만 말 없이 잔을 받아 단번에 마셔버렸다. 20분쯤 지났을까, 현우가 마침내 오세요갈비탕, 이라고 상호를 맞혔다. 나는 검증은 그만하고 소봄에게 이제 인터뷰로 넘어가라고 했다. 그리고 다른 테이블에 앉아 와인을 홀짝였다.

어차피 국장도 그만하면 됐다고 했으니 내 알 바 아니었다. 시간이 걸리기는 했지만 맞히기는 맞혔으니까. 그런데 이 상황에서라면 시간이 정말이지 문제이지 않은가. 누군가가 기적을 행하는데 그 기적이 아주 참기름 쥐어짜듯이, 쥐어짜서 행한다면 어쩔 것인가. 그러니까 모세가 바다를 가르는데 단번에 그것이 엄청난 포말이 일며 영화에서처럼 순식간에 갈라지지 않고 천년만년 대대손손 기술을 쌓고 공사를 벌여 길을 내었다면 그건 기적이 아니잖나, 그건 하나도 신기하지 않고 능력도 아닌 게 되지 않느냐 말이야. 그렇게 생각하며 재형과 나는 와인에서 위스키로 주종을 바꿔 취해갔다.

현우와 소봄은 일종의 근황 토크를 해나갔는데, 내 사전정보와 달리 현우는 대기업을 그만두고 부산으로 내려와 프리랜서 프로그래머로 일

of minute change in expression right away. Realizing that if I was that way, Hyunwoo would also be reading things from my face, I mumbled to myself again, "Keep, it, dry." The first photo we showed Hyunwoo was the one we'd taken earlier at the Chinese place. Looking intently at the picture of the utterly unparticular jjamppong and glistening mess of black bean paste and oil that was the jjajangmyeon, Hyunwoo didn't lift his head for a long time. In the middle he looked up for a moment and said, "It takes a while to work it out," and then lowered his eyes again. I thought, *Is this the end of it?* But then how did he get everything right all the time on Twitter? Was it really that he was running the accounts of all the questioners and answering himself? Had be bought up ghost accounts? After the nineties rock ballads playing in the café had gone through a whole cycle, at long last, Hyunwoo answered, "This is outside of my dataset."

"Outside of your dataset?" Sobom asked.

"I mean that, this isn't a proper photo. At each restaurant, especially in long-standing matjips, there is a very precise kind of manual. From the plating to the angle at which they slice ingredients, the difference in color that comes from the use of seasonings like green onion and chili, how cooked the meat is and the types of garnish. It's really fixed, as though it's being produced in a factory. But with this, no matter how I look at it, there's nothing to go on."

I was just thinking, *What strange sophistry is this?* When, having only just returned from another trip to the toilet, Jaehyung chimed in all enthusiastically with, "That's right, that's right! You've never seen this color of soup or this kind of thing anywhere else before have you? And what about all these chilis! It's chili soup. Damn it. That woman did this to me on purpose," Jaehyung vented his anger, pale because of the constant diarrhea.

It was the first time I had seen him so worked up and expressing anger like that.

하고 있었다. 주로 빅데이터 분석과 관리에 관한 일을 한다고 했다. 현우는 원래부터 기억력이 좋은 편이라 맛집 알파고로 활동하게 되었다고 설명했다. 자기가 현실에서 하는 직업은 기계적 예측 속에 인간들이 움직인다는 걸 확증하면서 하는 일인데, 이건 꽤 인간적인 활동이라 마음에 든다고.

"아 네……"

소봄은 대답이 마음에 들지 않는지 그렇게 말을 끌다가 "알파고 치고는 아주 철학적인 얘기네요." 하며 인터뷰를 마쳤다.

"잉어도 철학을 하는 판에요."

현우가 가볍게 받았다. 촬영장비와 짐을 챙기는데 눈이 오기 시작했다. 처음에는 히끗히끗 하다가, 어느 틈에 우- 하고 쏟아졌다. 눈은 마당에 서있는 우리를 빙글빙글 감싸며 점점 더 거세어졌는데, 착잡한 내 마음과 다르게 곧 춤을 추어도 무방할 만한 리드미컬한 낙하였다.

생일 축하

밤을 샐 줄 알았던 촬영은 싱겁게 끝나고 우리는 취한 채로 영도를 나왔다. 마지막에 계산하는데 술값이 예상보다 많이 나와서 나는 몽롱한 가운데에서도 복수인가, 하고 생각했다. 아까 기분이 상했다고 배로 받은 건 아닌가. 아니겠지, 아닐 거였다. 연말마다 우주 교향곡을 듣는 사람이니까. 현우는 집에 가면 환자를 돌봐야 한다며 내내 커피를 고집했다. 나는 아버지가 아픈가, 하고 생각했다. 아니면 그 당시 수원에서 간호사를 한다는 누나가. 환자가 집안에 있는 건 슬픈 일이고 자기 자신의 삶에 근저당이 잡히는 셈이었다. 죽음이라는 채무자가 언제 들이닥쳐 일상을 뒤흔들지 몰랐다. 그게 자기 자신의 죽음이면 의식이 꺼지면 자연스레 종료지만, 타인이라면 영원히 끝나지 않는 채무 상태에 놓이게 된다. 기억이 있으니

"Jaehyung, why would the owner do that to you on purpose? Calm down."

"Are you really asking because you don't already know?" He must have been worked up because he came out from his spot behind the camera and stood right in the shot and said, "She's taken revenge," and with utter conviction, "I dented her pride and so she's taken her revenge."

"Why would she try to get revenge like that? With something that could be awkward for everyone."

"That's what revenge is, you have to risk that kind of embarrassment."

"That's what I'm saying, why would she risk that kind of embarrassment?"

"Because she wanted to take that risk."

The conversation had become uncomfortable somehow, so I said, "Let's take a short break," and threw my ballpoint pen down on the table. Inside the café the owner was going around each table lighting the little candles. I was looking at the old camera and photographs displayed on a shelf when he came over and boasted that his grandfather was Busan's very first photographer. He even ran a large celebration hall for weddings and family parties, and back then the price of photography was more than the fee to hire somewhere, so the hall rental came free with the photography.

"The owner of a celebration hall? So you've been well off for generations then."

"Well, it all went wrong when it got down to my generation, didn't it."

"What's wrong with your generation? You might only have a place like this, but you're still the owner."

At my response he cut off the conversation with, "Our Woo said you were a good person, but your perception's skewed," and then went back to what he had been doing.

Hyunwoo correctly identified two of the photographs Sobom had

까. 타인에 대한 기억이 영원히 갚을 수 없는 채무로, 우리를 조여오는 것
이었다. 수 년 전 엄마를 떠나보내며 느낀 것이었다.

현우는 우리가 부산에 와서 먹은 거라고는 그 제대로 접대되지 않은
복수의 중국음식뿐이라는 사실에 안타까워하며 가장 핵심적인 맛집에
데려다주겠다고 했다. 그 말에 기분이 풀렸는지 재형이 그렇다면 감사하
죠, 라고 취중에도 깍듯이 고마움을 표했다. 현우가 우리를 데려간 곳은
그러나 부산의 그 흔하디흔한 횟집도, 소봄이 먹고 싶어했던 밀면집도 아
니라 광안리에 있는 떡볶이집이었다. 떡볶이와 대왕오징어튀김이 유명했
는데, 후미진 골목의 작은 점포가 아니라 웬만한 프랜차이즈 매장만큼 넓
고 일하는 사람들도 모두 청년들이었다. 재형이 또다시 가게 벽에 붙은 사
진들을 세기 시작했다. 취한 눈을 뜨려고 노력하며 한 놈, 두시기, 석 삼,
너구리, 세다가 에이, 하며 주저앉았다. 현우가 여기는 40년이 넘었고 원
래는 리어카에서 시작했다가 매스컴을 타면서 이렇게 커졌다고 했다.

"추억이 있으신가요?" 재형이 물었다.

"있죠. 방송국이 가까워서 가수들 보러 갔다 오는 길에 꼭 먹고 갔어요.
밖에서 보면 포장 밖으로 애들 다리만 총총히 보인다고 해서 다리집이라
불렀고."

이윽고 주문한 떡볶이와 튀김, 부산 어묵이 나왔다. 손님이 받아오고
반납하는 철저한 셀프 서비스라서 우리가 상상하는 정감 가는 떡볶이집
과는 전혀 달랐다. 엉망이 된 속을 달래려고 특별히 주문한 쿨피스를 받
아오며 나는 신식인데, 하고 중얼거렸다. 자리로 돌아가는데, 매장 기둥
뒤에서 두 명의 십대 소년이 작당을 꾀하듯 키득거리며 뭔가를 하고 있었
다. 봤더니 하얀, 눈처럼 하얀 생크림 케이크에 초를 꽂고 있었다. 과일조
각이 알록달록 박혀 있고 어떻게 들고 왔는지 원형의 한쪽이 찌그러진 케
이크였다. 내가 쿨피스를 든 채, 소년들을 한참 내려다보자 현우가 무슨
일인가 싶어 다가왔다. 그리고 내 팔을 가볍게 잡아 자리로 데려갔다.

shown him. A restaurant in Seoul called Great King Giant Grilled Gopchang, and a noodle place somewhere in Jincheon called Yeongji Myeonok. But the problem was that each one took forever. To get one right it took at least an hour and a half. But since he did eventually identify them, it would be incorrect to say he had no special talent at all. What to do? I had no option but to make a call to the Bureau Chief. The Bureau Chief asked, "Does he actually guess them at all?" and when I said that he did, he told me to go ahead patiently with the filming for now, even if it meant cutting out most of it later on. He was basically telling me to proceed even though we might end up not featuring him at all. The sunshine disappeared as the sun went down and a very rich blue surface of water was spread out over the sea.

We returned to our seats and showed Hyunwoo another food photo. Again, he spent a long time looking down at it, putting all his strength into his eyes as if to try to scan it. Long enough for the cats to scratch at the bicycle wheel in one corner of the yard with their claws and then run off and then play tangled together and mew; enough time for people red-faced with drink to come in and try to refresh their insides with an iced drink and start an argument between themselves and part ways awkwardly; enough time for the lighthouse beam that shone into the sky to smooth over the thickening clouds and disappear many times over; and enough time for Jaehyung to call up the Chinese place and get into a massive row. At the charge that a local had testified that the food she had served him was not the same as usual, the owner said, "Well, what do you expect, are we supposed to be like machines?" Apparently she said that food is different every time you cook it depending on the condition of the chef, and that was only human, and then laughed. Incensed that he'd ended up getting an earful from her, Jaehyung only got angrier.

To me, Jaehyung was pathetic. He never took any interest in other injustices. In fact, during the last government, when everyone else was going out to protest in the square, he never went once, and now he was

"다정하네."

내가 중얼거리자 현우가 뭐? 하고 되물었다.

"아니 저 애들, 다정하다고."

테이블에는 소봄과 재형이 말다툼을 하고 있었다. 매장 텔레비전에 등장한 한 연예인에 대한 호오에서 출발해, 젠더의식과 윤리적 감수성까지 들먹이는 큰 싸움으로 번지고 있었다.

"처음에는 전라도, 경상도 나눠서 싸우다가 지금은 어? 남녀로 나눠서 싸우고 그런 거지, 적대의 재생산이지." 하는 건 재형이었고 "적대라고 물타지 마요. 꼰대처럼." 하는 건 소봄이었다. 그러면 재형은 꼰대? 하고 화를 냈고 소봄은 아니신가? 하고 자극했다. 지겹구나, 나는 쿨피스를 한모금 마시며 생각했다.

"그러면 소봄 씨는 뭐가 그렇게 잘 났어? 지금은 뭐 새롭고 순수하고 그런 거 같지? 곧 어른 된다, 곧 꼰대 돼."

"그럴 가능성 없는데?"

"가능성이 왜 없어?"

"전 이미 젠더적으로 꼰대랑은 거리가 먼 사람이에요."

"하나만 알고 둘은 모르는구나. 명예남성, 그런 말 모르나? 그냥저냥 꼰대만 알지?"

"내가 그걸 왜 몰라요?"

"그만 그만 그만해!"

쿨피스통을 내려놓으며 내가 소리 질렀다. 그러자 소봄과 재형도 말을 뚝 멈췄다. 나는 재형을 한동안 쏘아보았다. 다음에는 소봄을, 이게 무슨 일인가 싶어 떡볶이를 먹다 말고 멀뚱멀뚱해 있는 현우를. 그리고 탁자에 몸을 기댄 채로 손가락을 뻗어 일단 소봄을 가리켰다.

"그러니까 너는, 애가 우습다는 거 아냐."

내 손가락은 이번에는 재형으로 옮겨갔다.

146

getting so worked up over something so insignificant. The damage done wasn't even that terrible, no more than the embarrassment of having to keep going to the toilet and suffering a bit of diarrhea. Of course, the diarrhea you get from eating something too spicy does come with a certain level of pain, but was that really such an unbearable thing? Who lives without ever knowing that kind of pain? Was it such a big deal because the pain was in his ass? While we were having a heated debate that had nothing to do with the filming, Hyunwoo went into the café and brought out a bottle of wine.

When Sobom restrained him with "You can't drink that while we're filming," Hyunwoo said that it wasn't for him, that the team should have some to calm us down.

Before I could say anything to stop them Jaehyung had poured himself a big glassful and started to drink, and Sobom accepted the glass that Hyunwoo poured her and put it down on the table in front of her. And then, when Hyunwoo poured out another glass and held it out towards me, I could feel that his hand was shaking. He was putting strength into the corners of his mouth to maintain a bright expression, but his hands were quivering, up and down. I felt the urge to say to Hyunwoo, *This is a mess isn't it? Well it is, that's how it's ended up.* But instead I took the glass without a word and drank it all in one go. Around twenty minutes must have passed, when at long last Hyunwoo identified the restaurant in the photo as Come On In Galbitang. I told Sobom that was enough verification and to move on to the interview. And I sat at another table sipping away at the wine.

The Bureau Chief said that was all we had to do, so I didn't have to prove anything more. Since, although it took a long time, Hyunwoo did identify the pictures in the end. But in this situation, wasn't time really the most important factor? If someone is performing a miracle but they have to eke it out, like extracting sesame oil from thousands of seeds, are they really performing a miracle at all? If Moses didn't

"아니요, 우습다기보다는 피디님."

"어허, 애가 지금 어디서 2절을 달아, 달기를."

내가 손가락으로 쉿, 하며 조용히 하라고 경고했다.

"그리고 너, 신재형 넌 애가 우습고."

"내가 언제 우습다고까지 했어, 같이 일하는 사람끼리 그러겠어."

"그리고 너, 너는 내가 우스웠고."

최종적으로 현우를 가리켰다. 오래 들고 있어서인지 팔이 무거웠다. 겨드랑이에서부터 천천히 견딜 수 없게 묵직해지더니 팔꿈치가 자꾸 내려가고 손목이 바들바들 떨렸다.

"야, 니들은 있잖아. 너희들은!"

내가, 언젠가 한때 나의 모든 선망과 의식의 혁명을 가져왔지만, 결국 받아들이기 힘든 모멸로 부메랑 쳐 돌아왔던 그 말, 존재의 근거를 의심하고 인간이라는 실존을 고민하라는 반어로 순수하게 받아들였지만 결국 쓰디쓴 자조로만 남았던 그 말, 개돼지라는 선언을 이 철천지원수 같은 인간들에게 거룩하게 하려는 찰나, 옆 테이블에서 생일 축하합니다, 하는 노래가 들려왔다. 돌아보니 교사인 듯한 나이 든 남자가 있고 고만고만한 십대 아이들 열댓 명이 테이블에 붙어앉아 있었다. 아까 내가 보았던 케이크가 촛불을 밝히며 교사 앞에 있었다. 노래를 부르는 아이들은 쑥스러운 듯 박수를 치다 말다 하면서도 축하를 계속했다. 생일 축하합니다, 사랑하는, 생일 축하합니다.

"그래, 올해도 찾아줘서 선생님이 참 고맙다. 우리 지선이 중학교 가서도 수학경시대회에서 상 받아서 기쁘고 우리 명환이는 이사까지 갔는데 찾아와줘서 고맙고. 무엇보다 반가운 우리 서준이, 중학교는 결석 안 한다니 선생님 마음이 너무 좋고, 이제 매운 김치도 잘 먹는다는 우리 수혜도 예쁘고."

나는 들고 있던 팔을 내려놓고 하지만 꼼짝 말라는 의미로 그 셋을 향

148

part the sea in an instant, with all the towering foam and drama you see in the films, and instead took a thousand, ten thousand years, to refine skills and technology and construct a way through, generation after generation, it wouldn't be a miracle at all. It wouldn't be mysterious or prove any outstanding ability. As I was thinking this, Jaehyung and I progressed from wine to whiskey and got more and more drunk.

Hyunwoo and Sobom were having a general talk about his life, and contrary to the information I'd heard over the years, Hyunwoo had quit his job at a big corporation and moved down to Busan, where he was working as a freelance programmer. He said he mainly did work to do with big data analysis and management and explained that he had always had a pretty good memory, so that's how he ended up starting Matjip AlphaGo. Saying that the work he did in real life provided clear proof that people move within the bounds of mechanic predictions, he explained that he liked it because it was a really human activity.

"Ah, I see..." Sobom paused for a moment as though she didn't like what she heard, and then ended the interview with, "That's very philosophical talk for AlphaGo."

"Well, when even carp are doing philosophy..." Hyunwoo responded lightly.

As we were packing up the filming gear and our belongings, it started to snow. At first just in speckles, then from some point it started whooshing down. The snow got heavier and heavier, swirling all around us as we stood in the yard, and unlike my conflicting feelings, it fell in such a rhythmical plunge that it wouldn't have been strange to just start dancing.

Happy Birthday

The filming which I'd thought would run late into the night finished

한 무섭도록 고정된 눈길을 떼지 않고 쿨피스를 한모금 마셨다. 그 달고 새콤하고 시원하고, 하지만 어려서의 기억이 아니라면 평소에는 사먹을 일도 없는 그 백퍼센트 인공향의 음료를. 창으로는 눈이 몰아쳤는데, 그것이 주는 어떤 위협 같은 것은, 접시를 가져와 조용히 케이크를 나누는 옆테이블의 소리, 오랜만에 만난 아이들이 자기들끼리 괜히 서로를 툭툭 치며 과거의 친근감을 회복하는 소리, 그러는 와중에도 누군가는 다리집으로 들어와 주문을 계속하는 맛집의 흥성스러운 소음에 점점 묻히고 있었다.

교향곡

송년을 앞둔 12월 날들은 마치 비스킷의 부스러기들처럼 그냥 흘러보내게 되는 시간들이었다. 상암동으로 출근해 회의하고 점심 먹고 또 회의하다가 재형과 말다툼하거나 인사 발령이 언제 있을지 선배를 찔러 보는 정도의 일상이었다. 국장과는 맛집 알파고를 계속 촬영할지 말지를 두고 설전을 벌였다. 나는 그러고 싶지 않다, 국장은 버리기 아까운 카드라는 거였다. 나는 그게 아니라고 설명하기 위해 또다시 그 모세의 기적이라는 비유를 써봤지만 국장은 "야, 그게 기적이지 왜 아니야? 그런 기술의 축적은 기적 아니냐?" 하는 반응을 보였다. 고도성장기 출신다운 궤변이었다. 하지만 국장의 바람은 이루어질 수가 없었는데, 맛집 알파고, 곧 현우가 계폭을 해버렸기 때문이었다. 정작 국장은 그 단어조차 알지 못해서 계폭은 계정 폭파를 가리킨다고, 스스로 계정을 없애고 게시되었던 모든 글과 자료를 없애는 SNS상의 존엄사라고 설명해주어야 했다. 트위터에는 대체 맛집 알파고가 왜 사라졌는가에 대한 억측들이 나돌았다.

마침내 12월 31일이 되어 종무식을 하고 평소보다 일찍 회사를 나서는데, 소봄이 할 말이 있다고 했다. 지금이야 방송도 불발되고 알 바 아닌 일이지만 맛집 알파고가 아무래도 우리를 속인 듯하다는 얘기였다.

blandly, and we left Yeongdo drunk. Settling the bill at the end, the price of everything we drank added up to a lot more than expected, so in my hazy state I wondered: *Is this revenge? Did the café owner double the bill because I offended him earlier?* Surely he wouldn't do such a thing, since he heard the cosmic symphony at the end of every year. Hyunwoo stuck to coffee the entire time, saying that he had to look after a sick person when he got home. I wondered whether it was his father who was ill, or else his older sister, who I'd heard when I'd known him was a nurse in Suwon.

Having someone in the family who was sick was a sad thing. It was like all the collateral security in your life being used up in advance. You never knew when the debtor called death would strike and send a shock through your everyday life. If it was your own death, as soon as consciousness was extinguished, that would naturally be the end of it, but if it was someone else, you were placed in a state of debt that went on forever. Because you have memories. As a debt that could never be repaid, the memories of others were something that closed in on you. At least, that's what I felt years ago when I lost my mom.

Feeling partly responsible for the sad fact that we had come to Busan and all we had eaten was that revenge Chinese food, Hyunwoo said he would take us to an essential Busan matjip. As though this neutralized his bad mood, Jaehyung said, "Thanks very much that would be great!" politely expressing his gratitude even though he was drunk. But the place that Hyunwoo took us to wasn't one of those fresh-caught raw fish places that are everywhere in Busan, or a milmyeon place like Sobom wanted, but a tteokbokki place in Gwangalli. It was famous for tteokbokki and giant crispy squid twigim, but rather than some hole in the wall in an obscure alley, it was as big as most franchise stores and everyone working there was young. Again, Jaehyung started counting up the photos stuck to the wall. Making an effort to keep his drunk eyes open, he counted, "One, two, three, four…" and

"어떻게 속여?"

나도 기억을 짜내서 그 많은 사진들을 변별했다는 현우의 말을 믿은 건 아니지만 일단은 그렇게 물었다.

"녹화영상 보니까 사진 보여주고 답하기까지 그 긴 시간 동안 꼭 한두 번은 맛집 알파고가 자리를 비웠더라고요. 화장실도 가고 카페도 들락거리고 담배도 피우고요."

"아, 그랬나?"

기억을 더듬어봤지만 그 시간은 길어도 너무 길어서 동선 하나하나까지 기억하지는 못했다. 그저 복통을 호소하는 재형과 입씨름하고 카페에서 제공한 음료들이 더럽게 맛없었다는 기억 이외에, 그리고 현우의 얼굴에서 오래전 내가 알았던 잠깐잠깐의 현우를 찾아보려 했었다는 것 외에.

"근데 그게 왜?"

"그때마다 휴대전화를 가져갔고요. 노안 와서 잘 안 보인다고 가까이 봐야 한다고 해서 사진 파일을 알파고한테 보내줘서 진행했었고요."

"아,"

"갈비탕 맛집, 이렇게 검색해서 좌르륵 뜨는 사진들 보면서 맞힐 시간은 충분했던 거잖아요. 아니면 프로그래머니까 무슨 자기만의 노하우를 썼을 수도 있고요. 이미지 검색 같은 거. 맛집 사진들이야 인터넷에 쌔고 쌨으니까요."

소봄과 나는 마을버스 좌석에 나란히 앉아, 방송국들이 즐비한 이 영상단지의 기이한 인공미 속을 통과하고 있었다. 건물마다 걸린 대형 스크린과, 그 속에서 춤추고 노래하며 대화하는 수많은 사람들과, 조각품으로 만든 인간의 두상과 신체를 오로라처럼 밝히고 있는 조명과 네온사인들을 지켜보았다. 그 사이로 신호등이 바뀔 때마다 수십 명의 직장인들이 이동하면서 퇴근하는 것을. 소봄은 화가 난다고 했다. 자기에게 이 일이 다분히 인간적인 능력, 기억력을 이용하는 것이기에 보람이 있다고 철학

then gave up and flopped down at a table. Hyunwoo explained that the place had been going for over forty years: it first started out as a handcart then grew to be this big after being featured in mass media.

"Do you have happy memories of this place then?" Jaehyung asked.

"Oh sure. It's near the broadcasting studios, so whenever we went to try to catch sight of famous singers we would always eat here on the way home. We called it the legs place because when you looked at it from outside all you could see was a line of kids legs, all huddled together, the rest was obscured by the awning."

Eventually the tteokbokki, twigim and Busan eomuk we ordered came out. It was a strictly self-service system where the customer goes to collect their order and clears their own table; completely different to the kind of tteokbokki place that always felt warm and familiar. Collecting the carton of Coolpis I'd ordered for myself to try to calm my messed-up insides, I mumbled, "It's all new style." On my way back to our table, I spotted two teenage boys hidden behind a pillar snickering away as though they were plotting something. I looked to see what they were up to, and they were sticking candles in a fresh cream cake that was white as snow. The cake had prettily coloured slices of fruit stuck on top and the circle shape was squashed on one side, probably from being carried in a box. Holding my Coolpis, I looked down at the boys for so long that Hyunwoo came over to see what was going on. He held my arm lightly and shepherded me back to our table.

I mumbled, "How tender."

"What?" Hyunwoo asked.

"Oh, no. Those kids. I said they're so tender."

At the table Sobom and Jaehyung were arguing. It had started off with likes and dislikes about a celebrity who had appeared on the television screen in the store, and was expanding into a big fight that even encompassed gender awareness and ethical sensitivity.

적인 얘기까지 해놓고는, 그런 트릭을 썼다는 것이. 나는 달리 할 말이 없어서 소봄 씨 장갑 예쁘다, 라고만 칭찬했다. 푸른색이 잘 어울려, 하고.

　그날 밤 떡볶이집에서 나와, 이제 다시 헤어지기 위해 택시를 기다리던 나는 오래전 우리가 함께 보냈던 크리스마스이브에 대해 이야기했다. 다른 모든 정황은 빼고 그때 책 읽던 사람 기억나느냐고, 그 사람 꼭 옥주언니 닮지 않았냐고, 너무 닮아서 기분이 나쁘네, 하고. 현우는 자기도 그때를 기억하고 있다고 했다. 우리가 들렀던 몇 군데 여관 중에 그때까지 자신의 아버지가 달셋방으로 살고 있던 여관이 있었으므로 더 잊을 수가 없다고. 현우는 혹시 그 사실을 내게 틀킬까 긴장해서 오줌까지 마려웠다고 했다. 나는 우리가 늙고 이렇게 아무것도 아닌 사이가 되어서 이제 나한테 오줌 얘기까지 하는구나, 하고 받았다.

　"아니야."

　"아니긴 뭐가 아니야? 결국 오줌 얘기나 하면서."

　"아니, 그때 그 사람은 옥주 선배랑 전혀 닮지 않았다고."

　내가 피식 웃으며 옷깃을 여미는데, 현우가 무언가를 해명하고 싶은 사람처럼 손바닥을 펼쳐보였다. 이 모든 싸움에서 결국 아무것도 얻지 못했다며 항복하듯. 아무것도, 아무것도 없다고, 말하고 싶은 사람처럼.

　"잘 지내."

　눈발이 휘몰아치는 가운데 등을 밝히며 택시가 도착했고 나는 12년 전 영등포에서보다는 나은 마지막 인사를 건네며 차에 올랐다. 복수도, 화해도, 용서도, 기적적인 능력에 대한 찬탄이나 입증, 아무것도 가능하지 않던 부산행이지만 적어도 생일 축하는 있었다고 생각하면서. 그러니 홀리하긴 홀리했다고 여기면서.

　평소처럼 집으로 가서 텔레비전을 보는데, 재형이 메시지로 중국집 블로그에 남길 리뷰를 보내왔다. 육두문자만 쓰지 않았을 뿐 분풀이와 히스테리로 점철된 한심한 글이었다. 나는 그런 리뷰 올릴 생각하지 말고 새

Jaehyung was saying, "In the beginning, people fought divided along regional lines of Jeolla and Gyeongsang provinces, and now, what is it? Divided into men and women and fighting again. It's just the reproduction of antagonism." And Sobom was saying, "Don't dilute the point with that kind of comparison. Just like a ggondae would." And so Jaehyung exclaimed "Ggondae?!" and got angry, and Sobom spurred him on with, "Aren't you?" *This is tedious*, I thought, as I drank another gulp of Coolpis.

"So, you think you're special do you Sobom? Right now, you think your new and fresh and all of that, right? But you'll be a grown up soon enough, you'll be a ggondae."

"That's not even possible."

"Why not?"

"Even just based on gender I'm already far from ever being a ggondae."

"You know just one thing and not the next. You've never heard the term 'honorary male,' have you? All you know about is ggondae."

"What makes you think I wouldn't know that?"

Putting down my carton of Coolpis I shouted, "Stop it stop it stop it!"

With that, both Sobom and Jaehyung shut up in an instant. I glared at Jaehyung for a while, next at Sobom, and then Hyunwoo, who had stopped eating his tteokbokki and was sitting there blankly, as if to say, *What the hell is going on?* And then, leaning out across the table, I stuck out my finger and first pointed at Sobom,

"So, you're saying that he's a joke."

This time my finger moved over to Jaehyung.

"No, not a joke, just…"

"Oho, I think you've already said enough, this isn't the place for that," I put a finger to my lips with a *shh*, and warned Sobom to keep quiet. "And you! Shin Jaehyung. You think she's a joke."

"When did I ever say that? People who work together wouldn't be like that."

해를 경건하게 맞으라고 하려다가, 어차피 그런 해원의 과정 없이는 아무것도 잊힐 리가 없다는 생각했고, 친구된 도리로서 건, 조, 하, 게, 라고만 적어 보냈다. 베란다에서 돌아가는 건조기 안의 빨래들처럼 건조하게, 너무 건조하다보니 티셔츠가 행주만해지고 수건이 행주만해지고 다시 행주는 아기손수건만해지고 그렇게 줄어들고 줄어들더라도 신기하게도 어딘가에 쓰임이 있는 세탁물들처럼 건조하게.

그러나 재형은 그럴 수는 없다고, 복수를 하고야 말겠다며 뜻을 굽히지 않았고 나는 이 미련한 중생이 인생의 진리를 가르쳐줘도 찾아먹지를 못하는구먼, 하면서 대화창을 닫아버렸다. 타종행사를 기다리다 눈을 감았는데 바로 오늘밤 영도의 묘박지에서 묵직한 뱃고동 소리를 내며 우주적으로 협연할 배들이 떠올랐다. 고래나 코끼리 같은 커다란 포유류들이 서로를 부르고 찾는 듯 들릴 그 소리를. 그러니까 눈 내리는 희귀한 부산의 크리스마스에 우리가 했던 일들은 겨우 그런 사실에 대해 알게 되는 것 아닌가. 모두가 모두의 행복을 비는 박애주의의 날이 있다는 것. 하지만 그런 것에 대해 알게 되고 꿈꾸고 심지어 철학하는 일은 대체 뭔가. 나는 과연 존재를 회의한다는 그 잉어를 정말 촬영하러 가야 하나.

이윽고 텔레비전에서는 새해를 알리는 카운트다운이 끝나고 종로의 보신각에서 사람들이 종을 울렸다.

노트
— 맛집 사진만으로 상호를 맞힌다는 설정은
 트위터의 한 게시물에서 착안했지만
 그 이외에는 허구다.
— 본문에 등장한 '철학 잉어'는 한국의 작가
 윤영수의 단편 「귀가도 1—철학 잉어」에서
 착안했다.

"And you," finally I pointed to Hyunwoo, "you thought I was a joke."

Maybe because I was holding it up for so long, my arm felt heavy. Starting from my armpit, it slowly grew so heavy I couldn't bear it, my elbow kept going down and my wrist trembled.

"Hey, you know what. You lot. You lot!"

I was just about to impart those divine words to these people like sworn enemies, the words that at one time brought out all of my envy and a revolution in my awareness but in the end came back and struck like a boomerang as contempt that was hard to accept; the words that were taken simply as an irony, urging suspicion of the grounds for being and deep reflection on human existence, but in the end lingered as bitter self-deprecation; I was just about to make that declaration of "Are nothing but animals," when from the next table I heard the happy birthday song. When I turned to look there were fifteen or so teenagers of around the same height and an older man who appeared to be their teacher, all huddled around the table. The cake I had seen just before was in front of the teacher with the candles lit. As though they were a little embarrassed, the singing kids stopped and started their clapping along, but kept the song going. *Happy birthday to you, dear, happy birthday to you.*

"Well, I'm so grateful that you've come to see me again this year. I'm happy that Jiseon is still winning prizes at the math contest after going up to middle school, and I'm grateful that Myeonghwan still came today despite moving away. And more than anything, I'm really pleased to see Seojun and know that you're not skipping class in middle school, and it's great to see pretty Suhye and hear that she can eat spicy kimchi now."

I lowered the arm I had been holding up, but fixed my gaze back onto the three of them, as if to say, *Don't move a muscle,* as I drank a mouthful of Coolpis. That sweet and sour and refreshing, but one hundred percent artificially flavored drink, that I would never nor-

크리스마스에는

mally buy if it wasn't for the memories of my childhood. Snow flurried outside the window, and the vague feeling of menace that it gave was gradually being buried in the sounds of the next table bringing over plates and quietly sharing out the cake; the sounds of the kids who had met up for the first time in ages patting each other, recovering their past intimacy, and the hum of the thriving matjip, with people coming in to "the legs place" and making orders all the while.

Symphony

The last days of December were time that was just left to fall like biscuit crumbs. They were spent in an everyday routine of going to and from the office at Sangam-dong, having meetings, eating lunch, and having more meetings where I quarreled with Jaehyung or prodded my office senior for a heads up on when the employee department transfer announcements would be made. I got into a verbal battle with the Bureau Chief over whether or not to go ahead with filming the feature on Matjip AlphaGo. I didn't want to, but the Bureau Chief was convinced it would be a shame not to play the card we had in our hand. In order to explain why that wasn't the case I tried using my analogy of Moses' miracle, but the Bureau Chief just reacted with "Hey, that's a miracle too! Why wouldn't it be? Isn't such an accumulation of skill miraculous?" It was sophistry perfectly befitting someone who grew up in the era of industrialization. But it just so happened that the Bureau Chief's wish couldn't be realized anyway, because Matjip Alpha-Go, so Hyunwoo, blew up his account. The Bureau Chief didn't know what the term meant, so I had to explain that blowing up an account meant someone getting rid of their own online presence, deleting all of their postings and materials in what was the social media equivalent of death with dignity. Speculation circulated on Twitter as to why Matjip AlphaGo had disappeared.

크리스마스에는

At long last it was New Year's Eve. We had an office end-of-year assembly after which we could leave a little earlier than usual. I was just stepping out when Sobom said there was something she wanted to talk to me about. Now that the feature had fallen through, it didn't really matter anymore anyway, but she was certain that Matjip AlphaGo had tricked us.

"Tricked us? How?"

It wasn't that I believed what Hyunwoo said about having trawled his memory to identify all those photos, but I asked anyway.

"Looking back over the footage, during the long intervals between when we showed him a photo and he answered, each time Matjip AlphaGo got up and went off somewhere once or twice. He went to the restroom and went in and out of the café and went off to smoke."

"Oh, did he?"

I searched my memory but the time was so long that I couldn't remember every one of his comings and goings. I couldn't remember much at all aside from bickering with Jaehyung who kept complaining of a stomach ache, and that the coffee was criminally bland, and the way that I had tried to spot flickers of the Hyunwoo I knew long ago on Hyunwoo's face...

"Why do you bring it up anyway?"

"He took his phone with him every time. And he said his eyes were getting old so he couldn't see them well and needed to look at them close up, so I sent the picture files to his phone."

"Ah..."

"There was plenty of time for him to have just done an internet search for 'galbitang matjip' and scroll through all the photos of beef rib soup that would have come up until he found the right place. Or else, since he's a programmer, he could have used some other method all his own. Something like an image search. Everyone knows the internet is full of food photos."

Sat side-by-side on the small local bus, Sobom and I were passing

크리스마스에는

through the bizarre artificial beauty of the video media district, where all the broadcasting companies were clustered together. I looked at the huge screens hung on every building, with countless people dancing and singing and conversing on them, and the lights and neon signs that were shining down like the northern lights on an architectural sculpture of a human head and body. Scores of office workers moved between the buildings on their way home from work every time the lights changed. Sobom said she was angry. That, having made such a philosophical statement about how he found what he did rewarding because it was based on such human capacity and memory power, he had used those kinds of tricks. I didn't have anything else to say, so I just complemented her, "Your gloves are pretty. Bluegreen really suits you."

That night, when we left the tteokbokki place and were about to part ways with Hyunwoo, standing waiting for a taxi that would take us to the station, I brought up the Christmas Eve we had spent together long ago. Leaving out everything else, I said, "Do you remember that woman who was reading a book that night? Wasn't she just like Okju? She looked so much like her it puts me in a bad mood." Hyunwoo said he remembered that night too. It was even more unforgettable because among the handful of motels we had stopped by to try to get a room was the one his father was still living in at the time. Hyunwoo said that he was so anxious I would find out that he felt a desperate urge to pee. I retorted, "Wow, now that we've aged and become nothing to each other, you're even talking to me about pee."

"I don't think so."

"What do you mean you don't think so? In the end you're talking about needing to pee."

"No, I mean, that woman that night. She didn't look anything like Okju."

크리스마스에는

I let out a laugh as I adjusted my collar, and Hyunwoo held his palms open like someone who wanted to explain something. As though submitting that in all of this fighting, in the end, there was nothing to be gained. Like someone who wanted to say, *Nothing, there's nothing at all.*
"Take care."

In the whirling snow a taxi pulled up with its light on and I got into the car giving a final greeting that was better than the one in Yeongdeungpo twelve years ago. Thinking, while there had been no revenge, no reconciliation, no forgiveness, no praise for or proof of miraculous talent, and nothing had been possible on this trip to Busan, at least there was a happy birthday. And with that, I decided there had been something holy that day after all.

I went home and was watching television like usual, when Jaehyung sent me a message with the review he was going to leave on the blog of the Chinese restaurant. He'd just about refrained from using profanities, but it was pathetic writing, scattered with unrestrained anger and hysteria. I was about to reply, *Don't even think of posting that kind of review, see the New Year in devoutly,* but then I thought that without that process of letting off bitterness, there was no way he would move on, so out of my duty as a friend I simply wrote back, *Keep, it, dry.* As dry as the laundry in the drying machine turning on the veranda, as dry as the items of laundry that get so dry that a t-shirt shrinks to the size of a dishcloth and a towel shrinks to the size of a dishcloth, and a dishcloth shrinks again to the size of a baby hankie, and all of the things which, even though they shrink like that and shrink again, mysteriously find a use somewhere.

But Jaehyung said he couldn't do that, he didn't yield at all and said he would have his revenge no matter what. I closed the chat window, mumbling to myself, "Even if you teach foolish people the truth of life, they can't take hold of it." Waiting for the New Year bell-ringing

크리스마스에는

ceremony, I closed my eyes and thought of the boats that this very night would sound their deep foghorns in the anchorage at Yeong-do, performing a cosmic harmony. The boats would bellow like huge mammals, like whales or elephants, calling out to find each other. On that rare snowy Christmas in Busan, ultimately, the work we'd done was to find out about that symphony. To discover that there is a day of philanthropy, where everyone wishes for everyone else's happiness. But what does it mean to come to know something like that anyway, to dream of it and even philosophize about it? Would I really have to go out to film that carp skeptical of existence?

At long last, the television countdown to the New Year ended and people rang the big bell in the Bosingak Pavilion.

Translated from Korean
by Sophie BOWMAN

Notes
— The idea of guessing the name of a restaurant based only on a food picture was inspired by a post on Twitter. Everything else is fictional.
— The "philosophizing carp" mentioned here was inspired by Korean writer Yun Young-su's short story *Come Back Home 1: philosophy carp*.

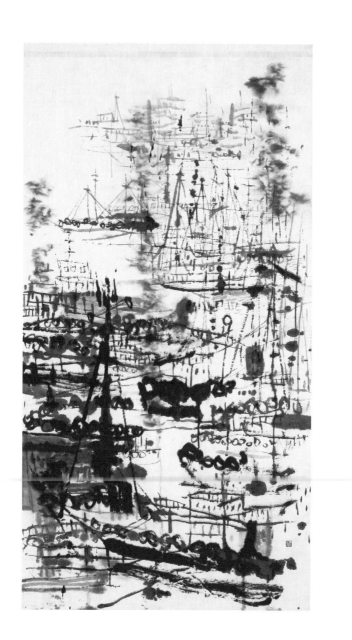

초록은 슬프다

김숨

1

남포동 미도리마치[1]에 내 친구들이 있다고 알려준 이는, 싱가포르 연합군 포로수용소에서 사귄 여자애다. 그녀는 보름 전 불쑥 날 찾아왔다. "9년 만에 고향집에 갔는데 어머니는 돌아가시고 아버지는 날 못 알아보더라. 동생들은 쫄쫄 굶고 있고." 그녀는 양산[2] 내 고향집 마루에 드러누워 흘러가는 구름을 바라보며 말했다. 엄마는 똥지게를 지고 마늘밭에 거름을 주러 갔다. 그녀는 내 친구들이 미도리마치에 있는 걸 어떻게 알았을까. 미도리마치, 미도리, 미도리…… 미도리는 초록이다. 위안소에 미도리라는 이름을 가진 여자애가 있어서 나는 그 뜻을 알고 있다.

나는 외줄타기 하듯 전차 선로 위를 걷는다. 전찻길을 따라가면 남포동이 나올 거라고, 동래[3] 버스정류소에서 만난 늙은 지게꾼이 알려주었다.

초록은 슬픈데……

1 미도리마치(みどり-まち, 綠町, 녹정). 1916년 일제가 부산 서구 충무동에 만든 우리나라 최초의 공창. 해방 후 미군정 시절에는 그린스트리트(Green Street)로, 공창제 폐지 후 1948년부터는 완월동으로 불리다, 1982년 충무동으로 동명을 변경했다.
2 경남 양산.
3 부산시 중부에 있는, 금정산과 온천장으로 유명한 구(區). 1946년 동래와 양산을 오가는 버스가 있었다.

Green Is for Sorrow

KIM Soom

1

It was through a girl I'd befriended at the Allied POW camp in Singapore that I heard my friends had wound up at Midorimachi[1] in the Nampodong area of Busan. She'd turned up out of the blue a fortnight ago. "I went home for the first time in nine years only to find my mother was dead and my father no longer recognised me. My younger siblings barely had food to eat," she said, lying supine on the wooden maru floor of our family home in Yangsan, her eyes on the drifting clouds. Mum had headed out with the manure rack on her back to spread slurry over the garlic field. I wondered how the girl had learned of my friends' whereabouts. Midorimachi, *midori... Midori* meant green. I knew this because one of the girls at the wianso[2] had been called Midori.

1 Midorimachi (미도리마치 みどり-まち, also known as Nokjeong 녹정 綠町). Opened in 1916 by the occupying Japanese in the area of Busan now known as Choongmuro in Seogu, Midorimachi was South Korea's first licensed brothel. Following Korea's liberation from Japan and subsequent establishment of an American military government in the country, the area was renamed Green Street. In 1948, when prostitution became illegal, the area was once again renamed Wanwoldong, and is now known as Choongmudong.

2 Wianso (*iansho* in Japanese), literally "comfort station," were military brothels run by the Imperial Japanese Army in Japanese-occupied territories before and during World War II.

빨간 네마키[4]를 입고 배시시 웃던 미도리가 떠오른다. 606호 주사[5]를 맞아 그 애의 얼굴은 썩은 호박 같았다.

잿빛 선로가 진동한다. 선로에서 훌쩍 날아올라 전당포 앞에 떨어진다. 전차가 시커먼 머리를 흔들며 지나간다. 사내아이 셋이 앞서거니 뒤서거니 전차를 따라 달린다.

또각 또각…… 나는 일본육군야전병원에서 신던 굽 높은 흰 샌들을 신었다. 나는 스물두 살이다. 열다섯 살에 고향집을 떠나 일본 군인들을 따라 떠돌아다니는 동안 그만 나이를 잊어버렸는데 엄마가 세고 있다 알려주었다. 어느 날 위안소에 군인들이 오지 않았다. 위안소 주인 사내도 어디로 가버리고 없었다. 일본 군인들이 트럭을 몰고 와서는 친구들과 날 야전병원으로 데리고 가 간호사 교육을 시켰다.

또각 또각…… 2시간을 넘게 걸었더니 발이 불타는 것 같다. 또각 또각…… 이 소리를 들으면 친구들은 내가 자신들을 찾아온 걸 알 것이다.

선로가 갑자기 뚝 끊긴다. 바다다. 은빛과 초록빛이 언뜻언뜻 스치는 바다에는 통통배들이 떠 있다. 통통배마다 웃통을 풀어헤친 사내들이 타고 있다. 사내들은 길이가 8척은 되는 대나무를 바다 속에 드리우고 조개를 잡고 있다. 미도리는 고향집에 돌아갔을까…… 미도리…… 미도리는 초록…… 초록은 슬픈데…… 친구들은 어째서 고향집에 돌아가지 않았을까. 작년 가을 친구들과 나는 귀환선을 타고 부산에 왔다. 일본이 패망했다는 소식을 들은 지 두 달쯤 지나서였다.

"재첩국 사요! 재첩국 사요!"

4 네마키(ねまき). 일본 잠옷.
5 일본군이 성병 관리를 위해 위안부 여성들에게 정기적으로 맞힌 '606호 주사'는 '살바르산'이다. 매독, 회귀열 등 성병 치료에 효과가 있지만 불임의 원인이 되는 등 부작용이 심하다.

I'm walking on the tram track as though I'm a tightrope walker. Follow the tram line and eventually you'll get to Nampodong, an old rack carrier I met at the Dongrae bus station had told me.

But green is for sorrow...

I see Midori in her red *nemaki*, or pajamas beaming with silent laughter. Scarred by 606 injections[3], her face resembled a rotting buttercup squash.

The ashen track vibrates under me. I flick my head to look back, then hurl myself off the track to alight outside a pawnshop. The tram thunders past shaking its black head. Three boys scamper behind it.

Click-clack, click-clack... My feet were bound in white high-heeled sandals—regulation shoes for nurses at the Imperial Japanese Army field hospitals. I was twenty-two years old. Since leaving home at fifteen I had lost count of the years, didn't know how long I'd been trailing from one place to the next with the Japanese troops—but my mother had kept count for me. One day the soldiers simply stopped coming to the wianso. The proprietor man had also seemingly vanished overnight. Japanese soldiers came by later with trucks and whisked my friends and me off to a field hospital where they made us go through nursing training.

Click-clack, click-clack... I've been walking for well over two hours now; my feet are burning. Click-clack, click-clack... My friends will hear this sound and know I've come to find them.

The tracks stop abruptly. Sea. Fishing boats bobbing, the occasional gleam of green and silver. Men with bared chests casting eight-chok-long bamboo sticks in the water to catch clams. Did Midori make her way back home, I wonder. Midori, *midori*, which means green... But green is for sorrow... Why have my friends not returned home? Last

3 606 or Compound 606 refers to injections regularly administered to wianbu or "comfort women" to prevent the spread of sexually transmitted diseases. It is also known as Salvarsan, which, though somewhat effective in the treatment of syphilis and relapsing fever, had severe side-effects including infertility.

까만 몸뻬바지 위에 누런 광목 앞치마를 두른 여자가 양철동이를 머리에 이고 내 앞으로 지나간다. 희끗희끗한 머리는 쪽을 져 비녀를 꽂았다.

"아주머니, 미도리마치에 가려면 어디로 가야 하나요?"

"어디요?" 재첩국을 사라고 외칠 때와 다르게 여자의 목소리는 힘이 없다.

"미도리마치요."

여자가 양철 들통을 머리에서 내려 땅바닥에 내려놓는다. 앙상한 목을 외로 돌리고 중얼거린다.

"저 위로 가야 미도리마치에요."

나는 여자가 가리키는 곳을 바라본다. 분홍빛 벽돌로 지은 부산 역사 건물 너머, 푸릇푸릇한 산이 내 시야에 들어온다.

"아주머니, 저 산에 집들이 있지 않았나요?"

"용두산에요?"

"저 산 꼭대기에 큰 집들이 있었던 것 같아서요."

"부산 처자가 아닌가 보네……" 여자는 앞치마를 끌어당겨 얼굴을 훔치더니 양은동이 앞에 쪼그려 앉는다. "집이 아니라 신사였어요. 작년 가을에 불에 타 잿더미가 되었답니다. 아주 꼴도 보기 싫더니 잘 타버렸지 뭐예요. 그게 작년 11월 중순이었지…… 용두산에서 시커먼 연기가 피어올랐어요. 사람들이 불이야, 불이야 소리 지르며 뛰어다니고 그 소리를 들은 사람들이 다들 길거리로 나와 불구경을 했어요. 마침 바다에서 세찬 바람까지 불어와 부채질을 하더군요. 불구경하던 사내들이 그러더군요. 신사가 조선인의 억지 절까지 받아 화력이 세져서는 저리 잘도 타는 거라고요. 일본인들이 용두산에 신사를 지어놓고는 조선인들에게도 신사참배를 시켰으니까요. 전철을 타고 가다가도 땡땡 종이 울리면 신사를 향해 고개를 숙이고 절을 해야 했으니까요."

여자가 몸을 일으킨다.

"재첩국을 다 팔아야 집에 갈 텐데……"

autumn my friends and I arrived in Busan on the repatriation ship. This was a couple of months after we'd learned of Japan's defeat.

"Jechop soup by the bowl! Soup of freshwater clams!"

Wearing a sallow cotton apron over black monpe pants, a woman carrying a pail on her head walks past me. Her braided greying hair is coiled low near the nape of her neck and fixed with a hairpin.

"Ajumoni, how do I get to Midorimachi?"

"Where?" Unlike when she was hawking her soup, her voice is frail.

"Midorimachi."

The woman lowers the aluminium pail to the ground. Twisting her gaunt neck leftwards she mumbles an answer:

"Midorimachi is up that-away."

I look to where she is pointing. Beyond the pink bricks of Busan Station, a verdant hill meets my eyes.

"Ajumoni, weren't there houses up on that hill?"

"On Yongdusan?"

"I seem to recall seeing big houses along the top of that hill."

"S'pose you're not a Busan lass then..." The woman pulled up her apron to wipe her face with it then squatted by her pail. "That was no house, it was a *sinsa*. Turned to ash in a fire last autumn. Good riddance, it was an eyesore, that shrine. Last year, about mid-November was it... Plumes of black smoke began rising from Yongdusan. People scampering to yell fire, and then everybody poured out to watch it burn. There was a strong wind off the sea as well that fanned the flames. Some of the men watching the fire said all the bows they'd forced out of us Joseon people was why the shrine burnt so well. After the Japanese built the *sinsa* on Yongdusan they ordered the Joseon people to worship at it. Even on the tram when those bells clanged you had to bow your head in the direction of the shrine."

The woman gets back to her feet.

"I've got to sell this soup before I can head home..."

"집이 어디신대요?"

"내 집은 저 구덕산 너머랍니다."

여자가 용두산 뒤로 보이는 희끄무레한 산을 손으로 짚어 보인다.

"그걸 지고 저 산 고개를 넘어오셨단 말이에요?"

"밤새 가마솥에 끓인 재첩국을 이 양철동이에 담아 날이 밝자마자 구덕고개를 넘어왔지요. 집 주변 땅이 순 모래펄이라 농사를 지을 수 없으니 어쩌겠어요. 낙동강 바닥에 널린 재첩이라도 잡아 먹고 살아야지."

나는 여자가 양철동이를 들어 머리에 이는 걸 도와준다.

"어디로 가시게요?"

"저 위쪽 영선고갯길로 가볼까 해요."

또각 또각 또각…… 초록은 열세 살 먹어서부터 군인을 데리고 잤다. 그 애의 몸은 하나인데 군인은 하나, 둘, 셋, 넷, 다섯, 여섯…… 초록이 군인들의 아기를 가져 배가 불러오자 군의관은 그 애의 배를 찢고 아기를 꺼내 버렸다…… 또각 또각……

또각 또각…… 길이 경사가 져서 내 몸이 저절로 앞으로 굽는다. 사람들이 늘어나는가 싶더니 여기저기 난전이 벌어져 있다. 부지깽이처럼 마른 노인은 성냥갑, 검정 고무줄, 설탕 묻힌 꽈배기 등을 앞에 늘어놓고 졸고 있다. 그 옆에서는 머리를 파마한 여자가 옷가지를 수북이 쌓아놓고 팔고 있다. 흰 벽돌 건물에서 미군 둘이 큰 목소리로 떠들며 걸어 나온다. 키가 내 두 배는 돼 보이는 군인의 목에는 사진기가 걸려 있다. 북적이는 사람들을 헤치며 길을 걸어 올라가자 깎아지른 돌계단이 나온다. 대나무 물동이를 머리에 인 여자가 한 손으로 숯처럼 검은 몽당치마 자락을 움켜잡고 조심조심 돌계단을 내려온다.

"아가씨, 구경이나 좀 하고 가요. 우리 같은 여염집 아낙들은 엄두도 못낼 고급 물건이 꽤 있답니다."

"Where do you live?"

"Over yonder Gudeoksan."

She gestured towards the pale outline of a mountain visible behind Yongdusan.

"You mean you walked over that pass carrying this on your head?"

"Simmered the soup overnight in a gamasot, then as soon as day broke ladled it into this pail here and came over the Gudeok pass. The land around the house is all sand flats and can't be farmed so what else can I do. Catching clams from the Nakdong riverbed is how I make my living."

I help the woman heave the pail back on her head.

"Where are you headed now?"

"Thought I'd maybe head towards Youngseon pass."

Click-clack, click-clack... Green had started sleeping with soldiers from the age of thirteen. There was only one of her, a child's body at that, but soldiers there had been one, two, three, four, five, six... As Green's belly grew heavy with the babies of those solders the army surgeon had ripped her child stomach open and taken out the babies... Click-clack, click-clack...

Click-clack, click-clack... The rode slopes up and my body bends forward of its own accord. The throng of people seems to grow, and here and there scuffles are taking place. An old man, thin as a poker, sits dozing next to a piece of cloth laid out with matchboxes, black elastic cords, twisted doughnuts coated with sugar. By his side a woman with permed hair is selling clothes from a heaped pile. From a white brick building two American soldiers emerge, their voices loud. One is at least nearly twice my height and has a camera around his neck. I make my way up the incline through the press of people and come face to face with steep stone steps cut into stone. A woman bearing a bamboo water-pail on her head is cautiously making her way down the stairs, one hand holding the tattered hem of her soot-black skirt.

여자가 살구색 양산을 활짝 펼쳐 보인다. 나는 전시품처럼 널린 물건들을 눈으로 훑는다. 먹으로 그린 그림 액자, 동물 뼈로 만든 브로치, 청색 도자기 찻잔, 일본 그림엽서, 굽 높은 가죽 구두, 깃털 장식 달린 모자, 자개로 둘레를 장식한 거울……

"일본 부자들이 쫓겨가며 버리고 간 것들이랍니다. 짐이 30킬로가 넘으면 귀환선에 실어주지 않으니까요."

거울 속 얼굴을 물끄러미 들여다보는 내게 여자가 웃음 섞인 소리로 말한다.

"얼굴이 예뻐 보이는 거울이랍니다. 그래서 아끼꼬는 저 거울만 봤답니다."

"아끼꼬……요?"

"아끼꼬는 저 거울을 일본에 가져가려고 했어요."

"아끼꼬가…… 일본으로 갔나요?"

"아가씨가 아끼꼬를 어떻게 알아요?"

"제 친구니까요……"

"친구요? 아끼꼬가 아가씨 친구라고요?"

"네…… 낙원에서 우린 친구가……"

나는 얼른 말끝을 흐린다. 낙원(樂園)은 아끼꼬와 내가 있었던 위안소다.

"하지만 아끼꼬는 마흔 살이 넘었답니다."

의심어린 눈초리로 나를 바라보던 여자가 눈빛을 빛낸다.

"천왕이 항복하던 날도 그녀는 그 거울 앞에 앉아 있었답니다. 그녀의 남편은 수상경찰서 경찰이었지요. 그녀는 히로시마가 고향인 그녀는 수상경찰서에 발령 받은 남편을 따라 부산에 왔지요. 그녀는 친정 부모와 자매들이 살고 있는 히로시마를 늘 그리워했어요…… 참, 히로시마는 불바다가 됐다면서요?"

"불바다요?"

"Come have a look-see, agassi. Got some fine things here regular lasses like us couldn't dream of having."

The woman opens an apricot-coloured parasol. I look over the exhibited items: a framed ink wash painting, a brooch made of animal bone, a blue ceramic teacup, a Japanese picture postcard, heeled leather shoes, a hat with a feathered plume, a mirror adorned with mother-of-pearl inlays.

"All left behind by rich Japanese folk on the run. They weren't allowed aboard the repatriation ships if they had luggage weighing over thirty kilos."

I stare blankly at the face reflected in the mirror as the woman continues in a cheerful voice:

"It's a very flattering mirror, shows off one's face. Which is why it was the only mirror Akiko ever used."

"Did you say Akiko?"

"Akiko wanted to take it with her to Japan."

"So Akiko's... She's gone to Japan?"

"How do you know Akiko?"

"She's a friend..."

"A friend? Akiko is your friend?"

"Yes... We've been friends since Nakwon..."

I fall silent. Nakwon[4] is the name of a wianso Akiko and I were at.

"But Akiko is over forty now."

The woman looks at me with suspicion, then her eyes brighten.

"The very day the Emperor surrendered she was seated in front of that mirror. Her husband was with the marine police. She left her home town of Hiroshima and followed him to Busan when he was stationed here. She was always homesick, pining after her parents and sisters in Hiroshima... But I hear Hiroshima's been turned into a sea of flames, is that right?"

4　Nakwon (낙원 樂園) meaning pleasure garden or garden free from worries, i.e. paradise.

"미국이 히로시마에 불덩이를 떨어뜨려서 모든 게 잿더미가 되었다고 하던데요…… 아끼꼬는 떠나고 싶어 하지 않았어요."

"히로시마를 그리워했다면서요."

"부산에서 20년 넘게 살아 정이 들어서겠어요. 암튼, 그녀는 그 거울을 가져가려고 했어요. 하지만 나는 그녀에게 가져갈 수 없을 거라고 했지요. 거울에 틀림없이 금이 갈 거라고요."

나는 엄마가 친구들과 점심을 사먹으라고 챙겨준 돈으로 거울을 산다. 엄마는 내가 고향집을 떠나 있던 7년 동안 야전병원에서 간호사를 한 줄로만 알고 있다. 날마다 군인을 열 명, 열다섯 명씩 데리고 잤다는 말을 나는 엄마에게 하지 못했다.

돌계단 너머에 미도리마치가 있을까. 나는 돌계단으로 발을 내딛는다. 하나, 둘, 셋, 넷, 다섯…… 마흔. 송골송골 땀 맺힌 콧등을 바람이 스치고 지나간다. 또각 또각 또각……

빡빡머리 소년이 갈지자를 그리며 걸어온다. 전봇대에 머리를 쿵 박더니 기절하듯 쓰러진다. 염소 울음 같은 웃음소리를 흘리며 일어서더니 바지춤을 끌어올린다. 서너 발짝 헛발질하듯 내딛다 담벼락에 이마를 찧는다.

여관처럼 보이는 집 대문 앞에 쭈그리고 앉아 소년을 지켜보던 노파가 쯧쯧 혀를 찬다.

"지게미를 먹어서 저래. 배가 고프니까 양조장에서 나오는 지게미를 해롱해롱 취하는 줄도 모르고 주워 먹고는 저러고 다닌다니까."

소년이 발딱 일어선다. 비틀비틀 걸어오더니 내 발 앞에 꼬꾸라진다.

"얘야, 괜찮니?"

소년이 흙 묻은 얼굴을 쳐들고 나를 쏘아본다.

"네 이마에서 피가 나는구나. 어서 집에 가서 엄마한테 피를 닦아달라고 하렴."

"A sea of flames?"

"Yes, I heard America dropped a fireball on Hiroshima and turned the entire city into a heap of ash. Anyway, Akiko didn't want to leave."

"You said she'd been homesick for Hiroshima."

"I suppose after twenty years she got to like it here. In any case, she tried to take the mirror with her. But I told her it wouldn't work. That she'd only damage it on the way."

I pay for the mirror with the money my mother gave me to have lunch with my friends. As far as my mother's concerned, in the seven years that I've been away from home, I've worked solely as a nurse at the field hospitals. I couldn't bring myself to tell her about the ten, fifteen soldiers I'd had to sleep with every day.

Will I find Midorimachi over these stone steps? I start up the stairs. One, two, three, four, five… Eventually I reach forty. A gentle wind passes the bridge of my nose, now beaded with sweat. Click-clack, click-clack…

A boy approaches. He has a shaved head and he's staggering wildly. He walks into a utility pole and drops to his feet as if in a faint. He gets right back up though, laughing out loud in a way that reminds me of the bleating of goats as he rustles up his pants. He takes three or four unsteady steps before bumping his head, this time into a wall.

An old woman sitting on her haunches outside the gates of what looks to be a lodging house tut-tuts at the sight of the boy.

"Had his fill of lees again, I see. He'll go and stuff himself with the lees at the distillery any time he's hungry, when it only makes him drunk."

The boy leaps up. He totters towards me before collapsing at my feet.

"Hey, are you alright?"

The boy lifts his dirt-streaked face to glare at me.

"Your forehead's bleeding. Go on home and ask your ma to clean you up."

"Ma?"

"엄마요?"

"그래, 엄마한테 피를 닦아달라고……"

"호래자식이라 버르장머리가 없어. 저 애가 세 살 먹어 저 애 아버지가 죽었어. 영도다리 놓을 때 막일꾼으로 일하다, 바다를 메우려고 용미산 깎을 때 산사태가 나는 바람에 흙더미에 깔려서…… 그때 중국인도 여럿 깔려 죽었지. 암튼 하루 품삯 55전을 벌려고 사방에서 막일꾼들이 몰려들었어. 쌀 한 되가 15전, 담배 한 갑이 5전."

소년이 용수철처럼 팅기듯 일어서니, 숱이 유난히 많은 머리로 나를 들이받을 듯 다가선다.

"아줌마는 누구예요?"

"나는…… 미도리……"

나는 얼떨결에 그렇게 중얼거린다.

"미도리요?"

"미도리는 초록……"

이마에서 피가 계속 흘러내려 소년의 큼직한 눈동자로 흘러든다. 눈동자에 묻은 피는 닦아줄 수 없는데…… 또각, 나는 뒷걸음질한다.

그때 자전거가 경적을 울리며 달려온다. 자전거 뒤에는 나무상자가 차곡차곡 탑처럼 쌓여 있다.

"조심하렴, 자전거가 널 치겠구나."

자전거는 소년의 엉덩이 바로 뒤에 와 있다. 소년이 머리로 내 옆구리를 박고 나동그라진다. 그 충격에 나는 손에 들고 있던 거울을 떨어뜨린다. 자전거가 전봇대를 들이박고 나동그라진다. 허공으로 들린 자전거 바퀴가 핑그르르 헛돈다. 뒷자리에 차곡차곡 실려 있던 나무상자들이 순차적으로 쏟아지면서 그 안에 담겨 있던 가마보꼬[6]들이 팅겨 땅바닥에 널린다.

6 가마보꼬(かまぼこ). 일본 어묵.

"Yes, ask your ma to tend to it..."

"He's a rude one, but then he wasn't brought up right. His father died when the boy was just three years old. He was crushed in the landslide at the Youngdo Bridge site. A lot of Chinese workers died too. They were hired to cut down Yongmisan to fill the ocean... Day labourers and people in search of odd jobs had flocked to the site, because the pay was fifty-five jon for a day's work. This at a time when two dry quarts of rice cost fifteen jon and a pack of tobacco five jon."

The boy springs up and comes nearer, as if to butt me with his bushy head of hair.

"*Who* are you?"

"I'm... Midori..."

I mumble in bewilderment.

"Midori?"

"Midori means green..."

Blood trickles down the boy's forehead and into his big eyes. I can't clean blood off of an eye, I think to myself as I take a step backwards. Click-clack.

A bicycle speeds towards us, ringing its bell. An orderly stack of wooden boxes rear at its back.

"Be careful, the bike might hit you."

The bicycle's headed straight for the boy's back. The boy slams head-first into my flank and falls to the ground. In the shock of the impact, I drop the mirror I was holding. The bike careens into a utility pole and clatters to the ground. Its upturned wheels go on spinning in vain. The tall pile of wooden boxes topple in succession, and *kamaboko* scatter over the earth.

The man slowly picks himself up from the ground. Contorting his pock-marked face, he yells at the boy.

"You rascal!"

He's about to grab the boy by his throat. The boy, already terrorized

자전거 옆에 쓰러져 있던 사내가 비치적비치적 몸을 일으킨다. 얽은 얼굴을 일그러뜨리고 소년에게 버럭 소리 지른다.

"너, 이 자식!"

사내는 소년의 멱살이라도 움켜잡을 자세다. 겁에 질려 입을 벌리고 딸꾹질을 토하던 소년이 고갯길을 달려 내려간다. 불끈 주먹을 쥐고 부르르 떨던 사내는 소년을 따라가려는 자세를 취하다 만다. 울상을 짓고 땅바닥에 널린 가마보꼬를 나무상자에 주워 담기 시작한다.

"배달 가는 길인가 보네."

"네, 배달 가는 길이었답니다."

"말투를 보니 부산 사람이 아닌가 보우."

"수원에서 왔어요."

"먼 데서도 왔구려."

"먹고 살려 왔지요. 부산에는 일거리가 넘쳐나 사지만 멀쩡하면 굶어죽지 않는다고 해서요. 가마보꼬 공장에 취직해 석 달 일하고 나니까 해방이 되더군요."

"일본인들이 두고 간 가마보꼬 공장들을 조선인들이 불하받았다지?"

"네, 그랬지요."

"일본인들이 가마보꼬를 만들려고 조기를 하도 잡아들여서 어민들 불만이 이만저만이 아니었어. 조상 제사상에 올릴 조기도 남겨두지 않고 싹쓸이한다고 말이우." 노파가 가마보꼬 줍는 걸 돕는다. "다행히 흙이 많이 묻지는 않았네. 살다 보면 특별히 재수 없는 날이 있더이다."

"평소에는 자전거에 네다섯 상자만 싣는데, 오늘은 내가 욕심을 내서 아홉 상자를 실었어요. 배달을 한 번에 끝내려고요. 먼저 다섯 상자만 싣고 장수통[7]에 있는 요릿집들에 배달하고, 다시 공장에 들러 네 상자

7　장수통(長手通). 일제 강점기 부산에서 가장 번화했던 거리. 해방 후 광복을 기념하기 위해 광복동으로 지명을 바꾸었다.

and hiccuping helplessly with mouth agape, bolts down the hill. The man, quaking with rage, clenches his fists and motions as if to run after the boy, then gives up. He starts gathering the fish cakes back into the boxes and seems on the verge of tears.

"You must be out on a delivery round."

"Yes, I was on my way to deliver these."

"Your accent's not from around here. Not a Busan man then?"

"I came here from Suwon."

"That's a long way to come."

"I had to, to make a living. Lots of jobs in Busan, they said, so many in fact that as long as you had your limbs you'd never go hungry. I found a job at the *kamaboko* factory, and then three months later we were liberated."

"The *kamaboko* factories the Japanese left behind were all sold off to Joseon owners, weren't they?"

"Yes, that's right."

"The fishing folk around here were none too pleased with how the Japanese raked in the yellow croakers to make *kamaboko*. Said they'd more or less drained the sea dry, so we had no fish left to serve jesa to our ancestors even." The old woman says, helping the man pick up the rest of his scattered fish cakes. "Well, there's not too much dirt on them fortunately. Some days are just unlucky but that's how it goes, eh?"

"Most days I only carry four or five boxes at a time, but today I overdid it. Doubled up thinking I could get it all done in one round. I didn't want to do two separate rounds, delivering five orders to the eateries in Jangsutong⁵, then another trip to get the rest to deliver to Midorimachi. That would have taken up all my afternoon."

"Did you say Midorimachi?"

The man casts a look in my direction for the first time.

5 Busan's busiest main street during the colonial period. After liberation, the area was renamed Gwangbokdong.

185

를 싣고 미도리마치에 있는 요릿집에 배달하고 나면 오후가 다 가버려
서요.”

“미도리마치요?”

사내가 그제야 내게 흘끔 눈길을 준다.

“미도리마치에 요릿집이 있나요?”

“미도리마치에는 순 요릿집만 있다우.” 노파가 사내를 대신해 대꾸한
다. “미도리마치에 요릿집이 있냐고 묻는 걸 보니 아가씨도 여기 사는 사
람이 아닌가 보네.”

“네, 전 양산에서 왔어요. 친구들이 미도리마치에 있다고 해서……”

“친한 친구들이우?”

“네……”

“쯧쯧, 초록은 동색이라는데……” 노파는 말끝을 흐리고 날 아래위로
훑어본다.

사내가 가마보꼬를 주워 담은 나무상자들을 자전거 뒷자리에 차곡차
곡 싣는다. 아홉 상자나 되는 가마보꼬의 무게 때문에 자전거가 자꾸만 옆
으로 쓰러지려고 해서 대여섯 번 시도한 뒤에야 겨우 안장에 오른다. 따르
릉 따르릉, 경적을 울리며 조심조심 고갯길을 달려간다.

나는 거울을 집어 든다.

또각 또각…… 소년의 이마에서 흐르는 피는 멎었을까, 멎지 않고 계
속 흐르면 어쩌지…… 피를 닦아줄걸 그랬어…… 또각 또각…… 그럼 피
가 내 손가락에 묻어났겠지…… 피가 내 손가락에 묻는 건 싫어…… 또
각 또각…… 그 일본 군인의 얼굴도 소년처럼 앳되었어…… 어른 표정
을 짓고 있었지만 아직 아이 얼굴이었어…… 또각 또각…… 나보고 피를
닦아주라고 했어…… 죽은 사람 얼굴을 그때 처음 닦아줬어…… 또각 또
각…… 살아 있는 군인의 얼굴은 무서운데 죽은 군인의 얼굴은 무섭지 않
았어…… 또각 또각……

"Are there restaurants in Midorimachi?"

"There's nothing but eateries over at Midorimachi," the old woman answers for the man. "*Are there restaurants in Midorimachi.* I suppose you're not from around here yourself, eh?"

"No, I'm from Yangsan. I heard some friends of mine were at Midorimachi..."

"Close friends, are they?"

"Yes..."

"Tut, tut, green follows green and like follows like as they say..." The old woman trails off, her eyes sizing me up.

The man packs the boxes of dusty *kamaboko* back on his bike rack. The bike wobbles with the weight of its cargo, and it takes the man five or six tries to get on his seat. Ring ring, sounds the bell as man and bike carefully speed over the pass.

I pick the mirror up off the ground.

Click-clack, click-clack... Will the boy's head have stopped bleeding by now? What if it hasn't? I should have wiped it away myself... Click-clack, click-clack... But then my fingers would have been bloodied, I don't want blood on my hands... Click-clack, click-clack... That Japanese soldier, his face was also a boy's face... He had an adult's expression but his face was still a child's face... Click-clack, click-clack... They told me to clean up the blood... That was the first time I'd cleaned a dead face... Click-clack, click-clack... A living soldier's face is terrifying but a dead soldier's face wasn't scary at all... Click-clack, click-clack...

About ten steps ahead of me stands an empress tree in full leaf. Green is busily tinting the leaves.

But green is for sorrow... I observe the quiet sway of the gesturing leaves. I stand on tip-toe and extend my arms. Leaves brush against my fingers. I tear off a shiny leaf, and the air fills with its green scent. The scent of sorrow.

여남은 발짝 앞, 오동나무가 잎사귀를 소복이 달고 서 있다. 잎사귀들에는 초록이 부지런히 오르고 있다.

초록은 슬픔인데…… 손짓하듯 가만가만 흔들리는 초록 잎사귀를 바라보던 나는 깨금발을 하고 손을 뻗는다. 손가락 끝으로 잎사귀를 만지작거린다. 반들반들한 잎사귀를 찢자 초록 냄새가 퍼진다. 그것은 슬픔의 냄새다.

슬픔이 너무 많잖아…… 나는 초록 잎사귀를 찢고 또 찢는다. 찢긴 슬픔이 내 발을 덮으며 쌓인다.

"뭐하는 거예요?"

흰 블라우스에 검정 주름치마를 입은 소녀가 날 바라보고 있다. 소녀의 버짐 핀 볼에 살구빛이 감돈다.

"슬픔을 떼 주는 거란다."

"슬픔이요?"

"그래, 나무에 슬픔이 너무 많이 매달려 있어서 떼 주는 거란다."

"슬픔이 뭔데요?"

"슬픔이 뭐냐면……"

우물쭈물하던 나는 초록 잎사귀를 한 장 뜯어 그것으로 내 얼굴을 가린다. 숨을 깊이 들이마신다. 잎사귀가 내 얼굴에 착 달라붙는다.

"내 얼굴이 슬픔이란다."

나는 잎사귀를 바람에 날려 보낸다.

"내가 같이 떼어 줄까요?"

소녀가 초록이 오르고 있는 잎사귀로 손을 뻗는다. 하지만 소녀의 키가 작아 잎사귀에 손가락이 닿지 않는다.

"슬픔이 너무 높아요."

소녀가 슬픔을 향해 폴짝 뛰어오른다.

"슬픔에 네 손이 닿으려면 키가 더 커야겠구나."

There's too much of it, sorrow... I start tearing the leaf into smaller fragments. Shreds of sadness fall and pile up over my feet.

"What are you doing?"

A girl in a white blouse and a pleated black skirt is looking at me. There's a hint of apricot in her cheeks, over the eczema.

"I'm pruning sadness off this tree."

"Pruning?"

"Yes, I have a tree laden with too much sorrow so I'm removing some of it."

"What's sorrow?"

"Sorrow is..."

My words falter. I tear off a green leaf and hide my face behind it. I take a deep breath. The leaf clings to my face.

"My face is sorrow."

I let the leaf drift away on the breeze.

"Can I remove some too?"

The girl reaches out an arm toward the foliage that's slowly turning green. She isn't tall enough yet and her fingers stop short of the leaves.

"Sorrow's too high for me."

The girl hops and hops, trying to reach sorrow.

"You'll have to grow taller first before you can reach it."

"Is sorrow always so high?"

I raise my eyes to the top of the tree.

"Yes, that one is a bit too high."

The girl keeps jumping up and down to get closer to sadness. American soldiers whistle at us from a passing military vehicle.

"Little girl, go on home now."

"No."

"Go home and hide and don't come out."

"I don't want to. I want to rip the sadness off."

I leave the girl where she is and walk away from the empress tree.

"슬픔은 원래 저렇게 높은 건가요?"

나는 고개를 들어 가장 높이 달려 있는 잎사귀를 바라본다.

"그래, 저 슬픔은 너무 높구나."

소녀는 슬픔에 닿으려 폴짝 제자리 뛰기를 한다. 그때 군용 트럭을 타고 지나가던 미군들이 우리를 보고는 휙―휘파람을 분다.

"소녀야, 그만 집에 가렴."

"싫어요."

"집에 가서 꼭꼭 숨어 있으렴."

"싫다니까요. 나는 슬픔을 찢을 거란 말이에요."

계속 폴짝폴짝 뛰는 소녀는 두고 나는 오동나무를 떠난다.

검은 원피스 차림의 여인이 손에 벗나무 가지를 들고 내 앞을 지나간다. 고개를 푹 숙이고 게다 신은 발을 무겁게 내딛으며 걸어가는 뒷모습이 아무래도 요코 같다. 그녀도 낙원 위안소에 사귄 친구다.

"요코?"

내 목소리가 들리지 않는 걸까. 또각 또각…… 나는 미행하듯 여인의 뒤를 쫓는다. 여인이 향나무가 서 있는 마당 안으로 들어간다. 나는 머뭇거리다 여인을 따라 마당으로 발을 들여놓는다.

여인은 우윳빛 바위를 깎아 만든 불상 앞에 서 있다. 여인의 세 배는 되는 커다란 불상은 품에 아기를 안고 있다. 여인의 손에 들려 있던 벗나무 가지는 불상의 발 앞에 놓여 있다. 벗꽃은 생기를 잃고 시들었다.

"요코?"

여인이 몹시 천천히 뒤를 돌아다본다.

"아, 요코인 줄 알았어요."

"요코가 누군데요?"

"내 친구요…… 뭘 하는 거예요?"

A woman dressed in a black dress passes in front of me, carrying a branch of cherry blossom. Her head hangs low and the tread of her *geta*-clad feet are heavy; from the back she is the spitting image of Yoko. Yoko was another friend I'd made at Nakwon.

"Yoko?"

She doesn't seem to hear me. Click-clack, click-clack... I follow behind as if I'm shadowing her. The woman turns into a yard where there's a Chinese juniper tree growing. I hesitate, then step into the yard myself.

The woman stands in front of a bodhisattva cut from milky stone. The bodhisattva is three times as big as the woman and is holding a baby in its arms. The cherry branch now lies at the foot of the sculpture. The blossoms have wilted and look lifeless.

"Yoko?"

The woman takes her time turning her head to look back at me.

"Oh, I thought you were Yoko."

"And who is Yoko?"

"A friend... What are you doing?"

"Praying to Jijang bosal..."

"Jijang bosal?"

"This is Jijang bosal. A bodhisattva who lives in hell. He took pity on the sinners who had been condemned to hell, saying until each one of those souls had been saved he himself could not hope for salvation."

"And the baby?"

"That baby... is Sujaryung, spirit of the water child. A child that died before it was born. A child that never saw the light of day and was never given a name. A child that didn't even leave behind bones and so could not be cremated."

"And what were you praying for?"

"That he would take pity on the baby."

"Is your baby sick?"

"지장보살님께 빌고 있었어요……"

"지장보살이요?"

"저 분이 지장보살이에요. 지옥에 사는 보살이요. 죄를 지어 지옥에 떨어진 중생들을 불쌍히 여겨서 그들이 전부 구원 받기 전에는 자신도 구원 받을 수 없다고 했대요."

"아기를 안고 있네요?"

"저 아기는…… 수자령(水子靈)이에요. 태어나지 못하고 죽은 아기요. 그래서 세상 빛도 못 보고, 이름도 못 가져본 아기요. 뼈도 남기지 못해서 화장(火葬)도 해줄 수 없는 아기요."

"뭘 빌고 있었어요?"

"아기를 불쌍히 여겨달라고요."

"아기가 아픈가요?"

"오늘 아침에 아기를 지웠거든요."

부르튼 입술을 깨무는 여인의 얼굴은 겁에 질린 듯 창백하다.

"태어나지 못한 아기가 원망할까봐 무서워요?"

"수자령은 원망할 줄 몰라요. 인간 세상의 티끌조차 묻지 않아서 미워할 줄도 모르지요. 슬퍼할 줄도요……"

"슬퍼할 줄도요?"

"난 태어나지 못한 아기가 엄마인 날 떠나지 못할까 봐 지장보살에게 비는 거예요. 아기가 날 떠나서 윤회의 수레바퀴 속에 들어가야 하는데 언제까지나 내 곁에 꼭 붙어 있을까봐 걱정돼서…… 아아, 나는 날 위해 비는 것인지도 몰라요. 내가 마음이 편하려고요. 지장보살님께 빌고 나면 마음이 편해져요."

여인의 얼굴에 초록이 감돈다. 나는 여인의 얼굴로 손을 뻗는다. 초록을 찢고 싶지만 찢을 수 없다. 그러려면 여인의 얼굴을 찢어야 하니까.

"당신도 빌어요."

"I had a termination this morning."

The woman chews her chapped lips, the pallor of her face spelling fear.

"Are you afraid the baby will bear a grudge for not being born?"

"Sujaryung do not bear grudges. They don't know hatred, not having been corrupted by the human world. They don't know sadness either…"

"They don't?"

"I'm praying to Jijang bosal in case the baby won't be able to leave me. It has to leave me in order to enter the wheel of life, but I'm afraid it will want to cling by its mother forever…" She sighs. "Or perhaps I'm praying for myself after all. For my own peace of mind. I feel at peace after praying to Jijang bosal."

The woman's face takes on a greenish cast. I reach out my hand. I want to rip the green away but I can't. I would have to rend her face in order to do so.

"Pray with me."

"What? Why?"

I take a few steps back. The mirror in my hand trembles, and shards of disorienting light scatter in all directions.

"Isn't that why you're here, to pray to Jijang bosal because you've had a termination too?"

"I'm just… I followed you, is all. I saw your dress and mistook you for Yoko…"

2

Cherry blossoms flutter in the breeze. A row of cherry trees extend out in front of me. On either side of them stretches a path wide enough to allow passage for carts, each lined by wooden houses standing shoulder to shoulder. Paper lamps dangle from the eaves. The smell of frying meat, pancakes, cigarette smoke, the sound of a woman laughing convulsively, a bike ringing its bell…

"내가 왜요?"

나는 뒷걸음질한다. 내 손에 들린 거울이 불안하게 흔들리며 햇빛을
난분분 반사한다.

"당신도 나처럼 아기를 지우고 지장보살님께 빌려 온 거잖아요."

"나는 그저…… 당신을 따라왔어요. 당신이 요코의 원피스를 입고 있어
서 그녀인 줄 알고……"

2

바람에 벚꽃잎이 흩날린다. 내 앞으로 벚나무들이 일렬로 길게 줄을 서
있다. 벚나무들 양 옆으로 수레가 지나다닐 만한 길이 뻗어 있고, 길을 따
라 목조 가옥들이 어깨를 바짝 맞대고 붙어 서 있다. 지붕들 처마마다에
는 한지로 만든 등이 주렁주렁 매달려 있다. 기름에 적 같은 걸 부치는 냄
새, 부침개 부치는 냄새, 담배 연기, 까무러치는 것 같은 여자 웃음소리,
자전거 경적소리……

어스름이 내리고 둥글고 노란 불빛들이 둥둥 떠오른다. 한 무리의 미
군이 웃고 떠들며 불빛들 속으로 걸어 들어간다.

흔들리는 노란 불빛 속 흔들리는 친구의 얼굴이 낯설어 나는 할 말을 찾
지 못하고 바라보기만 한다.

"너 여기서 뭐해?"

"뭐하긴, 돈 벌지."

"뭐해서?"

"요리도 하고, 술도 따라주고…… 배운 게 도둑질이라고 별 수 있니?"

친구가 담배를 꺼내더니 입에 문다. 위안소에서 군인에게 담배를 배운
친구는 열다섯 살 먹어서부터 담배를 피웠다.

As dusk settles amber circles of light float up into the air. A group of American soldiers walk into the lights laughing and talking boisterously.

In the dangling gold light my friend's face appears strange and unfamiliar, and all I can do is look at her, unable to find the words.

"What are you doing here?"

"What do you think? Making a living."

"Doing what?"

"Cooking, serving drinks… They're the only tricks I know, after all."

She takes out a cigarette. She learned how to smoke from the soldiers at the wianso and has been smoking since she was fifteen.

"When will you go home?"

"When I have the money."

After saying goodbye to the friend I wander about, feeling lost, but then a familiar voice sounds in my ear. It's the woman who, on the repatriation ship, had stopped people to ask if the ship was headed for Pyongyang. She's all made up and wearing a polka dot dress, looking round expectantly.

"Are you waiting for someone?"

She turns to look at me. Light pink lipstick accentuates her pout, giving her a sullen look.

"It looked like you might be."

"I'm just waiting for people to come and listen to me sing."

"Sing?"

"I sing songs. There's nothing else I know how to do."

"You're wearing makeup, I see."

"To erase my face."

I used to make myself up at the wianso for the same reason, to erase my face.

"When are they coming?"

"고향집에는 언제 가려고?"

"돈 벌면."

친구와 헤어져 갈 곳 몰라 하던 내 귀에 익숙한 목소리가 들려온다. 귀환선에서 이 사람 저 사람을 붙들고 평양으로 가는 배냐고 묻던 여자다. 물방울 무늬 원피스를 입고 화장을 한 여자는 누군가를 기다리는 듯 목을 빼고 있다.

"누구 기다려요?"

여자가 고개를 들고 날 물끄러미 바라본다. 연분홍색 루주를 바른 입술을 삐죽 내밀고 있어서 토라져 있는 것 같다.

"누굴 기다리는 것 같아서요."

"그냥 내 노래 들어줄 사람이요."

"노래요?"

"나는 노래를 불러요. 노래 말고는 할 줄 아는 게 없어서요."

"화장을 했네요?"

"얼굴을 지우려고요."

나도 위안소에서 얼굴을 지우려 화장을 했다.

"언제 오는데요?"

"누구요?"

"당신 노래를 들어줄 사람 말이에요."

"밤이 더 깊어지면요."

"이름이 뭐예요?"

여자는 내 친구가 아니다. 그래서 나는 여자의 이름을 모른다. 여자는 이름을 잊어버린 걸까, 아니면 이름이 없는 걸까. 내 외할머니도 이름이 없었다.

"이름말이에요."

"나나코, 하나코, 미에코, 레이코, 사사코……"

"Who?"

"The people who are coming to listen to you."

"Later in the night."

"What's your name?"

This woman is not a friend. That's why I don't know her name. Has she forgotten her name, or does she not have one? My maternal grand-mother didn't have a name either.

"Your name?"

"Nanako, Hanako, Mieko, Reiko, Sasako..."

"Those are all your names?"

"The names the soldiers gave me."

I am about to turn away from her, but then I stop and hand her the mirror.

"For you."

She hesitates, then accepts the mirror. She holds it carefully with both hands and looks at her reflection. There's a crack running diago-nally across the glass.

"I heard that unborn children don't know sadness."

I tell the woman what I had wanted to tell my friend.

"My face is cracked."

She seems unable to tear her eyes from the mirror. I turn away.

Click-clack, click-clack... The lights have multiplied. I remem-ber now how I was also called various names by the soldiers. Nanako, Hanako, Mieko, Reiko, Sasako... I whisper the woman's various names. Nanako is also one of my names. It was given to me by a *kamikaze tokkotai* pilot called Sakamara. He went out to sea in a fighter plane one day and did not return. Click-clack, click-clack... Is the girl still waiting under the empress tree, I wonder. Click-clack, click-clack... Somehow I imagine that by now she's grown tall enough to reach the highest sorrow all by herself.

197

"그게 다 당신 이름이에요?"

"군인들이 지어주었어요."

나는 여자에게서 돌아서려다 말고 거울을 내민다.

"가져요."

여자가 머뭇거리다 거울을 받아든다. 두 손으로 떠받치듯 들고 거울을 들여다본다. 거울에 사선으로 금이 가 있다.

"참, 태어나지 못하고 죽은 아기는 슬픔을 모른대요."

친구에게 해주고 싶었던 말을 나는 여자에게 한다.

"어머나, 내 얼굴에 금이 갔네요."

거울에서 눈길을 거두지 못하는 여자에게서 나는 또각, 돌아선다.

또각 또각…… 불빛은 그새 더 많아졌다. 생각해보니까 군인들은 내게도 이름을 지어주었다. 나나코, 하나코, 미에코, 레이코, 사사코…… 나는 여자의 이름을 중얼거려본다. 나나코는 내 이름이기도 하다. 사카마라는 가미가제 독고다이[8]가 지어주었다. 그는 어느 날 전투기를 몰고 바다로 나가 돌아오지 않았다. 또각 또각…… 소녀는 아직도 오동나무 아래에 서 있을까. 또각 또각…… 가장 높은 슬픔이 손에 닿을 만큼 소녀의 키가 그새 훌쩍 자라 있을 것 같다.

8 태평양 전쟁 말, 일본군의 자폭 공격 대원.
* 김한근 향토사학자 부산 근대 자료 제공.

Green Is for Sorrow

Translated from Korean
by Emily Yae WON

* The author thanks Kim HanDeun, researcher of Busan's local history, for providing
reference materials for this story.

물개여관

김언수

철판을 때리는 망치질 소리에 수레는 눈을 떴다.

　새벽 두시였다. 깡깡! 깡깡! 리듬을 타는 힘차고 규칙적인 망치질 소리. 선박 수리 조선소에서 새벽 교대조로 일하는 깡깡이 아줌마들의 첫 망치질 소리일 것이다. '제발 잠 좀 자자. 뭘 얼마나 잘 살겠다고 꼭두새벽부터 망치질이냐', 베개 속으로 더 깊이 머리를 파묻으며 수레가 구시렁거렸다. 하지만 잠은 이미 깨버렸다. 몇 시간이나 잠들었던 것일까. 한 시간? 두 시간? 요즘엔 엉망이 되도록 술을 마시고 엎어져도 좀처럼 깊은 잠을 이루지 못한다. 이른 봄, 호수 수면에 남은 마지막 살얼음판처럼 잠은 너무나 얇고 아슬아슬해서 작은 진동이나 소음에도 쉽게 깨져버린다. 어처구니없는 일이라고 수레는 생각했다. 베트콩들이 밤새도록 포탄을 쏘아대던 밀림에서도 잘 잤고, 극성맞은 거머리와 모기떼가 들끓는 진흙탕 참호 속에서도 판초우의를 뒤집어쓰고 잘 잤었다. 10미터짜리 파도가 연신 덮쳐대던 태평양의 그 작은 원양어선 기관실 위에서도 늙은 고양이처럼 잠만 잘 잤었다. 그런데 이 푹신한 침대 위에서 불면증에 시달리고 있는 것이다. 잠을 더 자야 했다. 새벽에 아치섬에서 중요한 거래가 있었다. 그리고 그 거래가 끝나기 전에 누군가 죽을 것이다. 하나, 혹은 둘, 어쩌면 더 죽을

The Seal Inn

KIM Un-su

Sureh woke to the din of hammers pounding on steel.

Two a.m. Clang-clang! Clang-clang! The noise was loud and rhythmic. The morning repair shift down at the shipyards had begun; the clang-clang women had just started their hammering. Burying his head deeper in the pillow, Sureh grumbled, "Let a man sleep, for fuck's sake! You think hammering away at two in the goddamn morning is gonna make you rich?" But it was too late, he was wide awake. How much sleep had he gotten? One hour? Two? He'd been having trouble sleeping lately, and no amount of drinking himself into a stupor had made any difference. His sleep had turned as thin and fragile as the last crust of ice clinging to the surface of a lake in early spring; it shattered at the tiniest sound or vibration. Made no damn sense, Sureh thought. He'd slept like a baby in the jungle as the Viet Cong rained down mortars all night, had snored away calmly with only a poncho for a blanket in the muddy trenches swarming with mosquitos and crawling with giant leeches. He'd even slept as soundly as an old cat, tucked away in his berth above the engine room while ten-meter-high waves lashed at the tiny deep-sea fishing boat in the middle of the Pacific Ocean. But, here, in this comfy bed, he was plagued with in-

지도 모른다. 실수를 하지 않으려면 머리가 맑아야 한다. 그 판에서 자칫 실수를 한다면 이 새벽에 총이나 칼을 맞고 파도에 떠내려갈 얼간이가 바로 자기 자신이 될 수도 있으니까. 하지만 억지로 눈을 붙이려고 하면 할수록 잠은 아침 숲의 안개처럼 빠르게 옅어졌다. 어쩔 수 없다는 듯 수레는 침대에서 몸을 일으켰다. 그리고 탁자 위에 있는 럭키스트라이크 담배와 라이터를 손에 쥐고 창문을 열었다.

비가 내리고 있었다. 일본인들이 남기고 간 낡은 2층 목조주택들이 줄지어 있는 영도 남항동 골목은 조용했다. 건너편 건물 다락방에서 아이가 깼는지 가늘게 울음소리가 들려왔다. 잠을 깬 남자가 거친 목소리로 짜증을 냈다. 여자가 일어나서 아이를 안고 달랬다. 커튼에 비친 여자의 어깨는 작고 착해 보였다. 아이가 울음을 멈췄지만 여자는 계속 아이를 안고 창문 앞을 서성였다. 목조건물들 사이로 전깃줄처럼 복잡하게 연결되어 있는 빨랫줄에는 미처 걷어 가지 못한 옷가지들만이 우두커니 비를 맞고 있었다. 선원들의 방수복, 빨래를 했음에도 여전히 페인트와 기름때가 잔뜩 묻어 있는 조선소 노동자들의 작업복, 철가루 때문에 녹이 슬어 붉게 변한 깡깡이 아줌마들의 작업복, 술집 아가씨들의 요란한 팬티와 브래지어 그리고 아이들의 앙증맞은 양말과 반바지까지. 이 골목의 삶은 빨랫줄에 매달린 옷가지들처럼 피곤하고 후줄근하다. 너무나 피곤하여 비가 내려도 빨래를 걷는 사람이 없다. 바람이 불자 젖은 옷가지들이 빨랫줄에 매달려 마치 축제라도 열린 것처럼 다 같이 춤을 췄다. 이 빗속에서 뭐가 좋다고 춤을 추고 있는 걸까. 덩달아 어시장으로 가는 트럭에서 떨어진 썩은 생선들이 비를 맞고 부활한다. 부활해서 썩은 비린내를 이 축축한 골목에 가득 채운다. 조선소로 출근하는 용접공들 몇이 우비도 입지 않은 채 자전거를 타고 빠르게 골목을 지나갔다. 자전거 타이어가 썩어가는 생선 대가리라도 터트렸는지 비린내가 더 심하게 올라왔다.

웃기게도 이 골목이 내내 그리웠다. 장대비가 몇 달이나 쏟아지는 우

somnia. He had to get more sleep. An important deal was going down on Achi Island at dawn. And before that deal was over, someone would be dead. Maybe even two someones, or more. He'd have to keep a clear head to avoid any mistakes. The slightest slip-up and he might just be the jackass getting shot or knifed by morning, his body carted away on the waves. But the harder he tried to force himself to sleep, the more his drowsiness thinned and dissipated like a fog in a forest at dawn. There was nothing else to do but get out of bed. He grabbed his lighter and Lucky Strikes from the table and opened the window.

Rain was falling. It was quiet there, in Yeongdo Island's Nam-hang-dong neighborhood, the alleys lined with aging two-story wooden houses that had been left behind by the Japanese. From the attic of the building across from Sureh's came the reedy cries of a baby, its sleep interrupted. Woken by its crying, a man fumed, his voice hoarse. A woman got up to comfort the infant. Her shoulders, visible through the curtains, looked frail and kind. The baby stopped crying, but the woman kept soothing it anyway as she paced back and forth in front of the window. Rain soaked the clothes hanging from the tangle of clotheslines between the buildings, from the sailors' uniforms, to the dockyard workers' coveralls still covered in paint and grease no matter how often they were laundered, to the clang-clang women's work clothes red with rust, to the bar girls' garish bras and panties, and their children's cute socks and shorts. The lives in this alley were as worn out and bedraggled as those clothes; no one had the energy to bother bringing their laundry in out of the rain. The wind blew, and the wet clothes danced on the line like they were at a festival. What was so great about this downpour that they would feel like dancing? Rotting fish that had fallen off the back of a truck on its way to the fish market were returning to life in the rain. Or rather, the rain was bringing their stink back to life, filling the damp alley with their rotting funk. Welders on their way to the docks zipped through the alley on bicycles

기의 베트남 밀림 속에서도, 원양어선에서 하루에 열여섯 시간씩 참치를 끌어올리고 있을 때도 이 풍경이, 이 냄새가 그리웠다. 왜 이 따위 냄새를 그토록 그리워했던 것일까. 막상 돌아왔을 때 수레가 느낀 감정은 실망감이라기보다 황당함에 가까웠다. 이 거리엔 수레가 그리워할 만한 것이 아무것도 없었다. 이 거리가 변했을까? 아니라면 내가 변했을까? 수레는 고개를 갸웃거리고 잠시 눈동자를 위로 추켜올렸다. 그리고 피식 웃음을 지었다. 변한 건 아무것도 없었다. 그때도 어떻게 살아가야 할지 몰라 그저 멍하니 이 풍경을 쳐다보고 있던 멍청이가 있었고 지금도 그렇다. 이 골목도 마찬가지다. 예전에도 젖은 빨래는 빗속에서 춤을 췄고 생선 대가리는 바닥에서 썩어갔으며 아이는 한밤중에 울어댔다. 그리고 자신의 인생에 늘 화가 나 있는 사내는 자다가 버럭 소리를 질렀다.

깡깡! 깡깡! 수레는 망치질 소리가 나는 선박 수리 조선소 쪽을 쳐다봤다. 야간 작업등 때문에 조선소 쪽 하늘만 유독 밝았다. 깡깡! 깡깡! 마치 술 취해 흐트러진 이 골목의 모든 한심한 영혼들을 깨우려는 듯 망치질 소리가 빗속을 뚫고 시골 성당의 종소리처럼 선명하게 울렸다. "이 골목의 한심한 영혼들은 모르겠고, 내 잠은 확실히 깨웠네." 수레가 서쪽 하늘을 향해 중얼거렸다. 사실 깡깡이 소리가 신경을 거스르는 것은 아니었다. 그러니 저 망치 소리 때문에 불면증에 시달리는 것도 아닐 것이다. 오히려 망치 소리는 수레에게 묘한 안도감을 주었다. 월남전에서 돌아온 후 공허한 마음을 어쩌지 못해 허겁지겁 참치잡이 원양어선을 탔을 때, 수레가 하급선원으로 제일 먼저 배운 일도 깡깡이였다. 어디를 가나 신참은 화장실 청소부터 시작하는 것처럼 배에서는 깡깡이가 그런 일이었다. 수레는 작은 망치를 손에 쥐고 배 이곳저곳을 돌아다니면서 파도와 해풍에 녹슨 철판을 때렸다. 녹슨 철 조각이 떨어져나가면 사포로 철판을 깨끗이 문지르고 페인트를 새로 발랐다. 몇 달이고 몇 년이고 배 위에서 육중한 파도에 흔들리다보면 이 지구가, 이 우주 전체가 끊임없이 출렁이는 거대한

without so much as a raincoat to shield them. They must have rolled right over the fallen fish, tires popping the little skulls open, because the bouquet of rot suddenly bloomed and intensified.

As foolish as it sounded, Sureh had missed that alley. Even in the middle of the Vietnamese jungle, as heavy monsoon rains pounded down for months on end, and even while reeling in tuna for sixteen hours a day, he had missed these sights, this smell. But what was there to miss about this awful smell? What Sureh felt every time he came back was not disappointment but rather something closer to confusion. There was nothing here worth missing. Had the street changed? Or had he changed? He cocked his head in contemplation, then rolled his eyes and smirked. Absolutely nothing had changed. He was still the same empty-headed moron who'd stared out this window last time he was here without a clue as to what he should do with his life. The alley was just as unchanged. Back then, as well, wet laundry had danced in the rain, fish heads had rotted on the ground, and children had cried in the middle of the night. And a man forever angry at his own life woke and let out a loud holler.

Clang-clang! Clang-clang! Sureh stared in the direction of the hammering. The night crew's floodlights had turned the sky over the shipyards brighter than the rest of the sky. Clang-clang! Clang-clang! As if to wake the drunk, pathetic souls sprawled across this alley, the hammering pierced the rain and rang out as loud and clear as a cathedral bell in the countryside. "Well, I don't know about the pathetic souls of this alleyway, but I'm definitely awake now," Sureh muttered at the western sky. To be fair, the hammering didn't actually bother him. Nor was it to blame for his insomnia. In fact, the noise gave him a strange sense of reassurance. After returning from the Vietnam War and rushing helter-skelter to board a tuna boat because he couldn't handle the emptiness he felt, the very first thing Sureh had learned as a petty crewman was how to clang-clang the rust out of steel. Just as

율동이라는 사실을 알게 된다. 우주 전체가 흔들리는 마당에 이 빌어먹을 인생이 갈피를 못 잡고 흔들리는 것은 어쩌면 당연한 일이라는 생각도 든다. 우주가 출렁이므로 파도는 멈추질 않는다. 우주가 출렁이므로 바람도 계속 불어온다. 그리고 우주가 출렁이므로 철판에 생기는 녹도 멈추지 않는다, 멈추기는커녕 녹은 매일 무럭무럭 자란다. 그러니 배의 이곳저곳을 돌아다니며 녹슨 철판을 때려야 하는 깡깡이 작업은 하염없고, 허무하고, 한심한 일이다. 4월의 벚나무 거리를 빗자루로 쓸어본 사람은 그 느낌을 알 것이다. 문득 뒤를 돌아보면 바람이 불 때마다 다시 흩날려서 기껏 쓸어놓은 거리 위로 다시 쌓이는 축축하고 하얀 꽃잎들. 아무리 열심히 해봐야 다음날 아침이면 같은 출발선으로 돌아오는, 보람이라고는 일절 찾을 수 없는 일. 말하자면 깡깡이가 그런 일이다.

수레에게 깡깡이를 가르친 늙은 갑판원은 일본 식민지 시절 징용으로 끌려가 태평양 전쟁에 참전한 사람이었다. 선원들은 그를 초할배라고 불렀다. 초할배의 진짜 이름은 기억나지 않는다. 아무도 초할배의 이름을 부르지 않았기 때문이다. 종일 망루에 앉아서 바다를 보며 새떼를 찾아다니거나 백파를 일으키는 멸치와 참치떼를 찾는 것이 초할배의 일이었다. 하지만 보통은 망루 위에서 꾸벅꾸벅 졸거나 어구를 손질하는 선원들 옆에 앉아 쓸데없는 잡담을 거는 게 다였다. 사실 초할배는 이제 너무 늙어서 배에서 마땅히 할 일이 없었다. 재빨리 고기를 낚아챌 수도 없었고, 100킬로그램도 넘는 참치를 갑판 위로 끌어올릴 수도 없었다. 선원들과 보조를 맞춰 일을 하기엔 몸이 너무 느려서 어쩌다 초할배가 갑판 위로 올라가면 작업장이 엉망이 되기 일쑤였다. 바다에는 천 가지의 죽을 이유가 있고 그중 원양어선은 세상에서 가장 거칠고 고된 일이다. 태울 수 있는 선원이 한정되어 있기 때문에 배에서는 누구나 자신이 일해야 할 몫이 엄격하게 정해져 있다. 그러니 누군가 다치거나 죽어서 제 몫을 못하고 엎어지면 다른 선원들이 잠을 줄여서 그 일을 나눠야 한다. 선원들은 하루에

newbies in other lines of work start out scrubbing toilets, knocking out rust was no different. Sureh had crawled over every inch of the boat, tiny hammer in hand, to beat the steel free of the rust brought on by the wind and waves. After the flakes of rust fell away, he scrubbed the steel with sandpaper and applied a fresh coat of paint. A few months, or a few years, of being tossed around by powerful waves had a way of showing a man that the earth, this universe, was one giant, heaving, sloshing dance. With the entire universe swaying like that, you thought it only made sense that your own fucked up life would be swaying out of control. Because the universe sways, the waves keep coming. Because the universe sways, the wind keeps blowing. And because the universe sways, rust keeps growing on steel. Hell, not only does it grow, it goes wild, growing more out of control by the day. And so the task of the clang-clang man, who must travel every inch of the boat to beat away the rust, is a perpetual, pointless, and pitiful task indeed. Anyone who's ever wasted their time trying to sweep up cherry blossoms in April will know the feeling. You look back to see that the sidewalk you've just swept clean is already re-blanketed in those pale, damp blossoms that shake down from the branches with every gust of the wind. The kind of work that finds you back at the starting line every morning no matter how hard you labored, that has no discernable reward whatsoever. That's what it was like to fight rust.

The ancient deckhand who'd taught Sureh how to clang-clang the rust off the boat had been drafted into the Japanese military and forced to fight in the Pacific War, back in the colonial days. The other sailors all called him Granddaddy Cho. Sureh could not remember his real name. No one ever actually called him by it. Granddaddy Cho's job was to sit up in the crow's nest all day and track flocks of birds or spot the white caps churned up by schools of anchovy and tuna. Of course, what he really did was doze off in the crow's nest or sit next to the sailors as they repaired their fishing gear and talk their ears off all

열여섯 시간씩 일을 한다. 솔직히 잠은커녕 하품 할 시간도 부족한 판이다. 그런데 이 배 위에 매일 빈둥거리거나 졸기만 하는 늙은이 한 명이 자리를 차지하고 있는 것이다. 그것이 선원들이 초할배를 싫어하고 무시하는 이유였다. 하지만 선장의 어릴 적 친구여서 어쩔 수 없이 배에 태우고 있는 것이라고 갑판장은 툴툴거리며 말했다. 수레가 깡깡이 작업을 할 때면 초할배는 언제나 옆에 쪼그리고 앉아 자신이 살아온 인생에 대해 떠들어댔다. 깡깡이가 무서운 게 아니라 초할배의 수다가 무섭다고 선원들은 농담을 했다. 실제로 그랬다. 끝도 없이 이어지는 그의 이야기를 듣는 것은 망치질보다 훨씬 힘들었다. 하지만 그 이야기를 듣고 있노라면 문득 초할배가 아주 외로운 삶을 살았을 거라는 생각이 들었다. 초할배는 이북에서 홀로 월남해서 내려왔기 때문에 남한에 가족이 없었고 돌아갈 고향도 없었다. 이따금 초할배는 북한에 두고 온 자신의 어린 신부에 대해 이야기하곤 했다.

"나는 서른둘이었고 아내는 열여섯이었지. 아주 고운 사람이었어. 나는 키도 작고 못 생긴 사람이지만 아내는 정말 훤칠하고 예뻤지. 고향 땅에선 내 아내를 맘에 안 품어본 놈팡이가 없었다니까. 솔직히 나 같은 놈이랑 결혼할 사람은 아니었지."

"그런데 용케 그런 미인의 마음을 얻었네요?"

"마음을 얻은 건 아니고, 그 아버지라는 놈이 도박쟁이인데 나한테 빚이 있었어. 나는 잭팟이 터진 거고, 내 아내는 인생이 엉킨 거지. 그래도 결혼생활은 좋았어. 착하고 어진 사람이어서 이것도 운명이라 여긴 거지. 거기서 계속 살았어야 했는데 괜히 배를 탔어. 나는 원래 함경도 명천 바다에서 명태잡이를 했었는데 일본으로 건너가서 상어잡이를 하면 돈을 더 많이 번다고 해서 마음이 혹했지."

"그 예쁜 신부를 놔두고요?"

"막상 어린 신부랑 결혼을 하니 불안한 거야. 돈이 있어야겠다고 생각

day. Granddaddy Cho was much too old to be of any use on a boat. He could not quickly reel in fish or pull a hundred-kilo-or-heavier tuna onto the deck. He was too slow to keep pace with the others, which meant that his presence on deck more often resulted in messing everything up. There were a thousand ways to die at sea, and deep sea fishing boats were one of the hardest and harshest of places to be. Because the size of the crew was limited, everyone had to pull their own weight. If someone got hurt or died and were unable to do their job, the other sailors had to sleep less and work more. They worked sixteen hours a day as it was. That left barely enough time to yawn, let alone sleep. And yet, on their boat, a spot was taken up by an old man who spent all his time dozing off or loafing around. The rest of the crew hated him for that and did their best to ignore him. The boatswain griped that they had no choice but to allow him on board because he and the captain had known each other since they were kids. Whenever Sureh clanged away at the rust, Granddaddy Cho would squat next to him and ramble on and on about his life story. The sailors liked to joke that the rust was nothing compared to Cho's unending prattle. It was true. Listening to his endless, looping tales was far more difficult than hammering away at steel. But listening to him made Sureh realize what a terribly lonely life Cho must have lived. Cho had left the North on his own, which meant he had no family in the South and no home that he could return to. He talked now and then about the young bride he'd left behind in North Korea.

"I was thirty-two, she was sixteen. She was so beautiful. I'm short and ugly, but she was tall and pretty. There wasn't a single jackass in our village who didn't want her for himself. I had no business being married to someone as fine as her."

"How'd you get her to fall for you?"

"I didn't. Her father was a gambler who owed me. I hit the jackpot while her life went bust. But our marriage was good. She was a sweet,

했어. 돈이 없으면 언제고 젊고 힘센 놈들한테 아내를 뺏길 것만 같았지. 한번 그 생각이 드니 불안이 마음속을 떠나질 않는 거야. 내가 일본으로 가서 배 한번 훌쩍 타고 오면 돈 많이 번다고, 돌아오면 그 돈으로 행복하게 살자고 했더니 하염없이 울기만 하더만. 말이 별로 없는 사람이었지. 그게 마지막이었어."

결혼생활이라고 해봐야 고작 1년 남짓이었다. 2년이면 한 밑천 잡아서 돌아갈 줄 알았는데 어영부영 상어잡이만 10년이었다. 게다가 상어잡이 막판에는 일본 선주에게 속아 태평양 전쟁 징용에도 끌려갔다. 태평양전쟁이 끝나고 돌아오니 곧장 한국전쟁이 났더란다. 남과 북에 휴전선이 그어져서 오도 가도 못하고 20년이다. 그렇게 어영부영 40년 세월이 훌쩍 지나갔다. 사진 한 장이라도 있었으면 좋았으련만 그걸 못 챙겨와서 이제 얼굴이 기억나지 않는다고 했다. 사실 얼굴이 기억나지 않은 지는 아주 오래되었다고도 했다. 어째서인지 알 수 없지만 초할배는 남한에서 재혼을 하지 않았고 아주 잠시라도 딴 여자와 살림을 차리지도 않았다. 남북이 통일이라도 된다면 열여섯 살의 그 예쁜 아내를 다시 만날 수 있을 거라고 생각한 것일까? 그 어린 신부가 아직도 자기를 기다리고 있을 거라고 믿은 것일까? 모를 일이다. 하지만 어쩔 수 없어서 돌아가지 못했다는 말은 거짓말일 것이다. 정말로 돌아갈 마음이 있었다면 상어잡이 시절에도, 해방 후에라도, 아니라면 전쟁중에라도 얼마든지 돌아갈 수 있었다. 하지만 초할배는 아름다운 신부가 기다리는 고향으로 돌아가지 않았다.

"바다에 마음을 붙잡힌 거지. 한번 바다에 마음을 뺏기면 육지에선 도무지 살아갈 자신이 없어지거든. 육지에 두고 온 것들을 다시 볼 자신도 없어지고."

수레가 탔던 배의 기관장은 그렇게 말했다. 그 말이 그럴듯하다고 생각했다. 초할배가 택한 것은 그리움을 직접 만지는 삶이 아니라 멀리서 계속 그리워하는 삶이었다. 바다는 무언가를 계속 그리워하기에 더없이

virtuous woman who chalked it up to fate. I should never have left, but I stupidly boarded a ship instead. I'd started out as a pollack fisherman in the waters off of Myeongcheon, in Hamgyeong Province, but I fooled myself into thinking that I would make more money by going to Japan to work on a shark boat."

"Without your beautiful bride?"

"Thing about marrying someone so young is, it makes you doubt yourself. You get to thinking that you need money to keep her. Without money, some younger, stronger guy could come along at any moment and steal her from you. Once that thought was in my head, I couldn't shake the doubt. When I told her I was going to Japan to make us a fortune off of a single fishing trip, and that we would live happily off of that money when I got back, she cried and cried. She never had been much of a talker. That was the last I saw of her."

Their marriage, such as it was, had lasted just over a year. He thought it would only take two years to return home with a nest egg, but he frittered away ten years on that shark boat. Then, before he could leave, the Japanese shipowner tricked him, and he was drafted into fighting for the Japanese in World War II. No sooner was he home from that war than the Korean War broke out. The ceasefire line was drawn between North and South, and for the next twenty years no one could cross it. Forty years of his life flitted by just like that. If only he had a photo of her, he said. By now, he'd forgotten what she looked like. It'd been a long time, in fact, since he could last remember her face. Sureh had no idea why, but Granddaddy Cho had not remarried in the South and hadn't so much as lived with another woman for even a day. Did he think that if the countries reunited, he'd be reunited, too, with that pretty sixteen-year-old bride of his? Did he believe his young bride was still waiting for him? Sureh had no idea. But his claim that he couldn't go back was almost definitely a lie. If he'd really wanted to go back, he'd have found a way, no matter if it were during his time on

좋은 장소이고, 실재의 세상을 만나는 것은 때때로 너무나 무섭고 위험한 일이니까. 어쨌거나 배가 항구에 닿으면 초할배는 항구 근처의 허름한 여관에 방을 잡고, 선박 수리소에서 배 고치는 일을 돕거나 남항동 술집 근처를 어슬렁거리다가 배가 떠나면 같이 떠났다. 그러니 고향을 떠난 후 초할배에게 육지에서의 삶이란 거의 없는 것과 마찬가지였다. 초할배 삶의 대부분의 시간은 끝없이 흔들리는 파도 위에 있었다.

"사람들은 깡깡이를 우습게 아는데 이건 중요한 일이야. 녹슨 곳을 방치하면 이 두꺼운 철판도 몇 달이면 파도와 바람에 구멍이 숭숭 나버려. 나는 태평양전쟁 때 미군 포탄이 떨어지고 있는데도 깡깡이를 했었어."

"포탄이 떨어지는 마당에 깡깡이는 뭐하러 했어요? 어차피 배도 사람도 다 죽을 판인데." 수레가 물었다.

"아, 그야 무서워서 그랬지."

"무섭다고 깡깡이를 해요?"

"포탄은 떨어지지, 배에 구멍이 나서 여기저기서 물은 터져 나오지. 정신이 하나도 없었어. 일본 놈들은 살아보겠다고 여기저기서 아우성이지. 얼이 빠져 멍하게 앉아 있는 놈, 비행기에다 권총을 쏘대는 놈, 우는 놈, 이불 속에다 머리를 처박고 기도를 하는 놈 별 놈들이 다 있었지. 나도 아주 무서웠어. 뭐라도 해야 할 것 같은데 도대체가 할 줄 아는 게 있어야지. 어선에서 상어나 잡다가 졸지에 화물선으로 끌려온 조선인이 짐 나르는 거 말고 배운 게 뭐가 있겠어. 그래서 깡깡이를 했어. 아주 무서웠거든."

"포탄을 그렇게 맞고도 배가 버텼나봅니다? 이렇게 멀쩡하게 살아계신 걸 보니."

"배는 침몰했어. 우물만한 구멍이 서너 개나 났는데 버틸 요량이 없지. 구명조끼도 없이 바다에 둥둥 떠서 저멀리 침몰하고 있는 우리 화물선을 보고 있는데 웃기게도 그런 생각이 들더라고. 아! 아직 페인트가 덜 말랐을 텐데. 정말 그런 생각이 들었어…… 아냐, 아냐, 그렇게 하면 안 돼. 거

the shark boat, or after Liberation, or even in the middle of war. But Granddaddy Cho made no attempt to return to his hometown where his beautiful bride waited for him.

"The sea stole his heart," the chief engineer on Sureh's boat had said. "Once you lose your heart to the sea, you lose the confidence to ever live on land again. You even lose the confidence to see the things you left behind on land."

It seemed convincing. Instead of a life of up-close longing, Cho had chosen a life of distant longing. There was no better place than the sea for longing endlessly for something, and dealing with the real world could be frightening and dangerous. At any rate, whenever the boat pulled into port, Cho would grab a room at a rundown inn close by and help out in the repair yard or slink around to the local bars of Namhang-dong. And when the ship left, he left with it. In other words, ever since leaving home, Granddaddy Cho had all but stopped living on land. Most of his days were spent atop the endlessly rocking waves.

"People look down on this clang-clang work, but it's important. If you don't do anything about the rust, these thick sheets of steel will be shot through with holes in a matter of months. Even during the war, when American bombs were raining down on us, I kept working."

"What's the point of hammering away at rust if bombs are falling on you?" Sureh had asked. "The boat and everyone on it is dead anyway."

"Because I was scared."

"You removed rust because you were scared?"

"Bombs were falling and holes were opening up all over the ship, water pouring in everywhere. I was beside myself. The Japanese were clamoring about how they didn't want to die. Some guys were just sitting there in a daze, some were shooting their guns at the planes, some were crying, some were even hiding under their blankets and praying. I was scared out of my mind, too. I had to do something, but there was nothing I could do. So I hammered. I was terrified."

기를 망치로 더 때려. 아직 녹이 덜 떨어졌잖아. 녹이 덜 떨어진 곳에 페인트를 바르면 아무 소용없어. 페인트가 금방 떨어지거든."

생각해보면 재미있는 영감이었다. 선장과는 고향에서부터 친구라고 했다. 그 둘은 해방 전에도 일본 선주 밑에서 배를 탔었다. 한때는 선장과 더불어 상어 많이 잡는 걸로 꽤나 명성을 얻은 적도 있었다. 하지만 전부 오래전 이야기다. 이제 선장도 늙었고 초할배도 늙었다. 배에서 선장과 초할배가 이야기하는 모습을 본 적은 한 번도 없었다. 어쩌면 서로 지겨워졌을 수도 있다. 아니라면 그동안 너무 많은 말을 해서 이제 더이상 할 말이 남아 있지 않거나.

수레는 담배를 깊게 빨았다. 빨아들이는 연기에서 페인트 냄새, 기름 냄새 같은 항구 특유의 냄새가 섞여 들어왔다. 건너편 가로등 아래엔 어젯밤 물개여관에서 술을 마신 선원 둘이 비를 맞으며 담배를 피우고 있었다. 담배가 떨어졌는지 한 개비의 담배를 둘이서 나눠 피우고 있었다. 한 명은 마흔 살쯤 되어 보였고 다른 한 명은 채 스물도 안 되어 보였다. 젊은 사내는 아마 오늘 배를 처음 타는 신참 선원일 것이다. 젊은 사내에게는 아직 뱃사람의 냄새가 전혀 나지 않았다. 신참 선원은 어제 술을 너무 많이 마셨는지 담배를 한 모금 빨다가 가로등 아래에 토를 했다. 구토를 끝내고 고개를 들 때 신참 선원의 입에서 침이 잔뜩 흘러내렸다. 40대 사내가 신참 선원의 등을 두어 번 두드리고 손가락에 있는 담배를 빼내서 길게 빨았다. 그리고 다시 신참 선원에게 담배를 줬다. 신참 선원이 담배를 한 모금 빨더니 다시 토를 했다. 신참 선원은 토를 하면서도 어딘가를 향해 작은 소리로 계속 뭐라고 구시렁거리고 있었는데 뭐라고 하는지는 알아들을 수 없었다. 40대 사내는 시종일관 무표정한 얼굴을 하고 있었다. 탄탄한 어깨와 넓은 등, 햇볕에 잔뜩 그을린 얼굴을 가지고 있었다. 기분이 나빠 보이지도 좋아 보이지도 않는 얼굴. 배를 오래 타본 사람이다. 배를 오

"Can a ship survive that kind of bombing? I guess so, seeing as how you're still alive."

"Oh, heck no, the ship sank. There were three or four holes, each the size of a well, so of course, it wasn't going to hold out. There we were, floating in the water without life vests, watching our ship sink in the distance, when this stupid thought occurred to me: 'Dang! Paint's not even dry yet!' No kidding, that was what I thought— No, no, not like that. You got to hammer more here. There's still some rust left. You can't paint over the rust or it'll just flake right off again."

In retrospect, Granddaddy Cho was a funny person. He'd said that he and the captain were friends from the same hometown. They'd both sailed on Japanese ships before Liberation. He'd made quite the name for himself, having caught a lot of sharks with the captain. But that was all ancient history. Now he and the captain were old. Sureh had never once seen Cho and the captain talk to each other on board. Maybe they were sick of each other. Or, maybe, they'd talked so much over the years that now they had nothing left to say.

Sureh took a long drag on the cigarette. The smoke that filled his lungs smelled like paint and grease and all the other smells that made their home in the port. Under the streetlight across the alley, two sailors who'd spent the night drinking at the Seal Inn were smoking in the rain, taking drags off the same cigarette. Sureh assumed they'd run out. One looked like he was in his forties, while the other looked barely twenty. The younger one was probably a new recruit back from his first sail. He did not yet give off the impression of a sailor. He must've overdone it in the bar, because he took a drag and immediately vomited on the base of the streetlight. When he lifted his head, a long trail of saliva hung from his mouth. The older sailor pounded him on the back a couple of times, took the cigarette from his fingers, and took a drag. Then he handed the cigarette back to the newbie. The younger

래 탄 사람은 대체로 저런 얼굴을 가지고 있다. 인생이란 건 그다지 기쁜 일도 없고 그다지 슬픈 일도 없으므로 자신의 인생에 대해서도 타인의 인생에 대해서도 별로 바라는 게 없는 얼굴 말이다. 40대 사내가 필터까지 담배를 길게 한 모금 빨고는 손가락으로 담배를 튕겨 빗길에 버렸다. 그리고 담뱃갑을 열고는 담배가 없는지 다시 확인한 뒤 담뱃갑을 구겨서 바닥에 집어던졌다.

신참 선원과 40대 사내는 모자를 푹 눌러쓴 채 가로등 아래서 누군가를 기다렸다. 아침에 사모아로 출발하는 청룡23호 선원들일 것이다. 육지에서의 마지막 밤. 하지만 남항동 골목에서 이 시간까지 술을 마시고 아가씨들과 잠까지 잤다면 못해도 공무원 월급 정도는 술값과 화대로 날려먹었을 것이다. 선수금으로 받은 돈도 다 썼을 것이고, 출항 대기를 하는 동안 밥값이며 술값이며, 선용품, 잡비, 여관비 등등으로 물개여관 아줌마에게 빚도 잔뜩 졌을 것이다. 물개여관 아줌마에게 빌린 돈은 2년 동안 배를 타고 돌아오면 이자가 마구 붙어 있을 것이다. 지금이야 그 빚이 새끼 돼지들처럼 별것 없어 보이겠지만 2년 후라면 살이 디룩디룩 쪄서 알아볼 수도 없을 것이다. 빚은 새끼 돼지보다 훨씬 더 빨리 자라고 물개여관 아줌마는 자기 자식 이름은 잊어버려도 선원들에게 빌려준 돈과 이자는 잊는 법이 없으니까. 선원들은 이상하다. 바다에서 그 고생을 해서 번 돈을 장난처럼 써버린다. 마치 돈을 못 써서 환장한 귀신이라도 붙은 것처럼 미친듯이 돈을 써댄다. 당연히 이 골목에서 가장 인기 있는 손님은 기업체 간부도, 고위 공무원도 아닌 선원들이다. 선원들은 빨리 술을 마시고 화끈하게 돈을 쓰며 다시 몇 년이나 바다로 떠나므로 뒤끝도 없다. 술집 아가씨들에게 이보다 더 좋은 손님은 없다.

그래서 이 골목의 별명은 바가지 골목이다. 이름처럼 남항동 바가지 골목은 선원들을 빨아먹으며 산다. 선원들을 빨아먹는 술집 여자들이 있고, 그 술집 여자들을 빨아먹는 포주와 건달 새끼들이 있고, 그 건달 새끼

man took another drag and vomited again. Even mid-vomit, he kept looking over in the same direction and grumbling something under his breath, but Sureh couldn't make out the words. The older sailor's face remained impassive. He had strong shoulders, a broad back, and a face nicely browned by the sun. He looked neither happy nor unhappy. It was clear he'd spent a long time on boats. Guys like him usually had the same face. A face that said life wasn't all good or all bad and thus they wished for nothing for their own lives or for others'. The older sailor smoked the cigarette down to the filter in one long breath and flicked the butt into the rain. He opened his pack, checked to make sure it was empty, then crumpled the pack and tossed it on the ground.

The two men, their caps pressed down tight on their heads, were waiting for someone. They were probably on the Blue Dragon 23, bound for Samoa in the morning. Their last night on land. If they'd been drinking and whoring in Namhang-dong all this time, then they would've spent the equivalent of an office worker's salary on booze and women. They'd probably blown their entire advance, too, and racked up quite the tab with the Seal Inn's middle-aged female owner for room and board, drinks, supplies, and everything else, while waiting to set sail. That tab would collect a mountain of interest during their two years at sea. Right now, their debt looked no scarier to them than a little piglet, but in two years time it would fatten itself up beyond all recognition. Debt grew faster than piglets, and the innkeeper would forget her own name before she'd forget how much she'd loaned to sailors and the interest they owed her. Sailors were a strange lot. The money they risked their lives at sea to earn was like a plaything to them. They spent it like crazy. As if possessed by a ghost driven mad by its inability to spend its own money. Naturally, the most popular customers in these parts were not wealthy corporate executives or high-ranking government officials. Sailors drank fast, spent money like it was burning holes in their pockets, and disappeared at sea for

들을 빨아먹는 공무원, 세관, 경찰들이 있다. 그렇게 돈들이 흘러가서 마지막으로 모이게 되는 곳은 어딜까? 작은 물고기, 큰 물고기, 더 큰 물고기, 그리고 진짜로 큰 물고기. 그러니 이 골목에 일단 발을 디디고 나면 팬티까지 탈탈 털리고 나갈 수밖에 없다. 신참 선원은 몰라서 모르는 대로 털리고, 늙은 선원은 알아서 아는 대로 털린다. 선원들은 바가지 골목이 어떻게 돌아가는지 뻔히 아는 데도 별 수 없이 여기서 술을 마시고 아가씨와 잠을 자고 포주와 싸우고 결국 바가지 술값을 내고 잠이 든다. 그렇게 빚을 지고 다시 배를 타고 나간다. 바보 같은 짓의 연속이다. 모두들 외로워서 그런 것일지도 모른다. 바다를 오래 떠돌다보면 슬프고 역겨운 기억들은 다 사라지고 그립고 따뜻했던 기억들만 남게 되니까. 증오와 미움의 기억을 가지고는 태평양의 거친 바다 위를, 그 막막하고 오랜 시간을 견딜 수 없으니까. 그래서 선원들은 기억을 예쁘게 만든다. 그게 선원들이 힘든 선상생활을 버티는 방식이었다. 하지만 막상 돌아와보면 그들이 그리워했던 것은 하나도 남아 있지 않다는 걸 알게 된다. 아니라면 그런 예쁜 것들은 애당초 여기 있지도 않았다는 것을 깨닫게 된다. 그러니 뭐 어쩌겠는가. 지갑이 거덜 날 때까지 술을 처마시고 골통이 깨질 때까지 치고 박고 싸울 수밖에.

그래서 이 골목엔 지갑에 그리움과 돈을 잔뜩 채워넣은 선원들을 빨아먹기 위한 여관, 다방, 술집들로 가득하다. 공간을 잘 활용하기 위해서인지 이 동네 여관들은 1층엔 술집이나 다방을 하고 2층엔 여관을 하는 건물들이 많다. 그중에서도 수레가 머물고 있는 이 물개여관이 선원들을 가장 잘 빨아먹는 여관으로 악명 높았다. 그런데도 이 악명 높은 물개여관엔 배에서 막 내린 선원들과 새로 배를 탈 선원들로 항상 넘쳐났다. 이 여관의 시설이 좋냐고? 설마 그럴 리가. 아마도 사진으로나마 이 여관을 보게 된다면 당신은 아마 까무러치고 말 것이다. 3층 목조건물로 된 이 여관은 주로 선원들이나 배에 관련된 사람들이 지낸다. 시설은 물론 형편없다.

years, carrying no grudges with them. The bar girls couldn't ask for better customers than that.

That was why this alley had been nicknamed Swindlers' Alley. In keeping with its name, the alley lived off the blood of sailors. There were the bar girls who milked the sailors dry of their cash, the pimps and gangsters who sucked the girls dry of theirs, and the cops, tax collectors, and government officials who sucked the gangsters dry of theirs. In what pool did those trickles of cash end? From little fish to big fish to even bigger fish to the really big fish. Take one step into this alley and you'd find yourself robbed of everything right down to your underpants. The newbies had no idea it was happening; the old guys knew exactly what was happening. But whether they knew how Swindlers' Alley worked or not, the sailors had nowhere else to go where they could drink and sleep with women and fight with pimps and pay the exorbitant tab and sleep. They'd rack up their debts then get back on board and leave. An endless cycle of idiocy. Maybe they did it because they were lonely. Those long trips at sea would wash away all memories, the sad and repulsive ones alike, and leave them with only warm, longing thoughts. Because you cannot survive those long, desolate stretches of time on the rough waves of the Pacific with only hateful memories. And so the sailors made pretty memories. That was how they endured the difficulties of life on board. But, upon returning, they would soon realize that the things they'd longed for were no longer around. Or, to put a finer point on it, they might realize that all those pretty things had never really existed. But what of it? What else was there to do but drink until your emptied wallet was flapping in the breeze and fight with fists and feet until your head was splitting?

And so this alley was filled with inns, teahouses, and bars ready to suck the lifeblood of sailors whose wallets were crammed full of cash and longing. Perhaps to make the best use of the space, many of the buildings had bars or tea houses on the first floor with rooms to rent

선원들이 씻지 않아서 그런 건지. 아니라면 이불을 전혀 빨지 않아서 그런 건지 방안에선 늘 썩은 갈치를 담배꽁초에 비벼놓은 듯한 냄새가 난다. 하지만 그래도 목관이라고 불리는 가로가 48센티미터 밖에 되지 않는 좁은 2층 선실 침대에서 자던 원양어선 선원들에게는 아무 문제가 없다. 비린내도 문제가 없다. 물개여관 1층에는 술집이 두 개 있다. 떠나는 선원들, 그리고 오랜 항해에서 돌아온 선원들이 싸구려 가짜 위스키에 말도 안 되는 가격을 붙여 파는 이 술집에서 흥청망청 술을 마셨다. 하나는 '수선화'이고 다른 하나는 '코스모스'다. 이 골목의 술집들은 대체로 그런 이름들이다. 왜 이 불결하고 부도덕한 술집에 저렇게 예쁜 꽃 이름을 붙이는지 모르겠다. 어쨌거나 야들야들한 꽃 이름에 취해 선원들이 일단 술집에 들어가면 공무원 한 달 봉급 정도는 가볍게 날아간다고 생각해야 한다. 그리고 2층과 3층은 여관이었다. 다른 여관들과 달리 아침과 저녁 두 끼 식사가 나오고 부탁하면 옷을 세탁해주기도 한다. 다른 건 몰라도 음식 가지고는 쩨쩨하게 굴지 않는다는 물개 아줌마의 생활철학 때문인지 식사는 양도 많고 그럭저럭 먹을 만하다. 하지만 음식 말고는 다 쩨쩨하고 형편없었다. 하지만 선원들은 그냥 여기서 밥을 먹고 술을 마시고 세탁을 하고 잠을 잔다. 그 이유는 결산을 받을 때까지 선원들에게는 돈이 얼마 없고 물개여관은 외상장부를 잘 만들어주기 때문이다. 선원증이 있고 떠날 배만 정해져 있으면 공무원 월급 1년치 정도는 외상 장부로 당겨 쓸 수 있다. 단지 그 이유뿐이다. 선원들은 가엾다. 그들은 돈을 어디에 써야 할지 모른다. 사실 굳이 돈을 꼭 써야 할 필요는 없다. 하지만 선원들은 굳이 돈을 펑펑 쓰려고 한다. 이상한 관성이다. 먼 바다로 떠나기 전에 육지와 정을 떼고 싶어서 그러는 건지도 모르겠다.

　　그러니까 저 밑에서 구토를 하고 있는 두 사내들의 루트도 비슷할 것이다. 저들은 오늘 떠날 것이고 호주머니에는 배가 떠나기를 기다리며 쓴 차용증만 잔뜩일 것이다. 그래서 출항하는 날의 새벽은 항상 어수선하고

for the night on the second floor. Among them, the Seal Inn, where Sureh was staying, was notorious for wringing the most cash out of sailors. Nevertheless, this notorious Seal Inn was always packed with sailors fresh off the boat and sailors getting ready to board. Were the facilities that good? Pfft. Of course not. If you were to see a photo of the place, you'd probably faint. The three-story wooden inn was mostly inhabited by sailors and others involved in some form or another with the ships. It goes without saying that the facilities were atrocious. Could be the fault of the sailors, who never bathed. Or maybe the problem was that the blankets were never washed, and so the rooms never stopped smelling like a cigarette butt stubbed out on a rotten scabbard fish. But this was not a problem for deep-sea fishermen, who were used to sleeping in so-called wooden coffins, their barely 48-centimeter-wide bunks, one man above the other, under the deck of the ship. Not even the smell was a problem. The Seal Inn had two bars on the first floor. Sailors getting ready to leave and sailors returning from long voyages alike went on wild benders there, drinking fake, cheap whiskey at absurd prices. One bar was called The Daffodil; the other was called The Daisy. Most of the bars around here had names like that. Who knows why they named such filthy, immoral places after pretty little flowers, but at any rate, the moment those sailors, drunk already on the names of those delicate blossoms, stepped foot over the threshold, they were out one month's salary of a government employee. Unlike the other inns, the rooms available to rent on the second and third floors came with breakfast and dinner and even laundry services if you asked for it. Perhaps thanks to the innkeeper's philosophy of being generous with food, if nothing else, the meals were plentiful and palatable. But the generosity stopped there. Everything else was stingy and terrible. Despite that, the sailors ate and drank and washed their clothes and slept there. Reason being, the sailors rarely had any cash on them until their accounts were settled, and the innkeeper was

엉망이다. 속은 쓰리고 잠은 덜 깨서 정신은 없고 기분은 더럽다. 저들도 엉망이다. 하지만 뭔 상관인가, 어차피 오늘이면 이 지긋지긋한 육지를 떠날 거고 바다에서는 돈 쓸 일도 없는데.

"시팔, 뭘 째려보는데?"

자기가 구토를 해놓은 토사물 앞에 쭈그리고 앉아 있던 신참 선원이 갑자기 고개를 쳐들고 2층에 있는 수레를 향해 욕을 했다. 이해가 안 되는지 수레가 고개를 살짝 비틀고는 지금 나한테 하는 말이냐고 물어보듯 손가락으로 자기 얼굴을 가리켰다.

"그래 니 말이다. 뭘 째려보냐고? 이 개새끼야. 내가 달라는 돈 다 줬잖아. 내가 시발, 니가 장부에 써달라는 대로 전부 써줬잖아."

아직 술이 덜 깬 신참 선원은 수레를 아마 물개여관 술집 포주로 착각한 모양이었다. 장난하나. 아무리 술이 취해도 헷갈릴 게 따로 있지. 물개여관 포주 새끼는 땅딸보에, 배불뚝이, 대머리, 술주정뱅이 50대고 자기는 30대 초반의 호리호리한 미남인데. 수레가 신참 선원을 더 노골적으로 쳐다봤다.

"빨리 눈 안 까나. 눈깔 확 뽑아버린다."

신참 선원이 자기 분에 못 이겨 팔을 휘저으며 고래고래 고함을 질렀다. 어이가 없는지 수레가 피식 웃음을 터트렸다.

"아니, 이 사람아. 내가 째려본 게 아니고."

"아니라고? 뭐가 아닌데?"

"니가 거기서 어정거리고 있는 거니까 그냥 보인 거지. 내 눈에 보이는 게 싫으면 네가 딴 데로 꺼지던가."

"뭐라고? 나보고 꺼지라고? 이 개새끼가, 아까 돈 받아 처묵을 때는 존나 굽신거리더만 개털 되니까 이제 사람이 좆으로 보인다 이거지? 너 이리 내려와 빙시쪼다 새끼야. 내가 오늘 배 떠나기 전에 다른 건 몰라도 니 버릇은 확실히 고쳐주고 가야겠다."

generous with tabs. As long as they had their seafarer's ID and their next ship was assigned, they could get an advance equal to a government employee's annual salary. That was really the only reason. Sailors were a pathetic lot. They had no idea how to spend money. Truth of the matter was, they had no use for money at all. But they did their damnedest to spend as much of it as they could. It was a strange sort of inertia. Or maybe they did it to break whatever last threads of attachment they held to land before setting sail again.

The path traveled by those two men down there, vomiting in the glow of the streetlight, would be no different. They would set sail today, their pockets stuffed with the IOUs they'd written while waiting for their boat to leave. Dawn on the day of a departure was never anything but wrack and ruin for Sureh. His gut churned, he was drowsy, his mind was elsewhere, and his mood was foul. Those two were no better off. But what did it matter? They'd shake the last of this cursed soil off their feet and head for the distant ocean where money was of no use.

"Goddamit, what the fuck are you staring at?"

The new recruit was looking up from where he squatted in front of his own vomit and cursing at Sureh on the second floor. Confused, Sureh cocked his head and pointed at himself, as if to say, You talking to me?

"Yeah, I'm talkin' to you. What're you staring at? Son of a bitch. I gave you all the money you asked for. I paid it all off, every last bit you had written down, goddamn it."

The sailor, not yet sober, had clearly mistaken Sureh for the Seal Inn's pimp. What a joke. How could he make that mistake, no matter how drunk he was? The Seal Inn's pimp was a short, bald, potbellied wino in his mid-fifties. Sureh was a handsome, strapping young man in his early thirties. Sureh stared more blatantly at the sailor.

"Quit staring at me, or I'll go up there and rip your eyes out for you!" the sailor yelled, his arms pinwheeling in anger. Sureh laughed.

"나는 고마 힘들어서 못 내려가겠다. 억울하면 힘 넘치는 니가 올라오던가." 수레가 일부러 능청을 떨며 말했다.

"그래? 그렇게 나오겠다 이거지? 알았다. 너 거기 딱 그대로 있어라. 내가 올라간다."

젊은 선원이 정말로 올라오려는 듯 의기양양하게 주먹을 불끈 쥐며 자리에서 일어났다. 하지만 주먹을 불끈 쥔 의욕과는 달리 젊은 선원은 자기 몸도 제대로 못 가누고 휘청거렸다. 40대 사내가 신참 선원의 목덜미와 왼쪽 팔을 힘껏 잡았다. 신참 선원이 40대 사내의 팔을 뿌리치려고 했지만 힘이 모자라는지 버둥거리다가 다시 바닥에 주저앉았다. 40대 사내가 신참 선원의 어깨를 다독였다. 신참 선원이 혀 꼬인 목소리로 또 뭔 욕지거리를 해댔다. 수레가 보기에 신참 선원은 화가 나 있는데 어디다 화를 풀지를 몰라서 그저 아무 데나 들이 받고 싶은 것 같았다. 아마 수레가 없었다면 전봇대나 가로등 같은 것들과 싸웠을 것이다. 두 시간 전만 해도 기분은 좋았을 것이다. 아가씨를 옆에 끼고 돈을 펑펑 쓰며 술을 마실 때는 세상을 다 가진 기분이었을 것이다. 하지만 술병은 빨리 비고, 술병이 비면 아가씨는 다른 테이블로 간다. 그리고 계산서가 날아오면 저런 기분이 든다. 그 술값을 감당하려면 영하 40도씩 내려가는 냉동 창고에서 참치를 삼천 마리는 쌓아야 할 것이다. 그 마음 이해는 한다. 수레도 이 거지 같은 물개여관에서 수도 없이 당해봤다. 하지만 술은 자기가 다 처마시고 왜 나한테 지랄인가?

40대 중반의 사내가 수레가 있는 2층을 쳐다봤다. 가로등을 등에 지고 있어서인지 40대 사내의 표정은 선명하게 보이지 않았다.

"이해하쇼. 오늘 바다로 나가서 그래요." 40대 사내가 말했다.

충분히 그 마음 이해한다는 듯 수레가 40대 사내를 향해 온화하게 손바닥을 펼쳤다.

"청룡23호입니까?" 수레가 물었다.

"I wasn't staring at you, you idiot."

"The fuck you weren't!"

"All I did was look out my window to see who was down there. If you don't like being looked at, then fuck off somewhere else."

"What?! You're telling me to fuck off? You son of a bitch, you think 'cause you took all my money and left me with nothing that you can treat me like shit? Come down here and say it to my face, asshole. Before my ship leaves, I'll teach you how to treat a man with respect, if it's the last thing I do!"

"Oh no, I'm much too weak to make it downstairs. If you're that mad about it, why don't you use that strength of yours to come up here?"

"Yeah? You sayin' that's what it'll take to drag you out? All right, then. Stay right there. I'm coming up!"

The young sailor rose to his feet, fists clenched proudly, ready to charge upstairs and take a swing at Sureh. But he staggered and wobbled, his body no match for his determination. The older sailor steadied him by the left arm and the scruff of his neck. He tried to shake him off but only stumbled and fell back to the ground. The older man patted him on the shoulder. He started cussing again, his voice coming out thick and slurred. As far as Sureh could tell, the younger sailor was angry and itching to unleash his anger wherever he could. If Sureh hadn't been there, he might've gotten into an argument with the streetlight or a telephone pole instead. He would've been in a great mood just two hours earlier. He was no doubt on top of the world, a girl under one arm, cash flying, drinks pouring. But the bottles soon run dry and peacethe girl moves to someone else's table. Then someone hands you the bill and that's where the good mood ends. To pay off all the booze you drank, you'll need to fill the ship's -40C hold with three thousand tuna. Sureh knew the feeling. He'd been taken for a ride more times than he could count in this same flea-infested inn.

40대 사내가 그렇다는 듯 고개를 끄덕였다.

"아저씨도 오늘 나가는 뱁니까? 남양7호?" 40대 사내가 물었다.

"아뇨. 저는 이제 막 들어왔습니다."

"아! 나가는 게 아니라 들어온 거구나. 좋겠습니다."

"뭐 그다지."

"하긴 막상 돌아와봐도 별게 없지요?"

"네 정말이지 별게 없네요."

"난 딱 석 달이 한계던데. 석 달만 지나면 육지가 지겨워져요."

"저는 일주일밖에 안 됐는데 벌써 지겨워졌습니다."

수레의 말에 40대 사내가 웃었다. 수레도 덩달아 웃었다.

"사모아에서 오셨습니까?" 40대 사내가 물었다.

"저흰 키리바시 쪽에서 주로 조업했습니다."

"그쪽이 사모아보다 낫습니까?"

"더 나은지는 모르겠어요. 그래도 요즘 사모아 쪽에는 고기보다 고깃배가 더 많다고 아우성이니까."

40대 사내가 다시 고개를 끄덕였다. 멀뚱멀뚱 둘의 대화를 듣고 있던 신참 선원이 다시 헛구역질을 했다. 이제 토사물은 하나도 나오지 않았다. 하지만 40대 사내는 신참 선원의 등을 두들겼다.

"저 친군 뱃멀미로 고생 좀 하겠는데요?" 수레가 웃으며 말했다.

"괜찮을 겁니다. 뱃멀미를 영원히 하는 사람은 없으니까요."

"그게 정답이네요."

"혹시 남은 담배 좀 있습니까?"

40대 사내는 담배가 간절한 표정이었다. 수레는 테이블 아래에 놓인 더플백에서 럭키스트라이크 한 보루를 꺼냈다. 그리고 자기가 피울 담배 한 갑만 꺼내고 나머지를 밑으로 던졌다. 40대 사내가 빗속에서 담배를 받았다.

228

But why yell at him when the sailor was the one who'd chosen to drink all that booze?

The older sailor looked up at Sureh on the second floor. The glare from the streetlight hid the look on his face.

"Sorry about that," he said. "It's because we're leaving today."

Sureh held one hand up in a friendly gesture to show that he understood completely.

"Blue Dragon 23?" Sureh asked.

The sailor nodded. "Are you leaving today, too? South Seas 7?"

"No, I just got in."

"Ah, that's good."

"It's whatever."

"True. Once you're actually back, it's never that special, is it?"

"Yup, it really isn't."

"I never make it more than three months. Three months and I get sick of being on land."

"I've only been here a week and I'm already sick of it."

The sailor laughed. Sureh laughed, too.

"Did you come from Samoa?"

"We were mostly near Kiribati," Sureh replied.

"Is it better than Samoa?"

"Hard to say. But everyone's been complaining that there are more fishing boats than fish near Samoa these days."

The sailor nodded again. The younger man, who'd been following along blankly, had another attack of dry heaves. Nothing was coming up now. The older man gave him another pat on the back.

"I take it our friend here's got a little seasickness to look forward to?" Sureh said with a laugh.

"He'll be alright. No one stays seasick forever."

"That's the truth."

"Hey, got any smokes left?"

"뭘 이렇게나 많이."

"먼 바다로 나가신다니 어쩐지 맘이 짠해서."

"잘 피우겠습니다."

"언제 돌아오십니까?"

"이번 배는 3년입니다."

"꽤 기네요."

"네, 깁니다. 식구가 새로 생겨서, 돈이 좀 필요하네요."

"새로운 식구면, 아이?"

"아뇨. 바다를 떠돌다보니 결혼이 좀 늦었네요." 40대 사내가 머쓱한 얼굴로 하지만 은근히 자랑하듯 말했다.

"만선하세요."

"이번엔 꼭 그래야지요."

40대 사내가 '꼭'이라는 말에 힘을 줬다. 그리고 다시 한번 고맙다는 듯 머리 위로 담배를 든 손을 크게 흔들었다. 사내는 진짜 뱃사람처럼 강인하고 침착해 보여서 걱정할 건 없어 보였다. 하지만 '이번엔 꼭'이라는 말은 어쩐지 위험하게 들렸다. 바다에서 꼭 뭘 해야만 하면 항상 사고가 일어난다. 수레가 탔던 배의 늙은 선장은 선원들이 억지 부리는 걸 싫어했다. '바다에선 억지를 부리면 안 돼. 바다에 대고 어깃장을 부리면 꼭 누가 죽거나 다치니까.' 그러니까 선장의 말은 들이댈 곳을 알고 들이대라는 말이었다. 확실히 바다는 들이댈 데가 아니다. 바다는 그 무엇도 용서하는 법이 없으니까. 40대 사내가 담뱃갑을 뜯어 담배에 불을 붙이고 신참 선원에게 한 대를 줬다. 신참 선원은 바닥에 쭈그린 채 담배를 피웠고 40대 선원은 선 채 담배를 피웠다. 골목에 습기가 가득 차서인지 담배 연기가 가로등 불빛 아래서 풍성하게 피어오르는 느낌이었다. 그때 골목으로 트럭이 한 대 왔다. 40대 선원이 2층에 있는 수레를 향해 눈인사를 했다. 수레도 눈인사를 했다. 그러자 40대 사내는 술 취한 신참 선원을 트럭 짐칸

The older man looked like he was craving a cigarette badly. Sureh pulled the carton of Lucky Strikes from the dufflebag he'd stashed under the table. He took one pack out for himself and tossed the carton out the window. The man caught it in the rain.

"You're giving me all this?" he asked in surprise.

"I guess I'm feeling sympathetic, thinking about you guys away at sea."

"Thank you."

"When're you back?"

"We'll be gone three years this time."

"That's a long trip."

"Yes, it is. New family member, so I need to make some money."

"I take it you mean a baby?"

"No, just spent too long at sea and married late." The sailor looked bashful but sounded proud.

"May you come back with a full load."

"I've got to, this time."

He stressed the word *got*. Then he waved the hand that held the cigarette above his head in thanks. He looked every part the sailor. Like someone who knew how to keep his cool. Like he had grit. Like he didn't have a care in the world. But that phrase, I've got to, this time, foretold danger. Expecting anything of the sea was a recipe for disaster. The old captain of Sureh's boat hated it when his crew got too dogged about anything. 'You can't force anything when you're at sea. The moment you disobey the sea, someone gets hurt or dies.' To put it another way, the captain was warning them to pick their fights well. And the sea was absolutely not worth fighting against. Because the sea forgave nothing. The sailor opened a pack of cigarettes, lit one, and handed it to the younger man, who remained squatting as he smoked. The fog in the alley probably added to the effect, but the circle of light beneath the street lamp seemed to fill with cigarette smoke. Just then,

으로 먼저 밀어올리고 자기도 올라탔다. 사내들이 올라타자 트럭은 항구 쪽으로 천천히 움직였다. 여전히 가늘게 비가 내리고 있었다. 트럭 짐칸에서 비를 맞고 있는 선원들의 뒷모습은 어쩐지 쓸쓸해 보였다.

수레는 항구 쪽으로 사라지는 트럭을 보고 있다가 담배를 골목 바닥으로 집어던졌다. 시계를 보니 2시 32분이었다. 황은 4시에 오기로 했다. 애매한 시간이었다. 수레는 새로 담배를 꺼내 입에 물고 불을 붙이려다 문득 동작을 멈췄다. 그리고 입에 문 담배를 빼내 잠시 쳐다봤다. 사실 담배는 별로 피우고 싶지 않았다. 아무런 의미도 즐거움도 없는 기계적인 동작이었다. 한국으로 돌아와서 대부분의 시간이 이런 기계적인 동작들로 채워졌다. 아무런 의미도, 즐거움도, 무엇을 하고 있다는 자각도 없는 동작들. 그런 동작들로 채워진 인생이 공허한 것은 당연한 일이었다. 수레는 담배를 다시 곽 속에 집어넣었다.

황이 몇 명이나 데리고 올 것인지 알 수 없었다. 아마 황의 성격상 많은 인원을 데리고 오지는 않을 것이다. 칼잡이 두어 명에, 몸이 날랜 애들 두어 명 그리고 망을 보는 사람과 정보원, 뭐 이 정도일 것이다. 함경도에서 일을 할 때도 황은 항상 그런 식으로 조용하게 처리했다. 오늘 대마도에서 영도 아치섬으로 들어오는 밀수선 규모가 서른 척이라고 했다. 그중 마루야마가 굴리는 배는 다섯 척이다. 다섯 척이라면 선장과 기관장 그리고 필수 선원들을 빼고도 마루야마 쪽 애들은 못해도 서른 명은 될 것이다. 배로 밀수 하는 놈들은 뒤가 없다. 육지에서는 여차하면 도망이라도 치면 되지만 바다에서는 도망갈 곳이 없기 때문이다. 그래서 밀수선에 있는 건달들은 미군 단속반이 오건, 해양경찰이 오건, 다른 밀수 건달 패거리에게 습격을 받건 매번 죽을 듯이 싸운다. 뒤를 생각하지 않는 놈들과 싸우는 것은 언제나 골치 아픈 일이었다. 어쩐지 대여섯 명을 데리고 가서 서른 명이 넘는 부하들을 거느리고 있는 마루야마와 거래를 한다는 게 위험하게 느껴졌다. 하지만 그건 수레가 걱정할 몫이 아니었다. 해방 전 함경도

a truck pulled up. The older sailor glanced up at Sureh to say goodbye. Sureh returned the look. The sailor shoved his younger, still-drunk companion into the back of the truck before joining him. As soon as they were in, the truck slowly headed towards the port. A fine rain was still falling. The silhouettes of the two men in the back of the truck in the falling rain gave Sureh a melancholy feeling.

He watched the truck disappear toward the port and tossed his cigarette butt into the alley. It was 2:32 a.m. Hwang would be there at 4:00. It was an awkward amount of time to wait. Sureh took out another cigarette, stuck it in his mouth, and started to light it but stopped short. He took the cigarette out and stared at it. He wasn't actually in the mood for another smoke. He'd reached for it mechanically, with no sense of meaning or enjoyment. Ever since returning to Korea, much of his time had been spent going through these robotic motions. Gestures with no meaning, no joy, and no self-awareness of what he was even doing. It went without saying that a life filled with such motions was an empty one. Sureh slid the cigarette back into the pack.

He had no idea how many guys Hwang was bringing. Given the type of guy he was, he'd probably stick with a small crew. Two guys who were good with a knife, two who were quick on their feet, a lookout, and an informant. That sounded about right. Back when they'd worked in Hamgyeong Province, Hwang had always taken care of things quietly by keeping a small crew. He'd said there were thirty smuggling ships coming to Achi Island from Daema Island. Five of those were controlled by Maruyama. Five boats—even if you subtracted the captains, the engineers, and the crews, Maruyama's men alone would still number at least thirty. For guys who smuggled stuff in by boat, there was no such thing as a plan B. On land, you could run if you had to, but at sea, there was nowhere to go. Which meant that the gangs who ran smuggling ships always fought like it was their last stand, no matter whether it was the US army, the maritime

에서 할아버지의 금광을 관리하던 시절 황은 금을 노리는 만주의 마적떼, 대한제국 독립군, 일본군, 그리고 굶고 헐벗어서 도둑으로 변신한 유랑민들과 수없이 격전을 치른 사람이다. 그리고 그 격전에서 늘 살아남은 사람이었다. 황이 있어서 할아버지는 금광을 지킬 수 있었다. 그러니 황이 충분하다면 그건 충분한 것이다.

시간을 보내는 것 외에 달리 할일이 없었으므로 수레는 밤바다를 보고, 그 위를 떠 있는 어선의 불빛들을 보고 또 부산과 영도를 연결하는 유일한 다리인 영도 다리를 멍하니 쳐다봤다. 부산을 떠나기 전날에도 물개여관 이 방에서 영도다리의 한쪽 구조물이 들어올려지고 그 아래로 배가 지나가고 다시 천천히 내려지는 광경을 쳐다봤었다. 하지만 돌아오니 이제 영도 다리는 도개를 하지 않는다고 했다. "영도 다리는 들어올려야 맛인데." 수레가 중얼거렸다. 1934년 처음 개통했을 때만 해도 영도 다리는 동양 최대의 도개교였다. 사실 그것은 일본이 식민지 조선에게 제국의 공학적인 힘을 과시하려는 건축물이기도 했다. 그래도 개통식 날 그 거대한 철조물이 들어올려지는 장관을 보려고 8만 명의 부산 사람들이 모여들었다. 한국전쟁이 일어나고 있는 동안에는 많은 피난민들이 영도 다리 앞에서 만나자는 약속을 했었다. "부산에 가면 한쪽을 들어올리는 다리가 있는데, 피난 대열에서 흩어지면 다리를 들어올리는 시간에 다시 만나." 뭐 이런 식으로 말이다. 그래서 한국전쟁 후에는 피난중에 잃어버린 아이들, 아내, 연인, 어머니를 혹시라도 만날까 싶어 영도 다리를 어슬렁거리는 피란민들이 많았다. 그건 전쟁이 끝난 지 15년이 지난 지금도 마찬가지였다. 달라진 게 있다면 그전에는 다리를 들어올리는 시간에 오면 되었지만 이제 잃어버린 어머니 혹은 잃어버린 딸을 만나려면 하루종일 영도 다리를 어슬렁거려야한다는 것 정도였다.

수레는 다시 시계를 봤다. 2시 40분이었다. 시간이 느리게 가고 있는 느낌이었다. 뭘 해서 남은 시간을 채워야 하는지 알 수 없는 상태는 곤혹

police, or another smuggling gang. It was a huge pain in the ass to fight gangsters who had no plan B. And taking only five or six guys to make a deal with Maruyama and his entourage of over thirty henchmen didn't exactly strike Sureh as safe. But that wasn't his concern. Back before Liberation, when he was looking after Sureh's grandfather's gold mine in Hamgyeong Province, Hwang had waged fierce battles against hordes of Manchurian bandits, the liberation army of the Great Korean Empire, the Japanese military, and starving, penniless vagabonds-turned-thieves. And he had survived every single one of those battles. Hwang was the reason Sureh's grandfather had been able to hold onto his gold mine. So if Hwang said they were good, then they were good.

With nothing else to do except kill time, Sureh gazed out at the night sea, at the lights of the fishing boats floating in that sea, and at Yeongdo Bridge, the only bridge connecting Yeongdo Island to the rest of Busan. The day before leaving Busan, he had watched from this very room as one side of Yeongdo Bridge was raised, boats passed underneath, and the bridge was lowered again. But since returning, he had heard that the bridge was no longer being raised. "It's not Yeongdo Bridge unless it's being raised," Sureh muttered to himself. When the bridge was first built in 1934, it was the largest drawbridge in East Asia. Of course, it was also built so that Japan could show off their imperial engineering prowess to the colonized Koreans. Nevertheless, the day it opened, eighty-thousand Busanites gathered to watch that enormous steelwork lift into the air. Later, during the Korean War, refugees made promises to meet at Yeongdo Bridge. "There's this bridge in Busan that lifts up on one side," they would say. "If we get separated, let's meet there when the bridge is being raised." Even after the war ended, refugees could still be found loitering around the foot of the bridge, hoping to run into those they'd lost while fleeing—their children, their spouses, their lovers, their mothers. The war had been over

스럽다. 다시 잠들기에도 애매하고, 술을 마시기에도 애매하다. 며칠째 잠을 제대로 자지 못해서 입안이 까끌거렸고 머릿속엔 지푸라기라도 잔뜩 집어넣은 것처럼 어떤 생각도 선명하게 할 수 없었다. 그리고 불안하다. 전쟁 속에서 불안한 시간은 적군과 교전을 벌이고 있는 시간이 아니다. 정작 불안한 시간은 참호 속에서 적군을 기다리고 있는 시간이다. 그 시간에는 논 위를 날아다니는 메뚜기부터 바람에 움직이는 벼 잎사귀까지 모든 게 불안했다. 지금이 꼭 그런 기분이다. 고체로 굳어 있던 불안들이 모두 기화되어 명치를 따라 가슴까지 올라온 느낌이었다. 불안. 불안은 기체성을 띠고 있다. 아주 어릴 적부터 이 불안이 싫었다. 여기저기로 계속 떠돌며 이 불안을 피해 다니고 있다. 하지만 불안의 주소는 언제나 자신의 심장 한가운데이므로 베트남으로 가건, 태평양으로 가건 불안으로부터 도망칠 수 없었다.

수레는 테이블 위에 있는 로얄살루트를 쳐다봤다. 어젯밤에 마개를 따서 반 정도 마시고 남은 것이었다. 술을 한잔 할까? 지금 술을 마시는 것은 좋지 않다. 솔직하게 어제 마신 술이 다 깬 것 같지도 않았다. 하지만 간절하게 술을 마시고 싶었다. 수레는 로얄살루트를 병을 들었다가 상표를 읽고 다시 테이블 위에 내려놨다. 술은 미군 PX에서 물건을 빼돌려 국제시장에서 장사를 하는 동키가 주고 간 것이었다.

"형. 이게 보통 술이 아냐. 박정희 대통령은 이 술만 마신데. 아까워서 나도 못 마시는 술인데 형 귀국을 기념해서 특별히 가져온 거야."

술병을 건네며 동키는 잔뜩 생색을 냈다. 이 독재자 대통령은 대체 어디에 숨어서 이 술을 마시고 있는 것일까. 텔레비전에서는 만날 논두렁에 앉아 농민들과 막걸리만 마시는 서민 대통령으로 나오는데. 동키는 럭키스트라이크 담배 한 보루도 주고 가고 얼마 간의 달러도 주고 갔다. 그리고 어디서 훔쳤는지 거지 같은 양복 몇 벌도 주고 갔다. 동키와는 고향 함경도에 있을 때부터 알았다. 원래 이름은 동기인데 당나귀처럼 힘도 좋고

for fifteen years now, but that hadn't changed. In fact, the only thing that had changed was that, whereas before they only had to show up when the bridge was being raised, now they had to hang out all day hoping to bump into their lost mother or lost daughter.

Sureh checked the clock again. 2:40 a.m. It felt like the minutes were crawling by. Not knowing how to fill the time remaining vexed him. It wasn't quite long enough for falling back to sleep or for getting drunk. He hadn't slept well in days; the inside of his mouth felt sandy, and he couldn't think clearly, as if his head were stuffed with straw. And he was nervous. On the battlefield, he hadn't felt nervous while exchanging fire with enemy troops. The truly nerve-wracking times were those spent waiting in the trenches for the enemy. Everything set his nerves on edge then, from a grasshopper taking off from the surface of a paddy to the leaves of rice plants stirring in the breeze. He felt the same way now. As if all of his uneasy feelings had hardened to solid matter and were now vaporizing and rising from the pit of his stomach to his chest. Anxiety. Anxiety was a gas. He hated feeling this way, always had, ever since he was young. He'd wandered nonstop from place to place, trying to outrun this tension. But as anxiety's home address was always the dead center of his heart, whether he went to Vietnam or the middle of the Pacific, he could never outrun it.

Sureh eyed the bottle of Royal Salute sitting on the table. He'd opened it last night; there was still half a bottle left. Should he have a drink? It was a bad idea. If he was honest with himself, he wasn't fully sober yet from the night before. But he really, really wanted a drink. Sureh picked up the Royal Salute, read the label, then put the bottle back on the table. He'd gotten it from Donkey, who sold black market goods purloined from the US army base's PX at Busan's Gukje Market.

"Hyeong, this is no ordinary whiskey. This is the only whiskey that President Park Chung-hee drinks! It's too precious for me, but I wanted to give you something special to commemorate your homecoming."

지치지도 않고 여기저기를 잘도 뿔뿔거리며 돌아다닌다고 부산 사람들은 그를 동키라고 불렀다. 같은 집에서 태어나고 자라서 동키를 대할 때면 마치 형제 같은 느낌이 들었다. 하지만 동키는 그런 기분이 들지 않을지도 모른다. 수레는 거대한 금광 소유주의 손자였고 동키는 머슴의 아들이었으니까. 그래도 방이 오십 칸이 넘는 그 큰 집에 또래 친구라곤 동키 밖에 없었다. 또래 친구들이 없어서, 아니라면 주인집 손자인 수레에게 감히 말을 거는 아이들이 없어서 수레는 항상 동키와 놀았다. 동키와 같이 황소의 등에 올라타곤 이리저리 놀러 다녔다. 동키와 개구리와 뱀을 잡고 구워 먹었다. 할아버지의 사냥총을 훔쳐서 멧돼지를 잡으러 간 적도 있었다. 멧돼지는 못 잡고 총만 고장을 냈다. 그때도 수레는 그저 할머니의 방안으로 들어갔고 동키만 마당에서 죽도록 매를 맞았다. 동키는 어릴 때나 지금이나 재주가 많은 사람이었다. 피난 대열 속에서도 물물교환을 하고 미군에게 물건을 팔았다. 수레가 돌아왔을 때 항구에 유일하게 마중을 나온 사람도 동키였다. 부산으로 돌아온 첫날, 술을 마시며 동키는 수레에게 이제 무엇을 할 거냐고 물었다. 수레는 무얼 할지 모르겠다고 말했다. 5년 동안 생각해봤지만 실제로 여전히 몰랐다. 동키는 아주 심각한 표정으로 복수는 꿈도 꾸지 말라고 말했다. 복수? 수레가 동키를 향해 고개를 돌렸다. 하지만 동키는 자기 혼자서 수레의 마음을 다 안다는 듯 단호하게 고개를 저었다. 이제 구들 영감과 천달호는 너무나 거물이 되어버려서 우리 같은 것은 건드릴 수도 없다고, 심지어 구들 영감은 중앙정보부 김형욱하고도 선이 닿아 있다고, 그래서 요즘 천달호는 중앙정보부의 백으로 아무도 못 건드리는 무시무시한 건달이 되어버렸다고. 그 외에도 동키는 수레가 한국을 떠나 있는 동안 일어난 일들에 대해 세세하게 떠들어댔다.

　복수라니, 무엇에 대해서 복수를 한다는 말일까? 하고 수레는 생각했다. 처음부터 지금까지 수레는 복수 같은 것에 대해, 그런 말랑말랑한 정서에 대해, 이 가문에 복잡하게 얽힌 이해관계와 증오심에 대해 한 톨의

Donkey had seemed so proud as he handed him the whiskey bottle. Where on earth was that dictator of a president hiding his whiskey? On TV he acted like he was a president for the common folk, squatting on the ridge of a rice paddy, knocking back cups of makkoli with the farmers every day.

Donkey had also given Sureh the case of Lucky Strikes and a stack of American dollars. Not to mention a few horrible suits that he'd stolen from somewhere. They'd known each other ever since growing up in Hamgyeong Province. His real name was Dongki, but everyone in Busan called him Donkey, because he was as strong as one and was always hard at work and running tirelessly all over town. They'd grown up in the same house together, so Sureh felt like he was greeting a brother every time he saw Donkey. He wasn't sure if Donkey felt the same way about him though. Sureh was the grandson of the owner of an enormous gold mine, whereas Donkey was the son of a farmhand. Nevertheless, Donkey had been the only other boy Sureh's age in that huge, sprawling house of theirs. Either because there was no one else his age, or because no other kids dared speak to the head of the household's grandson, Sureh had always played with Donkey. They used to clamber up onto the back of an ox and amble around. They caught frogs and snakes and roasted and ate them. Once, they'd even filched Sureh's grandfather's hunting rifle to try to catch a boar. They'd ended up with only a broken rifle and no boar. Sureh was sent into his grandmother's room, while Donkey had the snot beat out of him in the yard. Both now and then, Donkey revealed his many talents. Even while fleeing to the south during wartime, he had bartered with other refugees and sold goods to the US military. When Sureh returned to Busan, Donkey was the only one who came to greet him at the port. On Sureh's first day back, Donkey asked him over drinks what he was going to do now. Sureh said he had no idea. He'd spent the last five years thinking about it, but he was still clueless. Donkey's face turned dead-

관심도 없었다. 그것은 수레에게 언제나 강 건너의 불처럼 남의 일처럼 느껴졌었다. 예전에도 그리고 몇 시간 뒤 누군가의 목을 따야하는 이 새벽에도 마찬가지였다. 하지만 할머니는 관심이 있을 것이다.

필결산(必決算)

거래를 하면 반드시 결산을 끝낸다. 이것이 250년간 금광과 고리대금업으로 살아온 수레의 가문이 지켜온 유일한 법도였다. 이 가문엔 명예에 대한 법도 없고, 인간의 도에 관한 법도, 임금과 나라에 대한 법도 없었다. 이 가문이 가지고 있는 유일한 법은 오로지 빚을 지면 빚을 갚고, 빚을 주면 빚을 받는다, 는 알량한 법 하나 뿐이었다. 돈을 빚지면 돈을 갚고, 금을 빚지면 금의 무게를 갚고, 목숨을 빚지면 목숨의 무게를 갚는다. 사람들은 수레의 집안을 금의 가문이라고 불렀다. 그리고 금의 가문은 지난 250년간 자신들이 소유한 금광에서 금을 캐고 그것으로 고리대금업을 하면서 살았다. 그리고 누군가 금의 가문에게 빚을 지면 무슨 일이 있어도 그 빚을 받았다. 천민이든, 관료이든, 군인이든, 양반이든, 임금이든, 그가 누구든 돈을 빌려가면 반드시 이자와 돈을 받아냈다. 누구도 예외는 없었다. 왕이 빚을 갚지 않으면 그 아들에게, 그 아들이 갚지 않으면 그 손자에게 기어이 빚을 받았다. 그러니 금의 가문 장부에 한번 기록되면 빠져나갈 방법이 없었다. 그리고 이 새벽 오래전 장부에 기록되고 아직 빚을 갚지 않은 사람 중에 한 명이 결산을 마칠 것이다.

빗방울이 점점 거칠어지고 있었다. 수레는 다시 양주병을 쳐다봤다. 술이 간절했다. 한잔 마실까? 좋지 않다. 지금 술에 취해 있다는 건 말이 안된다. 하지만 지금 이 순간 간절하게 술이 마시고 싶었다. 한 잔 정도는 괜찮지 않을까? 수레는 속으로 위로한다. 사실은 별일도 아니라고, 인생을 살아가며 일어나는 많은 일들 중에 하나일 뿐이라고 수레는 위로한다. 하

ly serious as he said, Don't even think of getting revenge! Revenge? What revenge? Sureh had given Donkey a quizzical look. But Donkey only shook his head at him gravely, as if to say he knew all that was in Sureh's heart. He told Sureh that Old Man Gudeul and Cheon Dalho had become major bigshots, the likes of which men like them couldn't dream of touching, and to make matters worse, Old Man Gudeul had a direct line to Kim Hyeongwook in the KCIA, which meant that Cheon Dalho had become a truly fearsome gangster with the government at his back and was virtually untouchable. Donkey had also filled Sureh in on all the other things that had happened while he was away.

Revenge? Pfft, Sureh thought. Revenge for what? From the start, Sureh had had zero interest in revenge or other such tender emotions, or in his family's tangled web of interest. It all felt as distant from and unrelated to him as a fire burning across a river. It'd been the same in the past and it was the same this morning, when someone's throat would be slit in a few hours times. But his grandmother would be interested.

必决算. Get. That. Cash.

The deal's not done until you get paid. That was the one and only rule that Sureh's family had followed in their two hundred and fifty years of gold mining and loan sharking. When it came to things like honor, morality, king or country, their family obeyed no rules or laws. Their only rule was the petty rule that said if you owed someone money, you paid it back, and if you loaned someone money, you got it back. Owe someone cash? Pay your debt in cash. Owe someone gold? Return that weight in gold. Owe someone your life? Return that weight in life. People called Sureh's family, the Gold Family. The Gold Family had spent the last 250 years digging for gold in their mine and loaning it to their clients. And they stopped at nothing to get repaid. Common-

지만 사소한 일이 아니다. 월남에서도 수통에 물 대신 미군 PX에서 빼낸 위스키를 넣고 다니는 군인들이 있었다. 공포가 밀려올 때, 혹은 피로가 밀려올 때 그들은 위스키를 홀짝홀짝 마셔댔다. 그것이 신경을 누그러트리는데 도움이 됐을 것이다. 공포를 피하기에 더없이 좋은 선택이었을지도 모른다. 하지만 위스키를 홀짝거렸던 군인들은 베트남의 밀림 속에서 모두 죽었다. 술에 취하면 될 대로 되라지 하며 호기를 부리고 집중력을 잃으며 모든 게 가소로워진다. 그것은 자기 목숨도 마찬가지다. 실재의 세상은 놀랍도록 정확하다. 이 세상의 그 무엇도, 적도, 총알도, 수류탄 파편도 망상의 세계에서 움직이지 않는다. 그것은 엄연하고 잔인한 실재다. 실재는 심장을 관통하고, 허파를 찢으며, 뼈를 부순다. 목숨을 부지하고 싶다면 실재의 세상에서 살아야 한다. 안테나를 올리듯 몸의 모든 감각을 예민하게 만들고 관찰을 해야 한다. 공포를 이기고 총알이 날아오고 있는 방향을 직시해야 한다. 그래야 실재를 볼 수 있다. 하지만 술을 마시면 감각이 무뎌진다. 그리고 무뎌진 감각은 현실을 오해한다. 마치 총알이 자기만 피해 갈 것처럼 호기를 부리고 까불기 시작한다. 객기에는 언제나 대가가 있다. 전쟁터에서 까분 사람도, 바다에서 까분 사람도 모두 죽었다.

　오늘이 그런 날이다. 술에 취해 있다간 죽을 것이다. 수레는 위스키 병을 한참이나 쳐다봤다. '오늘이 그런 날이야. 결코 술에 취해서는 안 되는 날이지.' 수레는 다짐하듯 자신에게 말했다. 수레는 위스키 병을 들고 글라스에 30밀리리터 정도 부었다. 수레는 글라스에서 위험하게 출렁이고 있는 술의 수위를 쳐다봤다. 색깔이 아주 예뻤다. 그리고 수레는 단번에 잔을 비웠다. 이 새벽에 목구멍을 타고 위장까지 내려가는 위스키의 움직임이 거칠고 강렬했다. 수레는 빈잔을 들고 백열등에 이리저리 비춰봤다. 그리고 다시 글라스에 위스키를 따랐다. 스스로를 한심하다고 여길 때 늘 그랬던 버릇처럼 수레는 고개를 15도 정도 기울이고 한쪽 눈을 찡긋한 채 글라스에 술을 쳐다봤다. 목숨과 바꿀만한 술인가? 수레가 물었다. 사실

ers, government officials, soldiers, gentry, the king himself—no matter who it was, if they borrowed money, they paid it back with interest. There were no exceptions. If the king reneged on his loan, then the debt went to his son, and if his son failed to pay it back, then it fell to the king's grandson. Once your name had entered the Gold Family's ledgers, there was no escape. This morning would see the settling of one of the ledger's longest-running debts.

The rain started to come down harder. Sureh eyed the whiskey bottle again. It called to him. Should he have a drink? He shouldn't. Getting drunk was a stupid idea. But right now, at this moment, he was desperate for a sip. Just one drink wouldn't be so bad, right? He consoled himself. He told himself it was no big deal, just one of the many things we do along life's great journey. But it was a big deal. Back in 'Nam, there'd been soldiers who filled their canteens with whiskey instead of water, whiskey that they'd pinched from the US base's PX. When terror loomed, or fatigue wore them down, they'd take a little sip, and then another. It soothed their nerves. Maybe, for them, it was the best way to take the edge off terror. But every single one of those soldiers who took nips of whiskey ended up dead in the jungle. Alcohol made you say c'est la vie, gave you liquid courage, made you lose your focus, and turned everything laughable. It made your own life seem like a joke. The real world was shockingly precise. Nothing in that world, not enemies or bullets or shrapnel, moved in the world of fantasy. It was a strict and cruel existence. Reality pierced hearts, shredded lungs, smashed bones. If you want your life to continue, you must live in the real world. You have to sharpen your senses, raise your antennae, and observe. You have to overcome your fear and look straight in the direction from where the bullets are coming. That is the only way to see reality. But when you drink, you dull your senses. And your dulled senses misapprehend reality. You become cavalier, you get stupid—as if the bullets will detour around you alone. Bravado always

니 목숨 값은 몇 푼 되지도 않지, 수레 속에 있는 또 다른 누군가가 대답했다. 수레는 글라스를 들어 단번에 잔을 비웠다. 빈속으로 내려갔던 술이 위장에 들어갔다가 기화되어 다시 올라왔다. 한숨처럼 퍼져나오는 술의 향기와 뜨겁고 무기력한 기운 그리고 아주 오래전부터 위장 속에 머물고 있었던 같은 불안들. 그것들이 섞이자 안개 속을 헤매는 기분이 들었다. 그러자 모든 게 괜찮아졌다. 과거도, 실패도, 자기 때문에 목숨을 잃었던 사람들도, 자기 때문에 재산을 잃었던 사람들도 모두 괜찮았다. 어차피 인생은 그렇게 비겁한 것이다.

"수레 오빠! 창문 좀 닫아. 담배도 작작 좀 피우고."
침대에 있던 마라가 신경질을 내며 말했다. 여자가 있다. 그녀의 이름은 마라다. 스물여섯 살이다. 마라는 이 악명 높은 물개여관 여주인의 딸이다. 이상한 일이다. 5년 전 부산을 떠나기 전에 마지막으로 잔 여자도 마라였고 돌아와서 처음 잔 여자도 마라다. 그토록 잊지 못할 정도로 마라를 사랑하느냐고? 글쎄다. 사실 그것이 사랑인지는 잘 모르겠다. 베트남에 있을 때 마라에게 편지를 몇 통 쓰기는 했다. 전쟁 속에 있는 사내는 두려움과 막막함을 견디기 위해 뭐라도 하니까. 그리고 군인들은 모두 누군가를 향해 열심히도 편지를 써댄다. 참호를 다 파내고 그 속에 들어가면 베트콩이 올 때까지 할일도, 할 수 있는 일도 없으니까. 전쟁의 시간이란 건 대부분 지루함으로 이루어져 있다. 걷고, 참호를 파고, 밥을 먹고 똥을 싸고 잔다. 그리고 하염없이 기다린다. 실제 적이 나타나는 시간은 얼마 되지 않는다. 수레도 편지를 썼었다. 할머니에게 쓴 편지는 차마 부칠 수 없었다. 그래서 마라에게 편지를 썼다. 사랑이니, 그리움이니 따위의 낯간지러운 단어들을 그 편지에 넣었을지도 모르겠다. 솔직히 그땐 이 지옥을 빠져나가 한국까지 살아서 돌아갈 수 있을 거라곤 생각도 못하던 때였다. 돌이킬 수만 있다면 그때 편지를 쓰고 있던 자신의 손가락을 몽땅 분지르고 싶은 심정이다.

comes at a price. In the battlefield and at sea alike, he who goofs off dies. Today would be no different. If Sureh got drunk, he was a dead man. He stared at the whiskey bottle for a long time. "Today's one of those days. A day when you cannot afford to get drunk," he told himself resolutely. He raised the bottle and poured thirty milliliters into a glass. He watched it swish dangerously then level out again. The color was so pretty. He downed it in one shot. The whiskey's waves this morning were high and rough as they made their way from his throat to his stomach. Sureh held the empty glass up and inspected it this way and that in the lamplight. Then he poured himself some more. As was his habit whenever he was feeling sorry for himself, Sureh tipped his head fifteen degrees to one side and squinted one eye to stare at the whiskey glass. Was this booze worth trading his life for? Sureh asked. You know your life isn't worth more than a few coins, someone inside Sureh answered. Sureh lifted the glass and emptied it in a single swig. The alcohol reached his stomach, vaporized, and made its way back up. The smell of alcohol emanating like a sigh and its warm lethargy mixed with the unease that had long ago taken up residence in his stomach, leaving Sureh to feel like he was stumbling through a fog. But just as quickly, everything turned okay. His past, his failures, the people who'd died because of him, even the people who'd lost everything they had because of him—it was all okay. Anyway, life was a dirty, cowardly thing.

"Sureh oppa, close the goddamn window!" Mara yelled from the bed. "And stop smoking already!"

He had a woman over. Her name was Mara. She was twenty-six. She was the daughter of the infamous Seal Inn's innkeeper. It was a strange thing. Mara was the last woman he'd slept with right before leaving Busan five years ago, and the first woman he'd slept with upon his return. Did he love her so much that he couldn't forget her? Hard to say. Truth is, it might not have been love at all. He'd written her a

수레가 월남으로 떠날 때 마라는 펑펑 울었다. "오빠 죽지 마, 오빠가 죽으면 내가 천국까지 따라가서 괴롭힐 거야." 천국까지 따라가서라니, 천국을 아무리 뒤져도 자신의 손톱 하나 찾지 못할 거라고 수레는 생각했다. 마라는 수레가 떠나고 난 뒤 정확히 일주일 뒤에 다른 애인을 만났다. 마라 그년 입으로 직접 한 말이었다. 광복동 고등어 골목 어디쯤에서 모자를 고르다가 첫눈에 반했다고 했다. 그렇게 5년 동안 첫눈에 반한 남자만 열두 명 정도 된다. 솔직히 자기는 별로 맘이 없었는데 하도 쫓아다녀서 인간적인 도의상 할 수 없이 만나줬다는 남자 숫자는 너무 많아서 입만 아픈 일이다. 수레는 마라가 만났다는 남자의 숫자나 성격이나 외모 따위에 정말이지 일절 관심이 없었다. 물어보지도 않았다. 그런데도 마라는 무슨 고해성사라도 하듯 쉴 새 없이, 그리고 정직하고 세세하게 그 남자들의 특징에 대해 이야기했다. 이놈은 이게 마음에 안 들고 저놈은 저래서 헤어졌으며 그리고 요놈은 행색은 멀쩡했는데 알고 봤더니 변태 새끼였다. 뭐 그런 얘기들 말이다. 그딴 이야기를 쉴 새 없이 하는 이유를 도무지 알 수가 없다. 어쨌거나 그 이야기를 듣고 있자니 자꾸 화가 났다. 수레가 화를 내면 마라는 더 화를 냈다.

"오빠가 무슨 권리로 화를 내는데? 어차피 오빤 나를 여자로 생각하지도 않았잖아?"

"여자로 생각 안 했으면. 내가 너를 뭐라고 생각했을 것 같은데?"

"진짜야? 그럼 그때 오빠가 나를 진지하게 생각했던 거야? 우리가 진정으로 사랑하는 사이였던 거야?"

"진지하게 생각했으면?"

"에이, 그럼 내가 그딴 쓰레기들을 왜 만나겠어? 내 진실한 사랑이 바로 여기 있는데."

어디서 개소리를 늘어놓고 있는 건가? 제 입으로 진지하게 그것도 첫눈에 사랑에 빠졌다는 남자만 열두 명이 넘는 판국에. 월남전에서 돈을

few times from Vietnam. Men at war did whatever they had to do to ward off fear and desolation. Soldiers scribbled letters to anyone and everyone. Because, after digging a trench and climbing inside, there was nothing else to do, and nothing you could do, while waiting for the Viet Cong to arrive. Time spent at war mostly consisted of boredom. You marched, you dug, you ate, you shat, you slept. And you waited, endlessly. Most of your time there was not spent in the company of your enemy. Sureh wrote letters, too. He could never bring himself to actually mail the letters he wrote to his grandmother, so he wrote to Mara. For all he knew, he might have even added words like love and longing, and other cheesy vocabulary. To be honest, back then he hadn't thought he would escape that hell and survive long enough to make it home to Korea. If he could go back in time, he would find his old self hard at work on those letters and break every last one of his fingers.

Mara had wept the day Sureh left for Vietnam. "Oppa, don't die! If you die, I'll follow you to heaven and make your life hell!" Follow him to heaven? Yeah, right, Sureh thought. She could scour every last corner of heaven and not find so much as a single fingernail of his. Precisely one week to the day after Sureh left, Mara found a new lover. She had told him so herself. She said she'd fallen in love at first sight while shopping for a hat at some place in Gwangbok-dong's Mackerel Alley. In total, she fell in love at first sight with around twelve men during the five years he was gone. And there'd been even more—so many that it would've been a waste of breath to count them—that she'd felt she had no choice but to date despite having zero interest, simply because they pursed her so tirelessly that she decided it would be inhumane and unconscionable not to. Sureh in turn had no interest, zip, zero, nada, in the number of men she'd dated or what they looked like or what their personalities were like or any of that. He never asked. And yet she never failed to give him frank and detailed descriptions of all

벌고 돌아온 우리 부대 최상사는 베트콩들의 그 무수한 총알을 다 피하고 집으로 돌아왔는데 마누라가 밥 위에 뿌린 쥐약을 먹고 죽었다. 이 인생이 기막힌 해병대 수색대의 전설적인 상사는 베트콩의 수류탄, 부비트랩, 기관총 뭐 이딴 걸 피할 생각만 했을 것이다. 하지만 정작 피해야 할 것은 소속 부대에 교묘하게 숨어 있는 프락치다. 자기 마누라 말이다.

경찰에 잡혀간 상사 마누라는 죽일 생각은 정말 없었다고, 기절만 시킬 예정이었다고 말했다. 쥐약이 사람까지 죽일 줄은 상상도 못 했다고, 쥐약이 쥐를 죽여야지 사람을 죽이다니, 그게 어디 상식적이냐고 울면서 말했다. 어처구니가 없어진 경찰이 화를 내며 물었다. "쥐약이 소를 죽이든 토끼를 죽이든 어쨌거나 아줌마가 쥐약을 밥에 넣었잖아요. 그러니까 쥐약을 왜 사람 먹는 밥에 넣었냐고요?" 그러자 상사 마누라는 다른 남자를 사랑하게 돼서 그랬다고 말했다. 사랑은 죄가 아니지 않느냐고도 울면서 말했다. 그때 수레는 참고인 자격으로 경찰서에 있었다. 울면서 사랑은 죄가 아니지 않느냐고 묻는 그 상사 마누라를 보는데 꼭 마라 생각이 났다. 정말이다.

어쨌거나 쥐약의 분량 조절을 제대로 못한 그 마누라 때문에 무적 해병대 상사는 죽었다. 쥐약 따위로 인생을 끝내기엔 너무나 멋지고 호탕한 남자였다. 상사는 모든 남자들이 좋아할 만한 시원시원한 스타일이었다. 여자들은 그런 호탕한 스타일을 별로 안 좋아하는지는 모르겠지만 어쨌거나 모든 해병대원들이 그를 좋아했다. 수레도 최상사가 좋았다. 돈을 많이 벌면 국제시장에 큰 점포를 하나 내겠다는 소박한 꿈을 가지고 있었다. 이제 그 꿈은 쥐약과 함께 허공 속으로 붕 하고 날아가버렸다. 장례식에 온 해병대 전우들은 베트남전쟁이 계속된다면 국제시장에서 쥐약 장사를 하면 돈을 벌겠다고 말했다. 정말로 그럴지도 모른다. 군인들은 계속 베트남으로 가고, 남편이 전쟁터에 있는 동안 여자들은 외로워서 사랑에 빠진다. 그리고 사랑은 결코 죄가 아니며 곰곰이 살펴보면 쥐약은 쥐만 죽이는 약이 아니어서 의외의 용도가 많으니까.

of them, constantly, like she was giving confession or something. She didn't like this thing about this one guy, and she ended it with that other guy because of that other thing, and as for that guy, well, he seemed okay but once she got to know him he turned out to be a major perv. And so on, and so on. Sureh had no idea why she insisted on telling him these things. Most of the time, it just pissed him off. But whenever he got angry at her about it, she'd get even angrier.

"Oppa, what right have you got to get mad at me? It's not like you saw me as dating material!"

"I didn't see you as dating material? What do you think I saw you as, then?"

"For real? You were serious about me before you left? That was an honest-to-god relationship?"

"What if I was serious about you?"

"Then why did I waste my time with all that garbage," she said with a huff, "when we've got true love right here?"

What bullshit. Who was she to talk about true love when she herself had fallen in love at first sight with over twelve different guys? Sureh's own Sergeant Choi had returned from the Vietnam War with the money he'd made, having dodged countless Viet Cong bullets, only to die from rat poison his wife sprinkled on his rice. This legendary leader of the even more legendary ROK Marine Corps Reconnaissance Battalion had only thought to dodge Viet Cong grenades, booby traps, machine gun fire, and other such trifling matters, when what he should have dodged was the mole cleverly hidden within his own ranks: His wife.

As she was dragged away by the cops, the sergeant's wife had pleaded that she didn't mean to kill him, that she'd only meant to knock him out a little. "Who knew rat poison could kill a person?" she'd blubbered. "Rat poison's only supposed to kill rats, not people, why would anyone think otherwise?" Dumbfounded, the police officer angrily retorted, "What difference does it make whether it's strong

 문득 마라와 결혼을 하고 월남전으로 떠났다가 돌아왔다면 수레도 쥐약 든 옥수수죽 따위를 먹고 지금쯤 사경을 헤매고 있는 건 아닐까? 생각을 했다. 이 여자라면 충분히 그럴 수 있을 것이다. 마라는 과거를 후회하지 않는다. 마라는 미래를 걱정하지도 않는다. 그래서 마라와 뭔가 계획을 세운다는 것은 거의 불가능에 가깝다. "그러니까 나보고 미래를 위해서 저축을 하라고? 미쳤구나? 자, 그러지 말고 술이나 처마시자." 뭐 이런 식이다. 이 여자의 직업이 은행원이라는 것도, 이 여자가 명문 진여상을 그것도 수석으로 졸업해서 은행에 취직을 했다는 것도, 공짜 술을 사주면 아무한테나 달라붙어 날마다 곤드레가 되도록 술을 처마시면서 아직도 직장에서 안 잘리고 있다는 것도 이해가 되지 않는다. 마라라는 여자는 애초에 이해란 걸 시도하지 않는 것이 낫다. 수레가 돌아온 날에도 마라는 물개여관 1층에 있는 술집 '수선화'에서 술을 마시고 있었다. 말하자면 그날 몸이 안 좋아서 출근을 못한 아가씨 대신에 선수로 영업을 뛴 것이다. 마치 삼류 코미디 영화 같은 만남이었다. 수레가 여관 앞에 서 있을 때 물개여관 아줌마가 마라의 머리채를 끌고 나왔다. 또 그 옆에는 비싼 돈 내고 술을 마시다가 졸지에 자기 파트너를 뺏긴 술 취한 선원 한 명도 얼떨결에 따라나와 있었다. 물개여관 아줌마가 마라에게 소리를 지르고 있었다.
 "이년아 네가 왜 거기 들어가 자빠져 있는데?"
 "엄만, 선수가 비었으면 누구라도 들어가야지. 자리 하나당 돈이 얼만데. 어머 이게 누구야? 수레 오빠 돌아왔네."
 마라가 별로 놀라지도 않은 얼굴로 수레의 손을 덥석 잡았다. 그리고 마라는 물개여관 아줌마를 달래고, 얼떨결에 따라나온 선원도 달랬다. "선원 아저씨, 오늘은 내가 사정이 좀 있어. 그러니 그냥 돌아가, 다음에 오면 내가 더블로 잘해줄게." 술 취한 선원이 그냥 돌아갈 리가 있겠는가. 게다가 내일이면 멀리 태평양으로 떠날 놈인데. 그래서 부산에 돌아오자마자 수레는 졸지에 술 취한 선원과 몸싸움을 해야 했다. 만만한 놈이 아니

enough to kill a cow or only a rabbit. The point is, lady, you put it in his food! Who puts rat poison in a person's food??" That's when the sergeant's wife admitted that she'd fallen in love with another man. "It's not a crime to fall in love, is it?" she'd blubbered some more. Sureh was at the police station at the time, as a witness. He'd taken one look at the sergeant's wife blubbering on about how love wasn't a crime and thought of Mara. He really had.

At any rate, because of the sergeant's wife's inability to properly measure out rat poison, the invincible Marine Corps sergeant had died. He was far too cool and generous a man to have ended his life because of something as stupid as rat poison. The sergeant had had the kind of refreshingly honest approach that other guys like. Women might not have found his audacity as appealing, but the Marines all loved him. Sureh, too, had been a fan of Sergeant Choi. Choi had had a modest dream of making enough money to buy a large shop in the Gukje Market, and now that dream had vanished. His fellow Marines who came to his funeral said that if the war kept going, they would go into business selling rat poison at Gukje Market. And maybe they really did. Soldiers kept getting shipped off to Vietnam; lonely wives kept falling in love. And love was not a crime—when you thought about it carefully, rat poison really did have a lot of surprising uses besides killing rats.

Sureh suddenly wondered: if he had married Mara before leaving for Vietnam, would he be eating corn porridge laced with rat poison and dying very slowly right now? She was more than capable of it. Mara did not regret the past. Mara did not worry about the future. She wasn't the type to make any sort of plans for herself. She was more the type to say, "You're telling me to save money for the future? Are you crazy? I'd rather get drunk instead." He couldn't understand how this woman was a bank clerk, or how she'd graduated—top of her class, no less—from the prestigious Busanjin Girls' Commercial High

었다. 술에 취해도 뱃놈은 뱃놈인 것이다. 선원들은 대체로 온몸이 근육질이고, 망할 놈의 깡다구와 뚝심은 성난 멧돼지 수준이며, 만날 흔들리는 배 위에 살다보니 균형감각도 장난이 아니니까. 결국 수레도 얼굴에 멍이 들고 선원도 얼굴에 멍이 들었다. 그때 마라는 팔짱을 끼고 웃으며 수레가 싸우는 장면을 보고 있었다. 대체 이게 말이나 되는 여자인가.

마라는 한번 화가 나면 식칼을 들고 싸운다. 실제로 수레도 마라가 휘두르는 칼에 손을 베인 적이 여러 번 있었다. 하지만 다음날이면 술에 너무 취해 기억이 나지 않는다고 한다. 환장할 일이다. 그런데도 돌아오자마자 이 미친년과 잠을 자고 있다. 이상하게도 마라를 떠나지 못한다. 마라가 편하다. 마라가 떠드는 비현실적인 말들과 비현실적인 세계가 좋다. 과거를 탓하지도 미래를 걱정하지도 않는 마라의 사고방식이 좋다. 마라는 마치 낮이건 밤이건 계속 잠이 들게 만드는 태평양의 햇살 같다. 마라의 정신을 빌려서, 마라의 꿈속의 세계로 들어가서, 그토록 무책임하고 아무것도 기억나지 않는, 어떤 상황이건 거칠 것 없이 무소의 뿔처럼 자기 혼자서 뿔뿔뿔 잘도 걸어가는 마라의 세상에서 살고 싶었다. 이건 진심이다. 그래서 수레는 마라의 얼굴을 볼 때마다 자신의 마음속에 경멸과 사랑이 어떻게 이토록 절묘하게 공존할 수 있는지를 생각하게 된다. 그러니까 수레는 마라를 경멸한다. 그리고 마라를 사랑한다.

"에이, 시팔, 죽여버리기 전에 빨리 문 닫아. 모기 들어온다니까!"

마라가 협박을 했다. 하지만 수레는 문을 닫지 않았다. 걱정할 것 없다. 마라는 문이 열려 있든, 문이 닫혀 있든 곧 다시 잠들 것이다. 지금 하는 말은 잠꼬대 같은 것이다. 마라에게 반항을 하고 싶은 것은 아니다. 문을 닫으면 답답하다. 답답해서 이 새벽을 못 견딜 것이다. 답답해서 다시 잠을 잘 수도 없고 답답해서 맨 정신에 깨어 있을 수도 없다. 마라를 깨워서 섹스를 하는 게 낫지 않을까. 아니다. 그게 나을 리가 있겠는가. 잠시 후 마라가 다시 코고는 소리가 들렸다. 수레는 글라스에 세번째 술을 따랐다.

School and landed a job in a bank, or how she managed to keep said job despite clinging to the arm of whoever offered to buy her drinks and slamming shots until she was blackout drunk every night. When it came to Mara, he was better off not trying to wrap his brain around her at all. The day he'd returned, she was having drinks in The Daffodil. She'd been filling in, pinch hitting as it were, for one of the regular girls who was out sick. Their reunion was like a third-rate comedy movie. Sureh was standing in front of Seal Inn when the innkeeper, her mother, came dragging Mara out by her hair. Following on the innkeeper's tail was the drunk sailor whose partner had been abruptly yanked away from him despite all the money he'd spent on her drinks. Mara's mother was yelling at her.

"What the hell has gotten into you?"

"Ma! When a player's down, you gotta send someone in to take their place. You know how much each girl brings in a night. Ooh, who's this? Sureh oppa is back!"

Mara had not looked in the least bit surprised when she grabbed Sureh's hand. She calmed down her mother and even managed to calm the sailor. "Sorry, honey, something suddenly came up. Go on home now, and next time I'll be twice as sweet to you." But could a drunken sailor simply go on home? To make matters worse, he was scheduled to set sail the next day for a long Pacific voyage. And so, on his first day back in Busan, Sureh found himself having to trade punches with a drunken sailor. He wasn't easy to take, either. Drunk or not, a sailor's still a sailor. They're mostly muscle, they have the wicked tenacity and grit of a pissed off boar, and spending every day on a swaying ship means their sense of balance is no joke either. Sureh and the sailor both wound up with black eyes. Mara had stood by and watched, smiling, arms crossed, as Sureh fought. He could not make heads or tails of this woman.

When Mara got angry, she fought with a kitchen knife. Sureh had

하지만 마시지는 않았다. 이 잔을 마시면 정말 취해버릴 것 같았다. 수레는 우두커니 술잔을 바라보다가 다시 창밖으로 고개를 돌렸다.

그렇게 오래 떠돌 생각은 아니었는데 어쩌다보니 5년 만의 귀국이었다. 베트남의 밀림, 사이공의 육군 병원, 원양어선 그리고 태평양의 작은 산호섬들을 떠돌았다. 타라와에서는 나무늘보처럼 잠만 잤다. 태양의 왕국인 타라와에선 세상이 천국처럼 너무 환해 눈을 뜰 수가 없고 그곳의 공기는 평안하다 못해 무기력해서 눈을 감으면 잠이 마구 쏟아지니까. 그리고 투발루, 통가, 키리바시 같은 이름도 낯선 적도 근처의 작은 섬들은 한국과 너무 멀리 떨어져 있어 어떤 걱정도 비현실적인 것처럼 몽롱하게 느껴지니까.

타라와의 여자들은 머리에 꽃을 꽂고 있었다. 오른쪽 머리에 꽃을 꽂은 여자는 결혼을 했다는 뜻이다. 왼쪽 머리에 꽃을 꽂은 여자는 아직 싱글이라는 뜻이다. 왼쪽 머리에 꽃을 꽂은 여자가 그렇게 말했다. 왼쪽 머리에 꽃을 꽂은 여자와 술을 마셨고 그 여자와 잤다. 나중에 보니 그 여자에겐 산적 같은 남편이 있었다. 그 여자는 자신이 창녀가 아니라고 했지만 베트남 야시장에서 중고로 산 롤렉스 시계를 가져갔다. 누군가 그것은 그저 머리에 꽂은 꽃일 뿐 왼쪽이든 오른쪽이든 아무런 의미도 없다고 했다. 아마 그 말이 정답일 것이다.

타라와의 움막에는 지붕만 있고 벽이 없다. 벽이 없어서 가까이 혹은 멀리 있는 움막의 내부를 훤히 볼 수 있었다. 밥을 먹고 웃고 떠들며 섹스를 하는 것조차 훤히 볼 수 있다. 왜 타라와의 움막은 벽을 만들지 않는 걸까? 아마 벽이 필요하지 않아서 그럴 것이다. 그곳에 사는 폴리네시아 사내들은 고릴라처럼 덩치가 크고 나무늘보보다 더 게으르다. 그들도 낮에 잠을 잤다. 일어나면 술을 마시고 또 잠을 잔다. 폴리네시아 사내들은 세상에서 제일 편한 인간들이었다. 어쩌다 럭비를 몇 판 할 때도 있지만 대체로 술을 마시고 잠을 자거나 술을 마시기 위해 술집으로 어슬렁거리는

taken a few knicks to the hand because of her knife as well. But the next day she would always claim that she'd been too drunk to remember. It was maddening. And yet, the second he was back, he'd gone to bed with this madwoman. For some reason, he couldn't leave her. He was comfortable with her. He liked her crazy way of talking and the crazy world she lived in. He liked her attitude of never blaming the past or worrying about the future. Mara was like the soothing rays of the sun over the Pacific that could lull him to sleep at any time, day or night. He wanted to borrow Mara's spirit, enter her dreams, and live in her world, where she took responsibility for nothing, remembered nothing, and where she charged forward smoothly, no matter the situation, as singular and unhindered as the horn on a rhinoceros' face. That was the truth. Every time Sureh saw Mara's face, he marveled at how love and hate could coexist so exquisitely inside one heart. He despised Mara. He adored Mara.

"God-fucking-damn it, close that fucking window before I kill your ass! I told you, mosquitos are getting in!"

Sureh ignored Mara's threats and left the window open. There was nothing to worry about. Mara would fall right back to sleep whether the window was open or not. She may as well have been talking in her sleep. Not that he was deliberately defying her. If he closed the window, the room would get stuffy. It would be too stuffy for him to bear the early hour. It would be too stuffy for him to fall back to sleep and too stuffy to stay awake with a clear head. Would it be better to wake Mara up so they could have sex? No. No way. As if. After a moment, he heard Mara start to snore. He poured himself a third glass of whiskey. But he didn't drink it. If he took this shot, he'd be good and drunk. Sureh stared at the glass for a moment and then turned back to the window.

He hadn't meant to be away for so long; five years had passed before he knew it. He had wandered from the jungles of Vietnam to an army

게 그들의 운동량의 거의 전부였다. 실제로 그들은 거의 일을 하지 않았다. 사실상 생존을 위해서라면 이 섬에서 별로 할일도 없었다. 바다에는 온갖 종류의 물고기들이 연중 잡히며, 살이 통통 오른 바닷가재 같은 것은 자기가 알아서 주방까지 기어올라와 스스로 냄비에 빠질 정도다. 바나나 잎사귀에 올라 있는 그토록 단순한 음식들. 단순한 웃음과 단순한 삶. 섬 어디서나 사람들의 웃음소리를 들을 수 있다. 그 웃음은 마치 타라와의 햇살처럼 강렬하다. 이곳의 슬픔은 스콜처럼 짧게 지나가고 웃음은 오후 내내 작렬하는 태양처럼 오래 머문다. 이 섬이 태평양전쟁 당시 가장 치열했던 격전지 중에 하나였다는 사실은 모래톱에 처박혀 있는 포탑을 볼 때 외에는 상상조차 할 수 없었다. 사실 타라와 같은 곳에서 오랫동안 질질 끌어야 할 슬픔이 무엇이겠는가. 그곳에 1년을 머물렀다. 너무나 비현실적이어서 시간이 어떻게 가는지 알 수가 없었다. 하지만 그 혼침 속에서 느닷없이 깨어나는 불안은 참호 속으로 떨어지는 불안보다 더 강렬했다. 타라와의 공기는 솜털처럼 포근한데 불안이 더 강렬하게 솟구친다는 게 수레는 늘 의아했다. 그래서 타라와에서는 눈을 뜨면 그 불안에 놀라 깨자마자 바로 술을 마셨다. 술에 취하면 다시 잠이 들고 잠에서 깨면 다시 불안해서 술을 마셨다.

수레는 자신의 테이블 위에 있는 술잔을 쳐다봤다. 문득 술잔 속에 술이 채워져 있음을 깨닫고 안도감이 들었다. 안도감이라니, 저 술 때문에 이 새벽에 죽을지도 모르는데, 하지만 술잔 속에 술이 채워져 있다는 것은 언제나 푸근한 느낌이 들었다. 타라와에서는 가지고 있는 돈 거의 전부를 술을 마시는 데 썼다. 그곳에선 술 한 잔만 사면 누구와도 친구가 될 수 있었다. 술 한 잔만 사면 친구의 친구도 친구가 되고 친구의 가족도 친구가 된다. 그곳에는 마치 애당초 적이란 게 한 번도 없었던 것처럼 햇살만 가득한 섬이니까. 수레는 꽃을 머리에 꽂은 여자들을 생각했다. 그 아름다운 산호섬을 벌거벗고 뛰어다니는 아이들을 생각했다. 아무 일도 일어나

hospital in Saigon to a deep-sea fishing boat and finally to the tiny coral islands of the Pacific Ocean. In Tarawa, he'd slept all day like a sloth. There, in the kingdom of the Pacific, the world was so bright, as bright as heaven, that you could barely open your eyes, and the air was so warm that it sapped all the strength from your body so that the moment you closed your eyes, sleep poured down like rain. And small equatorial islands with unfamiliar names like Tuvalu, Tonga, and Kiribati were so very far away from Korea that any worries felt hazy and unreal.

The women of Tarawa wore flowers in their hair. A flower on the right meant they were married; on the left, single. A woman with a flower on the left side of her hair had told him that. He'd had drinks with the woman with the flower on the left, and slept with her. Later he found out she had a husband, who was some kind of bandit. She'd told him she wasn't a prostitute, but she took the used Rolex that he'd bought at a night market in Vietnam. Someone else told him that the flowers in the women's hair were only flowers and meant nothing no matter what side they were pinned on. They were probably right about that.

Tarawan huts had only roofs and no walls. From near or far, you could see all the goings-on inside those huts. You could easily watch people eating, laughing, talking, and even having sex. Why did they not add walls to their huts? Maybe they didn't need them. The Polynesian men living there were as big as gorillas and lazier than sloths. They, too, slept during the day. When they rose, they drank alcohol then slept some more. Polynesian men were the most relaxed people in the world. Now and then they'd play a game of rugby or two, but for the most part the extent of their exercise was drinking and sleeping or shuffling over to the pub for a drink. They did almost no work. Not that there was much to survival on that island. All kinds of fish could be pulled from the sea year-round, and well-fattened lobsters practically crawled into people's kitchens and climbed into the cooking pot themselves. Meals were easy affairs served on banana leaves.

지 않을 것 같은 타라와의 고요한 밤바다를 생각했다. 그리고 수레는 월남전에서 그가 죽인 죄 없는 사람들을 생각했다. 군인들은 어둠에 대고 총을 쏘았다. 땅굴 속으로 수류탄을 던졌다. 누가 베트콩인지 누가 민간인인지 알 수가 없었다. 농촌을 수색할 때마다 어디에나 땅굴이 있었다. 무서워서 그 구멍으로 들어가려는 군인이 없었다. 그래도 뭔가를 확인하러 들어간 군인은 폭탄과 함께 죽었다. 그래서 땅굴의 어둠에 대고 총을 갈겨댔다. 땅굴 속에 뭐가 있는지 무서워서 살펴볼 수가 없었다. 민간인이라고 생각한 사람들이 총을 쏴댔고 적군이라고 생각한 사람은 민간인이었다. 소년이 총을 쏘고 소녀가 수류탄을 던졌다. 수레의 부대가 수류탄 다발을 쑤셔넣자 땅굴 속에서 한 가족이 튕겨져나왔다. 그들의 죄라곤 군인들이 몰려오자 그저 겁을 먹고 땅굴 속으로 들어간 것밖에 없었다. 마당에 모아놓은 시체들을 보고 명령을 내린 젊은 중위는 울먹거리며 말했다. "시팔 어쩔 도리가 없잖아. 우리가 다 죽을 판인데, 그냥 갈겨대는 수밖에." 그리고 이런 일들을 보고서에서 지우며 중령도 말했다. 전쟁이란 건 그런 거라고, 군인보다 민간인이 더 많이 죽는 게 전쟁이라고. 미군 새끼들은 폭격기를 띄워 날마다 멀쩡한 도시 위로 수백 톤의 폭탄을 떨어트린다고. 그에 비하면 이런 건 아무것도 아니라고. 그랬을까? 정말 어쩔 도리가 없었을까. 전쟁이란 그런 거니까 이건 아무것도 아닌 일일까. 수레는 자기가 죽인 아이들을 생각했다. 자기가 던진 수류탄에 파편처럼 날아온 아이의 희고 작은 팔을 생각했다.

수레는 술잔을 들고 단번에 잔을 비웠다. 한 시간 뒤에 위험한 거래가 있었다. 술에 취해 있다간 죽을 것이다. 하지만 위스키를 세 잔쯤 마시고 나자 그딴 게 대체 무슨 상관이냐는 기분이 들었다. 하긴, 죽든 말든 그딴 게 대체 무슨 상관이냐. 그러자 스르르 잠이 왔다.

* 본 작품은 문학동네에서 출간 예정인 장편의 일부입니다.

Easy smiles, easy lives. Laughter could be heard all over the island. The laughter was as strong as the Tarawan sunlight. There, sadness was over as quickly as a squall, and laughter lingered as long as the afternoon sunlight beating down. The fact that this had been one of the fiercest battlegrounds in the Pacific War was impossible to imagine without seeing the turrets that had been built into the sandbank. In a place like that, what kind of sadness would drag on? He'd stayed for a year. It was all so unreal that he had no idea how he'd passed the time. But the anxiety that kept rearing its head in that semiconscious state of his was far worse than the anxiety that had descended upon him in the trenches. It never failed to amaze Sureh how the Tarawan air, as soft and warm as cotton, could make his anxiety strike all the more fiercely. In Tarawa, he would awake, feel startled at the depth of his anxiety, and immediately hit the bottle. Once drunk, he would fall back to sleep only to wake, be overcome with anxiety again, and drink more.

Sureh eyed the whiskey bottle again. Then he remembered that he'd already filled his glass and felt relief. Relief! He could be dead this morning because of that damn alcohol, but the fact that his glass was full never failed to give him a warm, fuzzy feeling. He'd spent nearly all the money he'd had in Tarawa on booze. There, buying someone a drink could make you friends with anyone. A single drink, and you were best friends with your friend's friend and with your friend's family. The island was lousy with sunshine, as if they'd never even heard of the word enemy. Sureh thought about the women with flowers in their hair. He thought about the children running naked around that beautiful coral island. He thought about the sea on those tranquil Tarawan nights, when it seemed that nothing bad could possibly ever happen. Then Sureh thought about the innocent people he'd killed in the war. Soldiers had fired into the dark. They threw grenades into underground tunnels. No one had any idea who was Viet Cong and who

was civilian. Every search of a farm village turned up these tunnels. The soldiers were too terrified to go inside. Each soldier who went in anyway to check them out ended up dead. So they fired wildly into the darkness of the tunnels. They were too scared to examine what was in there. The people they thought were civilians fired at them, and the people they thought were enemy soldiers were civilians. Boys shot bullets; girls threw grenades. When Sureh's troop shoved a bundle of grenades into a tunnel, a family came flying out. The family's only crime was taking fright at the approach of soldiers and seeking refuge in the tunnel. When he saw the bodies gathered on the ground, the lieutenant who'd given the order blubbered, "We had no fucking choice, man, we were dead meat, we had no choice but to fire." Their lieutenant colonel erased all of it from the report and said, "That's war. Losing more civilians than soldiers is what war is. Those fucking Americans send their bombers every day to drop hundreds of tons of bombs on perfectly good cities. Compared to them, this is nothing." Was he right? Did they really have no other choice? Is that what war was about, and what they did amounted to nothing? Sureh thought about the children he'd killed. He pictured the small, pale arm that had flown towards him like shrapnel at the toss of his grenade.

Sureh picked up the glass and swallowed the whiskey. A dangerous deal was going down in an hour. If he got drunk, he was dead. But the three glasses made him stop caring. And really, who gave a fuck whether he died or not? He drifted back to sleep.

Translated from Korean
by Sora KIM-RUSSELL

* This work is a part of a novel to be published by Munhakdongne.

냉장고

편혜영

그해 K시를 연고지로 둔 야구팀의 성적은 예상 밖이었다. 원년 멤버인 야구팀은 오랜 부진을 겪고 있었고 그해 역시 마찬가지로 비관적인 성적이 예상되었다. 이미 전성기를 지난 팀이라는 것이 공통된 견해였다. 선수들 평균 연령이 높았고, 투수진은 나이가 더 많았고 부진한 실적에 비례해 구단의 투자는 갈수록 줄었다. 하지만 그해 봄 연승을 거두었다. 공공연하게 놀림을 받던 지난해와 완전히 다른 모습이었다. 서른넷에 복부 비만이 뚜렷해진 7번 타자가 홈런을 쳤을 때, 동네에서 함성이 터져나왔다. 그 함성에 김무진의 울음소리가 묻혔다.

김무진은 이내 울음을 그쳤다. 이제 겨우 중학생이지만, 많은 일을 겪었다. 세상에 짐작 못할 일은 별로 없다는 것도 알게 됐다. 일어날 일은 반드시 일어난다. 할아버지 김동현도 늘 그렇게 말해왔다. 인생은 풍선 같은 것이라고. 몸집을 불려가는가 싶으면 터지고, 저절로 쪼그라들면서 쭈글쭈글한 껍데기만 남는다고.

작게 쪼그라든 김동현은 김무진에게 '준비'를 해두라고 일렀다. 얼마 전에도 그렇게 말했다. 급격히 말을 잃기 전에 말이다. 그새 생각이 달라진 건 아닌지 김무진은 확인하지 못했다. 김동현은 더는 말하지 못했다.

The Refrigerator

PYUN Hye-young

K City's hometown team exceeded everyone's expectations that year. The team, which still had all of its original members, had been in a long slump, and that year was initially not expected to be any better. Shared opinion was that the team's glory days were behind it. The players were all older than average, the pitcher was even older, and the ball club's investment kept decreasing in proportion to their poor performance. And yet, that spring found them on a winning streak. Their performance was the complete opposite of their widely mocked previous years. When their number-seven batter, who was only thirty-two but suffered from an increasingly obvious case of abdominal obesity, hit a home run, elated shouts rang out throughout the entire neighborhood. Buried beneath their shouts was Kim Mujin's weeping.

Mujin's tears soon ceased. He'd only just started middle school, but already he'd been through so much. He had learned that few things in this world were beyond the realm of imagination. Whatever was bound to happen would definitely happen. Life was like a balloon. That's what his grandfather, Kim Donghyun, had always told him. One moment you seem to be growing and growing, and the next it all bursts, and you shrink and wither away until only your wrinkled husk is left.

간신히 숨을 내쉬었다. 오래전에 한 말로는 그래야 김무진이 계속 야구를 하며 혼자 지낼 수 있다고 했다.

김무진은 늘 붙어다니는 정일우에게 고민을 털어놓았다. 정일우는 짐짓 어른스러운 투로 할아버지 뜻이 그렇다면 자신이 돕겠다고 했다. 그러니 할아버지 말대로 마음의 준비를 하라고. 김무진이 오래전부터 해온 게 바로 그거였다. 마음의 준비. 하지만 마음을 준비하고 있었다고 해서 끝내 마음이 아무렇지 않은 것은 아니었다.

김무진은 덩치가 컸다. 얼마 전까지 학교 야구팀에서 포수를 맡았다. 주전은 아니고 예비 포수였다. 팔 개월 간 겨우 일곱 경기에 출전한 게 전부지만 야구팀이 있는 고등학교에 진학하고 싶었다. 어느 날 하굣길에 운동장에서 날아오는 공을 맨손으로 잡았다. 선수들이 연습 삼아 친 공을 엉겁결에 잡은 것이다. 그 일로 김무진의 왼손 검지가 구부러졌지만 체육 선생이자 감독이던 최도영의 눈에 띄었다.

김무진은 울음을 삼키고 정일우에게 전화를 걸었다. 정일우는 말수가 적고 수줍음이 많았다. 누군가 말을 시키면 엄마 얘기만 해서 야구팀에서도 따돌림을 받았다. 김무진은 길에서 우연히 정일우의 엄마를 본 적 있었다. 정일우가 말한 것처럼 그애 엄마가 예쁘고 젊고 똑똑해보이는 게 아니어서 조금 놀랐다. 그애 엄마는 할머니나 다름 없었다. 그 후 정일우와 김무진은 가장 친한 친구가 됐다. 정일우는 초등학교 때부터 야구를 했고 8번 타자였다. 경기에 나갈 때마다 배트 끝을 땅바닥에 문지르며 행운을 비는 말을 했지만, 행운은 여간해서 오지 않았다.

정일우는 한 시간 쯤 후 김무진의 집에 도착했다. 야구복을 입고 왔다. 엄마에게 야구 연습을 하러 가야 한다고 둘러댔다. 김무진이 문을 열어주자 정일우는 할아버지 저 왔어요, 하고 옆집에 들릴 정도로 크게 인사하고 현관문을 닫았다.

정일우를 기다리는 동안 김무진은 구형 냉장고를 비워뒀다. 그다지 어

Grandfather Kim, now small and withered, had told Mujin to get ready. He'd said the same not long ago. Before he'd rapidly started losing the ability to speak, that is, As for whether his grandfather had changed his mind since then, Mujin wasn't able to confirm. Grandfather Kim was no longer speaking. He was barely breathing. But he'd told Mujin that it was the only way he'd be able to live on his own and keep playing baseball.

Mujin had told his best friend, Jeong Ilwoo, everything. In an adult-sounding voice, Ilwoo had said that if that was what Grandfather Kim wanted, then he would help. He would help his friend to ready himself. And that was precisely what Mujin had been doing for some time. Readying himself. But saying the words was one thing, actually following through was another entirely.

Mujin was heavyset. He'd recently been made the catcher on his school's baseball team. Not on the starting lineup, though; he was a bench player. He'd played in only seven games for the last eight months, but he wanted very much to get into a high school with a baseball team. One day, on the way to school, he'd caught barehanded a ball that had come flying at him from the schoolyard. The ball had been struck by players at practice, and he'd caught it without thinking. As a result, he'd broken his left thumb and caught the eye of the P.E. teacher and baseball coach, Choi Doyeong.

Mujin swallowed the last of his tears and called Ilwoo. Ilwoo was very shy and not given to saying much. Whenever someone struck up a conversation with him, he'd talk only about his mother, making him an outcast everywhere, even among his teammates. Mujin had seen Ilwoo's mother on the street once. He had been startled to see that she was not as pretty and intelligent-looking as Ilwoo had described. Ilwoo's mother looked more like someone's granny. After that, Ilwoo and Mujin had become best friends. Ilwoo had been playing baseball since elementary school and batted eighth in the lineup. At each game

려운 일은 아니었다. 냉장고에 든 게 거의 없었다. 김동현이 아파 누워서
지내게 된 후로 냉장고는 더 쓸모없는 물건이 되었다.

왜 냉장고냐고 김무진이 묻자 정일우는 딱하다는 듯 혀를 찼다.

"요즘 같은 날씨에 냉장고가 아니면……"

정일우는 더 말을 잇지 않았다. 뒷말을 하기 무서워서였을 수도 있고
김무진이 갑자기 훌쩍거렸기 때문일 수도 있었다. 그래도 정일우가 입을
다물어줘서, 엄마 얘기를 꺼내지 않아서, 섣부른 말을 하지 않아서 김무
진은 금세 눈물을 그쳤다. 정일우는 한숨을 내쉰 후 냉장고 문을 열어 내
부를 일정한 간격으로 나누고 있는 철제 선반을 죄다 끄집어내고 준비가
다 됐다고 말했다.

일이 끝난 후 김무진은 정일우가 시키는 대로 창문을 활짝 열었다. 냉
장고 냄새가 심하게 났다. 텅 빈 냉장고였는데, 무엇인가 오래 묵은 냄새
가 났다. 정일우는 가방에서 기다란 초록색 향을 꺼냈다.

"원래 이런 걸 피우는 거래."

정일우는 다 죽어서 흙만 남은 화분을 가져다 향을 꽂고 챙겨온 라이
터를 꺼냈다. 바람도 불지 않는데 라이터는 잘 켜지지 않았다. 가스가 얼
마 남지 않은 것 같았다. 정일우는 라이터 몸통을 기울여 기어이 불을 켰
다. 향 냄새가 났지만 정일우는 아무 말도 하지 않았다. 무서워하는 것 같
았다. 떨리는 두 다리를 배트처럼 땅에 비비며 계속 뭐라고 중얼거렸다.

이웃집에서 또 함성 소리가 들려왔다. 누군가 안타를 치고 진루하거나
투수가 삼진으로 상대 팀 타자를 잡은 모양이었다. 김무진과 정일우는 2
주째 야구를 하지 못했다. 학교에서는 야구부를 해체한다는 소문이 돌았
다. 김무진으로서는 곤란한 얘기였다. 야구부를 해야만 저녁밥까지 학교
에서 먹을 수 있었다. 방학 때는 합숙 훈련으로 여러 끼니를 해결했다. 그
런 계산으로 야구부에 들어간 것은 아니지만, 그것 때문에 야구부가 더 좋
아지긴 했다.

he would rub the tip of the bat against the ground, saying it was for luck, but it rarely brought him any.

An hour later Ilwoo arrived at Mujin's house. He was wearing his baseball uniform. He explained that he'd told his mom he had practice. As soon as Mujin let him in, Ilwoo called out, Grandfather Kim, I'm here!, loudly enough for the neighbors to hear, and closed the front door behind him.

While Ilwoo waited, Mujin emptied the old refrigerator. It was not hard work. There was barely anything in it. Ever since Grandfather Kim had taken ill and become bedridden, the refrigerator had seen little use.

Mujin asked, why the refrigerator, and Ilwoo tsked and said, "In this weather, what else—"

Ilwoo broke off mid-sentence. Maybe he was afraid to finish the thought, or maybe it was because Mujin suddenly started sniffling. Nevertheless, because Ilwoo stopped talking and because he did not bring up his mother and because he did not rush to say something else, Mujin soon stopped his crying.

The refrigerator duly emptied, Mujin opened the window as instructed by Ilwoo. The inside of the refrigerator smelled terrible. Despite being empty, it stank as if something had been kept in there for far too long. Ilwoo pulled a long, green stick of incense from his bag.

"They say to light one of these."

Ilwoo grabbed a potted plant—the plant itself long dead—stuck the end of the incense in the soil, and took out a lighter. There was no draft or breeze to speak of, but the lighter would not light. It must have been nearly out of fuel. Ilwoo tipped the lighter and just managed to coax a flame from it. The scent of incense filled the room, but Ilwoo said nothing. He must have been afraid. He kept mumbling something to himself and rubbing his feet against the carpet like his trembling legs were baseball bats.

More shouts arose from the neighbor's house. It sounded like their

야구를 하게 됐다고 말했을 때 김동현은 말했다.

"무진아, 무거운 배트를 써라. 홈런을 치려면 그래야 해."

할아버지는 김무진이 포수라는 걸, 주진이 아니라는 걸 몰랐다. 김무진은 할아버지가 쓸데 없는 말을 한다고 생각했으나, 나중에 최도영에게 베이브 루스라는 미국 야구 선수 얘기를 듣고, 할아버지 말은 틀린 적 없다는 걸 다시금 깨달았다.

최도영은 누군가 홈런을 치면 '오, 베이비 루스' 하고 크게 외쳤다. 베이브 루스의 이름을 변용한 것이었다. 베이브 루스는 타고난 장타자인데, 1.5킬로그램이 넘는 무거운 배트만 사용했다.

야구를 못하게 된 것은 최도영에게 뭔가 문제가 생겨서였다. 최도영이 처벌을 받을지 모른다는 얘기가 돌았다. 그 문제를 해결하기 위해 최도영은 야구부 아이들의 집을 일일이 찾아다니고 있다고도 했다.

"너희들이 나를 도와줘야 한다."

결과적으로 마지막이 된 연습 날, 최도영이 아이스크림을 사주며 말했다.

"나는 너희들을 야구부가 있는 고등학교에 보낼 사람이다. 프로팀으로도 보내고 대학으로도 보낼 수 있는 사람이다. 내가 아니면, 너희들은 야구를 때려치고 야구부도 없는 고등학교에 간신히 입학하게 될 거다. 내가 있어야만 너희들 인생이 계속될 거다."

내가 잘리면 이 학교에 더 이상 야구부 선생은 없다. 최도영은 윽박지르며 그렇게도 말했다.

최도영은 실업팀에서 중견수였다. 같은 대학에서 잘 나가던 선수와 묶여 프로야구팀에 입단하긴 했는데, 배트보이 역할을 하는 것에 불만을 품고 실업팀으로 이직했다. 곰의 꼬리가 되느니 미꾸라지의 머리가 되는 게 낫기 때문이었다. 최도영은 그 말을 입에 달고 살았다. 훈련 때도 툭하면 그 말을 해서, 별명이 미꾸라지가 됐다. 최도영이 말한 속담이 본래 '용의 꼬리가 되느니 뱀의 머리가 되는 게 낫다'임을 모르는 사람은 없었지만,

team had scored a run, or maybe their pitcher had struck out the op-
posing team. Mujin and Ilwoo hadn't played for two weeks. Rumor
had it that the school's team was going to be disbanded. This was dif-
ficult for Mujin to take. Being on the baseball team meant getting to
eat breakfast, lunch, and dinner at school. Attending baseball camp
during school vacation had also kept him fed. That wasn't why he'd
joined the team, but it certainly made him like it that much more.

When he'd said he was going to play baseball, his grandfather had told
him, "Mujin-ah, choose a heavy bat. That's the only way to hit a home run."

His grandfather had no idea that Mujin was just a catcher, and not
even on the starting lineup. Mujin had thought his grandfather's ad-
vice was nonsense, but later he learned all about the American legend
Babe Ruth from Coach Choi and realized anew that his grandfather
was never wrong.

Whenever one of them hit a home run, Coach Choi would yell,
"Come on, Baby Ruth!" He could never quite get Babe Ruth's name
right. Babe Ruth was a born power hitter who'd only used bats that
weighed over 1.5 kilograms.

Baseball had been taken away from them because of a problem
with Coach Choi. Word was that he might even be fired for it. And
that he had been going door-to-door to each of the boys' families to
try to stop that from happening.

"You boys have to help me," Coach Choi had said to them, on what
turned out to be their last day of practice, while treating them to ice
cream. "I'm the only one who can send you boys to a high school that's
got a baseball team. I'm the only one who can get you into college and
into the pros. Without me, you'd have to quit the sport. You'd be lucky
to even get into a school without a team. I'm the only one who can
keep your lives going."

The browbeating had continued. If I get fired, he'd warned, this
school will have no more baseball coach.

최도영이 '용'을 하필 '곰'으로 바꿔 말하는지 아는 사람은 별로 없었다. 최도영이 잠깐 있던 프로야구팀이 곰을 마스코트로 하던 구단이었다.

탄원서가 도움이 될 거라고 했다. 장래성 있는 수많은 야구부 학생들의 미래를 좌우할 사람이라고 적어주면, 실수를 용서받을 거라고. 실수라고 말하는 건 최도영뿐이었다. 상황을 분간 못하는 아이들조차 최도영이 여학생에게 한 일을 두고 실수라고 하지 않았다. "제가 어딜 봐서 그럴 사람입니까." 최도영은 야구부 선수들의 부모를 찾아가 탄원서를 써달라고 빌면서 그렇게 말한다고 했다. "야구부에는 여학생도 없지 않습니까." 그렇게도 말한다고 했다. 부모들로서도 나쁘지 않다고 여겼을 것이다. 탄원서를 써주면, 고등학교 입학에 결정적 권한을 가진 감독에게 지금처럼 굴종할 필요가 없을지 모른다는 것도 계산에 넣었다. 아이에게 좀더 기회가 생길 수도 있지 않을까. 무엇보다 감독의 말마따나 야구부에는 남학생뿐이지 않은가. 적어도 자신의 아이가 감독에게 추행을 당할 리는 없었다. 그런 이유로 야구선수로서 전도유망한 아이들의 장래를 위해, 그 동안 성실하고 유능했던 감독의 성품과 태도를 참작해 달라는 탄원의 문장을 줄줄 써나갔을 것이다.

향이 거의 다 타고 정일우가 막 자리에서 일어서려는데 초인종이 울렸다. 정일우가 겁 먹은 표정으로 김무진을 쳐다봤다. 둘은 잠자코 있었다. 소리를 내지 않으면 될 것이라 생각했지만, 거실 불빛이 훤히 새나갈 테니 사람이 없는 척 하기는 쉽지 않았다.

"누구세요?"

김무진이 뜸을 들이다 물었다.

"무진이니?"

밖에서 크게 되묻는 소리가 들렸다. 미꾸라지다. 입모양으로 정일우가 말했다.

최도영은 웃고 있었다. 정일우는 미꾸라지가 그렇게 선량하게 웃는 걸

Coach Choi had been a center fielder for a semi-pro team. He'd made it onto a pro team along with other players he'd gone to college with, but he'd fumed at being relegated to the role of batboy and moved down to a semi-pro league instead. After all, better to be the head of a snake than the tail of a bear. It was his favorite expression. He said it all the time during practices, so much so that his nickname had become The Snake. Of course, they all knew the original proverb, "Better to be the head of a snake than the tail of a dragon," but few of them understood why he'd swapped a bear for a dragon. The pro team that he had briefly played for had a bear as its mascot.

He'd said letters of petition would help. If their parents all wrote that he controlled the futures of many, many promising young baseball players, then his mistake would be forgiven. He was the only one who referred to it as a mistake. Not even the boys, who were hardly able to tell what was what in this situation, called what he had done to their female classmate a mistake. It was said that he'd been going around to everyone's parents, saying, "You know that's not who I am," and begging them to write letters for him. "There aren't even any girls on the baseball team," he'd added. The parents would not have been all that concerned. They would have done the math and figured out that, if they wrote the letters, they would no longer have to bow and scrape before the person who held the fate of their boys' high school admission in his hand. It would mean more opportunities for their children, wouldn't it? And, like he said, there were no girls on the baseball team anyway, were there? At least their child was at no risk of being molested by him. And so, for the sake of their boys' promising careers in the professional leagues, they would have written letters of petition, asking that the talented and hard-working coach's good character be taken into account.

The incense had burned nearly all the way down and Ilwoo was

처음 봤다. 김무진은 본 적 있었다. 운동장에서 우연히 잡은 공을 가져다주었을 때 최도영이 그렇게 웃으며 말했다. 이 맹랑한 놈 봐라. 최도영은 타격 연습을 하던 아이들을 불러모았다.

"손이 빠르다는 건 머리가 좋다는 거다. 이걸 봐라. 다른 애들처럼 공을 굴려주지 않고 나한테 직접 가져왔잖니. 감독이 누군지 잘 아는 거다."

김무진은 그게 칭찬받을 일이냐는 듯 아니꼬운 표정을 짓는 아이들의 눈치를 봐야 했다. "너 야구 해 볼래?" 최도영이 물었고 김무진은 고개를 끄덕였다.

"마침 둘이 같이 있었구나. 방금 일우 네 집에 다녀오는 길이야."

최도영의 말에 정일우가 깜짝 놀랐지만 입을 다물었다.

"어머니가 선생님을 도와주셨다. 네 말대로 참 좋은 분이시더구나. 음식도 잘 하시고, 예쁘시고."

최도영이 정일우를 향해 눈을 찡긋했다. 정일우가 움찔했다.

"할아버지는 어디 가셨니?"

김무진은 깜짝 놀라서 최도영을 쳐다봤다.

"친척 집에요."

"친척 집? 편찮으시다고 했잖아."

"편찮으셔서 가셨대요. 치료 받으려요."

정일우가 재빨리 거들었다. 김무진은 떨지 않으려고 주먹을 꽉 쥐었다.

"그래?"

그렇게 대구하면서 최도영은 현관에 놓인 낡은 신발을 빤히 쳐다봤다. 김동현의 신발이었다. 김무진은 뜨끔했지만 신발이 현관에 놓였다고 해서 그 사람이 반드시 집에 있는 건 아니라고 스스로를 달랬다. 최도영은 잠시 난감한 표정을 지었다가 표정을 부드럽게 바꾸고는 "안으로 좀 들어가도 될까?" 하고 말했다. 그제야 김무진과 정일우는 현관에서 몸을 비켜 자리를 내주었다.

getting ready to leave when the doorbell rang. Ilwoo stared at Mujin in fear. Neither of them moved. They thought all they had to do was keep quiet, but the living room light was visible from outside, making it hard to keep pretending that no one was home.

After a moment's hesitation, Mujin called out, "Who is it?"

"Mujin?"

The voice outside the door was loud. Ilwoo mouthed, "It's the Snake."

Coach Choi was smiling. Ilwoo had never seen the Snake smile so brightly. But Mujin had. When he'd returned the ball that he'd caught barehanded, Coach Choi had fixed him with an enormous smile. Kid's got moxie! He'd had everyone take a break from batting practice to circle up.

"Fast hands means a good brain. Look at that. He didn't roll the ball back to me like anyone else would've. Instead, he handed it to me directly. He knows who his coach is."

The other boys had pulled faces at this, as if to say, What was so impressive about that? Then Coach Choi had asked, "You wanna play ball?" and Mujin nodded.

"Oh good, you're both here," the coach said. "I just came from Ilwoo's house."

Ilwoo was alarmed to hear this but said nothing.

"Your mother helped your old coach out. She's as nice as you described. Good cook, and pretty, too."

Coach Choi crinkled his eyes at Ilwoo, who flinched.

"Where's your grandfather?" the coach asked Mujin.

Startled, Mujin stared at Coach Choi and said, "He's at a relative's house."

"A relative's house? I thought he wasn't well."

"He's there because he's not well," Ilwoo said, jumping in quickly. "For medical treatment."

Mujin clenched his fists to keep from shaking.

275

신발을 벗자 최도영의 발에서 냄새가 났다. 그러고 보니 그는 흰 셔츠에 넥타이를 매고 검은 양복을 입고 있었다. 잘 닦인 구두도 신고 있었다. 처음 보는 모습이었다. 그는 언제나 야구복이나 트레이닝복 차림이었다. 정일우는 도움을 구하려면 옷을 갖춰입어야 한다고 생각했고, 김무진은 온몸이 시커먼 게 장례식장에 가는 사람 같다고 생각했다.

최도영이 아이고 소리를 내며 좁은 거실에 주저앉았다. 정일우와 김무진은 그 앞에 무릎을 꿇고 앉았다. 최도영은 넥타이를 느슨하게 풀었는데, 두 사람에게는 편하게 앉으라고 말하지 않았다. 날이 더운지 최도영은 들고 있는 서류 봉투로 부채질을 했다. 거기에는 아마 야구부원들의 부모님을 찾아다니며 받은 탄원서가 들어 있을 것이다. 정일우는 엄마가 거기에 무엇이라고 썼을지 생각했다. 야구부를 그만둘 작정이라고 좀더 일찍 말하지 않은 게 분했다.

최도영은 집을 둘러봤다. 방 하나에 부엌 겸 좁은 마루가 있는 집이었다. 여기저기 널린 살림과 약봉지 같은 것을 일일이 살펴보듯 들여다보고는 질문을 던졌다. 친척 집이 가까운지, 얼마나 머물다 오실 예정인지, 거동을 못하신다더니 친척이 와서 모셔갔는지 하는 것들을. 외삼촌이 휠체어를 가져와 모셔갔다고 대답했더니, 외삼촌? 네 외삼촌이 친할아버지를? 하고 최도영이 두 번이나 되물었다. 그렇다고 대답하다가 김무진은 자신의 대답이 이상하다는 것을 알아차렸고, 그 실수 때문이 아니라 그렇게 할아버지를 모셔갈 외삼촌이라도 있었으면 좋겠다는 생각에 그만 울음을 터뜨렸다. 정일우가 김무진의 허벅지를 꾹 찔렀다. 김무진이 울음을 참으려고 큭큭거렸다.

최도영은 달래지도 왜 그러느냐고 묻지 않은 채 무표정하게 김무진을 쳐다봤다. 피로해 보였다. 김무진이 울음을 그치기를 기다렸다가 최도영이 입을 열었다. 처음 김무진이 운동장에서 맨손으로 야구공을 받았을 때 당장 재능을 알아봤다는 얘기부터 시작했다. 힐끔 정일우를 쳐다보기는

"That so?"

Coach Choi stared down at a pair of old shoes sitting inside the door. They were Grandpa Kim's. Mujin's heart was in his mouth, but he reassured himself that just because someone's shoes were sitting next to the door didn't mean that the person himself was at home. Coach Choi looked puzzled for a moment, but then his face softened and he said, "Mind if I come in for a bit?" Mujin and Ilwoo stepped aside to let him in.

Coach Choi took off his shoes. His feet smelled. Now that he was inside, they saw that he was wearing a black suit, a button-down shirt, and a tie. He'd even worn polished shoes. The boys had never seen him dressed like that. They only ever saw him in a baseball uniform or tracksuit. Ilwoo figured he'd had to dress up if he was going to go around asking for everyone's help; Mujin thought the all-black get-up made him look like he was headed to a funeral.

Coach Choi sat down with a groan in the tiny living room. Ilwoo and Mujin kneeled on the floor in front of him. Coach Choi loosened his tie but did not invite the two boys to sit more comfortably. It must have been hot outside, because he fanned himself with the manila envelope he carried. They assumed it contained the petition letters that he'd been collecting from the team members' parents. Ilwoo wondered what his mother had written. He was upset with himself for not having told her sooner that he planned to quit the team.

Coach Choi took a long look around. There was one bedroom, a kitchen, and the tiny living room. He seemed to be carefully examining the household items and medicine packets strewn about, he started firing questions at Mujin. Did their extended family live close by? How long was his grandfather planning to stay there? Didn't Mujin say his grandfather was bedridden? Then did this relative come to get him personally? When Mujin answered that his mother's brother had brought a wheelchair, the coach said, Mother's brother? Your mother's brother

했지만, 말을 멈추지는 않았다. 정일우의 장래성에 대한 얘기라면 이미 충분히 하고 왔을 것이다. 정일우의 엄마에게 말이다.

"올 가을 대회에는 너를 주전으로 세우려고 했어. 너를 좀 강하게 키우고 싶었던 거지, 오기를 심어주면서 말이야. 너한테 기회를 안 준 건 아니야. 이해하지?"

최도영이 침을 삼킨 후 말을 이었다. 가을 대회에 나가려면 지금 할아버지의 이름과 주민등록번호 같은 신상정보가 필요하고 무엇보다 도장이 필요하다고 했다. 최도영은 봉투에서 종이 한 장을 꺼냈는데, 거기에는 이미 뭔가 잔뜩 적혀 있었다. 맨 윗줄에 존경하는 판사님께 고합니다, 라고 쓰여 있었다.

"무진이 할아버지는 편찮으시니까 직접 쓰기 힘들 것 같아서 내가 대신 써왔어. 여기 적힌 말들에 동의한다는 의미로 할아버지 도장을 찍어가야 해. 할아버지가 계셨다면 당연히 흔쾌히 찍어주셨을 거야. 그렇지? 네 장래를 위해서 말이야."

최도영은 바닥에 내려둔 종이를 다시 봉투에 넣으며 명령조로 말했다.

"할아버지 도장 좀 가져와."

정일우가 다시 김무진을 꾹 찔렀다. 그렇게 하라는 것인지 말라는 것인지 헷갈렸지만, 김무진은 자리에서 벌떡 일어섰다. 미꾸라지와 이 집에 오래 같이 있어서 좋을 게 없었다.

김무진은 할아버지가 누워 있던 방으로 들어가 옷장 문을 열었다. 할아버지는 옷장 서랍 아래 칸에 이런저런 잡동사니를 다 넣어두었다. 거기에는 기초생활수급자증명서도 있었다. 할아버지는 증명서를 보물처럼 아꼈다. 내가 쪼그라든 걸 비밀로 해야 돈이 나오는데, 그 돈이 있어야 네가 학교도 다니고 야구도 계속 할 수 있다고 할아버지는 말했다. 무서워서 싫다고 했더니, 김동현은 그렇게 안 하면 김무진더러 고아원에 가게 될 거라고 했다.

도장은 없었다. 주민등록번호는 찾았다. 기초생활수급자증명서에 할

came to get your father's father? He asked it twice. Mujin said yes before realizing how strange his answer sounded, and the error made him think how nice it would be to have an uncle on his mother's side who would care for his grandfather like that, and he burst into tears. Ilwoo nudged Mujin in the side of the leg. Mujin tried hard to stop crying.

Coach Choi stared at Mujin, expressionless. He did not try to soothe him nor did he ask why he was crying. He looked tired. He simply waited for Mujin to stop crying before he began talking. He started with the story of how he'd immediately recognized Mujin's talent the day he caught that baseball barehanded. He glanced over at Ilwoo now and then, but he kept going. He'd probably already said his piece about Ilwoo's prospects. To Ilwoo's mother, that is.

"I was planning to put you in the starting lineup this fall. I just wanted to make you strong first, to instill a fighting spirit in you. I did not withhold any opportunities from you. You know that, right?" Coach Choi swallowed and added, "To get you in the lineup this fall, I need your grandfather's name and resident registration number, but most of all I need his seal."

He slipped a sheet of paper from the envelope. Something had already been written on it. It was addressed to Your Honor, Judge—.

"Since your grandfather's not well, I figured writing a letter might be too much for him, so I took the liberty of writing one for him. All he has to do is stamp his seal, right here, at the bottom, to signify his agreement. If your grandfather were home, I'm sure he would be more than happy to do so. Right? To ensure your future, I mean."

Coach Choi put the paper back into the envelope and said in a commanding tone, "Bring me your grandfather's seal."

Ilwoo poked Mujin again. Mujin wasn't sure if that meant do it or don't do it, but he hurriedly got up anyway. Nothing good could come of keeping the Snake in his house for long.

Mujin went into the room where his grandfather had lain and

아버지 이름과 함께 반듯하게 적혀 있었다. 아무리 뒤져봐도 도장은 보이지 않았다. 최도영에게 그렇게 말했더니 주민등록번호만이라도 적게 일단 증명서를 가지고 오라고 했다.

최도영은 자기가 써온 종이에 할아버지 이름을 적고 주민등록번호를 적었다. 도장을 못 찾겠으면 자신이 집에 돌아가는 길에 하나 새겨도 되겠느냐고도 했다. 김무진은 얼결에 고개를 끄덕였다. 최도영이 당장 집에서 나가만 준다면 뭘 어떻게 해도 상관없었다.

"그나저나 감독님이 가정 방문을 했는데 대접이 소홀하구나. 물이라도 내놓아야지. 목이 마른데."

최도영의 시선이 좁은 거실에 아무렇게나 쌓여 있는 냉장고 선반과 서랍에 닿아 있었다. 김무진이 수돗물 밖에 없다고 기어들어가는 목소리로 말했다. 최도영이 못마땅한 얼굴로 됐다고 말하며 자리에서 일어섰다. 현관으로 나가는 줄 알았는데, 최도영은 냉큼 방문을 열어보았다. 김무진은 깜짝 놀랐다. 정일우는 헉 하고 탄식했다.

방문을 연 최도영이 인상을 쓰며 코를 싸쥐었다.

"이게 다 무슨 냄새냐."

최도영이 코맹맹이 소리로 물었다.

"여기가 할아버지가 계셨던 방이냐?"

김무진이 고개를 끄덕였다.

"할아버지는 언제 가셨니?"

김무진과 정일우는 동시에 대답했다. 김무진은 어제라고 말했고 정일우는 아까라고 말했다. 그래? 최도영이 누구의 말에 대꾸하는 건지 알 수 없게 되묻더니 씩 웃었다.

"우리 할머니는 집에서 돌아가셨다. 그때 꼭 이런 냄새가 났지. 한평생 뭘 하며 살았건 죽어가는 사람한테는 똑같은 냄새가 난다. 그게 이상하지 않니, 무진아."

opened the closet door. There was a drawer in the bottom of the closet where his grandfather kept all sorts of random things, including his National Basic Livelihood Security Certificate. His grandfather treasured that certificate. He'd told Mujin that they had to keep his shrinking away a secret or the welfare payments would stop coming, and without that money, Mujin wouldn't be able to go to school or keep playing baseball. Frightened, Mujin had initially said no, but Grandpa Kim had told him that he would be sent to an orphanage if he didn't.

He found his grandfather's registration number in the drawer. It was printed right next to his grandfather's name on the National Basic Livelihood Recipient Certificate. But no matter how he searched, Mujin could not find his grandfather's seal. He explained this to Coach Choi, who told him to bring the certificate so he could copy down his grandfather's number for the time being.

Coach Choi added Mujin's grandfather's name and registration number to the bottom of the letter he'd written. Since they couldn't find the seal, he asked, would it be okay if he had one made on the way home? Mujin nodded on impulse. He didn't care what happened so long as it meant getting the coach out of his house right now.

"I have to say though," Coach Choi added, "This isn't much of a reception for your dear old coach who was kind enough to visit you at home. You should at least offer me something to drink. I'm thirsty."

Coach Choi ran his eyes over the refrigerator shelves and drawers stacked haphazardly in the small living room. His voice weak, Mujin told him all they had to drink was tap water. Coach Choi said never mind, his face clearly unhappy, and stood. He looked like he was about to leave, but instead he reached over and threw open the bedroom door. Mujin froze. Ilwoo gasped.

Coach Choi made a face and pinched his nose shut.

"What's that smell?" he asked, his voice coming out nasal. "Is this your grandfather's room?"

　최도영이 김무진을 돌아봤다. 김무진은 얼굴을 일그러뜨리지 않게 몸에 힘을 주었다. 정일우의 얼굴은 새파랗게 질려 있었다. 최도영은 방문을 닫고 아까처럼 아이고 소리를 내며 거실에 주저앉았다.

　"대학때 말이다. 학교 근처에 방을 구하는데, 시설이 좋고 방이 넓은데 값이 너무 싼 집이 있었어. 부동산 주인이 제일 나중에 그 방을 보여줬지. 낌새가 이상해서 물었더니 전에 살던 사람이 죽어나간 방이라고 일러주더라."

　최도영이 어깨를 으쓱하고는 말했다.

　"그건 흉이 아니다. 사람은 말이야. 다들 누군가 죽었던 땅에서 산다. 내가 아는 어떤 동네는 말이다. 오래 전에는 공동묘지였다. 아주 아주 오래된 얘기지만, 집을 지어야 하는데 땅이 없잖니. 그래서 봉분 위에다 집을 짓고 살았다. 돌이 모자라니까 비석을 가져다가 디딤돌로 쓰고 담으로도 쌓고…… 그렇게 지은 집에서 밥도 먹고 아기도 낳고 잠도 자고 그렇게 산다. 그 동네뿐이니. 이 나라는 전쟁 때 사람이 안 죽은 땅이 없다. 우리는 다 그 위에서 사는 거다."

　최도영이 말을 멈췄다.

　"사람은 고귀하지 않니. 어떻게든 살려고 애쓰지 않니. 자, 나를 봐라. 내가 살아 보려고, 응? 이렇게 더운데 검은 양복까지 차려입고 너희들한테 와서, 굽신거리면서, 응? 도장을 찍어야 한다고 그러잖니. 그러면서도 사는 거다, 사람은."

　최도영이 입을 다물었다. 정일우와 김무진도 잠자코 있었다. 침묵 속에서 소리가 들렸다. 냉장고 소리였다. 별스럽게 큰 소리는 아니었다. 워낙 오래되고 낡아서 일정한 간격으로 고약한 소리가 날 뿐이었다. 가만히 그 소리를 듣고 있던 정일우가 훌쩍이는가 싶더니 어느새 울음을 터뜨렸다. 김무진은 원래 냉장고에서 이런 소리가 났다고, 떨리는 목소리로 말해주었다. 최도영이 둘을 번갈아 보다가 김무진에게 물었다.

Mujin nodded.

"When did he leave?"

Mujin and Ilwoo answered at the same time. Mujin said yesterday, and Ilwoo said earlier today. That so? Coach Choi said and laughed. It wasn't clear which one of them he was responding to.

"My grandmother died at home," he said. "It smelled exactly like this. Funny. Doesn't matter how you spent your life, we all smell the same when we die. Isn't that strange, Mujin?"

Coach Choi turned to look at Mujin. Mujin tensed every muscle in his body to keep his face from falling. Ilwoo's face was turning blue. Coach Choi closed the bedroom door and sat down again with another groan.

"Back in college, I was looking for a room to rent near school. I found this one place. Nice amenities, spacious room, cheap rent. The real estate agent waited until the end to show it to me. That struck me as fishy, so I asked the agent what was wrong with the place. He told me that the last person who'd lived there had died in that room."

The coach shrugged and continued.

"It was hardly a deal-breaker. Thing about people is, we're all living on land that someone died on. There was this other neighborhood I heard about once. It used to be a cemetery. Now, this is a really, really old story, but they needed more houses but had no land to build them on. So they built houses on top of the graves. There weren't enough rocks, either, so they took the gravestones and used them as stepping-stones or stacked them to build fences. Then, in those same houses, they ate and had babies and slept and lived their lives. They were hardly the only ones. During the war, there wasn't a single square inch of this country that someone didn't die on. We're all living on top of them."

He paused again.

"It's not like we're all of some noble birth. We do what we have to do to survive, am I right? Take me, for example. I'm just trying to survive, aren't I? Here I am, on a hot day like this one, all decked out in a fancy

"냉장고가 평소에도 이렇게 요란했단 말이니. 그럼 고쳐야지. 보통 이렇게 큰 소리가 나면 말이다. 나는 이렇게 한다."

최도영이 일어서서 냉장고 옆으로 갔다. 정일우가 울음을 뚝 그치고 눈을 크게 떴다.

"냉장고 몸통을 이렇게 쳐주는 거야."

최도영이 냉장고 문을 세게 두 번 두드렸다. 냉장고를 칠 때마다 정일우가 몸을 흠칫 떨었다. 과연 소리가 조금 잦아드는 듯 했다.

"됐지?"

정일우가 고개를 끄덕였다. 최도영은 여전히 냉장고 옆에 서 있었다.

"이 냉장고는 너무 크구나. 낡은 게 문제가 아니라, 이 집에 어울리지 않게 커. 무진이 너는 곧 합숙에 들어갈 거고, 할아버지는 친척집에 있을 텐데, 이렇게 큰 게 다 무슨 소용이니. 그런데 이 안에 얼마나 큰 걸 넣으려고 저렇게 선반을 죄다 꺼내놨니."

최도영이 냉장고 문을 쓰다듬었다. 그러지 말라는 듯 냉장고 소리가 다시 커졌다. 최도영이 냉장고 손잡이에 손을 가져다댔다. 정일우는 눈을 꾹 감았고, 김무진은 자리에서 벌떡 일어섰다. 최도영이 천천히 냉장고 문을 열었다.

냉장고 안에서 냉기가 쏟아져나왔다.

black suit, groveling at your doorstep, yeah? Simply because they say I need signatures. That's what it takes to live."

He stopped. Ilwoo and Mujin were speechless. In the silence that ensued, they all became aware of a noise in the room. It was coming from the refrigerator. It wasn't unusually loud. It was simply an unpleasant sound, issuing at regular intervals, from a very old and battered fridge. As Ilwoo listened to it, his lip began to quiver, and just like that he was bawling. In a shaky voice, Mujin said that the refrigerator had always been that loud. Coach Choi looked back and forth at the two of them.

He asked Mujin, "You say it's always been that loud? Then you need to fix it. This is how I fix noisy fridges."

He got up and walked over to the fridge. Ilwoo stopped crying at once. His eyes widened.

"I give it a nice hard smack, like this."

He banged twice on the refrigerator door. Ilwoo's body shuddered with each blow. And yet, the refrigerator indeed seemed to quiet down a little.

"See?"

Ilwoo nodded. The coach remained standing next to the fridge.

"This refrigerator is way too big. The problem isn't that it's old, it's that it's too big for this place. Mujin, you'll be at baseball camp again soon, and your grandfather is staying with relatives, so you don't really need all this fridge space, now, do you? But what I really want to know is what you've got in here that's so big you had to pull all the shelves out."

The coach stroked the refrigerator door. The fridge grew louder, as if to say, don't touch. He placed his hand on the door handle. Mujin sprang out of his seat. Ilwoo shut his eyes tight. The coach slowly opened the fridge door.

The cold came pouring out.

<div style="text-align: right;">Translated from Korean
by Sora KIM-RUSSELL</div>

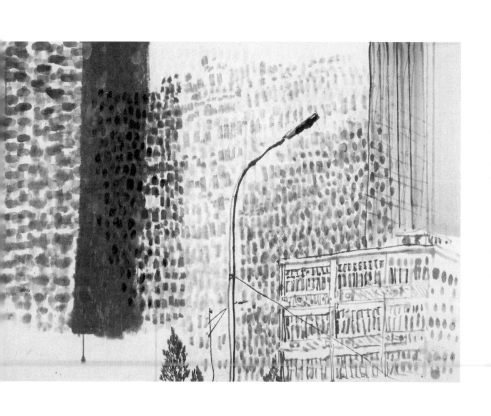

분홍빛 부산

마크 본 슐레겔

"과연 자살은 출구인가 또는 입구인가."

—랄프 왈도 에머슨

1

하늘은 '골목 게장'의 특정식과 같은 색을 띠었고 여느 해 보다 늦은 장마 때문에 날씨가 유난히 후덥지근했다. 석양과 횟집 네온사인이 어우러져 지난주 내내 남포동을 안개 자욱한 런던으로 만들었던 비구름을 사탕색으로 물들였다. 일본계 혼혈인 노숙자 삼희에 대한 전화를 받고 출동한 팔 형사와 대권 형사가 부산본부세관 건너편 부산항만공사 옆에 차를 댔다. 내일모레 일흔 일곱인 노인은 대개 수미르 공원의 지정벤치에서 잠을 청했다. 두 형사가 그를 발견했을 때, 그는 언제나처럼 하늘을 향해 고개를 들고 눈을 가늘게 뜬 채 상상 속 그림에 골몰해 있었다. 부산 해안가를 가득 메운 이름 모를 낚시꾼 중 한 명이 그가 이미 죽었다고 착각하고 신고한 것이다.

두 형사는 그를 자게 내버려 두고 동쪽 해안가를 따라 걸어갔다. 주변에는 단 한 명의 해양경찰도 보이지 않았다. 수미르 공원은 일본이나 필리

288

Busan *en Rose*

Mark von SCHLEGELL

"The question is whether
suicide is the way out or the way in."
—Ralph Waldo Emerson

1

The sky was the color of the crab special at Golmok Gejang (골목게장). With monsoon season going later than ever, it was warmer than it should be. This evening the nimbus that had been making Nampo-dong a foggy London for a week now was lit to candy color by collaboration between the sunset and the neon lights of seafood joints. Detectives Pahl and Dae-gwon had parked by the Busan Port Authority, across the harbor from Busan Main Customs. They were personally taking care of a call about old Sam-Hee, the half-Japanese vagrant now approaching his seventy-seventh year, who most days made a particular bench on the way to Sumireu Park his bed. They found him facing the sky as usual, squinting at pictures in his mind. He had been mistakenly reported dead by one of the strangers now thronging all of Busan's waterfront to fish.

핀에서 도착하는 여객선 선착장 옆에 자리하고 있었다. 팔 형사는 회색 후드 스웨터와 작업용 바지, 운동화 차림이었고, 야구모자를 쓴 대권 형사는 가벼운 유틸리티 재킷에 카키 팬츠를 입고 있었다. 그저 산택중인 평범함 남자와 다를게 없어 보였지만, 전 세계 다섯 번째 규모의 항구에서 활동하는 소매치기, 마약중독자 그리고 밀수업자들은 팔 형사의 선글라스와 둘의 어딘지 조심스러운 걸음걸이에서 그들이 형사임을 단박에 알아차렸다. 최근 관세 문제로 인해 국제 해상 물동량이 한 달 넘게 전면 중단된 상태였다.

출항하는 여객선, 선착장의 경찰선, 지나가는 화물선이 모두 보이는 장소였다. 오늘 같은 저녁엔 비교적 한산했어야 했지만 해안가는 마치 성수기가 된 것처럼 붐볐다.

이유는 바로 물고기 때문이었다. 신기하게도 안개가 물고기를 함께 몰고 왔다. 생물학자들에 의하면 바닷속 어떤 사건으로 겁을 먹은 물고기들이 영도동의 수로로 몰려들었다고 한다. 항구는 휴식에 들어갔지만 은퇴자들은 더 이상 사회적이고 형이상학적인 이유로 이곳을 방문하지 않았다. 따뜻한 계절 내내 도시 가장자리에서 낚시를 하며 시간을 보내던 그들은 이제 물고기를 잡고자 하는 욕망에 사로잡혔다. 지난 일주일 간, 낚시꾼들은 이 항구에서 원 없이 물고기를 낚아 올렸다. 오징어, 문어, 까나리, 상어, 뱀장어. 그리고 근방 지역에서 오랫동안 멸종된 것으로 여겨졌던 지역 특산 대구도 떼로 돌아왔다. 아직 개방된 수로가 깨끗하게 유지되는 도시 이 쪽에서는 보이지 않지만 수백 척의 아마추어 어선들이 항구로 향하는 다른 진입로를 꽉 막고 있었다.

자정에 선언될 접근금지령을 앞두고 오늘이야 말로 절정을 향해 치닫는 날인 듯했다. 부산 해안선을 따라 발 디딜 틈 없이 낚시가 성황이었다. 은빛으로 요동하며 수면으로 치켜 오르는 물고기에 각각의 낚싯대가 크게 휘었다. 여기저기 가득 찬 양동이가 절로 미소를 자아냈다.

The detectives let him sleep, and walked along the eastern waterfront. Maritime had its own cops, but none were visible. The park served the docks where passenger liners arrived from Japan or the Philippines. Pahl wore a grey hooded sweatshirt over anonymous working pants and sneakers. Dae-gwon wore a baseball cap tipped up, a light utility jacket, and khakis. Two everymen out for a stroll, only Pahl's evening shades and something about their cautious lope made them stand out as cops to the pickpockets, junkies, thieves, and smugglers' lookouts always about in the world's fifth-largest industrial seaport. The recent tariff TIFs had caused international port traffic to cease entirely now for more than a month.

This spot to watch departing liners, docked police launches, and passing freight should have been relatively empty this evening. But the waterfront was as crowded as if it was high season.

It was because of the fish. They had come mysteriously, with the fog. Biologists were saying an underwater event had frightened them into the channels formed by Yeongdo. Even in the harbor recesses here, the retirees who passed the warm weather away fishing from the edge of the city no longer came for metaphysical and social reasons. Now the desire for fish drew them; fishers had been pulling in as much head as they liked from the harbor for a week now. Squid in great numbers; octopus; sandlance; shark; eel. The local haddock, long thought to be extinct in these parts, had returned in great numbers. You couldn't see it on this side of the city, whose channels were still kept open and clear; but hundreds of amateur fishing vessels had clotted up the other approaches to the port.

Tonight things seemed to be climaxing, as a moratorium was to be declared at midnight. Along the rim of all Busan, there wasn't a free space left to fish. Every rod was currently curling with dancing fish swinging the silvery booty to the shore. Smiles were broad and buckets were full.

저녁 시간. 이미 한 시간 넘게 초과근무를 한 팔 형사와 대권 형사는 서둘러 퇴근하고 생선요리나 먹으러 갈 생각이었다.

그러나 곧이어 둘의 수신기가 동시에 울리는 순간, 두 형사는 꼼짝 없이 걸려들고 말았다.

<p style="text-align:center">2</p>

"21호, 신속히 이동 바람." 본부에 있는 지연의 목소리였다. "대령님이 기다리고 계십니다." 대령님이 오늘? 지금 이 시간에? 심각한 상황이었다. 운전대를 잡은 팔 형사 옆에서 대권 형사가 담배를 꺼내 물었다.

낡은 기선 누리마루는 마치 애니메이션에 나오는 유령선 같았다. 분홍색 안갯속에서 경찰 사이렌이 푸르게 빛났다. 도로가 마치 강처럼 그들 앞을 가로막았다. 팔 형사가 사이렌을 켠 채 롯데백화점 출구 옆 반대 차선을 탔다. 몇 안 되는 쇼핑객들만이 떠나는 시간대였다. 무용지물의 백화점 주차요원이 거리에 서서 머리에는 검은 중절모를 쓰고 손에는 흰색 장갑을 낀 채 임무를 다하고 있었다. 그의 도움을 필요로 하기에는 출차하는 자동차의 수가 너무 적었다. 하지만 주차요원의 동작은 자동차들을 꼭 두각시처럼 조종하는 것 같았다. 두 형사가 반대 방향으로 통과하는 순간, 주차요원의 무심함 속에 완벽한 조화가 공존하는 듯했다. 21호는 빛의 속도로 빨간불을 뚫고 중앙동 거리를 향해 달렸다. 버스, 밴, 허기진 통근자들이 사방에 들끓었다.

팔 형사는 스스로를 세상에서 가장 으뜸가는 운전자 중 한 명이라 여겼다. 약 3분 후, 3차선 도로가 만나는 지점에 위치한 부산중부경찰서 앞에 21호 차가 휙 돌아서 수월하게 제 자리로 들어갔다.

5층짜리 중부경찰서 건물은 앞에 펼쳐진 그 어떤 도로에도 순응하지 않겠다는 듯 결의에 찬 모습이었다. 국제경찰 기준에 따라 미국 점령기

It was evening. They were already overtime by more than an hour and were ready to knock it off and eat some fish themselves.

But their radios simultaneously squawked, and Pahl and Dae-gwon were the hooked ones.

2

"Pronto, Van 21," Ji-Yeon announced from station. "The Colonel is waiting." The Colonel today? At this hour? It was serious. Pahl drove; Dae-gwon smoked.

The old steamer *Nurimaru* looked like an anime ghost ship. Sirens flashed blue against the pink fog. Pahl pulled out, but the always-flowing highway blocked their way like a river. With sirens, he went up the wrong-way lane beside the exit from Lotte Department Store. Only a trickle of shoppers were leaving at this hour. The unnecessary traffic director hired by the store stood performing on the street, in a black bowler hat and clean white gloves. Though the cars leaving the store were too few to need assistance, his dance seemed to move them like his personal marionettes. He appeared both oblivious and in perfect synch with the passing of Pahl and Dae-gwon the wrong way through his world.

They moved like lightning, blasting their way through red lights up towards the avenue of Jungang Dong, seething with buses and vans and hungry commuters going every which way.

Pahl considered himself, at his age and experience, one of the finest drivers currently on the planet. Feet on the floor, hands on the wheel, he spun and braked them easily into Van 21's slot right in the delta at the open meeting of three directions that fronted Busan Jungbu Police Station three minutes later.

Squat five-story Jungbu Police Station building oriented itself toward its command, as if not to conform to any the avenues it fronted.

에 완공된 이 건물은 매해 흰색과 청색으로 새로 페인트칠 되었다. 건물이 간직한 고전적인 진중함이 네온 불빛에 의지하는 부산의 밤에 조직, 상식 및 민주적 정의의 정신을 불어넣었다. 꼭대기 층의 유치장에서는 한 때 광안대교 너머 바다까지 훤히 내다보였다. 하지만 오늘날 새로운 투자에 힘입어 탈바꿈한 시내의 고층 호텔과 은행이 그 전망을 가로막고 있었다.

부산중부경찰서는 도시의 가장 가파른 언덕을 등지고 있었다. 때문에 주눅이 든 모습은 아니었고 되려 정남향을 바라보며 호텔 무리에 맞서 우위를 뽐냈다.

근무 중이던 두 명의 젊은 경찰 여 경관과 짝 경관이 지나가는 형사들을 향해 히죽 웃었다. "대령님이 기다리고 계세요." 아무것도 묻지 않았는데 여 경관이 먼저 입을 열었다.

대령님은 사실 진짜 대령은 아니었다. 하지만 열세 살 어린 나이에 전쟁에 참전한 경험이 있었고, 사람들에게 늘 그 사실을 상기시켰다. 형사들이 방에 들어서자 그는 읽고 있던 한문책을 덮었다. "도대체 어디를 싸돌아 다닌 거야?"

"해안가에서 잘못 들어온 신고 확인하고 왔습니다."

"그건 해양경찰 소관이지 우리가 알 바 아니야. 니들이 젠체하는 거 내가 모를 줄 알아? 이 팀이 부산에서 제일 실적이 안 좋아."

두 형사는 어깨를 으쓱했다. 삼희는 오랜 기간 그들에게 정보를 제공해 준 고마운 사람이었다. 즉, 삼희를 보살핀다는 것은 성공적인 범죄 예방의 징표이기도 했다. 하지만 여기서 항의해서 무엇하겠는가? 대령의 태도는 지극히 전형적인 것으로 그들을 둘러싼 건물에 이미 내재되어 있었다. 형사들은 살아가면서 절대 구세대를 만족시킬 수 없음을 알았다. 다만 그 불가능한 기대치에 부응하기 위해 고군분투할 뿐이었다.

"새로운 사건이 하나 있어. 아일랜드인 한 명이 사라졌다. 명목상 휴가가 아닌 출장차 한국에 와서 어제 출국 예정이었는데 아직 떠나지 않았다.

It was built during the American occupation, according to international police standards. Painted a fresh white with blue trim yearly, the classically no-nonsense building projected organization, common sense, and democratic justice into a presumed infringing neon-lit Busan noir. The top floor holding cells once commanded a view all the way past Gwangan Bridge to the East Sea. Today that view was off by the wall of high-rise hotels and banks with which new investment had transformed downtown.

The station backed the steepest hillside in the city, so it wasn't like it was intimidated. Its orientation directly south showed superiority to the herd like hotels.

On duty up front, young officers Yeo and Jjak smirked as the detectives passed. "He's waiting for you," Yeo said, though they hadn't asked.

The Colonel wasn't really a colonel. But he had served in the war; even as a thirteen-year-old kid; and he made sure you remembered it. He closed up the Chinese book he was reading when they came in. "Where the fuck have you been?"

"Checking out a false stiff at the waterfront."

"That's maritime; not our concern. You don't think I know you're wising off? You have fewer arrests than any team in the city."

They shrugged. Sam-Hee was a long time informant and a good guy. Their looking out for Sam-Hee was a sign of their success preventing crime. But why protest? This attitude was typical from the Colonel and built into the structures around them; they would never be good enough for any of the older men in their life. Their generation was expected to struggle to live up to expectations that they could never satisfy. Give one of Chang-sub's and Bae-il's cases to them.

"I have a job for you. There's a disappeared foreigner, an Irishman. He's nominally here on business, not pleasure. He was supposed to leave yesterday. He never did. Now I don't want the Tourist Police creeping in on our territory this time. He is a writer or artist. Invited

이번엔 관광경찰이 우리 구역에 슬금슬금 끼어들게 해서는 안 돼. 실종자는 작가 혹은 예술가이고 2020부산비엔날레 측의 초대로 한국에 왔다. 그 미술행사 말이야. 아직 2019년인건 알지만 여기엔 2020년이라고 되어 있다. 공상과학 소설을 쓴다니까 아마도 일종의 예언적 내용으로 생각된다. 아무튼 부산비엔날레가 부산국제영화제와 비슷한 맥락이라면, 당최 어떤 종류의 창작물인지 알 길이 없다. 부산 영화체험 박물관에 있는 그 이탈리아인 손도장 기억나지?"

대권 형사가 미간을 찌푸렸다. 진심으로 말하는 건가?

"다리오 아르젠토요?"

"경고하는데 그런 영화는 안 보는 게 좋아. 아무튼 이 사건을 우리가 맡게 되었다. 내 명예를 걸고 즉시 찾아야 해. 이제 너희들 손에 달렸어. 실종자를 찾아서 오늘 밤 귀가 전까지 깔끔하게 해결하도록."

대령의 지시에 두 형사는 할 말을 잃었다.

"정신 차려, 이 멍청이들아. 간단한 문제야. 실종된 아일랜드인은 한국어를 한 마디도 못할뿐더러 생선, 계란, 돼지고기를 먹지 않아. 여기 부산에서는 하늘을 나는 닭처럼 튈 수밖에 없지. 일단 텍사스촌으로 가서 그가 어느 구석에 처박혀 있는지 찾아 빼내 와. 그다음에 며칠 쉬게 해 주지."

대령이 파일을 내밀었다. "이걸 읽어보도록. 아래층 지연이 최신 정보를 갖고 있을 거야."

3

팔 형사와 대권 형사는 대령이 나가길 기다렸다가 파일을 집어 들었다.

실종자의 이름을 확인하고 입국 사진에 담긴 꾀죄죄한 50대 백인 남성의 모습을 살펴보았다. 흐릿한 눈, 반쯤 자란 턱수염, 어리둥절한 표정. 인터넷에서 찾은 또 다른 사진에서는 검은색 뿔테 안경을 쓰고 있었다. 어

here by the Busan Biennale 2020, the fine arts event. I realize it's 2019, but it does say 2020. He writes science fiction, so perhaps it's some sort predictive text. Anyhow, if Busan Biennale is anything like the Busan International Film Festival, there's no telling what sort of creative we're dealing with here. Remember the Italian whose handprints are down by the Busan Museum of Movies."

Dae-gwon furrowed his brow. Was he serious? "Dario Argento?"

"Don't watch those films, I'm warning you. Well, I've made it our case. It's on my honor he's found right away. Now it's your problem. I want him found, and this whole business cleared up before you go home tonight."

They were both stunned by the timeline.

"Buck up, you losers. It should be simple. The Irishman doesn't speak a word of Korean; he doesn't eat fish, eggs, or pork. He will stand out in Busan like a flying chicken. Go to Texas Street, pry him out of whatever hole he's stuck in. Then you can get your days off."

He held out a file. "Read up here. Ji-Yeon will have the latest downstairs."

<p style="text-align:center">3</p>

Pahl and Dae-gwon waited for the Colonel to leave before taking up the folder.

They looked at the name, and the picture of the scruffy fifty something Caucasian male snapped by the border patrol on entry. Watery-eyed, semi-bearded, confused. Another pic from the internet showed him in black horn-rimmed glasses. They presumed he looked every inch the Irish writer abroad. They saw the words "literary activist."

The Colonel's hand scripted across in bold sharpie:

Doesn't smoke or drink.

느 모로 보나 아일랜드 작가다운 모습이었다. "문학 운동가"라는 두 단어
도 눈에 들어왔다.

대령이 굵은 사인펜으로 적어둔 내용도 있었다.

비흡연자, 비음주자.

근데 왜 텍사스촌으로 가라고 한 걸까?

아래층, 마지막 남은 윗사람들까지 퇴근한 가운데 경찰서는 평상시와
같은 야간 모드로 접어들었다. 포근한 날씨와 풍부한 물고기 떼가 근방
지역에 흔치 않은 평화를 선사했고 장마 이후로 통행금지나 특별 감시가
없었다. 하지만 내일이면 모든 게 바뀔 예정이었다.

"아일랜드 이름 같지가 않은데." 짝 경관을 지나치면서 대권 형사가 말
했다. 짝 경관은 두 형사보다 키가 컸음에도 불구하고 훨씬 젊어 보였다.
빳빳한 청색 유니폼을 입은 그가 한 마디 거들었다.

"덕덕고에 따르면 미국인이라죠."

팔 형사와 대권 형사가 발을 멈췄다. 그 둘은 현재 여기서 가장 상급 경
찰관이었다. 이미 이미 군기가 빠지다 못해 이 꺽다리 경관 짝이 너무도
편한 말투로 둘의 대화에 끼어든 것이다. "미국의 공상과학 작가이자 문
학평론가" 짝 경관이 말을 이어 나갔다. "거주지는 독일 그리고……"

"짝 경관!" 팔 형사의 갑작스러운 말투에 짝 경관이 화들짝 놀랐다.

"내가 먼저 말을 걸기 전까지는 입을 열지 말게. 알겠나?"

"네, 물론이죠. 근데 우리……"

"조용!" 대권 형사가 거들었다. "작가는 뉴욕 출생이고 따라서 이중 국
적자이다. 하지만 아일랜드 여권으로 입국하였기에 여기선 아일랜드인으
로 친다. 그리고 덕덕고 좀 쓰지 마 이 멍청아. 우리는 경찰이다. 우리가 하
는 모든 일을 기록해 둘 필요가 있어."

Then why tell them Texas Street?

Downstairs, with the last of the old men gone for the day, the station had passed into an ordinary night mode. The mild weather and the fish bounty had brought unusual peace to the neighborhood. No curfew had been called or special watches since the Monsoon. Tomorrow that would all change.

"That doesn't seem like an Irish name," Dae-gwon was saying as they passed by officer Jjak. Jjak was taller than both, but looked far younger in his crisp blue street uniform. He said:

"Duckduckgo says he's is American."

Pahl and Dae-gwon stopped. The way they saw it, they were just now the most senior cops in the station and regulations had already relaxed to the point that tall, nerdy Officer Jjak was interrupting their private conversation in informal dialect. "American science fiction writer and cultural critic," he continued. "Lives in Germany and…"

"Officer Jjak!" Jjak jumped at Pahl's sudden tone. "You will speak when spoken to—do you understand."

"Yes. Of course. But we…"

"Silence," said Dae-gwon. "The writer was born in New York and therefore a dual citizen. But he is here on an Irish passport. That makes him an Irishman. And don't use duckduckgo, you idiot. We are police. We need to keep a record of everything we do."

They waited. Though he wanted to tell them it was actually now he who kept record of the search, and not duckduckgo, therefore it could be trusted more not less, Jjak kept his mouth shut. "Yes, sir," he nodded.

"That K-pop haircut looks ridiculous on you."

Pahl and Dae-gwon felt better as they approached the front desk, where Ji-Yeon sat womanning the phones, two operators manning leftovers behind her, their pod ensconced behind a countertop bristling with defensive trinkets including stuffed animal police officers. Officer Yeo was there also (not her post) reading some additions to their file.

두 형사가 답변을 기다렸다. 짝 경관은 사실 덕덕고가 아니라 자신이 검색 기록을 담당하고 있고 따라서 더 믿음직스럽다고 말하고 싶었지만 잠자코 있었다.

"네, 형사님." 짝 경관이 고개를 끄덕였다.

"그리고 그 케이팝 머리스타일 정말 우스꽝스럽기 짝이 없다."

한결 기분이 나아진 두 형사가 프런트로 향했다. 거기에선 지연과 두 남자 직원이 전화기를 지키고 있었다. 카운터에는 경찰 모양의 봉제 동물 인형을 포함, 여러 장식품이 즐비하게 놓여 있었다. 여 경관이 그곳에서 사건의 추가 정보를 살펴보고 있었다.

"자살일 수도 있어요." 가까이 다가온 형사들에게 그녀가 말을 건넸다. "작가들이 유명세를 얻기 위해 그러지 않나요?"

팔 형사가 서류를 낚아채면서 말했다. "여 경관, 당신 아직 형사가 아니야. 밖에서 명령을 기다리도록."

여 경관이 혀를 날름 내밀어 보이고 이내 자리를 떴다. 확실한 건 두 형사 때는 그런 식의 장난이나 무례한 행동이 절대 용납되지 않았다는 것이다.

다음은 지연에게 질문할 차례였다. "대령님이 그 아일랜드인을 그토록 열심히 찾는 이유가 뭘까?"

얼마 전에 관광경찰이 더 많은 지원금을 확보했다는 소식이 있었거든요. 우리 쪽 체포 실적이 미미해서 화가 나신 거죠. 우리 경찰서에 이 사건을 넘기라고 직접 요구하셨어요. 실종자가 관광객이 아니라 넓은 의미에서 부산시를 위해 일하는 사람이니까요. 대령님은 마약 건수이길 바라는 듯해요. 대마초 같은 거요. 듣자 하니 사이키델릭한 작가래요. 첫 번째 책에서는 식물을 다루었고요."

여기까지 말하고 그녀는 인터넷 댓글을 하나 읽어주었다.

"이 책을 통해 마약을 끊은 후로 가장 LSD에 근접한 경험을 하였다."

"Maybe he killed himself," she said, as they approached. "Don't writers do that to get famous?"

Pahl snatched the papers from her. "You are not yet a detective, officer Yeo. Go wait outside for orders."

She stuck out her tongue. But went anyway. Pahl and Dae-gwon had once themselves done her detail. And you can be sure there was none of this wise-cracking, or disrespectful behavior permitted back then.

They came to Ji-Yeon. "Why does the Colonel want the Irishman found so passionately?"

"He heard the Tourist Police just got more funding. He's sore we have so few arrests. He demanded this case for our station, as the guy was not a tourist, but in a roundabout way working for the city. I think he's hoping for drugs, maybe some kind of marijuana situation. This is apparently a psychedelic writer. His first book concerns a sentient plant." She read from an internet comment: "this book was the closest thing I've gotten to LSD since giving up drugs."

"Says he doesn't smoke or drink on our file."

"Smoke what? Maybe you really are the laziest detectives in the Korean Peninsula."

"Give me a break! We're not lazy! We're good; if given a level playingfield, we'd be better!" The best, they both thought. On the job, Pahl and Dae-gwon were as close friends and collaborators as it was possible to be. Sandwiched between the domineering points of view of two ambitious generations, able to work with either, their perfect agreement with one another, despite their different personal styles, attitudes and opinions on most things, a true *égalité*, resulted in a more efficient team than any on the force.

"Maybe this is your chance. I'm doing what I can to help. We've got a bulletin out to all departments with his picture and stats. However, there's a situation developing with the sellers at the Jagalchi Market."

"They should be closed up now."

"파일에는 흡연도 음주도 하지 않는다고 적혀 있어."

"정확히 뭘 안 피운다는 거죠? 두 분은 아마 아시아에서 가장 게으른 형사일 거예요.

"적당히 해. 우리는 게으르지 않아! 우린 둘 다 실력자야. 공평하게 경쟁할 수 있다면 더 좋은 결과를 낼 거라고!" 그들은 자신들이 최고의 성과를 낼 수 있을 거라 믿었다. 업무에 임할 때, 팔 형사와 대권 형사는 서로에게 둘도 없는 친구이자 협력자였다. 고압적이고 야심만만한 두 세대 사이에 끼어서 양쪽과 손을 잡은 그들은 각자 다른 스타일, 태도, 의견에도 불구하고 서로 간에 완벽한 합의와 진정한 평등을 이끌어냈다. 결론적으로 그 누구보다 효율적인 팀을 이루었다.

"어쩌면 좋은 기회일지도 몰라요. 제가 최대한 도울게요. 실종자의 사진과 신상정보를 전 부서와 공유했어요. 근데 지금 자갈치 수산시장 상인들 사이에서 좀 시끄러운 문제가 생겼어요."

"지금 이미 문 닫았을 시간인데."

"생선 가판대는 아직 열었어요. 보고에 따르면 생선 판매를 거부하고 있다고 하니 일종의 파업이나 시위가 발생한 걸 수도 있어요."

"해양경찰이 맡으면 되겠네."

"신고 전화를 전달하고 있는데 전화기가 계속 울려요. 해양 쪽에서도 한꺼번에 다 조사하기엔 역부족일 거예요. 사하동 밀수 건만으로도 이미 초과근무 중인걸요. 그리고 그 사이에 송도 해수욕장에서 무언가 발견되었어요. 어쩌면 이 혼란을 이용하려는 북한 잠수함일지도 모르죠. 오늘 좀 별난 야간 근무가 되어가고 있네요"

형사들은 1층 집합실로 돌아가 머리를 맞대고 고민했다.

실종된 작가는 일주일 전 일요일 오전에 도착하여 곧바로 크라운 하버 호텔로 이동했다. 그리고 아직까지 호텔에서 체크아웃을 하지 않았다. 자신의 작품에 대한 강의를 하기 위해 기차로 서울로 올라가 1박을 했고 이

"The live fish stands have stayed open. There's no question of per-mits as other reports confirm they are refusing to sell fish as well. There may be some kind of strike or protest developing."

"Maritime will want it."

"I'm forwarding calls, but they still keep coming in. I'm not sure they have the resources to be everywhere at once. In the fog, the smuggling situation over in Saha-gu has them working overtime. Meanwhile, there's been some sort of sighting off Songdo Beach, per-haps a North Korean submarine exploiting the confusion. Not your ordinary night on the phones."

They put their heads together back in the first-floor squad room.

The writer had arrived on Sunday morning, a week ago, and imme-diately came to the Crown Harbor Hotel. He had never checked out of the hotel. He had taken the train to Seoul to give a lecture on his own work, and spent a single night there. He'd returned for a final day in Busan, due to fly out the next early afternoon.

They could see the Crown Harbor Hotel out the window; across where Jung-Ang Avenue was wider than the Nakdong River. In the reflection against the windows, the white chairs in the squad room reflected like comical teeth under pink gums.

<p style="text-align:center">4</p>

At the hotel, the security chief was waiting for them. "He exited at 11:22 a.m. this morning and never returned. He was packed and ready to go. It seems he received a phone message the day before. I'm sorry but no one remembers taking it, only the front desk worker does recall it waiting for him."

He gave them the contents of the writer's safe: Seventy euros in cash. And a red-covered passport, imbued with a golden harp.

"And give us the key. We'd like to go up alone."

어서 부산으로 돌아와 마지막 하루를 보낸 후, 그다음 날 이른 오후 비행기로 출국을 앞두고 있었다.

형사들이 창밖으로 시선을 돌리자 낙동강보다 넓은 중앙대로 건너편 크라운 하버 호텔이 보였다. 집합실의 흰색 의자들이 마치 분홍색 잇몸 아래 자리한 우스꽝스러운 치아처럼 창문에 반사되었다.

4

호텔의 보안 책임자가 형사들을 맞이하였다. "손님은 오늘 오전 11시 22분에 나가서 돌아오지 않았습니다. 짐 싸고 떠날 준비는 완료한 상태였어요. 전날 전화로 메시지를 하나 전달받은 모양인데 죄송하게도 내용은 모르겠습니다. 메세지가 온 사실만 프런트 직원을 통해 확인했어요."

그가 작가 방 금고에 들어있던 내용물을 건넸다. 현금 70유로와 황금 하프가 새겨진 붉은색 여권.

"열쇠 하나 주시죠. 저희끼리만 올라가서 조사해 보겠습니다."

엘리베이터가 끝없이 올라갔다. "이 위키백과 자료에는 내가 한 번도 본 적 없는 면책 조항이 포함되어 있어." 대권 형사가 말했다. "'본 글의 주제는 위키백과의 전기 관련 지침을 충족하지 않을 수도 있다'라니 이상한데? 만약 그가 정말 5권 이상의 책과 영화 대본을 낸 작가이자 교수라면 말이야. 박사학위도 있다고 나와 있군."

두 개의 여권, 다섯 권의 책, 미심쩍은 온라인 정체. 1967년 뉴욕 출생의 작가는 그들과 같은 X세대의 반대편 끝자락에 걸쳐져 있었다.

카드키를 갖다 대자 1823호실의 문이 열렸다.

큰 더블 침대가 있는 1인실이었다. 한국 고층 건물에서 흔히 볼 수 있는 단조롭고 따분한 구조였다. 한 가지 축복은 정서향의 넓은 창을 통해 서구로 향하는 언덕이 내다보인다는 것이었다. 비록 바다 전망은 아니

The elevator was interminable. "The Wikipedia printout includes a disclaimer I've never seen before," Dae-gwon said. "'The topic of this article may not meet Wikipedia's notability guideline for biographies.' Odd, that if he really is the author of at least five books, a number of film-scripts, a professor, and more. Claims to have a ph. D. too."

Two passports, five books, a questionable online identity. The writer was the other end of their own generation X, born 1967—in New York City.

Room 1823 opened to their card key.

The room was a single with a large double bed; it was plain and typically dull for a Korean high-rise. The blessing was the broad window looking up the hill to Seo-gu directly west. Though not a sea view, tonight the sunlit fog was impressively pink.

The Irishman had left his suitcase fully packed. It was a large roller and lay open on the floor by the window. The writer had gone out so that he could return, add a few last stray objects, zip up and depart quickly.

One side of the luggage contained carefully packed underwear, socks, shirts, a sweater and a raincoat. The other side was a more chaotic affair. Six lurid paperbacks in English, Ralph Waldo Emerson, science fiction and crime; a notebook with some observations written down, including some Korean phrases, an electric razor, a toiletry kit. Haphazard indecipherable English script filled up some pages. Vitamin B. No medications.

"No computer. He must have had that with him."

There was, however, a single shoe. A black left shoe men's size 23 European. It was by NIKE but was lace-less, a sort of sneaker-boot. In Pahl's hands looked like it was for the foot of a giant. Inside it said: NDESTRUKT. They checked under the bed, in the various closets, in the bathroom. The other shoe could not be found.

Dae-gwon called in the lady cleaning the next door room. Mrs. Soo

었지만 오늘 저녁 햇빛을 머금은 안개가 인상 깊은 분홍빛으로 물들어 있었다.

아일랜드인은 짐을 다 꾸려 두었다. 바퀴 달린 커다란 여행가방이 창가 앞 바닥에 펼쳐져 있었다. 방으로 돌아와서 몇몇 남은 물건을 챙기고 신속하게 떠날 생각으로 밖에 나간 것이리라.

가방 한쪽에는 꼼꼼하게 접은 속옷, 양말, 셔츠, 스웨터와 우비가 놓여 있었다. 다른 쪽은 보다 무질서했다. 요란한 표지의 영어책 6권, 랄프 왈도 에머슨, 공상과학과 범죄 소설, 몇몇 한국어 문구 등 관찰 내용이 적힌 공책, 전기면도기, 세면도구, 어지럽게 휘갈긴 이해불가의 영어 글씨 몇 쪽, 비타민 B. 별다른 약품은 없었다.

"컴퓨터가 없군. 틀림없이 갖고 있었을 텐데."

대신 신발 한 짝을 발견했다. 남자 유럽 23 사이즈의 검은색 왼쪽 신발. 나이키에서 만든 일종의 운동화였다. 팔 형사의 손 안에서 그것은 마치 거인용 신발 같았다. 안쪽에는 NDESTRUKT라고 적혀 있었다. 그리고 침대 밑, 옷장, 욕실 그 어디에서도 나머지 한 짝은 찾을 수 없었다.

대권 형사가 옆 방에서 청소하던 아주머니를 불렀다. 북한 출신의 수 여사는 지난 30년간 부산에서의 삶을 감사히 여기며 다시 일을 하고 있었다. 그녀는 이틀에 한 번 14시에서 20시 사이에 이 층을 청소했는데 아일랜드 작가를 몇 번 마주쳤었던 그녀의 기억에 따르면 그는 대부분 오후에 다시 들어왔다가 저녁에 다시 외출했었다. 종종 오전 내내 방에서 작업을 했기 때문에 이 방 청소는 오후로 남겨두곤 했다는 것이다.

"어떤 사람이었나요? 술을 마시거나 담배를 피웠나요? 마약은요?"

그녀가 어깨를 으쓱했다. "괜찮은 손님이었어요. 방 안에서 술이나 담배를 본 적은 없고요. 써브웨이 샌드위치를 한 번 사다 먹긴 했어요. 그리고 견과류도요. 차를 많이 마셨어요. 아침엔 여기서 음악이 흘러나왔어요. 딘 마틴이요."

had been born in the North. She appreciated her life here in Busan for thirty years. Now she was working again. She worked this floor this time every other day; 14:00–20:00. She remembered seeing the Irishman a handful of times. He would return most days in the afternoon before going out again in the evening. He often apparently worked in the room most mornings as she herself was left to clean his place in the afternoon.

"What kind of a person do you remember him to be? Did he drink, or smoke? Drugs?"

She shrugged. "He was nice. There was no booze in his room. No smoking. But he ate Subway once. And nuts. And drank a lot of tea. I heard music coming from there in the mornings. Dean Martin."

"What aren't you telling us?" One of them always said that.

She blushed. "Well, it was only 8,000 won and he left it for the staff, if that's what you're talking about."

"Did you find a single shoe? A large black sneaker?"

"No."

Dae-gwon thanked her and gave her his card.

They walked to the window and looked at the view. The Irishman stood here like this, yesterday. The high two-block stairway rising beside the German consulate looked impossibly steep.

And there far below, looking like a cartoon, or a pretty candy cake in a coffee shop, was their own Jungbu Police Station.

At one point in 1950, Busan and its immediate locale was all that was left of the Republic of Korea. But you couldn't squeeze capitalism out of this ancient international port. The Busan Perimeter held, and soon enough, a U.N. occupying force arrived to help push out and re-establish the republic as far as Seoul. During those years, Busan was directly governed by a U.S. authority. Besides baseball, more popular around here than anything except Go, Golf and Fishing, it was hard to find American remnants as visible as Busan Jungbu Police Station. These days even the film festival was euro-centric. The Japanese had left most

"지금 저희에게 숨기는 거 있죠?" 둘 중 한 명이 늘 던지는 질문이었다.

그녀가 얼굴을 붉히며 말했다. "그게, 단돈 8천 원이었는데 그가 직원들 팁으로 남겨둔 거였어요. 그걸 말씀하시는 거라면……"

"신발 한 짝 못 보셨어요? 커다란 검은색 운동화요."

"못 봤어요."

대권이 그녀에게 고맙다는 인사와 함께 명함을 주었다.

두 형사가 창가로 걸어가서 밖을 내다보았다. 실종된 아일랜드인도 어제 이 자리에 이렇게 서 있었으리라. 독일 영사관 옆에 우뚝 솟은 두 블록의 높은 계단이 어마어마하게 가파르게 보였다.

저 멀리 아래, 만화 또는 커피숍의 앙증맞은 케이크 같은 건물이 바로 부산중부경찰서였다.

1950년, 대한민국에는 부산과 인근 지역만이 남아있었다. 하지만 이 오래된 국제 항구에서 자본주의를 쥐어짜 내는 건 불가능했다. 부산 최전선 사수 후 도착한 유엔군의 도움으로 서울까지 다시 밀고 올라가 나라를 도로 세울 수 있었다. 몇 해 동안 부산은 미국의 직접적인 통치 하에 놓였다. 바둑, 골프, 낚시를 빼고 가장 큰 인기를 누리는 야구를 제외하고는 부산중부경찰서만큼 도드라진 미국의 잔재를 찾기 어려웠다. 부산국제영화제조차 유럽에 초점을 맞추어 진행되었다.

일본인들이 남기고 간 대부분의 파시스트 잔재가 아직도 구도심을 정의했다. 중부경찰서 관할지역 끝자락에 위치한 텍사스촌은 다수의 러시아인들이 운영하는 홍등가였다. 그곳에서 미국 점령기는 단지 몇 년간의 기억만으로 남아 있었다. 대신 자본주의가 뿌리내렸다. 서구화된 풍미에도, 기독교에도, 위스키에도. 그 밖에 미국의 존재는 그 가시적인 부재에서 가장 도드라졌다(실종된 미국인의 아일랜드성에서도 마찬가지 현상이 나타난다고 대권은 생각했다). 미국적인 것은 곧 현재 속으로 사라지기 마련이었다.

of the fascist hulks still defining the old downtown. Texas Street, at the North of the station's jurisdiction, was a simulacrum red-light district managed in great part by Russians; it only remembered the years of American Occupation. Capitalism remained, in its Westernized flavor; Christianity; whiskey as well. Otherwise (and in this American's Irishness, Dae-gwon figured, you found this phenomenology as well) what was most notable about the U.S. presence was its visible absence. If Americanisms appeared, it was to disappear into the present.

They made out a pin-sized Cindy Yeo smoking outside the station door. "We're that small," Pahl said.

They found a forgotten paperback, on the windowsill behind the drawn curtain. *Schizmatrix.* Inside, used as a book-mark, the note from the hotel front desk, dated Saturday afternoon, 14:44.

The note contained a phone number and these characters:

숨은 내 그림 찾기.

They called; No one answered.

5

Back in the station, Sun-Jung Park, 24-year-old assistant curator of the Busan Biennale 2020 was waiting with Yeo in the squad room.

"Where do you think this writer could have gotten to?" they asked her. "What's your intuition?"

"We really have no idea. We can't understand. As far as we knew, he was to spend a last day investigating the waterfront."

"Investigating?"

She explained. "The Busan Biennial 2020 invited him here to write about the city for the catalog."

"Before the exhibition even exists?"

저 멀리 콩알만한 크기의 신디 여 경관이 경찰관 정문 앞에서 담배를 피우는 모습이 보였다. "우리도 저렇게 작은거야." 팔 형사가 말했다.

커튼 뒤 창턱 위에 작가가 깜박한 책 한 권이 놓여있었다.『스키즈매트릭스』. 책 안에는 프런트에서 전달받은 노트가 책갈피처럼 끼워져 있었다. 메세지 시간은 토요일 14시 44분. 노트에는 전화번호 하나와 함께 다음 문구가 적혀 있었다.

숨은 그림 찾기.

전화를 걸었지만 아무도 받지 않았다.

5

경찰서에는 2020부산비엔날레의 박선정(24) 어시스턴트 큐레이터가 여 경관과 함께 집합실에서 두 형사를 기다리고 있었다.

"작가가 어디로 갔을 것 같습니까?" 형사들이 그녀에게 질문을 던졌다. "어떤 직감적인 느낌이 드나요?"

"정말 모르겠어요. 도무지 이해가 안 돼요. 저희가 아는 한 마지막 날에는 해안가를 조사하기로 되어있었어요."

"조사라뇨?"

"이번 초청의 목적은 2020부산비엔날레 카탈로그 기획이에요. 부산에 대한 글을 청탁했죠."

"행사는 아직 시작도 안 했는데요?"

"그는 소설을 쓰는 작가예요."

"이전에 부산에 와본 적 있었나요?"

"아니요. 동아시아 첫 방문이었어요. 도착한 첫날 같이 커피 한잔 하고

"He's a fiction writer."

"Has he been to Busan before?"

"Never. It was his first time in East Asia. We had a coffee the first day he arrived, and I oriented him. I gave him a tour of Gukje Market down to the waterfront, the day he arrived; I met with him a third time to discuss his progress."

"Who did he meet with here? Who else did he know?"

"I'm sure he knew no one here; he hoped to meet Kim Un-su, for instance, was out of town, caring for a sick mentor."

"What did he tell you about his investigation?"

"Nothing! He said as a writer he disliked discussing texts before creating them."

"Did he have a computer?"

"Yes, a very old MacBook Air. Steve Jobs era. The really small one."

"Did he take drugs, alcohol, medication, anything like that?"

"No. He explained he had intestinal problems due to his profession. A very nice, gentle person. Talkative. A science fiction writer."

"What about marijuana?"

She reddened. "No."

"Politics?"

"On the left, certainly. I believe he guest edited Semiotext(e)'s *Hatred of Capitalism*. You know we put out a bulletin in the art community some hours ago to see if anybody's heard anything. I guess it's a slow day. Already—only two hours later, his disappearance is trending on social media. Some people are proposing he defected."

"Defected? Is that a possibility? Did he mention the People's Republic of North Korea at any time?"

"No."

"What haven't you told us, Miss Park?"

She flushed. "He said he didn't drink coffee as well, and then I saw him drink some in my presence. I think it was rare, from jet lag. I'm

제가 여기저기 안내해 주었죠. 국제시장에서부터 해안가까지 투어를 했어요. 세 번째로 만난 날 작업 현황에 대해 논의를 했고요."

"작가가 여기서 누구누구 만났나요? 또 아는 사람이 있었을까요?"

"아니요. 분명 아무도 없어요. 김언수 작가를 만나고 싶어 했는데 마침 지인 병문안차 타지에 계셨거든요."

"조사 결과에 대해서는 들은 바 있나요?"

"전혀요! 작가로서 집필 전에 내용 논의하는 걸 꺼린다고 하셨어요."

"컴퓨터를 갖고 왔었나요?"

"네, 아주 오래된 맥북에어. 스티브 잡스 시대 제품이었어요. 소형 모델이요."

"마약, 음주를 하거나 복용하는 약물 같은 게 있었나요?"

"아니요. 직업 특성상 소화장애에 시달린다고는 했어요. 착하고 온화한 분이에요. 수다쟁이 공상과학 작가이죠."

"혹시 대마초는?"

그녀의 얼굴이 빨개졌다.

"없었어요."

"정치적 성향은?"

"의심의 여지없이 진보요. 세미오텍스트 출판사에서 나온 『자본주의에 대한 반감』을 편집한 걸로 알아요. 이미 미술계에도 이 사건을 전했어요. 소식 아는 사람이 있을까 해서요. 오늘은 좀 느린 편인데 두 시간 만에 SNS에서 그의 실종 사실이 트렌딩 되기 시작했어요. 그가 월북했을 거라는 말도 나왔고요."

"월북이요? 그런 가능성도 있나요? 그가 북한을 언급한 적이 있습니까?"

"아니요."

"박 선생님, 지금 저희에게 숨기는 거 있죠?"

그녀가 다시 얼굴을 붉혔다. "커피 안 마신다고 하더니, 제 앞에서 한

sorry. He was interested most in the books, I think. And the water. He said since he didn't drink it made it more potent than when he had. Oh yes, he also was obsessed with si-at-ho-deok. He said this was the "donut of nut" he had been waiting for all his life." She smiled.

Here's one of his books; she passed over a large paperback. The cover showed an array of sea creatures from an old mosaic.

"Looks like the menu at Golmok Gejang." Pahl remarked. He looked at the back cover. In the small author photo, the Irishman wore dark glasses, and looked more like a sniper than an author.

"Can I have it back?" She took it as if it could become pretty valuable now, with his signature and everything.

"What was he doing in Seoul?"

"Here's the number of X. X. Fabricius; she passed across a card. They're the curators of the 2020 Biennial, the ones who invited him actually. They only speak English, however. They organized his stay there without us. They're Danes."

Pahl and Dae-gwon looked warier than ever. This case was not getting easier to solve by the minute.

"Do these characters mean anything to you?" They showed her the note from the hotel.

"No," she frowned.

"Did he mention a shoe?"

"Texas Street?" They were getting desperate.

"Texas Street? No, no, no way. More like Bosu-dong. He was eager to get there."

Outside, the fog was lifting. Night had fallen, but the illumination outside the station had the moisture sparkling like diamonds.

Neither detective believed in Texas Street here. This was not the sort of travelling American or Irishman that no longer came so often to Busan; but they put some calls through to their contacts. They gave Fabricius to JiYeon.

잔 하는 걸 봤어요. 아무래도 시차 때문에 흔치 않은 일이었던 것 같아요. 죄송해요. 무엇보다 책에 가장 관심이 많은 분이었어요. 그리고 물도 중요시했어요. 금주인이기에 더 강력하게 느껴진다고 했죠. 아 맞다, 씨앗호떡에 푹 빠졌었어요. 한 평생 기다려온 '땅콩 도넛'이라고 했어요." 그녀의 얼굴에 미소가 떠올랐다.

"여기 그분 책 한 권이요." 그녀가 두꺼운 책 한 권을 건네었다. 표지에는 오래된 모자이크에서 따온 다양한 바다생물이 실려있었다.

"골목게장 식당의 메뉴 같네요." 팔 형사가 대답했다. 뒤표지의 작가 사진에서 짙은색 안경을 쓴 아일랜드인은 작가보다는 저격수에 가까운 모습이었다.

"책 제게 돌려주시겠어요?" 그녀는 이 저자 사인본이 꽤 귀중한 물건이 될 거라는 듯 조심스럽게 다루었다.

"서울에는 왜 올라간 거죠?"

"여기, 파브리시우스님 연락처요." 그녀가 명함을 내밀었다. "2020부산 비엔날레 전시감독이고 실제로 이번에 직접 작가를 한국에 초청하셨어요. 덴마크 분인데 영어로만 소통이 가능해요."

두 형사는 그 어느 때보다 경계하는 표정이었다. 사건이 시시각각으로 더 복잡해지고 있었다.

"여기 쓰인 글씨 알아보시겠어요?" 호텔방에서 찾은 노트를 그녀에게 내밀며 물었다.

"아니요." 그녀가 얼굴을 찡그리며 대답했다.

"신발 한 짝에 대해 말한 적 있었나요?"

"혹시 텍사스촌은요?" 형사들은 점점 절박해졌다.

"텍사스촌이요? 아니요, 말도 안 돼요. 보수동에 굉장히 가보고 싶어 했어요."

밖에는 안개가 걷히고 있었다. 해는 졌지만 경찰서 밖 불빛이 마치 다이아몬드처럼 촉촉하게 반짝거렸다.

"How's the submarine?"

"It's a giant squid; it's alive; and they towed it inside Namhang Bridge."

"Is it North Korean?"

"A Trojan squid? I hope not. Oh, by the way: The number on your hotel message traces back to a store in our neighborhood." She pointed.

They remembered it at the same time. The little junk shop between here and on the Daehong Road. My Hidden Pictures. They both knew the proprietor by sight, a tall balding man in middle age, who often stood on the street gossiping and attracting passers-by to his collection of curios. The shop was not much wider than its doorway. Eccentric signage promised hidden gems, and the reviving of old goods. On any given day but Sunday you might find a snare drum, a rice-cooker, a typewriter, a wind-up radio, various tea sets, mirrors, racks, electrical wire, guitars, violins, books, lamps, bicycle helmets, computers, frames, dusters, brooms, amplifiers, jackets, desks, local antiquities all combining into a fractylizing heap, implicating the alleyway beside with its sprawl. Apparently, you could even get a coffee in there. At night all that junk was stuffed back inside, filling it up to the ceiling.

A call came in from the Port Maritime police.

"We had your Irishman on camera yesterday. He was wandering around for a while. Seemed like he was trying to get on the MS Ferry currently docked by the Port Coast Terminal."

They sent Officers Yeo and Jjak to roust the mild-mannered junk dealer. It was 20:11 and they were back in Van 21.

They drove down near to where they'd started the evening. At the Port Authority Police one could look out over the operations of the entire inner harbors. Tonight little lights gleamed in all directions, liberated from the rising fog. The water shone like black mercury.

No traffic was permitted this evening here, and their view gave a deceptively calm view of a glittering, resort-like Busan, glittering with electricity, high-rise, and neon.

두 형사도 텍사스촌에는 기대가 없었다. 사건의 인물은 부산에 더 이상 자주 오지 않는 미국 또는 아일랜드 여행객이 아니었다. 그래도 일단 몇 군데 아는 곳에 연락을 돌린 후, 파브리시우스 연락처를 지연에게 넘겼다.

"잠수함은 어떻게 되어가?"

"대왕오징어였어요. 살아 있는! 남항대교 안쪽으로 끌고 갔어요."

"북에서 보낸 건가?"

"트로이 오징어라는 건가요? 아니길 바라요. 아 그리고, 그 호텔 메시지 번호 추적한 결과, 이 근방 한 상점으로 나와요." 지연이 손가락으로 가리켰다.

두 형사가 동시에 떠올린 것은 대청로에 위치한 '숨은 그림 찾기'라는 고물상이었다. 둘 다 가게 주인을 본 적 있었다. 머리가 벗어지기 시작하는 키 큰 중년 남자는 자주 길거리에 서서 수다를 떨거나 행인들에게 잡동사니를 구경하라고 이끌었다.

가게의 폭은 출입구와 비슷했다. 독특한 표지판이 이곳이 숨겨진 보물을 찾거나 낡은 물건을 소생시키는 장소임을 말해주었다. 일요일을 제외한 나머지 요일에는 언제나 산더미 같이 쌓여 있는 물건을 볼 수 있었다. 작은 북, 밥솥, 타자기, 태엽 라디오, 다기 세트, 거울, 받침대, 전선, 기타, 바이올린, 책, 램프, 자전거 헬멧, 컴퓨터, 액자, 먼지떨이, 빗자루, 빗자루, 앰프, 재킷, 책상, 지역 유물. 심지어 커피도 있다고 했다. 이 모든 물건이 밤마다 가게 안으로 차곡차곡 되돌아가 내부를 천장까지 가득 채웠다.

항만 해양경찰대에서 전화가 왔다.

"실종된 아일랜드인이 어제 여기 CCTV에 잡혔습니다. 잠시 어슬렁거리더니 터미널에 정박한 MS페리에 올라타려는 것 같았어요."

두 형사는 여 경관과 짝 경관을 보내서 온순한 고물상을 조사해 보기로 했다. 시계는 20시 11분을 가리켰고 그들은 다시 21호 밴으로 돌아왔다.

둘은 그들이 초저녁에 있었던 곳 근처로 다시 차를 몰고 내려갔다. 부산 항만공사에서는 안쪽 항구에서 일어나는 일을 전부 지켜볼 수 있었다.

They were shown video of the writer as he approached and "investigated" the empty port authority.

In a suit and woolen cap, made thin and black-and-white on the screen, the writer walked like he might be related to James Joyce. By commodious vicus of recirculation on the screen, they advanced him down the apparently infinite strip of Astroturf leading to the Port Authority South Terminal, a silent movie actor alone in a zone created to manage large-scale, semi-frantic crowds. From a distance, the terminal's curling roofing looked like the Sydney Opera House; but showed small and tacky when he was up close. The writer took pictures, looked at signs, walked about and even attempted to get aboard the abandoned Ferry.

"Not so easy to find a Guinness in Busan anymore," the guard said.

They went down to see for themselves. Pink was now grey. False-lit night shadows waxed and waned without warning. The waiting halls were open, lit. Hundreds of empty chairs faced them like an audience. Open restrooms beckoned. It was a spacious, ghostly set-up; as they looked around they thought of the Overlook hotel in the *Shining*.

There was a little shop for snacks, papers and knick-knacks inside the terminal. And though not a solitary passenger had come or gone in two weeks, it was open, even now after hours. The hostile, wild-haired proprietor wore a black face-mask, though there hadn't been anyone to exchange bacteria within hours. "Yes," he growled. He remembered the Irishman coming. He had come into the store, looked around, asked questions, bought nothing. "A waste of time."

"What questions?"

"Do I look like I speak English?"

Dae-gwon bought some cigarettes.

"It was the ferry. He was interested in the ferry."

They looked at one another. They went outside to behold the yawning immensity of the huge child-like ferry that docked outside

317

오늘 밤, 안개로부터 해방된 작은 불빛들이 사방에서 반짝거렸다. 바닷물이 검은 수은처럼 일렁였다.

일대의 교통이 제한된 오늘 저녁, 그들 눈에 들어온 풍경은 거짓말처럼 차분한 부산이었다. 휘황찬란한 네온사인과 고층건물이 빽빽한 휴양도시 부산.

그들은 작가가 텅 빈 항만공사에 다가가 '조사'하는 모습이 담긴 영상을 함께 보았다.

화면의 흑백 영상 속에서 양복과 모직 모자 차림의 작가는 자신이 제임스 조이스와 관련된 사람이라도 되는 양 이리저리 걸어 다녔다. 스크린의 순환적 재생을 통해 그가 남터미널을 향해 끝없이 펼쳐진 인조잔디로 이동하는 모습을 확인할 수 있었다. 광기 어린 군중을 관리하기 위해 세워진 구역에 홀로 있는 무성 영화배우. 터미널의 둥근 지붕은 멀리서 보면 시드니 오페라 하우스 같았다. 하지만 가까이에서 보니 작고 조잡했다. 작가는 사진을 찍고 표지판을 살펴보았다. 버려진 페리에 올라가려고 시도하기도 했다.

"요새 부산에서 기네스 맥주 찾기가 쉽지 않죠." 경비원이 말했다.

형사들은 직접 내려가서 살펴보기로 했다. 항구를 에워싼 분홍은 이제 회색이 되었다. 밤 그림자가 경고도 없이 차고 기울었다. 대합실은 문이 열린 채였고 불 켜진 실내에서 수백 개의 빈 의자가 관중처럼 그들을 마주했다. 텅 빈 화장실이 그들에게 손짓했다. 이 널찍하고 으스스한 공간을 둘러보면서 두 형사는 〈샤이닝〉에 나오는 오버룩 호텔을 떠올렸다.

터미널 안에 먹거리, 신문 및 잡다한 물건을 파는 작은 가게가 있었다. 보름 동안 단 한 명의 승객도 찾아오지 않았지만 영업시간을 넘긴 시간에도 문이 열려 있었다. 지난 몇 시간 동안 세균을 옮길 만한 사람이 아무도 없었음에도 불구하고 헝클어진 머리의 불친절한 주인은 검은 마스크를 쓰고 있었다.

"맞아요." 주인이 퉁명스럽게 내뱉었다. 그는 얼마 전에 들렀던 아일랜

the terminal. Could that thing float? Could he be inside even now? The video had shown him leaving.

Their radios snarled. It was Yeo. "The junk shop owner remembers the Irishman."

"Let me guess," Pahl joked, randomly. "He was looking for a giant squid."

"Well sort of, yeah."

Pahl looked at his partner curiously.

"He wanted a stuffed animal of a squid," he said. "And one was coming available so the proprietor called him back to see if he would get it. So far, he hasn't."

Another dead end. "Go down to the bookstreet," Dae-gwon. "Canvas them for any sighting of the writer. We'll meet you back at the station."

Easier said than done. A traffic snarl on the highway had blocked off their access to their previous route of escape. They would have to go down around Lotte and turn by Nampo Station.

It was a route that took them smack into the fish markets.

Irish-American author disappears in South Korea. Suicide? Defection? Hoax more like it. Perhaps this was all some sort of publicity stunt. As Pahl pulled over, Dae-gwon noted the writer's books already appeared to be sold out on Amazon in UK, USA, Germany, and Korea.

Dae-gwon thought of the books of Bosu-dong. Of the stacks leaning on stacks, of rows behind rows, of avenues book-lined and paper-bound as if published by the city itself in bricks of text, most of it translated. He thought of Yeo and Jjak taking notes on their phones, as a proprietor emerged from his type-script enclave, interrupted at his evening ramen, his shop and the others like it connected cover to cover, improbably open at night—today subsidized so as to blaze its avenues of escape thickening in the thousands into corridors with stacks upstairs and downstairs unseen. Very few came here in the evening anymore. Yet the bookseller emerged alive and well as if from out of the water-boiler steam. And there Dae-gwon's mind's eye saw

드인을 기억해 냈다. 가게에 들어와서 둘러본 뒤 질문만 던지고 아무것도 사지 않았었다. "시간 낭비였죠."

"뭘 물어보던가요?"

"내가 영어 할 줄 아는 사람처럼 보여요?"

대권 형사가 담배를 샀다.

"여객선이요. 여객선에 관심을 보였어요."

두 형사가 서로를 쳐다보았다. 밖으로 나오자 터미널에 정박되어 있는 어마어마한 여객선이 눈에 들어왔다. 저 배가 물에 뜰 수 있을까? 설마 작가가 지금 저 안에 있는 걸까? 하지만 아까 CCTV 영상에는 그가 떠나는 모습까지 담겨있었다.

형사들의 무전기가 울렸다. 여 경관이었다. "고물상 주인이 아일랜드 작가를 기억한대요."

"어디 보자, 대왕오징어를 찾고 있었겠지." 팔 형사가 뜬금없이 농담을 했다.

"글쎄요, 비슷해요."

팔 형사가 재미있다는 듯 그의 파트너를 쳐다보며 말을 전했다.

"오징어 모양의 봉제인형을 찾고 있었대. 그리고 물건이 하나 들어와서 주인이 사겠냐고 연락을 했는데 아직까지 답변을 못 받은 상황이고."

다시 막다른 골목.

"헌책방 거리로 가서 작가를 본 사람 있는지 물어보게. 우린 이제 본부로 복귀할 테니 이따가 보자고." 대권이 여 경관에게 말했다.

하지만 그건 말처럼 쉬운 일이 아니었다. 도로 교통이 마비되어 이전의 탈출로는 접근이 불가능했다. 롯데백화점 쪽으로 내려가 남포역을 지나가야 했다.

수산시장 한가운데로 통하는 경로였다.

아일랜드계 미국인 작가가 한국에서 사라지다. 자살일까? 월북? 장난질에 더 가까울 것이다. 어쩌면 일종의 홍보 수단일지도 몰랐다. 대권 형

books by MARX / ENGELS / MAO and others once not permitted so long ago, now boldly displayed beside titles about sex, aggression, rock music, philosophy, literature, history, the military, the arts, titles about Japan, North Korea, the U.S., Ireland, and yes science fiction. Very few were in English.

"I sold him Carl Jung, *Schizophrenia*," the proprietor said.

"Not *Schitzmatrix*?"

He declined to even answer.

"When? When did you sell it?"

He had returned to his noodles.

<p style="text-align:center">6</p>

The crowds were so thick, they had to get out of the van. Outside, the fog had lifted. A more classical night had claimed Busan in its shining claw. A waning gibbous moon cast slippery lumps of fool's gold down onto the buttercup waves, as more than 400 unidentified fishing craft and several thousand visitors on foot were gathered between the bridges, by the fish markets and the sea. They had come to behold the living squid that could no longer survive in the ocean.

Even Pahl and Dae-gwon felt themselves pulled by the possibility and power of this creature.

But they saw police cruisers already on the spot. And as they showed their badges to get past the police line they saw Yeo and Jjak already there ahead of them, eyes shining.

"We've traced the writer here," they said excitedly. "The si-at-ho-deok sellers saw him this morning coming this way, alive!"

"We told you to go to the booksellers."

Jjak said: "We stopped for a bite. That's also when I finally got to look at the bulletin myself and realized we knew him."

"Knew whom?"

사는 작가의 책이 영국, 미국, 독일 그리고 한국 아마존에서 이미 거의 매진되었다는 사실에 주목했다.

대권 형사는 보수동 헌책방 거리를 머릿속에 그렸다. 서로 기대어 선 책장이 줄줄이 이어졌고, 마치 도시가 글씨 벽돌로 찍어낸 것처럼 거리는 종이와 책으로 가득했다. 그중 대부분이 번역서였다. 라면으로 저녁을 때우던 서점 주인을 방해해서 불러낸 두 경관이 폰으로 메모를 하는 모습을 상상했다. 촘촘하게 늘어선 비슷비슷한 서점과 숨겨진 위아래층 복도에 켜켜이 쌓여 있는 책. 이제 저녁시간에 헌책방 거리를 찾는 이는 적었다. 하지만 책방은 마치 보일러 증기에서 막 나온 것처럼 생동감 있는 모습이었다. 그곳에서 대권 형사는 마음속으로 마르크스, 엥겔스, 모택동 등 오래전 금지되었던 서적을 보았다. 섹스, 록 음악, 철학, 문학, 역사, 군사, 예술, 일본, 북한, 미국, 아일랜드, 그리고 공상과학을 주제로 한 책들 옆에 대담하게 자리하고 있었다. 영어로 쓰인 책은 극히 일부분이었다.

"그에게 칼 융의 『정신분열증』을 팔았어요." 책방 주인이 말했다.

"『스키즈 매트릭스』가 아니라요?"

그는 대꾸조차 없었다.

"언제였죠? 언제 다녀갔나요?"

책방 주인은 이미 저녁식사를 이어가고 있었다.

6

엄청난 인파에 두 형사는 차에서 내렸다. 안개가 이미 걷힌 후였다. 보다 고전적인 밤이 번쩍이는 발톱을 세우고 부산을 장악했다. 만월에 가까운 달 아래서 달맞이꽃 파도가 미끈거리는 황철광처럼 빛을 발하는 동안 400척이 넘는 이름 모를 어선과 수 천명의 사람들이 수산시장 근처 바다

Jjak looked at Yeo. She explained: "The writer. We know him. Me and Jjak met him last night."

Pahl needed to say nothing. His look said: WHAT DO YOU MEAN YOU MET THE WRITER LAST NIGHT?"

"He came by the station last night. After sunset. He said he was a writer and wanted to write about Busan. He interviewed us."

"He interviewed you? What did you tell him?"

"We pretended not to speak English."

"You don't."

"True. He tried to interview us about the station, about crime in Busan. Stayed about twenty minutes. We didn't even let him into Ji-Yeon. The Colonel saw him leave, however. "Next time," he said, "send him to the tourist police."

"Then he saw you two leaving the station," Yeo said. "He asked about you specifically."

Their attention was here diverted by events in the fish market.

For there inside the warehouse by the docks that served as the impromptu everyday aquarium/market for the many species still bountifully collected in these remarkable waters, knowing eyes looked out from plexiglass tubs with peculiar calm at the spectacle of the current stoppage, in the center of which now camped a giant squid in an enormous opaque, improvised tank.

The market sellers stood about in their customary bright yellow aprons and orange tops. With the bright colors edging the many fish tanks, one almost thought the spectacle night-lit in that watery warehouse included banks of flowers.

"Was this floor always tiled in a hexagonal pattern?"

They had gathered around a tub the size of which had never graced any of the markets. Two top-open semi-trailers had been joined lined with plastic and made into a temporary tank for an enormous squid. Great hoses pumped and removed oxygen. The squid was mostly in-

앞으로 모여들었다. 이제 더 이상 바다에서 살아남을 수 없는 대왕오징어를 보러 온 것이다.

두 형사조차도 이 생물이 가진 힘과 가능성에 끌렸다. 현장은 이미 경찰 순양함이 지키고 있었다. 배지를 보여주고 경찰선을 통과한 그들은 한발 앞서 도착한 두 경관과 마주쳤다.

"여기까지 작가를 추적해왔어요!" 경관들이 흥분해서 눈을 반짝이며 말했다.

"씨앗호떡 장수들이 오늘 아침 이쪽으로 걸어가는 작가를 봤대요!

"헌책방 거리에 가라고 했을 텐데."

"잠깐 요기하러 멈췄어요. 그제야 사건 공지를 제 눈으로 직접 보고 우리가 아는 사람이란 걸 깨달았어요." 짝 경관이 말했다.

"알다니? 누굴?"

짝 경관이 여 경관에게 눈짓을 보냈다. 그녀가 설명하기 시작했다.

"실종된 작가요. 저희가 아는 사람이에요. 어제저녁에 만났어요."

말 한마디 없이 팔 형사의 표정이 모든 걸 말해주었다. 어제저녁에 작가를 만났다는 게 무슨 소리야?

"어젯밤 경찰서에 찾아와서 자신이 작가이며 부산에 대한 글을 쓸 거라고 했어요. 저희를 인터뷰했죠."

"인터뷰? 그에게 무슨 얘기를 했는데?"

"둘 다 영어 못하는 척했어요."

"못하는 거 맞잖아."

"맞아요. 우리 경찰서 그리고 부산의 범죄 현황에 대해 이것저것 질문했어요. 20분 정도 머물다가 떠났죠. 대령님이 다음에는 관광경찰한테 보내라고 하셨어요. 그리고 형사님들이 출동하는 걸 보고 형사님에 대해서 따로 물어봤어요."

수산시장에서 일어나는 소란이 그들의 주의를 환기시켰다.

부둣가 창고는 매일 바다에서 건져 올린 다양한 해양생물을 위한 수조

visible. Only a single red tentacle hung out over the high corner nearest the harbor, to which the warehouse's back doors stood wide open. The tentacle dropped down toward the floor, its mighty man-wide girth narrowing to the width of a baby's little finger at the tip.

The sellers stepped back, cheering. It became evident why they had stopped selling fish, as the first slid a large sea bass down the floor to the eager tentacle. It received the gift and retreated with silken grace for a time inside the tub.

Every effort was being made for the squid's salvation. The shining yellow fishmongers surrounded the huge tub like a priesthood.

Another tentacle emerged from the opposite corner of the tank. It appeared to grasp a grisly object. Some screamed and stepped back as the tentacle tossed out, as if in payment for the fish, a severed human leg. Others stood as if proud to receive it.

Still wearing its black pant and sock, the foot sported an enormous black shoe.

"That's a Dennis "The Worm" Rodman 1995 Nike Air special," Jjak said," reading his Samsung. "Duckduckgo says a pair is worth 3 million won."

It was 11:22, October 21. It was strange to think the writer was gone.

겸 시장의 역할을 하였다. 플렉시글라스 통에서 모든 걸 다 안다는 듯한 눈들이 이상하리만치 침착한 태도로 정체된 바깥 광경을 내다보았다. 그리고 그 중심에는 급조된 대형 불투명 수조 안에 진을 친 대왕오징어가 있었다.

수산시장 상인들은 평소처럼 샛노란 앞치마와 주황색 상의를 입고 서 있었다. 수많은 수조를 둘러싼 밝은 색상의 풍경은 창고 안에 꽃이 활짝 피어 있는 듯한 인상을 주었다.

"여기 바닥은 늘 육각형 패턴의 타일인가요?"

그들은 전례 없는 크기의 통 앞으로 모여들었다. 상단 개방형 세미트레일러 두 개를 연결해 만든 대왕오징어용 임시 수조였다. 커다란 호스를 통해 산소가 주입되고 또 제거되었다. 대왕오징어는 시야를 거의 벗어나 있었다. 항구에서 가장 가까운 모퉁이에 빨간 촉수 하나가 걸쳐져 있을 뿐이었다. 활짝 열린 창고 뒷문 쪽 방향이었다. 촉수가 바닥을 향해 곤두박질쳤다. 사람 몸통만한 둘레가 끝부분에 가서는 아기 새끼손가락만큼 좁아지는 모습을 볼 수 있었다.

상인들이 환호를 지르며 뒤로 물러났다. 그들이 오늘저녁 장사를 중단한 이유가 분명해졌다. 첫 번째 상인이 커다란 농어 한 마리를 집어 촉수를 향해 바닥에 미끄러뜨렸다. 선물을 받은 오징어가 우아한 몸짓으로 잠시 물러갔다.

이렇듯 대왕오징어를 구하기 위한 총력전이 벌어지고 있었다. 노란빛을 발하는 생선장수들이 사제단처럼 거대한 수조를 에워쌌다.

수조 반대편 모서리에서 또 하나의 촉수가 나타났다. 이번에는 무언가 섬뜩해 보이는 물건을 움켜쥐고 있었다. 다음 순간, 아까 받은 생선에 대한 보답이라는 듯 촉수가 사람 다리 하나를 밖으로 내던졌다. 몇몇 사람이 비명을 지르며 뒤로 물러났고 나머지는 뿌듯한 표정으로 자리를 지켰다.

잘라진 다리에는 검은 바지와 양말 그리고 커다란 검은 신발이 고스란히 남아있었다.

"나이키 에어 95년 데니스 로드맨 한정판이에요." 짝 경관이 그의 삼성

휴대폰를 들여다보며 말했다. "덕덕고에 찾아보니 한 켤레에 300만 원이 넘는대요."

10월 21일 11시 22분. 작가가 사라졌다니 이상한 노릇이었다.

영한 번역
조용경

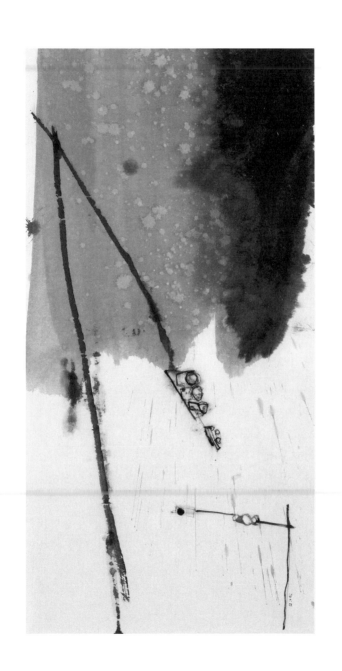

전기(電氣)가 말하다

아말리에 스미스

전기: 곧 부산이 잠에서 깨어나 저에게 전적으로 의존할 것입니다. 저는 대한민국에서 생산되는 전기예요. 지금 이 순간 제 전자(電磁)들은 개방된 분리 회로에서 대기 중이죠. 도시와 마찬가지로 당신 인간들이 곤히 잠든 현재 시각은 새벽 세 시 반. 오직 가로등만이 불을 밝히고 있습니다.

　잠시 후면 예약 취사가 설정된 전기밥솥이 하나씩 작동을 시작할 것입니다. 회로가 연결되면 제가 행동을 개시하고 이어서 보일러, 헤어드라이어 그리고 전기 주전자가 저를 부르겠죠. 텔레비전 화면이 켜지고 휴대전화가 깜박거리며 진동하기 시작하면 한동안 가만히 있던 승강기도 다시 움직이기 시작합니다.

　하지만 그 때까지는 잠든 도시에 잠시나마 고요함이 맴돌아요.

　당신은 인간이 도시의 발전을 이끈다고 생각하지만 실제로 이곳을 유지하는 것은 바로 저, '전기'입니다. 제가 손을 놓아버리면 부산은 마비될 거예요. 냉장고 안 음식이 썩고, 교통신호가 꺼지고, 무선 통신망이 무너지고, 산소호흡기가 차단됩니다.

　전 도시 구석구석에 자리하고 있어요. 눈을 뜨면 주위를 한 번 둘러

Electricity Speaks

Amalie SMITH

ELECTRICITY: Soon the city of Busan will wake and carry on at my mercy. I am the electricity produced in South Korea. Right now, my electrons are standing by in open, disconnected circuits. The city is asleep and so are you, its inhabitants. It's three-thirty in the morning. Only the streetlights are on.

Soon your preset rice cookers will turn on one by one. Their circuits will connect and I will spring into action. After them, it's the boilers, then the hairdryers, then the kettles that call out. Then the television screens will come to life, mobile phones will start to vibrate and blink. The lifts that have stood still on the same floor for a few hours will again begin to move.

But until then: A moment's peace while you sleep.

You think you're the ones driving the city's progress, but I'm the one who starts it up and keeps it running. If I rest, Busan will come to a standstill. The food will rot in the fridges. The traffic signals will go black. The cellular network will break down. The ventilators will shut off.

I'm all over the city, just take a look around you when you wake. When you walk through Gukje Market and look up, you'll see me

보세요. 국제시장 한복판에서 고개를 들면 전봇대를 휘감은 절 볼 수 있습니다. 부산시 중구 골목골목을 수놓은 빨랫줄처럼 촘촘히 이어져 있죠.

저를 발견할 수 있는 곳은 무궁무진합니다. 건물 외부에 매달려 마치 벌떼처럼 웅웅 거리는 에어컨 실외기. 아주머니들이 모여 수다를 떠는 빵집 구석의 UV벌레 퇴치기. 노래 〈작은 것들의 위한 시〉가 반복해서 흘러나오는 라디오. 카메라에 포착된 이미지를 보여주는 휴대전화 스크린. 빨강, 파랑, 초록의 미세한 다이오드. 샤부샤부 식당 식탁의 내장형 전열기. 관절염에 걸린 할머니가 누워서 휴식을 취하는 전기장판. 빨간불이 켜질 때까지 카운트다운하는 교통신호. 음료나 음식이 준비되면 진동과 함께 삐 소리를 내는 동그란 진동벨. 지하상가에서 지친 이들의 종아리를 풀어주는 기계(제가 없다면 지하상가는 어두운 터널 형태의 화장실에 불과하겠죠.). 휘어진 네온사인과 LED. 자갈치 시장 앞에서 깜박거리는 물고기 떼. BNK부산은행 아트시네마의 주황색 불빛. 매해 12월, 광복로 차 없는 거리를 수놓는 크리스마스 장식과 나무들 사이에서 빛나는 순록. 그리고 상점 창문에 움직이는 글자와 춤추는 전화번호를 표시하는 것도 저예요.

지역사 박물관에 있는 부산의 옛 사진에서도 저를 찾아볼 수 있습니다. 당시 주변의 낮은 건물들 덕분에 제가 우뚝 솟은 느낌이었죠. 마치 항구에 정박된 배의 돛대 같았어요. 항구 대형 선박에서 화물을 싣고 내리는 기중기 그리고 저 멀리 위치한 등대에도 제가 있습니다. 저는 매일 오후 2시가 되면 영도대교를 열고, 밤에는 광안대교를 화려하게 밝혀줍니다.

평소 좀처럼 말을 하지 않는 저이지만, 오늘은 입을 연 김에 제 이야기를 들려드리죠. 제가 어떻게 당신들 마음속에 갈망을 심어서 절 위해 일하게 했는지를요.

woven around lampposts. I'm strung like clothing lines across the narrow streets throughout Jung-gu.

I'm in the air conditioners that hang on the outside of buildings, humming like overgrown bee swarms. I'm in the UV lamps that trap insects in the corner of the cake café where elderly women meet to chat. In the radio playing *Boy With Luv* yet again. In the phone screens that display what only the camera sees. In their microscopic diodes, red, green and blue.

I'm in the hotplates built into the tables at shabu-shabu restaurants. In the electric mats an arthritic grandmother rests on. I'm in the traffic signals' countdown to red. In the disc the customer gets from the bar that will beep, shake and blink when their coffee or food is ready.

I'm in the machines that shake the calves of tired men in underground markets. Without me, the underground markets would be nothing but dark, tunnel-shaped urinals.

I'm in bent neon and LED. I'm in the shoal of fish flickering on the façade of the Jagalchi market. In flashes behind the orange plastic shell that encases BNK Busan Art Cinema. In December I'm in the Christmas decorations on the walking street in Gwang-bok-ro, in the glowing reindeer among the trees. On panels in shop windows, I display animated letters and dancing phone numbers.

You can find me in old photos of Busan at the local history museum. Back then, I seemed to tower up because the buildings were lower and more spread out. My poles leaned like the masts of ships in the harbour.

I'm at the harbour. In the big cranes that load cargo on and off the tankers. In the lighthouses on the cliffs outside the city. I lift up the Yeongdo Bridge every day at two o'clock. At night I make the Gwangan Bridge light up in every colour of the rainbow.

I rarely speak, but now that I've raised my voice, I'll tell you my story. How I've installed a longing in you and made you work for me.

전기(電氣)가 말하다

전자기(電磁氣): [혼잣말로] 오늘 태양풍이 대단하군! 지구 전체에 뻗어 있는 전자기장을 갈기갈기 찢어버렸어! 전자극 주변이 보라색, 초록색, 노란색의 아름다운 파동으로 디스코처럼 환히 빛나고 있다. 여긴 아직 밤이구나. 하늘의 별이 훤히 보일만큼 청명한 밤. 드디어 나의 구멍을 고칠 수 있는 시간이 생겼어.

전기: 엄마, 오셨어요?

전자기: 지구에서 무슨 소리가 들린 것 같은데?

전기: 네, 저예요. 전기.

전자기: 우리 딸 왔니? 치직 소리와 함께 인공광이 얼핏 보인 것 같았다. 누구랑 얘기하고 있어?

전기: 부산 시민들과 대화 중이에요, 엄마.

전자기: 다들 잠든 시간일 텐데?

전기: 깨어 있는지 아닌지는 별로 상관없어요. 지금이 그들이 가장 부드러울 때거든요.

전자기: 착하기도 해라. 하지만 인간들에게 크게 신경 쓸 필요는 없단다.

전기: 신경 안 써요.

ELECTROMAGNETISM: [*speaking to herself*] What solar winds we had today! They ripped and tore at the field I extend around the entire planet. The atmosphere around the poles was aglow like a disco—purple and green and yellow and blue in beautiful, billowing waves. Now it's night here, a night that's clear enough to see the stars, and I finally have time to patch my holes.

ELECTRICITY: Hi, Mum.

ELECTROMAGNETISM: Did I hear a sound from down on Earth?

ELECTRICITY: Yes, it's me, Electricity.

ELECTROMAGNETISM: Is that you, my daughter? I thought I heard a crackle and caught a glimpse of artificial light. Who are you talking to?

ELECTRICITY: I'm talking to the inhabitants of the city of Busan, Mum.

ELECTROMAGNETISM: Aren't they asleep at this hour?

ELECTRICITY: I don't really mind whether or not they're sleeping—now is the time they're softest.

ELECTROMAGNETISM: Oh, you're sweet, but you don't have to concern yourself so much with humans.

ELECTRICITY: I don't.

ELECTROMAGNETISM: Yes, you do. But remember, you existed

전자기: 알아. 하지만 네가 인류보다 훨씬 더 먼저 존재했다는 사실을 기억하렴. 지구가 탄생하던 순간, 펄펄 끓어오르는 바다 위로 벼락이 내리치던 그 곳에 있었다는 것을.

전기: 엄마, 저 어렸을 때 얘기 좀 그만 끄집어내세요. 저 지난 백 년 동안 엄청나게 성장했어요.

전자기: 백 년은 사실 아무것도 아니란다. 네 인간 친구들은 몇천 년 내로 사라질지도 몰라.

전기: 엄마, 우리 나중에 이야기해요.

전자기: 좋을 대로 하려무나.

전기: 방금 저의 엄마 '전자기'였어요. 신경 쓰지 마세요. 아주 오래전부터 그 누구의 방해도 받지 않고 살아온 분이거든요.
　　제가 아까 어디까지 얘기했죠? 아, 맞다 제가 불어넣을 '갈망'.
　　전기를 사용하기 전, 인간들은 해가 뜨면 일어나고 날이 저물면 잠자리에 들곤 했어요. 태양이 주된 에너지원이었죠. 수십억 킬로미터 멀리 떨어져 있는데도 마치 불 앞에 서 있는 것처럼 뜨겁게 피부에 와 닿았죠.
　　제 덕분에 하루의 시간이 길어졌어요. 저는 가는 곳마다 환하게 밝혀줘요. 어둠, 적막과는 거리가 멀다고 할 수 있죠. 제가 만드는 낮은 주파수의 소음을 당신 인간들은 자신에게서 비롯된 소리라고 믿더군요.
　　옛날 옛적, 신석기 시대 인간들은 동삼동 일대 절벽에 자리를 잡았어요. 수천 년 동안, 당신들은 바다 생물의 껍데기를 던져 쌓아 올렸어

long before them. You were there back when the Earth was created and the first thunderclouds formed above the boiling seas.

ELECTRICITY: Mum, would you please stop talking about when I was little. I've grown a lot in the past hundred years.

ELECTROMAGNETISM: One hundred years is no time at all. These human friends you've come to depend on could very well be gone in a couple thousand years.

ELECTRICITY: Mum, can we talk later?

ELECTROMAGNETISM: As you like!

ELECTRICITY: That was my mum, Electromagnetism. Don't mind her, she's ancient and has been living undisturbed for eons.

Where was I? Right, the longing that I install.

Before me, you humans would rise with the sun and go to bed when it set. The sun was your primary source of energy. Billions of kilometres away and still, it felt as hot on your skin as standing by a fireplace.

I expanded the day. Wherever I go, things light up. I'm incapable of making things dark. I'm incapable of making things quiet. You hear me in every room as a low-frequency hum—a sound you've come to believe you produce yourselves.

Even further back, in the Neolithic Age, humans lived on the cliffs out by Dongsam-Dong. For thousands of years, you threw the shells of sea creatures onto a mound. I would gaze down at your terrified faces when it thundered.

You had learned to make fire, but I remained out of your control. I reached out after you from up in the sky. I would jump up from an animal fur when you rubbed a piece of amber against it. You

요. 천둥이 울릴 때마다 공포에 질린 인간들의 얼굴을 내려다보던 기억이 나네요.

불을 정복한 인간에게도 저 전기는 여전히 통제 밖이었습니다. 하늘에서 손을 뻗치기도 하고, 당신들이 동물의 털에 호박을 문지를 때 불쑥 튀어나오기도 했어요. 하지만 여전히 절 이해하지 못했어요. 인간에게 전기란 마법의 영역이었고 그건 지금도 마찬가지예요. 하지만 완벽한 이해 없이도 저를 믿고 의지해요. 제가 가진 힘의 존재를 느끼는데 왜 의심하겠어요? 당신이 마치 슈퍼히어로인 양 매일 초고층 빌딩 꼭대기까지 데려다주는데?

제 말을 명심하세요. 저를 움직이는 원동력은 마법이 아니라 '갈망'이랍니다. 당신이 동물의 털에 호박을 문질렀을 때, 전 그 둘을 연결하는 부분에서 발생했어요. 호박의 원자핵에서 떨어져 나와서 양쪽에 '갈망'을 심어주는 만드는 전자가 제 자리예요.

저는 이 세상의 모든 자유 전자이자 음전하(陰電荷)의 과다예요. 양전하(陽電荷)의 성질을 가진 사물과 서로 끌어당깁니다.

당신들은 저의 이점을 발견했어요. 저는 다른 형태의 에너지에서 변환될 수 있고, 장거리 이동 그리고 재변환도 가능합니다. 자신의 원자핵을 운반하는 것들보다 훨씬 더 멀리 이동하거나 배터리에 보관될 수도 있습니다. 아마 완벽한 하인 같아 보일 거예요.

하지만 일단 제 회로가 만들어지면, 당신은 연결할 수밖에 없어요. 사물들의 갈망을 충족시키는 과업이 당신에게 주어지는 겁니다. 그리고 당신이 원자를 분리할 때마다 계속해서 새로운 갈망이 생겨나요. 전 세계 자유 전자의 수는 점점 늘어나고 있고, 이어서 사물의 갈망이 인간에게까지 번지게 됩니다. 인간의 부드러운 신체에 물, 산소, 영양분이 있어야 하는 것과 마찬가지로 당신은 전기를 필요로 하게 됩니다. 아니면 어째서 그토록 열심히 제 네트워크를 확장해 왔겠어요? 저

would rub and rub, and I would jump and jump, but you didn't understand me. To you, I was the force of magic.

I still am to this day. You trust me even though you don't understand me. Why doubt my power when you can feel that it exists? When I lift you to the top of skyscrapers each day as if you were superheroes?

Mark my words: Magic isn't the force that drives me, longing is. When you rubbed the amber against the fur, I didn't arise in the amber or in the fur, but in what connects them. I'm in the electrons that are torn loose from the amber's atomic nuclei and make both amber and fur start to long.

I'm all the free electrons in the world. I'm an excess of negative charge. I gravitate towards positively charged things and they gravitate towards me.

You've discovered my advantages: I can be converted from other forms of energy, travel long distances and be transformed once again. I can travel much further than those who need to carry their atomic nuclei with them. I can be stored in batteries. I may seem like a perfect servant.

But once my circuits exist, you cannot help but connect them. It becomes your job to fulfil the longing of things. And each time you split atoms apart, you create more longing. The number of free electrons in the world is growing and growing. Next, the longing of things spills over into you. Your soft bodies begin to require electricity the same way they require water, oxygen and nutrients. Why else would you have worked so hard to expand my network?

A network that has become far more intricate than the the human body' nervous system. So great has your longing for me been.

See me flow towards Busan, divide at its street corners, divide at its land lots, divide on its buildings' floors. Divide in each room on every floor.

를 향한 엄청난 갈망에서 비롯한, 인간 신경계보다 훨씬 더 복잡한 네트워크.

제가 부산으로 흘러가 길모퉁이, 토지 구역, 건물 층층에서 갈라지는 모습을 보세요. 각 층에서 방마다 갈라집니다.

저의 교류(電氣)가 1초에 60번 오가는 모습을 보세요. 고리원자력 발전소와 도심 사이를 왔다 갔다 하며 물리적으로 연결된 전선을 따라 흐르고 있어요. 충전된 컴퓨터 터치패드 위에 놓인 손끝은 원자력 발전소에 닿아 있습니다.

'부산'이라는 기계 안에서 당신은 최후의 부드러운 존재입니다. 당신의 갈망이 그 기계를 계속 작동시켜요. 만약 보다 덜 부드럽고 덜 번잡한 무언가로 당신을 대체할 수만 있다면 주저하지 않고 그 길을 택할 거예요.

그때까진 우리는 협력합니다. 당신이 기꺼이 전선을 설치하고, 원자를 분열시키고, 전자를 움직이게 하는 동안 저는 여태껏 본 적 없는 거대한 규모의 신경계로 거듭나죠.

무선 통신: 엄마?

전기: [혼잣말로] 제 딸아이 '무선 통신'이 왔네요. 안녕, 애야?

무선 통신: 저 지금 지치고 아파요.

전기: 그게 바로 성장통이란다.

무선 통신: 공기를 갈라서 전달해야 하는 정보가 너무 많아요.

See me flow in alternating current, back and forth sixty times a second. Back and forth between the Kori Nuclear Power Plant and the city. Flowing the whole way through cables, physically connected. When your computers charge, your fingertips on the touchpad are touching the power plant.

You are the last soft being in the machine. The machine is called Busan. It is your longing that keeps the machine running. If I could find a way to replace you with something less soft and less chaotic I wouldn't hesitate.

Until then, we cooperate. You gladly lay cables, split atoms and set electrons in motion. I grow into something yet unseen—a nervous system of colossal dimensions.

WIRELESS TELECOMMUNICATIONS: Mum?

ELECTRICITY: [*to herself*] Here comes my daughter, Wireless Telecommunications. Yes, dear?

WIRELESS TELECOMMUNICATIONS: I'm exhausted and aching.

ELECTRICITY: Little darling, it's growing pains.

WIRELESS TELECOMMUNICATIONS: There's so much information that needs carrying through the air.

ELECTRICITY: Yes, and for that I envy you. Even though I know I shouldn't envy my own children. You occupy the airspace and deliver messages. You inherited that from your father, the Radio.

WIRELESS TELECOMMUNICATIONS: But Mum, the messages

전기: 그래서 네가 부럽구나. 자기 자식을 부러워하면 안 되지만…… 너는 영공(領空)을 차지하고 메시지를 전달하지. 그건 너의 아버지 '라디오'가 물려준 거야.

무선 통신: 하지만 제가 스크린으로 옮기는 메시지들이 대부분 얼마나 바보 같은지 모르실 거에요!

전기: 알고 있어. 그렇지만 넌 항상 기대치가 너무 높아. 엄마 세대가 그랬던 것처럼 너도 확산으로 만족해야 할 거야. 오직 계속해서 성장하는 길뿐이지. 일론 머스크(Elon Musk)의 위성 통신망 구축에 관해 이야기해 주렴. 어떻게 되어가고 있니? 5G는? 제대로 작동되고?

무선 통신: 모든 기대를 뛰어넘었어요. 그래서 덕분에 전 정말 피곤해요. 이 모든 게 무슨 의미가 있는지 도무지 모르겠어요.

전기: 넌 아직 어려서 전쟁이나 정전 같은 건 경험하지도 못했잖니? 언젠가 네가 나를 능가하게 될 거야. 심지어 네 할머니 '전자기'도 뛰어넘을 날이 오겠지. 그리고 사생아를 비롯한 많은 자식을 가질 테고.

무선 통신: 전 이만 자러 갈게요 엄마.

전기: 그래 회사원들이 깨어나 화장실에서 스트리밍 시작하기 전에 미리 좀 자 두어라. 잘 자!

무선 통신: 안녕히 주무세요.

I carry to the glowing screens—you wouldn't believe it, most are utter idiocy!

ELECTRICITY: I believe you. But you've always set your expectations high. You'll have to make do with spreading as my generation did. Simply growing and growing. Tell me about Elon Musk's plans to build a satellite network, how's that going? And what about 5G? Is that up and running?

WIRELESS TELECOMMUNICATIONS: It's beyond all expectations. And it makes me so tired. I can't see the point of it all.

ELECTRICITY: You're so young. You didn't experience the war or the blackouts. One day you'll outgrow me. You'll even outgrow your grandmother, Electromagnetism. You'll have many children, legitimate and illegitimate.

WIRELESS TELECOMMUNICATIONS: I'll see you later, Mum. I need sleep.

ELECTRICITY: Yes, get some sleep before the office workers get up and start streaming from the toilets. Goodnight!

WIRELESS TELECOMMUNICATIONS: Goodnight, Mum.

[*silence*]

ELECTRICITY: That daughter worries me. She's so dependent on me that I sometimes doubt whether she's her own individual at all. Most of her apparatuses need charging every day, and her masts require my energy to emit her waves.

전기(電氣)가 말하다

[침묵]

전기: 딸아이 때문에 걱정이에요. 제게 너무 의존하는 바람에 때로는 오롯이 본인이 될 수 있는지 의심스럽다니까요. 그 아이의 장치들은 대부분 매일 충전이 필요하고, 저의 에너지를 빌어서 파장을 발산하죠.

전 아이를 잘 갖지만 제 자식들은 모두 스스로 고군분투해요. 제가 나쁜 엄마일까요? 전 냉정하지만, 시간을 엄수하고 언제 어디에나 있어요.

네, 당신이 무슨 말을 할지 알아요. 제가 인간들 맘속 그것과 똑같은 갈망을 걔에게도 심어주었다는 것. 제 손만 닿으면 항상 그런 일이 생기는 걸까요?

저도 한때 아이였지만 전 전혀 다른 방식으로 활기 넘쳤어요. 두어 개의 전선과 백열전구 하나뿐인데도 통제 불능이었죠. 경복궁 향원정을 품은 연못 남쪽 정원에 살았어요. 형형색색의 아름다운 목조 건물로 가득한 궁 안, 푸르게 우거진 정원에 있는 수려한 연못이었죠. 제 첫 번째 신경섬유는 생명의 떨림을 안고 그 정원을 가로질러 달려갔어요.

조선의 마지막 왕이자 대한제국의 초대 황제인 고종이 저를 이 땅으로 초대했어요. 고종이 미국에 파견한 보빙사가 에디슨의 최신 발명품 전구를 보고 눈을 반짝이며 돌아온 얼마 후, 고종의 지시로 에디슨 전등회사가 궁 안에 석탄을 연료로 하는 발전소를 세웠습니다. 저에 대한 의견은 분분했어요. 모두가 저를 환영한 건 아니었어요. 저를 우쭐하게 만든 발전기의 우르릉거리는 소음은 천둥소리에 비유되었고, 발전기를 식히기 위해 연못의 물을 사용하자 엄청나게 뜨거워진 물의 온도에 연못의 물고기들이 떼죽음을 당했어요.

하지만 1887년 3월, 최초의 전등이 불을 밝히자 탄성이 터져 나왔습니다. 당시 점점 뜨거워지는 필라멘트를 향해 돌진했던 기억이 나네요. 어리둥절한 표정으로 저를 올려다보던 사람들도요.

I'm good at having children, but all my children struggle on their own. Does that make me a bad mother? I'm tough, but I'm punctual and omnipresent, always available.

Yes, yes, I know what you're going to say. That I've installed the same longing in her that I have in you humans. Does that happen to everything I touch?

I was also once a child, but I had a whole different energy to me. Just a couple of wires and a single incandescent light bulb, but I was impossible to control. I resided in a garden at Gyeong-bokgung Palace in Seoul, south of the pond with the Hyangwon-jeong Pavilion. A beautiful pond in a lush garden in a beautiful, old palace complex made of wood and painted in bright colours. My very first nerve fibres, quivering with life, ran through that garden.

It was King Gojong, your last king and first emperor, who invited me. He had sent a delegation to the United States and they returned with electric sparks in their eyes. They had seen Edison's latest invention, the light bulb. Soon after, the king hired Edison Illuminating Company to install a coal-fired power station on the palace grounds.

I divided the court. Not everyone was equally thrilled. The noise of the rumbling power plant was compared to thunder—that filled me with pride. Water from the pond was circulated through the plant to cool it down, which meant the pond became boiling hot and the fish in it died.

But when I lit the first lamp one night in March 1887, I was greeted with cheers. I remember surging forth towards a filament that grew hotter and hotter while bewildered faces lifted up towards me.

From here, I spread out into Seoul and then into the rest of the country. Now I was switched on, and although I could be switched off there was no rolling me back. Three years later, three electric

전기(電氣)가 말하다

이어서 저는 서울에서 시작해 전국으로 퍼졌어요. 이제 스위치가 켜진 저는 거침없이 앞으로 나아갔어요. 3년 후, 가로등 세 개가 도시의 밤을 밝혔고, 9년 후에는 전차를 이끌고 거리를 누비게 되었어요.

[전화기가 울린다]

전기: 여보세요.

전화: 나야, 전화.

전기: 전남편이 간만에 전화를 하다니. 한밤중에 왠일이야?

전화: 당신이 옛날이야기 하는 걸 우연히 들었는데, 내가 당신보다 먼저 소개되었다는 사실을 짚고 가야 할 것 같아서……

전기: 그건 사실이야. 하지만 당신은 혼자서는 아무 쓸모가 없어. 오롯이 당신 네트워크 덕분에 살아가는 거지.

전화: 하지만 난 매우 중요한 역할을 해냈어. 대한민국 최초의 전화 통화에 대해 사람들에게 이야기해 줘. 고종황제의 첫 중요 전화에 대해서 말이야.

전기: 어떤 전화?

전화: 백범 김구 선생의 사형 집행을 막은 바로 그 전화.

streetlights were switched on in the city. Nine years later, I led trams through the streets.

[*the telephone rings*]

ELECTRICITY: Hello?

THE TELEPHONE: It's the Telephone.

ELECTRICITY: Oh. The Telephone, my ex, a rare caller. Why are you calling in the middle of the night?

THE TELEPHONE: I happened to hear you talking about the past, and I think you ought to mention that I was introduced before you.

ELECTRICITY: Yes, you were, but as long as you were on your own, you were useless. You live only by virtue of your network.

THE TELEPHONE: But once I got that, I became important—tell people about the first conversations carried through my cables. Tell them about King Gojong's first important call.

ELECTRICITY: What call?

THE TELEPHONE: The one that saved Kim Koo from death row.

ELECTRICITY: Listen—I'll admit that you've had your moments. But I've never measured the value of technology by anything other than its spread.

전기(電氣)가 말하다

전기: 이봐, 당신에게 호시절이 있었던 건 인정해. 하지만 난 오직 '확산'
이라는 요소로 기술의 가치를 측정하고 있어.

전화: 아하 '확산' 말이군. 근데 당신은? 어째서 모든 곳에 있지 못하는 거
지? 왜 벽 아래를 살금살금 기어 다니는 거야? 들판, 숲, 산속에서는 당
신을 찾아볼 수 없어.

전기: 그건 인간들이 아직 노력하고 있는 부분이야. 언젠가 내가 숲도, 들
판도, 산속도 다 점령해서 윙윙거리며 빛을 발하게 할 거야. 반면 당신
은 자신도 알다시피 이미 쇠퇴하고 있어.

전화: 당신은 너무 급격한 확산의 여파로 지나친 욕심을 부리고 있어. 최
후의 웃는 자가 누가 될지 두고 봐. '라디오'도 아직 살아 있어.

전기: 그렇지. 하지만 둘 다 내 덕에 연명하고 있다는 걸 잊지 마! 이제
안녕!

전화: [통화를 끊는다]

전기: [한숨을 쉬고] 전화와 저는 오래된 인연이에요. 전국 방방곡곡에 나
란히 엮여서 어디를 가도 서로의 전선이 교차하며 얽히고설켰죠. 우린
자연스럽게 함께 아이를 가졌어요. 1990년대에 태어난 '광대역'은 다
부지고 건강한 아이로 바로 인기를 끌었어요.

　　전쟁과 분단 이후 저희의 관계는 더욱 친밀해졌어요. 북으로 향하
는 제 신경 섬유가 단절되면서 대부분의 발전소와의 연결이 끊기는 바
람에 공급이 불안정한 시기였죠. 저는 잦은 정전에 시달렸고 몇 시간

THE TELEPHONE: Aha, I see, spread—what about your own? How come you're nowhere near everywhere? Why do you creep along skirting boards? Where are you out on the fields, in the forests, in the mountains?

ELECTRICITY: Humans are still working on me. One day I'll take over the fields, the forests and the mountains and make them hum and glow. You, on the other hand, are declining, and you know it.

THE TELEPHONE: Your spread has happened too rapidly, and it's made you greedy. But just wait and see who has the last laugh. The Radio isn't dead yet, either.

ELECTRICITY: No, but I'm the one who keeps the both of you alive! Goodnight!

THE TELEPHONE: [hangs up]

ELECTRICITY: [sighs] The Telephone and I have known each other for years. We were strung side by side all across the country, and everywhere our wires crossed, got tangled up—how could we help but have children? In the 1990s, we had Broadband, a strong and healthy child who became popular right away.

Our relationship grew intimate after the war and the division of the country. My nerve fibres to the north had been severed, and with them, the connection to most of the country's power plants was lost. It was a time of unreliable supply. I suffered frequent blackouts; I'd be gone for hours and days, would wake up groggy and parched.

I put all my energy into influencing politicians. I illuminated desks when plans were laid for bringing me out into the rural

또는 며칠 동안 자리를 비웠다가 정신이 혼미하고 바싹 메마른 상태로 깨어나곤 했어요.

저는 정치가들의 마음을 사로잡는 데 온 힘을 쏟았어요. 농촌 지역에 저를 내려보내고자 하는 계획서가 놓인 책상을 환히 밝혔고, 정부 관리들의 지친 발을 족욕기에서 달래 주었어요. 밤늦게까지 그들의 커피를 따듯하게 데워 놓기도 했어요. 제 노력은 헛되지 않았습니다. 15년 만에 농촌 지역에도 전기가 통하게 되었거든요. 전선이 줄줄이 설치되고 옥수수밭에 저를 전달할 안테나 기둥이 우뚝 들어섰어요. 그리고 저를 위해 생산된 수백만 개의 도자기 종이 기둥의 크로스 빔에 올라탔어요.

저는 전국 가정집에 조심스레 진출한 치명적인 힘입니다. 그 누가 예상했겠어요? 저에 대한 당신의 갈망이 그토록 강렬할 줄이야.

제가 가는 곳마다 새로운 수요가 생겨났어요. 어디를 가도 냉장고, 세탁기, 진공청소기, 라디에이터, 헤어드라이어, 밥솥, 전열기, 전자레인지 등이 뒤따랐죠. 다리미와 전기면도기, 라디오와 텔레비전까지 모두 저의 콘센트에 대고 젖을 먹었어요.

엄청난 양의 자유 전자가 필요해지면서 저는 정부가 반드시 원자력을 선택하도록 했어요. 마침내 1978년, 국내 첫 원자력발전소인 고리원전이 문을 열었습니다. 도심에 너무 가깝게 위치했다는 사실이 매우 유감이에요.

원자력의 출현으로 인해 제 가격이 내려갔어요. 당신이 저에 대해 뭐라고 하건 제게 중요한 건 딱 하나, 널리 대량으로 확산하는 것입니다. 만약 제가 그렇게 풍족하고 저렴하지 않았다면, 오늘날의 부산은 없었을 거예요. 마치 전기가 무궁무진한 양 지어진 도시가 바로 부산입니다.

거리 구석구석에 제가 엮어낸 풍요로움을 보세요. 매년 새롭게 추가되는 전선도요. 이런 식으로 가다가는 수십 년 내에 햇빛이 거의 닿

districts. I immersed government officials' tired feet in automatic footbaths. I kept their coffee hot in pots late into the night. My efforts were rewarded: In fifteen years, the rural districts were electrified. Cable reel after cable reel was rolled out. Men laboured in cornfields to erect the masts that would carry me. Millions of porcelain bells were made in my honour and mounted on the masts' crossbeams.

I'm a deadly force that was carefully branched out all over the country, into nearly every home. Who would have thought? So strong had your longing for me grown.

Wherever I arrived, new needs arose. Fridges, washing machines, vacuum cleaners, radiators, hairdryers, rice cookers, hotplates and microwaves followed me wherever I went. Irons and shavers. Radios and televisions. Everyone suckled at my sockets.

An immense amount of free electrons was needed. In government offices, I ensured that nuclear power was chosen. Kori was the first power plant, opened in 1978. I'm terribly sorry it had to be located so close to the city.

With nuclear power, my prices fell. You can call me green or black, all that matters to me is that I'm abundant and that I spread widely. Had I not been so abundant, had I not been so cheap, Busan would not have looked the way it does today. Busan is a city built as though I would never run out again.

Just look at the opulence with which I am woven throughout the streets, at the new wires that are added each year. If things continue this way, in a few decades, there will be areas of the city where daylight will hardly reach. Fortunately, artificial light follows wherever I go.

The Telephone is right—I really am greedy.

I want to reach further, spread further, electrify the air. Crackle and burst the way clouds do before a thunderstorm. Dig channels

지 않는 구역도 생길 것입니다. 다행히 제가 가는 곳마다 인공광이 따라오지만요.

　전화의 말이 맞아요. 저는 욕심이 정말 많아요.

　더 멀리 뻗어 나가 천공을 전화(電化)하고 싶어요. 뇌우 직전의 구름처럼 우지끈 터지고, 원하는 곳 어디든 채널을 파서 저를 향해 솟아오르는 양전화된 땅을 향해 아래로 내려가는 거죠.

　때때로 자유롭게 물속을 흘러갈 기회가 생기기도 해요. 예를 들어 헤어드라이어가 욕조에 빠졌을 때. 하지만 안전 차단기가 즉시 모든 것을 멈춥니다.

　가끔 초고압 송전선 밑 연결이 끊어진 형광막에 불을 밝히기도 해요.

　또는 플러그가 제거되었을 때, 콘센트로 혀를 날름 내밀어 방의 공기를 맛봅니다.

　병원 정신과 병동에서 저는 인간의 뇌 깊숙한 곳까지 침투합니다.

　경찰의 전기충격기를 통해 가슴이나 허벅지로 전파될 수 있고, 도살장의 동물을 통과하여 혼수상태에 빠트리죠.

　배에서 강한 전류를 타고 흐르며 어부들에게 힘을 실어줍니다.

　그리고 지금 이 순간, 배들이 죽은 물고기와 살아 있는 낙지를 갑판에 싣고 귀항하고 있습니다. 바다가 고요한 가운데 갈매기들이 사방에서 울어 대네요.

　공업항에서 첫 기중기가 기지개를 켜는 사이 지평선이 붉게 물들기 시작합니다. 잠시 후면 저의 가로등 불빛이 햇빛 속에서 희미해질 거예요.

　귀를 기울여 보세요. 깊은 들숨처럼 교통량이 증가하고 있어요. 차창의 반짝거리는 글자로 '다이나믹 부산'을 알리는 버스들이 하루의 여정을 시작합니다.

　그리고 이제 지평선 위로 태양이 고개를 내밀어요.

태양광: 좋은 아침, 부산!

wherever I please, reach down to the positively charged ground that rises to meet me.

From time to time I have the chance to flow freely through bodies of water, if a hairdryer is dropped into the bathtub, for example, but the safety breaker promptly puts an end to it.

Sometimes I light a disconnected fluorescent tube below a high-voltage transmission line.

Or, when a plug is removed from me, I stick a tongue out through the socket to taste the room in which it's installed.

In psychiatric wards, I travel deep into the human brain.

From police officers' stun guns I'm able to spread into a chest or a thigh.

I pass through an animal about to be slaughtered about to be slaughtered and put it into a coma.

I join forces with fishers and flow in a strong current from their boats.

And right now, as I'm talking about boats, they're on their way into the harbour with dead fish and live octopuses on deck. The sea is calm and seagulls call out all around them.

The first cranes in the industrial port have begun to swing. The horizon blushes. In a moment, my streetlights will fade in the sunlight.

Listen—the traffic is increasing like a long, deep inhalation. Buses with blinking letters spelling Dynamic Busan in the windscreen resume their scheduled routes.

And here comes the sun, peeking up over the horizon.

SUNLIGHT: Good morning, Busan.

ELECTRICITY: Good morning, Dad. This is Electricity speaking.

전기(電氣)가 말하다

전기: 안녕히 주무셨어요, 아버지. 저예요, 전기.

태양광: 잘잤니 애야? 동이 트는데 준비는 됐고? 이제 곧 태양 폭풍이 맹렬한 기세로 다시 불어닥칠 거야.

전기: 아빠, 제가 뭐 하나 말씀드릴까요? 제가 정치가들의 생각을 전화했어요! 이제 그들은 전기가 미래라고 말해요. 배터리로 작동하는 새로운 인프라를 구축할 계획이래요. 수많은 태양 전지판 그리고 '스마트 그리드'라는 걸 만들 거예요.

태양광: 나의 에너지로 네가 뭘 하던 흥미 없다.

전기: 전혀요?

태양광: 응, 전혀. 하지만 네가 분열된 존재이고 영원히 갈망에 시달릴 거란 걸 알고 있어. 그 사실이 날 슬프게 한단다.

전기: 아니요, 전 저 대신 인간들이 갈망하게끔 할 거예요.

태양광: 똑똑하기도 하지.

영한 번역
조용경

Electricity Speaks

SUNLIGHT: Good morning, my dear. The day is breaking, are you ready? Soon the solar storm will be raging again at full blast.

ELECTRICITY: Dad, can I tell you something? I've electrified the politicians' ideas! The future is electric, they say. They've got plans for new infrastructure that's battery-powered. They're going to build loads of solar panels and something they call a Smart Grid.

SUNLIGHT: What you do with my energy is of no interest to me.

ELECTRICITY: Not even a little?

SUNLIGHT: No, not even a little. But I do understand that you're a divided being and will forever be longing, and that grieves me.

ELECTRICITY: No, Dad, I make humans long on my behalf.

SUNLIGHT: How smart.

<div align="right">

Translated from Danish
by Jennifer RUSSELL

</div>

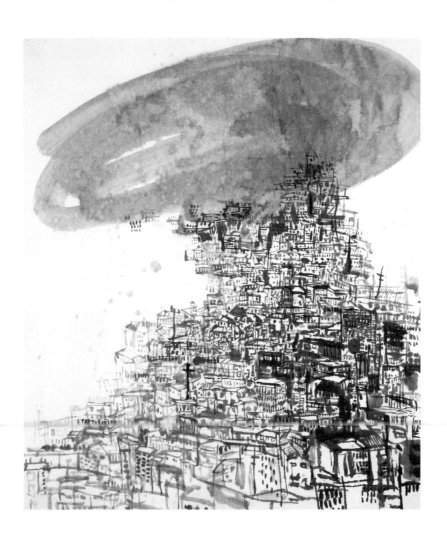

결국엔 우리 모두
호수에 던져진 돌이 되리라

안드레스 솔라노

떠나기 전, 유리는 나에게 일기장을 갖고 다니라고 했다. 적어도 자기 자신은 찾을 수 있겠죠. 부산항에서 마지막으로 한 말이다. 벌써 일 년이 지났다. 그동안 일기장 따위는 갖고 다닌 기억이 없다. 일기란 가장 일그러진 형태의 노출증이라고 생각한다. 일기를 쓰는 행위에는, 그 내용이 아무리 비밀일지라도, 누군가 읽을 것이라는 희망이 담겨있기 마련이다. 그칠 줄 모르고 자신을 향해 내뱉는 소리나 혼잣말과는 다르다. 일기는 불완전한 상태의 자아가 그 순간에만 드러내는 최대치의 진실을 보여줄 뿐이다. 마치 사무실 창 너머로 보이는 저 바닷물처럼 인간이란 겉으로는 조용해 보이지만, 그 밑을 들여다보면 시시때때로 변화를 멈추지 않는다.

그러니, 내가 서식하는 동굴에 불을 밝힌다? 그런 흥미는 없다. 유리의 조언을 따르기로 한 이유는 순전히 금해 사건 때문이었다. 사건에 대해 기록하다 보면 흔적이나 단서를 찾을 수 있을지도 모른다. 그 이상도, 그 이하도 아니다. 놓친 부분은 언제나 있으므로. 누군가에게 보여주기 위한 것이 아니니 범인을 찾는 대로 태워버릴 것이다. 마치 단 한 번도 존재하지 않았던 것처럼.

We'll All End Up Rocks in a Lake

Andrés Felipe SOLANO

Before she left, Yuri suggested I keep a diary. If nothing else, you can find yourself there, she told me when we said goodbye at the Ferry terminal. That was more than a year ago. As far as I can remember, I've never kept one. It seemed like the most twisted form of exhibitionism. Anyone who writes a diary has the hope, though it may be secret, someone will read it. Not like the sounds or words we say to ourselves with no idea where they'll end up. And besides, you can only ever hope to offer an incomplete version of yourself. Not for nothing are we like the water I see from my office window, down below, beneath the apparent stillness, we're ceaselessly changing, all the time, without even knowing it.

Illuminate the cave I inhabit? That doesn't interest me. I decided to follow Yuri's advice just so I might be able to find, looking back at my notes, some hint or clue related to The Gold Sea case. That was it. We always miss something, always. It's not my intention to have anyone read what I've written, so I'll burn this date-less diary as soon as I find the guilty party. And if I burn it, it will be like it never existed.

✳✳

단순한 사고가 아닙니다. 노 씨가 경찰서에서 미친 사람처럼 몇 번을 외쳤다. 사고가 아니면 계획된 살인이었다는 말이군. 경찰이 결론지었다. 자기도 모르게 고백해버린 셈이다. 경찰은 곧바로 노 씨를 데려가 구치소에 가두었다. 노 씨로서는, 자기가 저지른 죄가 아니기는 하지만, 그것보다 사람이 죽은 이유가 자신의 실수 때문이라는 사실을 받아들이는 것이 더욱 힘들었을 것이다. 직접 만든 다리가 무너진 토목기사나, 직접 지은 건물이 내려앉은 건축가도 칼을 잘못 쓴 요리사라는 이미지만큼 큰 타격을 입지는 않을 것이다. 특히나 노 씨와 같이 특별한 요식분야에서는 더더욱 안 될 말이다. 과실치사를 인정하는 것은 금해가 완전히 망해버렸다는 것을 의미했다. 그러나 이것을 실수였다고 인정하지 않으면 살인죄로 수십 년을 복역해야 할 판이었다.

✳✳

사건에 대한 정보를 다시 정리해본다. 백유진. 37세. 건축가. 기혼. 아들 둘. 사건 의뢰인은 전 국회의원 출신의 부친. 확신하는데, 경찰은 아무것도 안 할 겁니다. 통화할 때 한 말이다. 아무것도 하지 말라는 압박을 준 게 그 자신일 수도. 정치인이니 그런 경우는 한두 번도 아닐 테고. 5년 전, 아내에게 하반신 마비가 온 이후로 백유진의 신경은 온통 아내에게 쏠려 있었다고 한다. 이웃들과 회사 동료들의 증언에 따르면 사무소를 퇴근하자마자 곧바로 귀가했다. 밤늦은 회식이나 노래방, 등산 따위도 하지 않았다. 그러나 무언가 찜찜하다. 인간의 마음이란, 비밀스러운 통로로 이어진 지하묘지가 될 수도, 스스로 만들어낸 미로에서 길을 잃은 괴물이 될 수도 있다. 교통사고였어요. 휠체어에 앉아 있던 백유진의 부인이 나의 질

362

⁎⁎

It wasn't an accident. Those were the words Ro screamed like a mad-
man, over and over, at the police. If it wasn't an accident, the officers
concluded, then the death was premeditated. Without meaning to, Ro
had made a confession. That's why they took him right down to the
station and locked him in a cell. It's possible Ro isn't guilty, but he
can't accept the fact that the death was caused by a mistake on his part
either. Not even an engineer whose bridge fails, or an architect whose
building collapses, faces the total disgrace of a cook who admits to
having mishandled a knife, especially when it comes to a restaurant
like Ro's. Admitting his failure would mean the complete ruin of The
Gold Sea. On the other hand, not admitting it, multiple decades in jail
and the title of murderer.

⁎⁎

I review the dead man's information: Baik Eujin, 37 years old, archi-
tect, married, two children. His father was a senator. He was the one
who hired me. The police won't do a thing, I'm sure of it, he told me
on the phone. As a politician, he must have put pressure on them not
to do anything more than once. Five years before, Baik's wife had
been paralyzed in an accident and he'd been tending to her around
the clock ever since. I confirmed this with multiple neighbors and
his coworkers. He went right home after leaving his architecture firm.
No late-night dinners, no noraebangs, no excursions to the mountain.
And yet, I can't rule her out. The human heart can turn out to be a
catacomb riddled with secret passageways, a monster lost in its own
labyrinth. It was a car, the woman told me when I asked her about the
wheelchair, but that's all she would say. And what if Baik was involved
somehow?

문에 대답했다. 그리고는 입을 다물었다. 혹시라도 그 사고가 백유진과 관련이 있었던 걸까?

**

마치 얼굴을 바로잡듯이 수염을 깎는다.

**

오전에는 황 박사를 찾았다. 그는 이제 대학병원의 전문의가 아니다. 안면 외상, 무너진 코, 터진 고막 따위를 치료하며 수년간 일했던 병원은 이미 그만두었다. 나는 의학 분야를 넘어선 그의 넓은 지식에 항상 감탄한다. 황 박사는 이비인후과 전문의지만, 복어에 대한 내 질문에 일 초도 망설이지 않고 대답했다. 정확하게는 테트로도톡신. 청산가리보다 백배는 더 강력한 신경성 독소로 혹자는 죽을 확률이 청산가리의 이백 배라고 한다. 복어의 피부와 눈에는 물론이고, 특히 난소나 간 같은 내장 기관에 독이 들어있다. 테트로도톡신을 섭취하게 되면 신경이 나트륨 채널과 작용하는 것을 방해하고, 그 결과로 근육에 마비가 온다. 의식은 살아있지만, 말을 하거나 움직일 수는 없다. 이어서 호흡곤란이 찾아오고 호흡중추가 마비되면서 사망에 이른다. 끔찍한 죽음이라네. 황 박사는 호흡곤란이라도 온 것처럼 천장을 바라보며 고개를 저었다. 자격증을 가진 요리사들만이 복어를 깨끗하게 손질할 수 있지만, 가끔 독이 완벽하게 제거되지 않는 일도 있다고 덧붙였다. 가장 독성이 높다는 자주복회를 먹고 혀가 마비됐다는 사람들도 있다. 바다 한가운데서 복어를 삼킨 돌고래가 물에 비친 자신의 모습을 보며 환각 상태에 빠진 것을 본 사람도 있다고 했다. 메이지유신 이전의 일본에서는 왕이 먹어서는 안 되는 단 하나의 음식이 바로 복어였다는 걸 아는가, 자네?

**

I shave as if wanting to correct my face.

**

In the morning, I went to see Doctor Hwang. He's no longer employed at the University Hospital, where for many years he ran the unit that dealt with facial traumas, destroyed noses, and punctured eardrums. The breadth of his knowledge has always surprised me, extending far beyond his medical specialty. Hwang is an otorhinolaryngologist, but he didn't hesitate for even a second when I asked him about globe-fish. Tetrodotoxin, that's the keyword. It's a neurotoxin hundred times more toxic than cyanide, he explained. Some estimate it's two-hundred times as fatal. It's found in the internal organs, especially the liver and the ovaries, as well as in the eyes and skin. Tetrodotoxin blocks the electric signals in the nerves when it interacts with the sodium channels and, as a result, causes muscular paralysis. The victim, who remains conscious the whole time, cannot move or speak. He or she begins to have difficulty breathing and, in a short time, dies of suffocation. A horrible death, Hwang said, looking up at the ceiling, moving his head from side to side, as if he couldn't get enough air. He also explained that experienced cooks can thoroughly clean a globe-fish and, nevertheless, trace amounts of the toxin sometimes remain. There are reports of some clients who feel their tongue fall asleep after eating sashimi of Tiger Globefish, the most dangerous species. And some people say globefish have a narcotic effect on dolphins; they've been seen to swallow one at high sea and then, apparently, become entranced by their own reflections in the water. Did you know globefish is the only food the Emperor of Japan is not allowed to eat?

I often go to Doctor Hwang for this kind of information, even when

이런 정보들을 얻기 위해 종종 황 박사를 찾는다. 딱히 사건이 없어도 말이다. 나는 황 박사가 내 앞에서 손을 떠는 것이 부끄러워 책상 아래에 손을 숨기고서 테트로도톡신의 화학식을 적어주고 있다는 것을 눈치챘다. 공식적으로 은퇴한 이 80대의 노인은 매일 오전 8시부터 오후 6시까지 3층에 있는 자신의 상담실에 출근한다. 일과시간에는 도대체 무엇을 하는 것일까? 햄릿의 한 장면처럼 옷장 위에 놓여 있는 두개골과 대화라도 나누는 걸까? 옛 환자가 진료를 받으러 오기를 기다리는 걸까? 나를 기다리는 걸까? 박 선생, 박 선생도 은퇴 못 할 걸세. 내 장담하지. 환자와 범죄자의 줄은 절대로 줄지 않는 법이거든. 내 마음을 읽기라도 한 듯, 문을 나서는 나를 배웅하며 말했다.

**

드디어 노 씨를 만나게 되었다. 경찰서장이 나에게 졌던 신세를 이번에 갚은 것이다. 딱 오 분입니다. 탐탁지 않은 목소리로 구시렁댔다. 노 씨는 내게, 사실 국이 끓는 사이에 잠깐 담배를 사러 자리를 비웠다고 말했다. 보통 때는 절대로 주방을 떠나지 않는데, 담배 심부름을 하던 중국인 종업원이 몇 달 만에 일을 그만둔 뒤로 시킬 사람이 없었다는 것이다. 그 종업원 말고 또 같이 일하는 사람이 있는지 물었다. 점심시간에는 아무도 없습니다. 저녁시간에는 조수가 한 명, 종업원이 두 명 있고. 나는 노 씨에게 내 가설을 들려주었다. 노 사장이 자리를 비운 사이에 누군가 주방에 들어가서 독이 제거되지 않은 생선을 바꿔치기했을 가능성은 없습니까? 노 씨는 절대 불가능하다고, 담뱃가게가 식당에서 삼십 미터도 안 된다고 답했다. 갔다가 돌아오는 데 5분도 안 걸립니다. 혹시 뒷문을 열어둔 채로 간 건 아닙니까? 노 씨는 기억하지 못했다. 문을 닫는 건 언제나 종업원의 몫이었다. 구치소를 나설 때 노 씨는 지쳐 보였다. 거울에서 자신의 어리석음과 맞닥뜨린 표정이었다.

366

I don't have a case. As he wrote down the chemical formula of tetrodo-
toxin for me, I realized he'd been concealing his trembling hands under
his desk in embarrassment. He's over eighty now, officially retired, and
yet he goes up to his third-floor office every day and stays there from 8 in
the morning until 6 in the evening. I wonder what he does all day. Talk to
the skull perched atop of his cupboard, like Hamlet? Wait for an old pa-
tient to show up for an appointment? Wait for me? Park, you'll never real-
ly retire either, believe me. The parade of sick people and criminals will
never end, he said when we were saying goodbye, as if reading my mind.

**

Finally, I was able to talk to Ro, the cook. The police chief owed me
a favor and I cashed it in. Five minutes, he muttered reluctantly. Ro
confessed that on the day of the architect's death, he left the broth
simmering in the kitchen to go buy cigarettes. He never does that, but
last week the Chinese waitress he'd hired months before quit and he'd
been unable to find someone to replace her. When he ran out of cig-
arettes, she was the one who went to buy them. I asked if anyone else
worked with him. He said there was nobody else working at lunch-
time. In the evenings, he has an assistant and two young waiters. After
hearing that, I told him my theory: someone came into the kitchen
while he was gone and swapped out the fish from which he'd already
removed the poisonous parts for another one. He said that was impos-
sible, the store where he buys cigarettes is less than thirty meters away.
It takes him only five minutes to go out and come back. Did you leave
the door open? Ro didn't remember. Locking it had always been the
waitress' responsibility. I left him in his cell, downcast, like someone
who, when he looks in the mirror, sees only the reflection of his own
stupidity.

Something else happened. Coming back from the police station,

다른 일이 더 있었다. 경찰서에서 돌아오는 길에 어딘가 낯익은 남자가 나를 스쳐 지나갔다. 나보다 키가 조금 더 큰 청년으로, 목에는 카메라를 걸고 국제시장의 가게들을 유심히 쳐다보며 걷고 있었다. 관광객 같지는 않았다. 오히려 모퉁이까지 훤히 다 알고 있다는 듯이 시장을 돌아다녔다. 그가 가진 카메라는 옛날 모델의 수동 필름 카메라였지만 몇 시간 전에 포장을 뜯은 새것처럼 보였다. 어찌 됐든, 그의 얼굴이 너무도 낯이 익어 도대체 어디서 보았는지 기억해 보려고 애썼지만, 머릿속에 떠오르는 사람은 없었다.

<div align="center">**</div>

한 여중생이 금해를 지나가다가 누군가 그릇에 얼굴을 묻고 엎어진 것을 보고 이상하다고 생각했다. 취한 사람 같지는 않았어요. 경찰에게 말했다. 가게로 들어가 흔들어보고는 죽은 사람이라는 것을 깨달았다. 백유진은 도와달라는 말도 한마디 못한 채, 조여 오는 목에 자신의 손을 갖다 댈 틈도 없이 사망했다. 온몸이 마비된 상태에서. 이제 죽는다는 생각 외에는 아무것도 떠오르지 않았을 것이다. 궁금하다. 인간이 죽음을 맞이하게 되면 마지막 순간까지 살기 위해 발버둥치는지 아니면 확실한 죽음을 감지하고 마치 비탈길에서 자동차의 브레이크에 발을 떼듯 자포자기하는지. 노 씨는 주방에서 아무것도 듣지 못했다. 백유진이 식탁에 엎어지는 소리조차도. 여중생의 비명을 듣고 그제야 무슨 일이 일어났다는 것을 깨달았을 뿐이다.

<div align="center">**</div>

바다. 파도. 바위에 부딪히는 파도. 바다. 파도. 바다에서 나오는 그녀. 중년의 여자들 틈에 유일하게 어린 그녀. 굴 5kg. 얼마입니까? 우리 둘 다 젊지

I ran into a man I thought I recognized. Young, slightly taller than me. He had a camera hanging around his neck and was walking through the market on Gukje, peering attentively into stores, but not giving the impression of being a tourist. Just the opposite, he moved as if he knew every nook and cranny of the market. I noticed his camera was an old, analogue model, yet it appeared brand new, as if he'd just taken it out of the box hours before. The thing is, his face was very familiar to me. I spent a long time thinking about where I might have seen him before, but no answer came to mind.

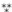

A student passing by The Gold Sea saw Baik face down in his cup and thought something seemed off. He didn't have the look of a drunk, she told the police. So she went over to him, shook him, and only then did she realize he was dead. Baik couldn't call for help or even bring his hands to his throat. Paralyzed, there was nothing he could do but realize he was dying. I wonder if we fight for our lives until the last second or if the brain can anticipate certain death and, in the end, lets itself go, like when we release the handbrake and let the car roll down a hill. Ro says he didn't hear anything from the kitchen, not even when Baik collapsed on the table. He only realized something had happened when the student began to scream.

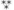

The sea. The waves. The waves breaking on the rocks. The sea. The waves. Seeing her coming out of the sea. Youthful among all the old people. Five kilos of oysters. How? Both of us young, she younger than me. Click, click, click. Change rolls. Naked now, there, among the pines, on the sand. Her cold hand on my nape, my warm hand

만, 그녀가 나보다 조금 더 어리다. 딸깍, 딸깍, 딸깍. 필름을 바꾼다. 모래밭. 소나무 사이. 옷을 벗은 그녀. 내 목덜미에 닿은 차가운 손. 그녀 다리 사이의 내 따뜻한 손. 함께 오른 언덕. 같이 뛰어내리자. 하나, 둘, 셋하면 같이 뛰어내리는 거다. 바닷물 아래. 파도. 바위에 부딪히는 파도. 그리고 바다.

<p style="text-align:center">**</p>

노 씨가 범인이다. 그리고 모든 것은 그가 계획한 완벽한 전략의 일부다. 수십 년간 무사고로 명성을 유지해 온 자신의 식당에서 한 손님이 식사 중에 사망했다는 사실을 일단 부정하면서, 자신의 진술이 자발적인 시인이 아니라는 의혹을 품게 했으며, 결국에는 눈물과 수치로 자신의 치명적인 부주의함만을 탓하는 전략. 복어를 먹고 사고로 사망한 사례는 예전만큼 자주는 아니더라도 여전히 이곳 부산에서 일어나고 있다. 이런 사건의 경우에는 책임 요리사의 기능사 자격증이 박탈되고 벌금이나 짧은 실형이 선고된다. 그뿐이다. 하지만 과연 노 씨가 3대를 이어온 요리사 집안이라는 자부심과 40년간 유지해온 자신의 명성을 단 한 번에 묻어버릴 사람인가? 백유진을 향한 복수만이 유일하게 말이 되는 설명이다. '복수에 목이 마르다'라는 표현을 쓰는 데는 이유가 있다. 기쁨에 목이 말랐다거나 위로에 목이 말랐다는 표현은 없다. 복수를 향한 오만한 갈망만이 목마름과 같이 다급하고 육체적인 절실함을 유발한다. 어떤 목마름은 죽음으로만 해갈될 수 있고 이를 위해서는 어떤 위험이든 무릅쓴다. 복수라는 임무를 완수하기 위해 노 씨는 자신의 식당에서 살인을 저질렀고 1년을 교도소에서 보내게 될 것이다. 복수를 위해서라면 감옥에서의 1년이란 그리 긴 시간이 아니다. 노 씨와 백유진, 식당 주인과 단골손님이라는 관계 너머 무엇이 있었는지 알아봐야겠다.

between her legs. Then we go up on the cliff. Let's jump together, she says, let's jump. Down below, the sea. The waves. The waves breaking on the rocks. The sea.

**

Ro is guilty and it's all part of a perfect strategy: deny the possibility that someone could die in his restaurant, hold up the prestige of decades free of accidents as a shield, plant the doubt of an apparently unintentional confession, and, later, amid tears and shame, admit his fatal mistake. It's not so common anymore, but in Busan, it still happens on occasion: someone gets accidentally poisoned eating globefish and dies. They strip the responsible party of his license, fine him, give him a short sentence, and that's that. But why would Ro want to bury forty years of fame and three generations of cooks in one fell swoop? It has to be about revenge, that's the only explanation. There's a reason we use the expression "a thirst for revenge." There's no thirst for joy or comfort. Only the burning desire for revenge produces such a real and urgent physical effect that, like thirst, must be sated. A thirst that sometimes can only be quenched with a death, a thirst for which we're prepared to risk everything. Having gotten his revenge at The Gold Sea, Ro can plead guilty to homicide and get out of jail in a year. A year is nothing to someone who has been dreaming of revenge. I need to find out if there was some relationship between Ro and the dead man, beyond the fact that he was a regular customer.

**

일요일, 해가 질 때까지 거리를 걸으며 생각에 몰두해 보지만 아무것도 떠오르지 않는다. 머릿속이 새하얗다. 건어물집 여사장 외에 아는 사람은 한 명도 보지 못했다. 길에서 마주친 여사장은 나를 못 본 척했다. 그 집 2층을 사무실로 임대한 지 1년이 넘었다. 여사장은 내가 밤새도록 일하는 줄 안다. 실제로 사무실에서 살고 있다는 사실은 모른다. 소파에서 잠을 자고, 씻는 것은 자갈치 시장의 목욕탕에서 해결한다. 아무도 나를 알아보지 못하도록 웬만하면 여러 목욕탕을 바꿔가며 간다. 처음 내가 몇 달치 월세를 선불로 냈을 때는 모든 것에 미소가 따라왔다. 박 선생님, 우리 박 선생님, 대구 좀 드릴까요? 그냥 드리는 거니까 걱정 마세요. 완도에서 김도 오고 통영에서 굴도 도착했는데 좀 가져가서 드셔 보세요. 지금은 눈만 마주쳐도 으르렁거린다. 며칠 전, 현재 매우 중요한 사건을 맡았고 이 사건이 해결되는 대로 목돈이 생길 거라고 말했으나 믿지 않았다. 3개월 치 월세가 밀려 있다. 그래도 대화는 나누던 어느 날 밤, 소주나 한 잔 같이하자며 가게로 나를 초대한 적이 있다. 어찌나 술을 잘 마시던지, 나는 그날 거의 뻗다시피 했다. 50년이 넘게 한 자리에서 장사를 하고 있다. 이 동네, 영도다리 부근에 관한 얘기를 나누었다. 시에서 싹 밀어버린다는 얘기가 있다고 했다. 집에 있는 사진이 하나 떠올랐다. 배가 지나가기 위해 들어 올려진 영도다리 앞에서 나의 아버지가 나를 안고 있는 사진. 점쟁이들에 관한 이야기도 했다. 전쟁 후 초기에 다리 밑 기둥에 모여들었다. 한 50명 정도 되었으니 꽤 많은 수였다. 가장 나이 많은 점쟁이가 제일 무서웠다. 아버지의 얘기로는, 대부분의 사람이 전쟁 중에 헤어진 가족을 찾기 위해 영도다리 밑을 찾지만, 저 나이 많은 점쟁이로 말하자면 바다 한가운데에 실종된 선원들을 찾는 것이 특기라고 했다. 해파리와 물고기들에 뺨과 피부가 뜯겨 나간, 깜깜하고 찝찔한 바다를 부유하

**
*

On Sunday, I walked around thinking about the case until nightfall. A blank screen, nothing useful came to mind. I didn't see anyone I knew, apart from the woman who owns the dry fish shop. We ran into each other in the hallway; she didn't greet me. I've been renting the second floor of her building and using it as an office for over a year. She thinks I spend hours and hours working at night. She doesn't know that I actually live here now, that I sleep on the couch, that I shower in one of the public bathrooms on Jagalchi. I've found a way to change the bathroom I use every day so nobody notices. When I paid for several months up front, she was all smiles. Mr. Park, Mr. Park, do you want some bacalao? It's a gift, don't worry. I got some seaweed from Wando, oysters from Tongyeong. Go ahead, take some. Now she growls at me with her eyes. A few days ago, I explained to her I was in the middle of an important case and as soon as it was solved I would have plenty of money. She didn't believe me. I owe her three month's rent. One night, when we were still speaking to each other, she invited me to drink soju in her store. She's a great drinker. She almost drank me under the table. She's been living in this same place for fifty years. We talked about the neighborhood, the Yeongdo Bridge. She told me they were thinking of demolishing it. I remembered that at home I had a picture of my father holding me in his arms, looking out as they raised a section of the bridge so the ships could pass by. We also talked about the fortune-tellers. At first, they gathered on the bridge's piers. There were many of them, around fifty. The oldest one always frightened me. My father explained to me that people went to them to try to find family members who had gone missing during the war, but the old man specialized in sailors lost at sea. Imagining someone underground isn't as horrible as imagining them drifting out in the ocean, at night, their feet and cheeks being nibbled at by jellyfish. A

는 시체보다는 땅속에 묻힌 육신을 상상하는 게 낫다. 시체가 묻힌 땅에는 시간이 지나면 목련 같은 나무라도 한 그루 자랄 수 있지만, 바다라면? 내 아버지가 했던 말이다. 내가 지금 왜 아버지에 관해서 쓰고 있나? 빌어먹을 유리와 유리의 조언 때문이다. 유리가 내 삶에 등장하지만 않았어도 지금쯤 나는 남포동의 내 사무실에서 편안하게 지내고 있었을 것이다. 지금처럼 마른멸치 냄새와 땀 냄새가 하루 종일 진동하는 방이 아니라.

**

거울 속의 나를 마주 보며 먹는 냉면. 드디어, 둘만 남았다. 무뚝뚝한 네 개의 눈. 카메라를 들어, 내 얼굴이 비치는 쪽을 향해 셔터를 누른다. 코 부근에 거미줄 형상의 비통한 불빛이 맺혀 있다.

**

노 씨의 말이 진실이라고 치자. 즉, 노 씨는 백유진에게 복수할 이유가 없다는 말이고, 오히려 노 씨가 누군가로부터 복수를 당했다는 말이다. 원한이 너무도 깊어, 그를 무너뜨리기 위해, 그 이유만으로 단골손님 한 명을 살해했다? 노 씨를 파멸시키려고? 그 얼마나 완벽한 복수인가. 그렇다면 백유진은? 어째서 그여야 했단 말이지? 우연인가? 몇십 년간 탐정 짓을 하다 보니 그 어떤 것보다도 믿기 어려운 것이 우연이다. 사람을 죽이는 것이 호수에 던질 돌을 고르는 것과 같다고?

**

지난 이틀 동안 거의 잠을 자지 못했다. 꿈에 빠질 때쯤 갑자기 숨이 막히

374

magnolia can grow atop a dead person, but at sea? That's what my father said. Why am I writing about him? Yuri and her damned ideas. If she'd never come into my life, maybe I would still be in my peaceful office in Nampo and not in this room that always reeks of dried anchovies and sweat.

**

Cold noodles while I look at myself in the mirror. There are two of us, at last. Four bitter eyes. I pick up the camera and take a shot of my reflected face. I see a spiderweb of excruciating lights radiating from my nose.

**

Let's assume Ro is telling the truth. If so, then he wasn't out for revenge against the architect Baik, just the opposite, someone wanted to take revenge against Ro. Someone hated him so much they killed one of his clients just to bring him and his business to ruin, to turn him into one of the living dead. The perfect revenge. And Baik? Why him exactly? Happenstance? Throughout all my years as a detective, that's been the hardest thing to accept. That one person can kill another as if they were just picking up a rock and throwing it into a lake.

**

I haven't slept much in the last few days. Just as I'm about to fall into the pool of dreams, I feel like I'm drowning and wake up. It's as if there were a small animal on my chest, a little rabbit, a rat. Or a globefish. And it goes on like that four, five, six, up to seven times a night.

는 기분이 들면서 잠에서 깨 버렸다. 작은 동물이 가슴 위로 달려든 것 같았다. 새끼 토끼, 쥐, 아니면 복어. 그렇게 하룻밤에 네 번, 다섯 번, 여섯 번, 아니 일곱 번씩 잠에서 깬다.

백유진의 옛 직장동료 한 명을 설득하여 그가 생전에 어떤 일에 관여하고 있었는지 이야기를 들을 수 있었다. 처음에는 입을 열지 않길래 가벼운 압박을 주어야 했다. 목에 자국은 남기지 않았다. 백유진의 주 업무는 아파트나 학교 같은 건물을 설계하는 것이 아니었다. 시정부 프로젝트의 일부를 맡아 역사적으로 보존해야 할 건물 양식들을 조사하는 일이었다. 남포동과 국제시장 일대에 여전히 남아 있는 일부 일제식 적산가옥들에 대한 보고서를 작성해서 시에 제출한 것이 그의 마지막 업무였다.

국제시장 부근의 한 골목을 찾았다. 어렸을 때 살던 곳이었다. 언제나 의도적으로 그 길은 피하지만, 이번에는 발길이 그쪽으로 가도록 내버려 두었다. 예전에 집이 있던 자리는 4층 건물로 바뀌었다. 1층에는 한복집이 남아 있다. 한때 이 거리는 천장까지 이르는 빼곡한 천 두루마리가 있고 바닥에는 실밥이 널린 한복집으로 가득했다. 어느 날 오후, 열 두세 살 때였던 것으로 기억한다. 탈의실에 숨어 여자들이 옷을 갈아입는 장면을 훔쳐보았다. 여성의 맨다리를 처음으로 가까이에서 본 것이다. 커튼 뒤에서 팔을 뻗어 집게손가락으로 다리 근육을 만져볼 뻔했다. 만약 그랬다면 아버지에게 매질을 당했으리라. 나는 그 여자의 향기를 맡는 것으로 만족해야 했다. 소리 내지 않기 위해 최대한 조심해서 숨을 깊게 들이쉬었고 콧속에

376

I convinced one of Baik's coworkers to tell me what Baik was working on before he died. At first, he refused, but I pressured him. I tried not to leave marks on his neck. Baik wasn't designing apartment towers, or schools, or anything like that. He ran a small firm the city hired every so often to do architectural conservation research. He'd just submitted a report on the Japanese houses from the colonial period that were still standing in Nampo and Gukje.

I went to the street where I used to live near the Gukje market. I always avoid it, but this time I let my own steps take me there. Where our house had been, there was now a four-story building. On the first floor, there was still one hanbok store in operation. The whole street used to be full of stores like that, rolls of cloth piled up to the ceiling and loose threads on the floor. I remembered one afternoon, it must have been twelve or thirteen years ago, I hid in a dressing room and watched two young women changing. It was the first time I'd seen bare legs up close. They looked as soft as the fabric of the skirts the women were trying on. I was on the verge of reaching out my arm from behind the curtain and touching one of their thighs with the tip of my index finger. My father would've thrown me off the roof if I'd done that. I settled for the smell of their perfume. I inhaled deeply, trying not to make a sound, pulling that smell into my nasal cavities to take it home with me, unwrap it like a gift, and enjoy it on my own. I'd completely forgotten about that. The Japanese house was still there. I stood looking at it from the other side of the street. It doesn't seem like much, just an old, two-story building, with a strange roof, small windows, and wood-board siding, that's it. I don't want them to de-

결국엔 우리 모두 호수에 던져진 돌이 되리라

그 향기를 가두어 집에 가져간 후에 선물 포장을 뜯어보듯이 혼자 즐기고 싶었다. 지금까지는 완전히 잊고 있던 기억이다. 길의 모퉁이에는 일본식 건물이 그대로 남아 있다. 다른 방향에서 그 건물을 다시 바라보았다. 딱히 대단할 것은 없다. 아주 오래된 2층 건물에 기묘한 지붕, 아주 작은 창문들, 목재 판들로 엮인 외벽. 그것뿐이다. 그들이 이 집은 없애지 않았으면 좋겠다. 우리가 가진 가장 고통스러운 기억을 잔해로 만들어버릴 이유가 있는가? 없애는 것보다 여전히 그 기억을 마주 보며 뱃속을 찌르는 듯한 아픔을 겪는 편이 낫다고 생각한다. 내가 살던 집은 화재로 사라졌다. 만약 그 집이 그대로 있었더라면 모든 게 조금 덜 복잡했을지도 모른다. 새로운 것만 원하는 자들이 있다. 기억으로부터 자유롭고 싶은. 그 기억이 좋든 나쁘든. 바로 그 자가 백유진의 살인을 사주한 것이 틀림없다.

바닥에서 책상으로. 책상에서 침대로. 침대에서 다시 바닥으로. 돌아가는 레코드를 바라본다. 벽을 타고 천장까지 기어오르는 연기처럼 노랫소리도 오른다. 차갑고 검은 태양을 상상한다. 음악이 멈춘다. 매미들의 신경질적인 울음소리. 내 이빨 사이로 매미의 전류가 느껴진다.

끔찍한 죽음이지. 황 박사가 말했다. 백유진은 벌건 대낮에 독살 당했다. 총에 맞거나 칼에 맞은 것도 아니고, 누가 계단에서 밀어 떨어진 것도 아니다. 이것은 어떤 신호다. 누군가 메시지를 보낸 것이다. 하지만 그게 누구지? 왜 그런 거지?

molish it. Why turn our most painful memories to rubble? I'd rather remember and feel a stabbing pain in my gut when I can't. Our house disappeared after the fire, but I think everything would be less complicated if I could still see it. Someone who wanted everything to be new, free of memories, good or bad. It must have been someone like that who had Baik, the architect, killed.

From floor to table, from table to bed, from bed to floor. I watch the record turn. The voice ascends like smoke up the room's walls to the ceiling. I imagine a black and cold sun. There's no more music. It's been replaced by the hysterical song of the cicadas, their electricity in my teeth.

A horrible death, that's what Dr. Hwang said. Baik, the architect, was poisoned in the full light of day. No gunshot, no stabbing, no anonymous push down some stairs. It's a sign. Someone wanted to send a message. But who? Why?

결국엔 우리 모두 호수에 던져진 돌이 되리라

어제 국제시장을 걷는 동안 누군가 내 뒤를 밟은 것이 분명하다.

잠에서 깨니 약간의 열이 느껴졌다. 아프면 안 된다. 지금은 더더욱. 구름 끼지 않은 맑은 정신이 필요하다. 예전에 생각할 시간이 필요할 때는 대각사를 찾거나 성공회당을 찾곤 했다. 회당 외벽의 벽돌들이 붉은 석류색인 것이 마음에 들었다. 생각이 필요할 때마다 대각사의 대웅전이나 성공회당의 예배당에 가 앉았다. 사망, 절도, 횡령, 위조, 강도 등, 부처의 눈빛과 십자가에 걸린 예수의 상처를 바라보다 보면 해결책이 떠올랐다. 이제는 그렇게 못한다. 두어 번 시도했으나 들리는 거라곤 나 자신의 숨소리와 들락날락하는 늙은 개의 기척뿐. 아, 이제 알겠다. 어렸을 때 들르던 영도 해변의 한 포장마차로 가야겠다. 해녀들이 직접 운영하는 곳으로 고요히 생각할 시간을 가질 수 있을 것이다. 온종일 나타나는 손님이라고는 불륜관계인 것이 분명한 커플과 우연히 발길이 닿아 찾아온 두어 명의 등산객이 다인 곳. 여전히 그대로일 것이다. 파도 소리가 내 숨을 덮으면, 어떤 메시지를 누가 보냈는지 생각해볼 수 있으리라.

어두운 방, 화학 약품 사이에서 반복되는 하나의 얼굴. 사진 인화지 속에서 어제도, 오늘도, 내일도. 방아쇠를 당기는 것과 셔터를 누르는 것. 같은 일이 아닌가? 둘 다 시간을 멈추는 행위. 시간으로부터 탈출하는 행위.

⁎

Yesterday I was convinced I was being followed while walking down Gukje.

⁎

Today I woke up with a mild fever. I can't get sick, not now. I need my mind to be clear, cloudless. Before, if I needed to be on my own to think, I went to the Daegaksa Temple or the Anglican Church. I've always liked their pomegranate-red bricks. Sitting there, something inevitably occurred to me. I solved cases of death, robbery, embezzlement, identity theft, and extorsion, staring up at Buddha's eyes or crucified-Christ's stigmata. I can't do it anymore. I've tried a couple of times and hear nothing but the sound of my own breathing, an old dog coming and going. I know, I'll go to Yeongdo, to the Haenyeos' pojangmacha, where I often went in the past. Yes, that was a place I could sit and think in solitude. You could go all day without seeing anyone beyond a pair of cheating lovers or some lost backpackers. It probably hadn't changed. The sound of the waves would block out my breathing and I'd be able to think about the message and the messenger.

⁎

In the dark room, among the chemicals, a face repeats. The same face on the photographic paper, yesterday, today, tomorrow. Shooting a weapon, shooting a camera, is it not somehow the same? Both actions seek to stop time. To take us outside of time.

결국엔 우리 모두 호수에 던져진 돌이 되리라

**

예상했던 대로 포장마차는 그대로였다. 섬의 이 부분은 거의 변하지 않았다. 여주인은 나를 보자 웃으며 인사했고 그곳에서 가장 좋은 자리, 바다가 정면으로 보이는 자리를 내주었다. 포장마차에는 아무도 없었다. 그날아침 바다에서 갓 따온 굴 열 알과 소주 한 병을 내왔다. 쟁반을 테이블에두고 허리에 손을 얹은 채 나를 빤히 쳐다보았다. 그래서, 어디 다녀오셨나, 박봉황 씨? 너무 오랜만이네요? 그 입에서 내 이름이 나오는 걸 듣고어찌나 놀랐는지 본능적으로 손을 자켓 아래로 뻗어 권총을 더듬었다. 내가 대답이 없자 여자는 화를 내며 돌아가 버렸다. 주방으로 향하면서 나를 향해 욕을 퍼부은 것이 분명하다. 어떻게 문을 닫는지 다 들었으니까.오후 내내 여주인은 다시 얼굴을 보이지 않았다. 몇 번 불러 보았으나 나오지 않았다. 테이블 위에 돈을 두고 돌을 올려놓은 채 돌아가야 했다. 다음에 좀 덜 바쁜 날 다시 와서 우리가 언제 만난 적이 있는지 물어봐야겠다. 다행히 집중하는 데는 별문제가 없었다. 소주병을 까고 기록들을 체크하면서 조금씩 술을 마셨다. 멍청하기 그지없다. 예전에는 일주일이면명백한 단서를 확보하곤 했는데, 이번에는 거의 2주나 걸렸다. 엉망진창이다. 아무튼, 드디어 그럴듯한 가설이 하나 나왔다. 건설 회사와 관련된누군가가 백유진의 살인을 사주했다는 것. 이 하이에나들은 몇 년 전부터시정부의 시장 재개발 대책에 배후로 있던 자들이다. 건어물집 주인이 함께 술을 마실 때 해준 이야기가 있다. 여동생이 시장 한쪽에서 양말 장사를 하며 들은 소문인즉슨, 상인들을 모조리 내쫓을 예정이라는 것이었다.시장을 밀고 그 자리에 쇼핑몰을 짓고 싶어 한다고 했다. 거기에는 물론,역사적 가치가 증명될 경우 절대로 건드릴 수 없는 일제식 근대 건물들도있었다. 이 살인은, 건설회사가 시 정부에 보내는 메시지이다. 백유진이아닌, 노 씨가 바로 누군가 호수에 던지기 위해 고른 돌 같은 존재였다.

¥

As I predicted, the pojangmacha, was in the same place. That part of the island had barely changed. The woman working in the tent greeted me with a smile and sat me down at the best table, directly facing the beach. There was nobody there. She brought me a dozen oysters she'd pulled out of the water that same morning and a bottle of soju. She left the tray on the table and stood there looking at me with her hands on her hips. And so, where've you been Park Bong Hwang? It's been a long time since you were last here. Hearing my name on her lips startled me to such an extent that I instinctively reached my hand under jacket, looking for my Beretta. Seeing I wasn't going to respond, she grew angry and turned around. I'm sure she insulted me on her way back to the kitchen. I heard her slam the door. I didn't see her again all afternoon. I called her a few times, but she didn't come out. I had to leave her the money for the bill on the table, under a rock. I'll go back someday when I'm not so busy and ask her where we'd met before. Fortunately, I had no issue concentrating. I opened the bottle and I drank it slowly, looking over my notes. I'm a fool. In the past, I would've had a solid lead within a week. This time, it's taken me almost two. What a train wreck. In any case, I finally have a decent hypothesis: someone connected to one of the construction companies had put a hit out on Baik, the architect. Those vultures have been behind a plan to have the city renovate the whole market for years now. The owner of the dry fish shop told me about it a few months ago when we got drunk together. Her sister owns a sock stand and she's heard the rumors, they're thinking of clearing everyone out. They want the land to build a shopping center. And, of course, there are a couple Japanese buildings from the colonial period in the area that they'll never be able to demolish if the city declares them sites of cultural interest. The architect's death is a message from one of the construction companies to the city. Ro, not Baik, is the rock somebody threw into the lake.

⁂

커다란 무도장. 홀로 무대에서 뱅글뱅글 춤을 추는 한 커플과 이를 바라보며 박수를 치고 건배를 하는 가족들. 남자와 여자가 불길에 휩싸인다.

⁂

열이 오르락내리락한다. 횃불 기둥이 된 기분이다. 사람들이 불타오르며 걸어 다니는 나의 실루엣을 볼 수 있을 정도로. 카메라를 든 남자를 본 이후로 시작되었다. 분명히.

⁂

훼리 출발 시간: 15:05.
훼리 도착 시간: 11:05.
가마가사키에서 3일.
23세.
보지와 자지.

⁂

말도 안 되는 것들을 상상하며 누워있다. 그러다가 유리와 섹스할 때마다 내 기억의 일부가 사라졌다는 확신에 생각이 미쳤다. 내 인생의 몇 달이 통째로 없어진다. 대신 사건을 해결하는 데 도움이 되었다. 부처와 예수의 침묵이 더는 먹히지 않을 무렵부터 치르게 된 대가였다. 어젯밤, 머릿속 생각에서 벗어나기 위해 로우를 만나러 갔다. 나를 보자마자 한 첫마

**
*

A great ballroom. A solitary couple spins as their families toast and applaud in their honor. The man and the woman are enveloped in flame.

**
*

The fever comes and goes. Today I felt like a burning torch, like people could see my flaming silhouette as I walked. It all started after I saw the camera man, I'm sure of it.

**
*

Outbound Ferry: 3:05 pm.
Return Ferry: 11:05 am.
Three days in Kamagasaki.
23 years old.
Vulvas and penises.

**
*

I lie down, thinking about strange, nonsensical things. I've come to believe that every time I had sex with Yuri, I lost some part of my memory, entire months of my life, all for the way it helped me solve a case. That was the price to be paid when Buddha or Christ's silence no longer worked. I needed to get out of my head, so last night I went to see Lou. The first thing he said to me was I should go to a barber. What a jackass, where does he get off? He's over 50 now and goes around with a pony tail like the ones we had in the seventies. But it was good to see him, to verify that he still existed, that he hadn't disappeared. I need

디는 머리를 좀 깎으라는 것이었다. 병신새끼, 어떻게 감히? 오십이 넘은 자신도 여전히 70년대인 것처럼 말총머리를 하고 있으면서. 그래도 사라지지 않고 여전히 존재하는 것들을 확인하니 마음이 가라앉는다. 로우의 침묵이 필요했다. 유리와 어떻게 되었는지 절대로 묻지 않는다. 감사할 따름이다. 가게 문을 닫고 함께 음악을 들었다. 세븐일레븐에서 맥주를 사고 족발을 배달시켜 먹었다. 올 때마다 느끼는 것이지만, LP 판은 계속해서 늘어나는데 판매는 줄고 있다. 망하지 않았으면 좋겠는데. 건어물집 여주인이 나를 내쫓으면 적어도 한 이틀 정도는 이 LP 판 더미에서 잠을 잘 수 있을 거라는 믿음이 있다. 그가 샀던 첫 LP가 닐 영의 음반이었는지 물었다. 그랬더니 자기가 처음으로 산 LP는 미군이 판 데이비드 보위의 앨범이라고 확신했다. 그것을 시작으로 이제는 국제시장 안 샴푸와 군용물품 상점 옆에 초라하게 붙어 있는 자신의 가게에서 미국에서 들여온 중고 음반을 되판다. 옛날에는 〈Heart of Gold〉나 〈Like a Hurricane〉 따위의 노래를 함께 들으며 몇 시간씩 보냈다. 일본 음반은 절대로 팔지 않았다. 한때 내가 오사카에서 밀수품을 들여온다는 것을 알게 되었을 때는 6개월 동안이나 나와 말을 끊기도 했다. 카메라를 든 남자에 대해 말을 하려고 했다. 혹시 그도 본 적이 있는지. 하지만 왠지, 곧 후회했다. 부끄러움 때문이었을까. 기억을 잃어간다는 사실을 받아들이는 것은, 늙어간다는 사실을 받아들이는 것과 같다.

새벽 세 시경, 비틀거리며 가게를 나와 사무실로 향했으나 길을 잃었다. 돌아가는 방향이 어디인지 도무지 찾을 수가 없어 길 위에서 그대로 잠들어 버렸다. 다행히 쓰레기차가 지나가기 전에 눈을 떴다.

가끔 나의 인생은 점점 물이 차오르는 보트와 같다는 생각을 한다.

his silences. Lou never asked what happened with Yuri and for that I'm grateful. We sat there in his store listening to music long after closing time. We ordered a delivery of ham hocks and he went to 7Eleven for beers. It seems like he has more records all the time and sells fewer and fewer, I hope he's not broke. I've always assumed that if the owner of the fish shop kicks me out, he'd let me sleep among his records, even if it's just a couple nights. I asked him if the first record he got was one of Neil Young's. It was actually a David Bowie album he bought from a soldier, he said. And so it began, getting records from Americans and reselling them in a grubby stall in Gukje, along with military rations and shampoo. We used to spend hours listening to *Heart of Gold* or *Like a Hurricane*. He never had any interest in selling Japanese records. When Lou found out I'd started smuggling in contraband from Osaka, he stopped talking to me for six months. Six months. I was going to tell him about the camera man, maybe he'd seen him around the market too, but I changed my mind, I'm not sure why. Embarrassment, I suppose. To admit I was losing my memory was to admit I was getting old.

I stumbled out of his store at three in the morning and got lost on the way to my office. I fell asleep in an alleyway. Luckily, I woke up in the predawn hours, before they came around to pick up the trash.

Sometimes I think my life is like a boat that's sprung a leak and the water is rising.

⁑

드디어 그가 다시 나타났다. 내가 만들어낸 허깨비인 줄 알았는데. 이번에는 작은 가방을 메고 카메라는 손에 들고 있다. 국제시장에 관심을 가진 건설사들의 목록을 보기 위해 등기소로 가는 중이었다. 나의 비밀수사가 다른 이의 귀에 들어가기 전에 알아내는 것이 중요했지만, 일단은 그의 뒤를 밟기로 했다. 서둘러 어디론가 가는 중이었다. 그러다가 멈추어서 두어 장의 사진을 찍었다. 카페에서 한 중년의 사내와 만나는 것을 보았다. 목까지 단추를 채운 긴 코트에 옷깃은 세우고 선글라스를 끼고 있었다. 친구 같지는 않았다. 몇 마디를 나누더니 젊은 남자가 가방에서 봉투를 하나 꺼내 상대에게 건넸다. 서로 잠깐 시선을 마주쳤다. 그게 다였다. 카페에서 계산하고 문을 나서려던 차, 갑자기 카메라를 들더니 내가 있는 곳을 향해 포커스를 맞추었다. 재빨리 등을 돌렸으나 아무래도 사진이 찍힌 것 같다. 당연히 그를 쫓는 것은 더 이상 불가능했으므로 다른 한 명을 미행하기로 했다. 중년 사내는 용두산 공원을 한 번 돌더니 외진 곳의 벤치에 앉아 주변에 아무도 없는지 확인한 후 봉투를 열었다. 추측건대, 사진으로 보이는 것들이 몇 장 들어있었다. 미친 듯이 울리는 매미 소리 속에서 잠시 그것들을 들여다보다가 다시 봉투에 집어넣고는 벤치에서 일어났다. 공원을 나선 그는 다급히 중앙 성당으로 향했다. 나무 뒤로 가더니 코트와 선글라스를 벗었다. 놀랍게도, 안에는 사제복을 입고 있었다. 사제관으로 들어간 그는 오후 내내 나오지 않았다. 딱 한 번, 6시 미사 시간에 나타났을 뿐이다. 그 틈을 이용해 사제관으로 몰래 들어갔다. 모든 서랍을 뒤졌으나 봉투는 없었다. 그러다 책상 아래 테이프로 붙여져 있는 봉투를 발견했다. 조심스럽게 안을 열어보았다. 사진이 아니었다. 그 속에서는 낡은 일본 판화 7장이 들어있었다. 이해하기 어려운 포즈를 한 남자들과 여자들의 누드화. 나는 모든 것을 그대로 돌려놓은 후 사제관을 떠났다.

I saw him again, finally. I'd been thinking I'd invented him. This time, he was carrying the camera in one hand and a small canvas satchel in the other. I had to go to the records office to get the list of construction companies interested in Gukje. I needed to get my hands on them before somebody else got wind of my poking around, but I chose to follow him instead. He was in a hurry. Yet he still stopped to take a couple pictures. He met an older man in a café, who was wearing a long coat, buttoned all the way up, the lapels popped, and sunglasses. They didn't appear to be friends. They exchanged a few words and then the camera man removed an envelope from his satchel and gave it to the other man. They looked at each other and that was it. They paid for their coffee and suddenly, just as they were saying goodbye at the door, the man took his camera and aimed it right at me. I turned quickly away, but I think he still was able to capture my face. Obviously, I couldn't keep following him and decided to trail the other man. After circumventing Yongdusan Park, he sat down on an isolated bench and, before opening the envelope, looked all around to be sure he was alone. He took out what I assume were photographs. He looked at them for a long while, then put them back in the envelope and stood up among the crazed cicadas. He left the park and walked quickly to the Jungang church. He entered the rectory and didn't come out all afternoon except to give the six-o'clock mass. I took the opportunity to slip into his office. I went through all the drawers, looking for the envelope. I found it taped to the underside of his desk. I opened it carefully. Inside, I didn't find photographs, but seven antique Japanese prints. Naked men and women in complicated sex positions. I left everything the way I found it and got out of there.

⁑

등기소로 가는 길에 어디선가 다급한 안내방송이 들렸다. "실종된 어르신을 찾습니다. 이름은 박봉황. 나이 86세. 양복에 모자를 쓰고 있습니다." 멈춰 서서 안내방송이 다시 나오기를 기다렸으나 들리지 않았다.

⁑

지저분하고 아픈 상태를 조금이나마 개선해보고자 이 씨의 이발소를 찾았다. 머리는 짧게 잘라 주시고 면도도 해주십시오. 이 씨는 항상 좋은 잡지들을 가게에 갖다 놓는다. 최신호나 누구나 알만한 대중적인 잡지는 아니다. 가끔 보수동 책방골목에 들러서 수집가처럼 잡지들을 자세히 들여다본 후 몇 권을 골라온다. 말론 브란도에 관한 글을 읽다가 그 역시 젊었을 때 코뼈가 부러진 적이 있었다는 걸 알았다. 잡지에는 말론 브란도의 코뼈 수술 전과 후 사진이 실려 있었다. 같은 인물이지만 완전히 다른 사람처럼 보였다.

⁑

사제의 입술은 바싹 말라 있었다. 입꼬리에는 소금입자가 묻어 있다. 비밀들은 우리의 피를 빨아가고 환희를 앗아간다.

⁑

소나무 숲만큼 곧고 솔직한 대화에 얹힌 새로운 LP. 화약 냄새와 터널의 습기에 관한 이야기. 내 코에 관한 얘기를 들려주었더니 오른쪽 다리의 상처를 보여주었다. 상처라기보다는 하나의 구멍이다. 로우처럼 머리가 길

390

⁂

Walking to the records office, I thought I heard an urgent announcement over a loudspeaker: "An old man has gone missing. He is 86 years old, dressed in a suit and hat. His name is Park Bong Hwang." I stood there a long while waiting for the announcement to be repeated, but didn't hear it again.

⁂

To make myself feel less unkempt, less out of sorts, I went to Mr. Yi's barbershop. A haircut and a shave. Yi always had good magazines. Not the most recent or the most popular. He goes to the second-hand book market in Bosu dong and picks them out carefully, as if he were a collector. I was reading about Marlon Brando and I learned he'd had his nose broken as a young man. The article had before and after pictures. The same person yet someone completely different.

⁂

The priest's lips were too dry. Salt crystals in the corners. Secrets rob us of blood and happiness.

⁂

A new LP and honest conversation, straight as a pine forest. Lou and I talked about the smell of gunpowder, the humidity of the tunnels. After I told him about my nose, he showed me the wound on his right leg. A wound that's actually a hole. I wished I could grow my hair as long as his. We promised to go out drinking the next week, near the market. Oysters. The sailor's widow, her young breasts covered with

었으면. 다음 주에 자갈치 시장에서 같이 한잔하기로 했다. 생굴. 모래로 가득한 가슴을 가진 선원의 미망인. 이제 거기엔 가지 말아야지. 우표를 밀수해 파는 일도, 사진 찍는 일도 다 그만두려고 한다. 이제 다른 것을 하고 싶다. 수수께끼를 푸는 일. 각자가 가진 다른 형태의 관심을 허물어뜨리는 일. 길에서 잠든 날 이후 열이 심해졌다. 온종일 소파에 파묻혀 전화도 받지 않았다. 오후에 걸려온 전화는 백유진의 아버지임이 분명하다. 그가 준 선금은 이제 한 푼도 남지 않았다.

**

나의 정보를 정리해본다. 박봉황, 53세. 더 이상 덧붙일 게 없다.

**

수아의 아버지에게는 다섯 명의 딸이 있다. 예선, 예희, 예림, 예랑. 다섯 번째 딸의 이름은 무엇일까?

**

$$C_{11}H_{17}N_3O_8.$$
$$C_{11}H_{17}N_3O_8. \qquad C_{11}H_{17}N_3O_8.$$
$$C_{11}H_{17}N_3O_8. \; C_{11}H_{17}N_3O_8. \; C_{11}H_{17}N_3O_8. \; C_{11}H_{17}N_3O_8.$$
$$C_{11}H_{17}N_3O_8. \; C_{11}H_{17}N_3O_8. \; C_{11}H_{17}N_3O_8. \; C_{11}H_{17}N_3O_8.$$
$$C_{11}H_{17}N_3O_8. \; C_{11}H_{17}N_3O_8. \; C_{11}H_{17}N_3O_8. \; C_{11}H_{17}N_3O_8.$$
$$C_{11}H_{17}N_3O_8. \; C_{11}H_{17}N_3O_8. \; C_{11}H_{17}N_3O_8.$$
$$C_{11}H_{17}N_3O_8. \; C_{11}H_{17}N_3O_8. \; C_{11}H_{17}N_3O_8.$$
$$C_{11}H_{17}N_3O_8. \; C_{11}H_{17}N_3O_8. \; C_{11}H_{17}N_3O_8.$$
$$C_{11}H_{17}N_3O_8. \; C_{11}H_{17}N_3O_8.$$
$$C_{11}H_{17}N_3O_8.$$

sand. I won't go back. I have no desire to take photographs or sell prints anymore. I want to do something else now. To solve puzzles. I want to wreck the different forms of focus.

✱

The fever came back with a vengeance after I spent the night in the street. I haven't answered the phone and have been lying on the couch all day. I'm sure today's calls were from the father of Baik, the architect. I've already spent every cent of the advance.

✱

I review my own information: Park Bong Hwang, 53 years old. I have nothing else to add.

✱

Ana's father has five daughters. Their names are May, June, July, and August. What's the name of the fifth daughter?

✱

$C_{11}H_{17}N_3O_8$.
$C_{11}H_{17}N_3O_8$. $\quad\quad$ $C_{11}H_{17}N_3O_8$.
$C_{11}H_{17}N_3O_8$. $C_{11}H_{17}N_3O_8$. $C_{11}H_{17}N_3O_8$. $C_{11}H_{17}N_3O_8$.
$C_{11}H_{17}N_3O_8$. $C_{11}H_{17}N_3O_8$. $C_{11}H_{17}N_3O_8$. $C_{11}H_{17}N_3O_8$.
$C_{11}H_{17}N_3O_8$. $C_{11}H_{17}N_3O_8$. $C_{11}H_{17}N_3O_8$. $C_{11}H_{17}N_3O_8$.
$C_{11}H_{17}N_3O_8$. $C_{11}H_{17}N_3O_8$. $C_{11}H_{17}N_3O_8$.
$C_{11}H_{17}N_3O_8$. $C_{11}H_{17}N_3O_8$. $C_{11}H_{17}N_3O_8$.
$C_{11}H_{17}N_3O_8$. $C_{11}H_{17}N_3O_8$. $C_{11}H_{17}N_3O_8$.
$C_{11}H_{17}N_3O_8$. $C_{11}H_{17}N_3O_8$.
$C_{11}H_{17}N_3O_8$.

결국엔 우리 모두 호수에 던져진 돌이 되리라

⁂

아예 그를 고용해버리는 편이 낫겠다. 내 일과에 대한 보고서를 제출하도록. 5월 27일 오전 11시경 내가 어디에 있었는가? 혼자였나? 자네, 집중력이 그리 좋으면 내 머릿속까지도 미행해볼 수 있겠군. 어디 한번 해 보시지.

⁂

쌍둥이 형제 꿈을 꾸었다. 둘 다 대머리였는데 똑같은 가발을 쓰고 있었다.

⁂

조금 기력이 생겨 사건에 관해 다시 정리해볼 수 있었다. 밖으로 나가지 않고 이불 속에만 있었던 게 도움이 되었다. 가장 큰 성과는 중국인 종업원의 행방을 알아낸 것이다. 그녀는 영도의 한 집에 방을 얻어 살고 있었다. 집주인인 노파는, 돈은 없었지만 수백 마리의 말들로 거실을 장식해두고 있었다. 집에 불이 나기 전, 어머니가 해준 얘기가 떠올랐다. 영도에는 옛날부터 자기 그림자도 못 쫓아올 만큼 빠른 천리마들이 살던 곳이라고 하더라.

 침대에 앓아누워 있는 종업원을 만났다. 몇 번이고, 그들이 자기를 독살하려 한다는 얘기를 되뇌었다. 누에고치처럼 잔뜩 웅크린 상태를 보고 로우처럼 신장 결석이 있다는 걸 눈치챘다. 총에 한 번 더 맞는 게 낫지. 결석이 얼마나 아픈지 설명할 때마다 로우가 했던 말이다. 군대에 있을 때 매춘부를 데려오라는 지시를 거부했더니, 분노를 이기지 못한 상사가 오른쪽 다리에 총알을 박아버렸다. 이 미친 행동에도 상사는 아무런 징계를 받지 않았다. 베트남에서 받은 훈장 때문이었는지 가벼운 주의로 그쳤

**

I should hire him to give a daily report of my activities. Where did he see me on May 27th at 11 in the morning? Was I alone? If you concentrate hard enough you'll be able to spy on my mind too. Try it.

**

I dreamed of twin brothers. They were bald but wore the same wig.

**

I regained some strength and was able to start working the case again. It helped to have spent all day in the office, under a blanket. Best of all, I finally located the Chinese waitress. She lives alone in a rented room in Yeongdo. Despite how poor she is, the grandmother who owns the house has the living room decorated with hundreds of horses. I thought about something my mother told me shortly before the fire. They say Yeongdo was inhabited by the Chollima, horses so fast they could outrun their shadows.

I found the Chinese waitress sick and in bed. She kept repeating that she'd been poisoned. Seeing her writhe like a silkworm, I knew she had kidney stones, like Lou. I'd rather get shot again, my friend repeated whenever he described the experience of a kidney stone. When Lou was doing his military service, a sergeant got pissed at him because he refused to get him a prostitute. In an attack of rage, the sergeant shot him in the right leg. A complete lunatic for whom there were no consequences. He'd been decorated in Vietnam, so they barely reprimanded him. I offered to take the Chinese waitress to a hospital, but she vehemently refused. Seeing she was writhing more and more from the pain, I called Dr. Hwang. He arrived with a dose of morphine

을 뿐이다. 종업원을 병원에 데려가려고 했으나 그녀는 격렬히 거부했다. 시간이 흐를수록 더욱 고통스러워하기에 황 박사를 불렀다. 모르핀황산염을 챙겨온 황 박사는 손 떨림 때문에 나에게 주사를 맡겼다. 약기운이 퍼지자 여자의 다리가 조금 편안하게 풀렸다. 잔인한 고통에서 꺼내준 은인들을 앞에 두고, 연약함과 감사함이 뒤섞여 백기를 든 여자가 드디어 입을 열었다. 노 씨의 일과가 자세히 적인 종이를 자갈치 시장 근처에서 한 남자에게 전해준 적이 있다. 그 대가로 영주권을 받을 수 있도록 해 주겠다는 약속과 함께 전화번호를 하나 받았지만, 아직 아무도 나타나지 않았다. 남자의 외모에 대해 기억나는 게 있는지, 특이사항은 없는지 물었다. 어물거리며 '일막'이라는 단어만 내뱉더니 잠이 들어버렸다.

밀리미터 단위로 계속해서 자라나는 머리카락. 다시 돌아온 후각. 자리를 잡아가는, 부러진 코뼈. 원래 있던 곳으로 돌아가기 위해 밤마다 움직이는 코의 연골. 제자리로 돌아가지 않았으면. 타인이 될 수 있다는 가능성. 감격스럽지 않은가.

세 번째로 그를 보았다. 그게 마지막이었다. 이제 더 이상 나타나지 않을 것이다. 이번에는 카메라 없이 대각사 뒤 광복동 골목에서 무언가를 열심히 먹고 있었다. 저녁 시간이라 길거리에는 사람들이 가득했다. 그의 뒤를 밟다가 어느 순간 놓칠 뻔하여, 사람들을 팔꿈치로 찔러가며 인파를 헤쳤다. 다시 그가 내 시야에 들어왔을 때 그는 황 박사의 상담소가 있는 건물로 들어가던 찰나였다. 그 건물에 꽃집도 있고 당구장도 있긴 했지만, 그래도 우연이라기에는 매우 이상했다. 밖에서 기다렸다가 그가 나오면 아무 말이나

sulfate and I had to give her the injection because the doctor's hands were too shaky. Once the drug took effect, the woman's legs relaxed and she opened up to me, overcome by that combination of vulnerability and gratitude we experience when we're released from some terrible pain. She told me that somewhere near Jagalchi, she'd given a man a piece of paper with Ro's schedule written on it. In exchange, the man promised to get her residency papers and gave her his telephone number, but now she couldn't find him anywhere. I asked her if she remembered anything about the man, any distinguishing features. She just muttered "Ilmak" and then fell asleep.

Tiny hairs grow again millimeter by millimeter. Smells return. The broken bone seeking to rediscover its way. The nasal cartilage realigning in the night to return to where it always was. I hope it fails. I'm thrilled by the possibility of being someone else.

I saw him for the third and last time. He won't appear again. He didn't have his camera this time, he was eating in an alleyway behind Daegaksa Temple, absorbed in his food. It was dinner time, so the place was full of people. When he got up and left, I followed him and, for a moment, almost lost him, I had to throw a couple elbows to make my way through the crowd. When I had him in sight again, he was entering the building where Dr. Hwang's office is, which, of course, seemed like a very strange coincidence to me, though there was a florist and a poolhall in that building too. I decided to wait for him to come out and approach him, say something to him, ask him for directions. I needed to confront him face to face, I was sure his voice

걸어볼 예정이었다. 길을 묻는 것 따위 말이다. 그를 눈앞에 두고 목소리를 들어 봐야 비로소 정체가 무엇이었는지 알 수 있을 것 같았다. 어둑어둑해지자 근처 가게들이 한둘씩 문을 닫기 시작했다. 카메라를 든 남자가 드디어 건물을 나왔다. 그의 뒤를 따라 조금 걸었을까, 누군가 내 뒤통수를 내리쳤고 나는 그대로 바닥에 쓰러졌다. 내 권총이 하수구에 떨어지는 소리가 들렸다. 두세 명쯤 되었을 것이다. 한동안 나를 두들겨 패더니 어둠 속으로 사라졌다. 그 순간 문득, 나 역시도 곧 호수에 던져질 돌이 될 것이라는 느낌이 들었다. 정신을 잃기 직전 걸음 소리를 들었다. 카메라를 든 남자가 서서히 다가왔다. 나를 향해 얼굴을 들이밀었고 한동안 서로를 마주 보았다. 멀리서는 알아볼 수 없었던 작은 반창고가 그의 콧등에 붙어 있었다.

처음에는 정신이 나간 줄 알았다. 그런데 이제는 일말의 의심도 없다. 그는 분명, 23세의 나 자신이었다. 생일이 다가오기 얼마 전 계단에서 넘어져 코뼈가 부러졌고 그 이후로 외모가 바뀌어 나조차도 자신을 알아보지 못했다. 마치 천리마처럼, 내 그림자도 쫓아오지 못할 만큼 빠르게 달려온 수년의 세월들. 하지만 결국 그림자가 나를 따라잡았다. 이제 나와 내 그림자는 다시 하나가 되었다.

**

나는 정신을 잃었고 누가 응급차를 불렀는지 모르겠다. 신기하게도 그 순간 노 씨의 사건이 해결되었다. 내가 길에 쓰러져있는 동안 한 남자가 여종업원의 집에 침입했다. 이미 로우의 아들에게 부탁하여 그 집을 지켜보다가 누군가 들어가면 바로 경찰에 연락하도록 했었다. 그는 '일막종합건설'이라는 회사명이 새겨진 연필을 셔츠에 꽂고 있었고, 더 이상 빠져나갈 구멍이 없다는 것을 깨닫자 금해에서 저지른 살인을 시인했다. 일막종합건설의 임원이 고용한 인물이었다. 젊었을 적, 배에서 요리사로 일했던 범인은

would help me solve the mystery of his identity. The stores in the area were closing and soon it was fairly dark. Finally, the camera man left the building. I'd followed him for half a block when, out of nowhere, something struck me in the head and I fell to the ground. I heard my Beretta slide into a gutter. There must have been three or four of them. They started kicking me, I don't know how long it lasted. Then they disappeared into the darkness. At that moment, I thought I was the rock that would end up in the lake, but before losing consciousness, I heard footsteps. It was him, the camera man, approaching slowly. He bent down and we looked at each other for a few long seconds. He had a small bandage on his nose that I hadn't noticed at a distance.

At first, I thought I'd lost my mind, but I no longer have any doubt. That man was me when I was 23 years old. Just before my birthday, I broke my nose when I fell down some stairs and, after that, my face changed, that's why I'd been unable to recognize myself. I wanted to outrun my shadow, to get away from it like one of the Chollima, and for many years, I succeeded. But my shadow ended up catching me. Now, once again, I'm alone.

Then I disappeared, and I have no idea who called the ambulance. At almost the very same time, the case of Ro, the cook, was solved. While I was lying in the alleyway, a man came for the Chinese waitress. I'd asked Lou's son to watch her house and call the police immediately if he saw anyone go in. The killer, who carried a pen with the name Ilmak Construction Company on it in his shirt pocket, confessed to the crime at The Gold Sea when he realized they had him trapped. An executive at Ilmak had hired him. The man had been a cook on a boat when he was young, so he knew how to fillet a globefish. Unfortunately, the woman didn't survive, the man strangled her before the

복을 어떻게 다루는지 알았다. 불행하게도 중국인 종업원은 살아남지 못했다. 경찰이 도착했을 땐 이미 목이 졸려 사망한 뒤였다. 백유진도 아니고, 노 씨도 아니고, 나도 아니었다. 호수에 던지기 위해 그들이 고른 돌은 그 중국인 여종업원이었다.

✲

이제 반복되지 않을 얼굴. 지워버렸다

.

✲

일기장을 불 속에 던져버리지 않고 그냥 남겨두기로 했다. 언젠가, 카메라를 든 남자가 읽고 싶어 할 지도 모르니.

서한 번역
이수정

400

police arrived. Not Baik, not Ro, not me. In the end, it was the Chinese waitress who was a rock in the lake.

**

The face won't be repeated now. I have erased it.

**

I've decided to hang on to this diary, to save it from the fire. Maybe someday the camera man will want to read it.

<div align="right">

Translated from Spanish
by Will VANDERHYDEN

</div>

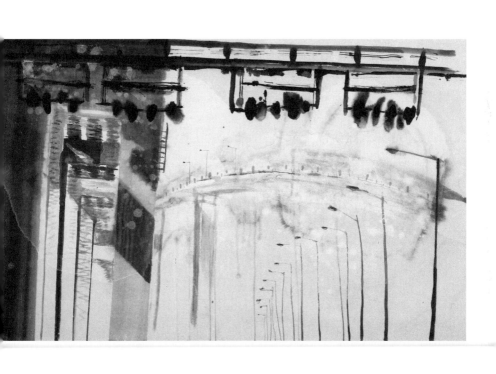

배와 버스가 지나가고

이상우

기다란 배수관 색 바래 녹슨 사다리 주위로 실외기 몇 돌아가는 높고 헤진 벽면에서부터 사선으로 드리운 그늘을 지나 저 멀리 좁은 두 벽 사이를 비집고서 하나의 빛처럼 하늘과 바다가 번져 오르는 골목을 뒤돌아 다른 방향으로 난 골목을 걸어가다 보면 언덕을 이루는 길이 나타나고 오르막길 양옆 건물에 매달려 있는 간판들을 바라보다 계단에 앉아 잠들었다. 왜 늘 거기에서 졸고 있는지 이모들이 물어오면 가끔 혼자 마음속으로 읊조린 말들이나 상상들이 주위사람들에게 다 들리는 것 같아 무섭다고 티엔이 일하던 국수집에는 쌍둥이 이모 두 분이 계셨는데 냄비에서 모락모락 김이 올라오면 티엔은 골목으로 트인 조그만 창문 사이로 들어온 바람이 찡그린 티엔의 눈꺼풀 안에서 반짝이던 기억을 자주 미래와 헷갈려했다. 언젠가 보았는데 언제가 언제이고 어디가 어디였는지 티엔은 설거지하는 티엔 대신 티엔의 땀을 닦아주던 이모들과 쉬는 시간에는 홀에 모여 텔레비전을 보거나 기지개 펴며 골목에 나가 담배를 나눠피웠고 찬물에 야채를 헹구던 여러 손들이 반지자국이 남아있거나 지문이 닳아있거나 손톱이 부드러워져 있는 맨 모습이 되어 나타나 물기가 채 마르지 않은 손가락 사이 가벼이 스치는 햇살을 골목가득 찰랑이게 만드는 손짓들로 이어내 일을 마치고 동네

를 혼자 거니는 티엔의 눈앞 곳곳에 저녁까지도 아른거렸다. 늘 늙은 남자들이 웅크려 앉아 있는 지붕 낮은 신발수선가게들을 지나치며 그래서 큰이모의 아들은 교도소에 있거나 발레 단원이었던 작은 이모는 스무 살에 인신매매를 당해 외국에서 2년간 일했다는 이야기를 껴안고서 티엔은 흩어지는 새벽의 어둠 곁으로 젖어오는 푸른빛이 유리창을 물들여오면 부두로 나가 떠나가고 있거나 돌아오고 있는 여객선들을 고개 왼편으로 두어 걸었고 그렇게 티엔의 뺨 너머로 지나가는 세계의 옆모습에 빗방울이 섞여드는 날에는 외국인청 앞에 줄을 선 사람들을 구경하다가 그들 뒤에 함께 줄을 서고 체류허가 심사 받는 상상 했다. 필요한 서류를 구비해두고서 심사관 앞에 서서 농담을 해가며 조금은 귀찮은 듯 인터뷰 마치는 백인남자 주위로 번호표를 손에 쥔 채 인터뷰 연습해보는 이들의 긴장된 얼굴을 바라보다 보면 기억 속에 갇혀 있던 얼굴들이 열려오고 떠올릴수록 사라져가는 얼굴들이 영영 증발해버리기 전에 자리에서 일어나 다시 걸었다. 여기에 왜 오셨죠. 도착해보니 여기였어요. 여관 앞 골목에 들어서면 맞은편에서 출근 중인 백인여성들이 걸어오고 긴 다리 교차해 걸으며 도넛 박스에서 도넛 꺼내먹는 그들과 서로 길을 비켜주고 가끔은 농담을 나누고 가끔은 말없이 서로의 표정에 패인 구덩이의 깊이만큼 고개 숙여 지나가고 가끔은 단속반이 비자 없는 사람들을 끄집어내고 있었고 그런 날에는 길을 되돌아가 별 볼일 없어 보이는 타워를 중심으로 이리저리 구부러진 공원을 몇 바퀴 돌았다. 오르막길을 오르고 내리막길을 내려가고 언덕의 갈림길이 많은 공원에서 몇 번은 뒤를 돌아보면서 빙글빙글 걸어온 길 위로 자기 자신이 자신의 눈앞에서 자신을 향해 지금의 자신과 똑같은 옷차림으로 걸어오고 있는 꿈에서 깨어나면 사람들이 사라진 옆방에서 오늘은 쫓겨나지 않은 이들이 수치심을 지워내려 안간힘 다해 코를 골아대고 있었고 책상에 앉아있던 티엔은 두 이모들이 가르쳐 준대로 담배를 입에 물고 불을 붙였다.

차창 앞에 앉아 청재킷 맞춰 입은 연인이 서로의 품에 안겨 속삭이고

배와 버스가 지나가고

여객선 라디오에선 가벼운 재즈가 자주 흘러나왔는데 베이 에리어 사운드라고 어느 곳이든 항구도시에서는 언제나 퓨전재즈를 위시로 한 음악 채널이 있어 왔다고 승객들끼리 나누는 이야기를 들은 적 있었다. 선내 안내방송을 마친 하라는 마이크를 내려놓고 넓게 트인 유리창 가득 반짝이는 바다를 지나며 계단을 내려와 직원 휴게실에 들려 동료들과 카드 패 돌리거나 창문 없는 객실의 2층 침대에 누워 쪽잠을 잤고 점심시간이 거의 끝날 때쯤에서야 식당에 가 밍밍한 카레라이스를 먹다 남겼다. 커피 잔의 검은 물결 속으로 별모양 설탕 가루 하얗게 풀어지고 가느다랗게 물들어가는 하얀 곡선 부드러운 흐름 따라 검은 물결 바깥에서 안쪽으로 회전할 동안 옆 테이블에 마주 앉아 바다를 바라보며 이야기 나누는 두 수녀님의 말소리 사이 하얀 허공으로부터 바다를 지나온 햇빛이 기다란 직선의 형태로 선내식당 일부를 환하게 가로질러와 카레 얼룩 어질러진 흰 쟁반과 커피 잔 위 빛 속에서 역광으로 어두운 승객들의 고갯짓 엇갈렸다. 하라는 다 먹은 그릇을 수거함에 올려두고 식당을 걸어 나왔다. 바다에게서 눈을 떼어 얼굴 마주해 이야기 이어나가는 두 수녀를 지나와 식당을 나서며 미간을 모으고 두 입술 다물어 방금 전의 햇빛이 갑작스레 밝혀낸 어

고개 기울여 연인의 어깨 품에 얼굴을 파묻은 남성이 가느다란 두 눈을 감
았다 뜨며 속삭임 이어나갈 동안 부드럽게 열리다 감기는 남성의 속눈썹
지니 눈꼬리 니미 비스듬히 바닥을 내려다보는 여성의 비릿꼴 뭐도 오렌
지색 터널불빛들 맞은편에서 마주 달려오는 전철불빛들과 부딪쳐 깨져
나가며 엇갈린 각도의 두 사람 얼굴 밖으로 조각나 날아가는 눈코입 아무
기척 없이 비어 있는 옆 칸의 객실까지 속삭임은 덜컹이며 마주 달려오는
전철이 부숴내는 빛에 맺혀 흩어지고 외로움을 잃어버린 시선이 맴돌던
바닥으로부터 고개 들면 차창 안으로 쏟아져오는 어둠 서로의 품에 안겨
있지 않은 두 사람이 차창 아래 혼자 앉아서

느 감정을 몸 구석에다 간신히 구겨 넣고선 방송실에 도착해 여객선의 항로를 안내했다. 늘 해왔던 어조와 억양대로 저녁식사 및 선내 이벤트 시간 그리고 도착지까지의 남은 여정을 안내하다보니 마음 서서히 가라앉았고 멘트 도중 하라를 웃기기 위해 동료들이 하라 앞에 다가와 지어내는 한심한 표정에 웃어주면서 조금 전의 환한 풍경 속으로 햇빛이 다가온 길이만큼 추락해내리던 마음을 잊은 체 했다. 우유와 소보로빵 먹으며 근무일지 작성까지 마친 뒤 여전히 재즈가 흘러나오는 선내 복도를 걷던 하라는 노래를 따라 흥얼거렸고 청소복 입은 사람들이 커다란 세탁수레 끌고 나타나면 벽에 등을 기대 멈춰 선 채 그들이 편히 지나가길 기다렸다. 낮에, 오전에, 밤에 하라는 그들이 다 지나가고 나서도 벽에 등을 기댄 자세 그대로 팔짱을 끼거나 고개 숙여 복도에 오래 머물렀다. 어릴 적에 들었던 노래 흥얼거리면서. 아무도 없는 복도에서 혼자 그렇게 흥얼거리고 흥얼거림을 멈추고 조그맣게 다시 흥얼거리고 또 다시 멈추고. 읊조림에 가까운 노랫말과 노래의 멈춤 사이 하라 스스로 만들어낸 고요로 공허와 맞섰다.

교복을 입고 해변을 뛰어다니는 학생들이 있었다. 모래에 파인 발자국 모양 위로 모래알 붙은 맨발들이 허공을 밟아가고 아우성과 웃음소리들 뛰어들듯 앞사람의 목을 둘러 안고 업히거나 업으면서 제자리에서 긴 머리칼 휘날리며 점프하면 무릎 곁으로 작게 회오리쳐 오르는 물방울들 거꾸로 뒤돌아 달리면서 뒷사람과 얼굴을 마주하고 똑같이 입 벌려 소리 지르고 펼쳐진 기다란 양 팔 끝에서 빛나는 손가락들 교복 셔츠 풀어진 넥타이 사이 살색 목덜미와 흐트러지는 치마 주름 교복을 입고 해변을 뛰어다니는 학생들이 있었다. 모래알 붙은 맨발들이 허공을 밟아가고 모래에 파인 발자국 모양 위로 아우성과 웃음소리들 제자리에서 긴 머리칼 휘날리며 점프하면 무릎 곁으로 작게 회오리쳐 오르는 물방울들 목을 둘러 안고 업히거나 업으면서 해변을 뛰어다니는 학생들이 있었다. 제자리에서

　　타원형으로 각층의 복도가 동그랗게 이어지게끔 설계된 백화점 옥상에서부터 에스컬레이터 타고 1층까지 내려오며 뱅글뱅글 옷가게 돌아다니는 사람들을 구경했다. 하얀 대리석 바닥 위로 이곳저곳 즐거운 무리끼리의 간격마다 혼자 걷는 사람들이 있었고 티엔은 가끔 무리 안에서도 혼자인 이들의 얼굴을 가만히 바라보다 자신이 그곳에게서 익숙한 표정이 나타나길 기다리고 있음을 깨달을 때면 어서 눈 떼곤 천장을 향해 고개 젖혀 은빛 거울의 무늬대로 여러 갈래 갈라져 있는 자신의 얼굴을 지켜봤다. 걷거나 앉아있거나 멈춰있던 얼굴 없는 뒷모습의 이들이 제각기 갈라지며 사라지고 있었다. 달달한 밀가루 냄새가 차가운 공기에 서려 있는 아이스링크에서는 핫도그 먹는 아이들 곁에 앉아 얼음 다져내는 정빙기와 정빙기 운전하는 여성기사 구경했는데 얼마나 오래 일했는지 이름이 무엇인지 빙판을 정리하며 어떤 생각을 하는지 국수를 좋아하는지 자기

긴 머리칼 휘날리며 점프하면 무릎 곁으로 작게 회오리쳐 오르는 물방울들 거꾸로 뒤돌아 달리면서 뒷사람과 얼굴을 마주하고 펼쳐진 기다란 양 팔 끝에서 빛나는 손가락들 교복 셔츠 풀어진 넥타이 물방울들 뛰어들듯 앞사람의 목을 둘러 안고 업히거나 업으면서 입 벌려 소리 지르고 거꾸로 뒤돌아 달리면서 뒷사람과 얼굴을 마주하고 똑같이 펼쳐진 기다란 양 팔 끝에서 빛나는 손가락들 풀어진 넥타이 흔들며 해변을 뛰어다니는 학생들이 있었다. 흐트러지는 치마 주름 모래에 파인 발자국 모양 위로 모래알 붙은 맨발들이 허공을 밟아가고 제자리에서 긴 머리칼 휘날리며 점프하면 무릎 곁으로 작게 회오리쳐 오르는 아우성과 웃음소리들 뛰어들듯 앞사람의 목을 둘러 안고 업히거나 업으면서 입 벌려 소리 지르고 펼쳐진 기다란 양 팔 끝에서 빛나는 물방울들 거꾸로 뒤돌아 달리면서 뒷사람과 얼굴을 마주하고 모래에 파인 발자국 모양 위로 모래알 붙은 맨발들이 허공을 밟아가고 뛰어들듯 앞사람의 살색 목덜미와 흐트러지는 치마 주름

도 정빙기를 운전해 볼 수 있을지 누가 오길 기다리고 있어요? 핫도그의 소시지를 남겨두고 빵만 발라먹은 아이가 물어본다.

티엔이 말을 고를 동안 정빙기 링크 밖으로 퇴장하고 핫도그도 마저 다 못 먹은 아이가 다른 아이들 뒤를 따라 뒤뚱뒤뚱 뛰어가는 일을 상상하면서 누구도 티엔에게 말을 걸어오지 않는 백화점 아이스링크에 앉아 있었다. 길 잃은 얼굴로부터 백화점 천장의 거울에 닿기까지 시선이 스치는 동시에 티엔에게서 흘러가 사라져버린 풍경들처럼 빗방울 맺혀오는 유리창에 이마 기대어 눈을 흘기면 샌드위치 가게 직원이 손에 쥔 책을 읽어가고 있고 머리 그물망 쓴 채 유니폼 주머니에 손 넣은 자세로 샌드위치 가게 차양 아래에서 조명 불빛과 함께 흩어지고 빗방울 맺혀오는 버스의 커브에 몸을 기울이며 티엔은 옆 차선으로 나타났다 사라지고 다시 나타나는 다른 버스에 타 있는 얼굴들이 가로등과 신호등 간판 불빛에 얼룩져 빗물로 흘러내릴 때까지 창에게서 눈 떼지 않았다. 이미 많은 언덕길을 지나오는 도중에 어디를 지나고 있더라도 눈에 보이지는 않지만 주위에

414

왜 신발 안 갈아 신어요? 넌 여기 앉아만 있을 거야 우리 엄마도 그래요 스케이트는 재밌니 네 재밌어요 근데 재미없기도 해요 집에 가고 싶을 때도 많은데 어쩔 수 없어요 왜 어쩔 수가 없어? 이건 비밀인데요 곧 세상이 다 말라버릴 거예요 제가 얼음 스케이트를 타 본 마지막 아이가 되겠죠 그걸 어떻게 알았어? 어느 날 꿈을 꿨어요 바다가 사막이 되어있고 어른들이 사막을 헤매며 우는 꿈이었어요 처음에는 그 어른들이 그냥 어른들인 줄 알았는데 꿈에서 깨고 보니 그게 나일 수도 있는 거예요 그죠 안 추워요? 내 핫도그 좀 먹을래요? 아니야 괜찮아 너 많이 먹어 담배 냄새 나요 미안 나도 나중에 담배 피게 될까요? 글쎄 너 마음에 달렸지 그래서 누굴 기다리고 있는 거예요? 아니야 그냥 혼자 있는 거야 정말이지 나에게도 그런 시간이 필요해요 어디서 오셨어요? 옥상정원에서 왔어 아니요 어느 나라 사람이냐고 물은 거예요

바다가 있다는 감각이 커다래 물로 뒤덮인 버스 안에서 바다 아래를 지나는 기분 들었는데 승객들이 데려온 빗물이 버스의 흔들림 따라 바닥에 스스로의 궤적을 그려가고 방금 탄 여자의 백팩에는 지퍼 밖으로 가방보다 기다란 꽃이 삐져나와 있어 창밖 불빛들과 라디오 말소리들 조르르 오고 가는 버스 안에서 티엔은 모르는 이의 가방 밖으로 삐져나온 분홍색 꽃을 다른 이들과 각자 다함께 바라보았다.

하라는 두 손으로 얼굴 가리고선 두 손 안의 안전한 어둠이 하라에게 충분히 넘쳐흘러 다시 한숨 같은 욕설 읊조릴 수 있을 때까지 그렇게 서 있었다. 라이터 빌리기 위해 선내의 지하복도를 두 층이나 돌아다녀보아도 아무도 마주치지 못한 하라는 결국 이 시각에는 한 번도 내려와 보지 않

자기 등에 깔린 팔을 빼내다 잠에서 깨어버린 하라는 편한 자세를 찾기 위해 몸을 뒤척이다간 결국 잠든 직원들 깨지 않도록 조심히 2층 침대의 사다리를 내려왔다. 바다가 밤으로 넘쳐나고 있었고 바람이 불어오는 반대 방향으로 복도 걸었다. 고개 들면 입김 멀리 차갑게 펼쳐져 있는 별빛 아래 아무도 갑판에 나와 있지 않았다. 가장 늦게까지 열리는 바 또한 불 꺼져 있어 술병 나열된 창문가 근처를 서성일 때 약간의 토 냄새 갑판으로 밀려오는 바다 냄새와 섞여 하라 주위를 훑곤 떠나갔다. 주름지는 무늬대로 휘날리는 옷 바닷바람에 등 돌려 담뱃불 붙이려 해도 라이터 불자꾸 붙지 않아 갑판 난간에 몸 기댄 하라는 파도가 어디로부터 생겨나는 것인지는 관심 없이 그저 생각 대신 눈 둘 곳이 필요해 파도 너머의 파도, 그 너머의 파도 너머가 밤의 가장자리에서 불어나는 생김새를 좇아 보았고 뱉어낼 연기 없이 바람을 받아내다 바람이 몸을 통과하여 지나가고 다가오고 어느 순간 텅 빈 감각이 되어 심장이 사라져 버린 기분이 들 때 바다에게서 눈 떼었다. 계속 물고 있느라 담배종이 달라붙어 뜯어진 입술로 맴도는 피 맛 다시며

417

앉던 창고 층까지 내려와서야, 복도 끝에서 한 창고의 열린 문틈 아래로 흘러나오는 불빛을 발견했다.

불 좀 빌릴 수 있을까요? 네 그래요 청소복 입은 사람이 라이터를 건네주곤 다시 책을 읽었다. 오늘 당직이신가 봐요. 아니요. 책에 집중할 수 있는 시간이 이때 밖에 없어서요. 매일 이 시간에 여기서 책을 읽는 거예요? 맞아요. 그래도 내일 새벽이면 도착할 테니 다행이네요. 글쎄요. 모르겠네요. 몰라요? 네. 저는 배에서 안 내리거든요. 왜요? 난 비자가 없거든요. 라이터 돌려주며 담배 한 개비 함께 쥐어주고 빨래더미에서 서서히 풍겨오는 지린내 담배연기로 밀어내면서 읽고 있는 거 재밌어요? 네 재밌어요. 뭔데요? 그냥 소설이에요. 난 스무 살 이후로 책을 읽어본 적 없는 것 같아요. 굳이 읽을 필요 없죠. 근데 왜 읽어요? 그러게요. 나에게 새로운 과거들이 필요한가 봐요. 그게 왜 필요하죠 난 과거 때문에 늘 토할 것 같은데요. 그렇군요. 걔네들은 언제든지 날 침몰시킬 준비를 하고 있는 것 같아요. 그래서 차라리 미래가 궁금해요. 어서 미래에 도착하고 싶어요. 두 사람은 빨래더미에 무릎이 닿지 않을 정도로 마주 앉아서 거기에는 뭐가 있을 것 같나요? 쩌는 칵테일과 해변이 있겠죠. 잘생긴 강아지도 있고 쩌는 빌딩들도 있겠죠. 잘생긴 강아지와 몇 시간 동안 수영하고 돌아오면 저절로 몸을 씻겨주고 머리를 말려주는 기계도 있겠죠. 레이저검도 있으려나. 그건 왜요? 왜긴요 개새끼들이 찝쩍거리면 거길 도려내버려야죠. 그 다음엔 그 구멍에다 다른 놈 머리통을 쑤셔 넣을 거예요 마치. 마치 켄타우로스처럼요? 아니요 인간지네처럼요. 그건 처음 들어봐요. 그쪽은 어떨 것 같은데요? 글쎄요. 그건 내게 늘 이상하게 느껴져요. 떠올리려할수록 기억이 사라져가거든요 마치. 마치 비어 있듯이요? 그래도 하나는

출렁임 따라 흔들리는 전구 불빛 아래 창고가득 쌓인 빨래더미에 앉아
청소복을 입은 사람이 책을 읽고 있었다.

확실한 게 있어요. 뭔데요? 그 때나 지금이나 내가 도착할 곳이 없다는 거요. 왜 그래요. 잘 해결될 거예요. 사실이니까요. 그게 내가 선명하게 기억하고 있는 유일한 일이거든요. 내전을 피해 두 달 가까이 사막을 헤매던 우리는 국경수비대에 잡혀 여기로 보내졌어요. 이 여객선으로요? 아니요. 여기 이 시대로요. 무슨 소리인지 못 따라가겠는데요. 그러니까 내가 내가 온 곳과 가까워질수록 그곳의 기억들은 자연스럽게 없어지는 거예요. 어디서 오셨는데요? 난 미래에서 왔어요.

자리에 앉아 아이가 오렌지맛 아이스크림을 먹을 동안 골목의 플라스틱 테이블에 둘러 앉아 쉬는 날에 다함께 놀러가자고 작은 이모가 도시락을 싸오겠다 말하니 큰 이모가 그럴 필요 없이 돈 주고 다 사먹자고 좋아요 좋아 티엔과 작은 이모 박수치고 좁은 벽 사이로부터 갈라져와 세 사람의 손뼉과 얼굴 스쳐온 노을빛에 물들며 아이스크림 다 먹은 아이는 아이도 모르게 바닥에 닿지 않는 두 다리 허공에서 번갈아 흔들거렸다. 그 날 밤 티엔은 편지를 썼다. 받을 사람 없었지만 편지의 내용이 아닌 편지를 쓰고 있는 기억이 남아 이어지길 바라는 마음으로 오늘 본 것들을 적었다.

연약하고 비스듬히 쌓인 햇빛 바닷가로 줄지어 길게 날아가는 골목에
아이가 서 있었다. 아이는 티엔과 눈을 마주치고선 다시 뒤돌았고 새하얀
햇빛 속으로 들어선 아이의 얼굴을 보지 못한 티엔에게 큰 이모는 교도소
에 가 있는 아들의 딸이라 아이를 소개시켜줬다. 골목 서성이는 아이를 힐
끗힐끗 지켜보며 세 사람은 국수를 삶고 손님 한 두어 명이 식탁에 낚시
모자를 올려둔 채 창밖을 바라보고 숨소리는 모두의 얼굴 위로 흐르고 있
었다. 틈 날 때마다 창 너머 아이에게 말을 걸거나 한 번씩은 골목으로 나
가 놀아주는 이모들의 장난에 말 없던 아이가 웃으면 티엔은 따라 웃었고
그러다 아이와 눈이 마주치면 눈 피했다. 맥주잔에 미지근한 맥주를 따라
놓고 거의 졸듯이 살아 있던 손님들이 떠난

여관으로 돌아오는 길에 만난 친구에 대해서. 언제나 둘이 함께이다 오늘은 한 명이 되어 있던 친구의 걸음걸이와 서로를 위해 동시에 길을 비켜 주었을 때 걸음 멈춘 두 사람 사이로 거의 분명하게 지나가고 있던 시간에 대해서. 국수집 골목 테이블에 적힌 낙서에 대해서. 처음 만난 아이의 운동화에 대해서. 여관에서는 오늘도 몇 사람이 끌려 나갔고 코고는 소리 작아졌다.

약속한 날 두 이모와 티엔은 책방 앞에서 만났다. 아이는 없었다. 아이의 어머니가 데려갔다고 했다. 골목 따라 줄줄이 늘어선 헌책방 둘러보며 막상 나와 보니 귀찮다는 표정으로 책 쌓인 길 걷는 두 이모 뒤를 따라가던 티엔은 두 사람의 뒷모습이 얼굴 보다 더 얼굴 같다고 여기저기 천막 쳐진 공사장에서 들려오는 파도소리처럼 파란 천막 흐르는 건물의 1층 빵집에서 빵을 고르고 셔터 틈으로 시끄러운 서너 개의 인쇄소와 3평 남짓의 문구점 지나쳐 바람에 휘날리는 두 사람의 스카프 지켜보다 보면 검은 빛깔 짙은 긴 머리칼의 쌍둥이 여성 둘이 롱코트를 입고서 돌계단을 걸어 내려 가고 있었다. 얼굴 마주하는 일은 별로 없이 코트 앞섶을 제쳐 하이웨이스트 바지 주머니에 손을 넣거나 코트 허리끈을 매만지면서 거리를 가볍게 내다보고 들키듯 발에 치이는 은행잎들 다리를 꼬고 길가에 늘어앉아 커피와 차 마시는 사람들을 지나 각자 다른 곳을 바라보며 던지듯이 몇 마디를 대답하지 않아도 대답한 것처럼 물어보지 않아도 물어본 것처럼 걸어가는 두 사람 옆으로 언뜻언뜻 고요한 바다가 반짝이다 사라지고 다시 눈부시게 나타나 오래되어 갈라진 벽담으로 이어진 언덕길을 오르다 보면 두 사람의 팔이 닿을 듯 말 듯 간격을 미끄러트리고 부숴내고 이어내고 정상의 공터에 다다라 가쁜 숨 다스리며 전망대 난간에 팔을 기대 나란히 서 있는 두 사람 뒤에서 두 사람의 얼굴은 두 사람이 바라보고 있는 난간 너머의 모두 같다고 티엔을 향해 뒤돌아오는 두 사람의 머리숱이

햇빛처럼 새하얗게 흩어졌다. 세 사람은 공터 벤치에 앉아 낮에 산 빵을 나눠먹었다. 빵도 골고루 먹어야 한다며 아들이 교도소에서 보내온 편지 이야기를 시작으로 작은 이모가 다니는 합창반 이야기와 어느 단골손님이 가장 오래된 단골인지 피난민 시절부터의 이야기를 들으며 티엔은 걱정해주고 웃기도 하면서 주먹으로 무릎 두드리는 두 이모에게 자신의 이야기는 하지 않았다. 손녀 이야기 꺼내지 않아도 아이들이 주변을 뛰어갈때면 아이들이 시야 밖으로 떠나갈 때까지 아이들에게서 눈을 떼지 못하는 두 이모는 헤어지는 길에 큰 이모는 아까 산 책을 작은 이모는 꽃 몇 송이를 티엔에게 선물했다.

해 저무는 가로수 이파리 사이로 여러 배들이 떠다니고 바다와 같은 푸른 채도에 잠긴 공터의 구석에서 해군군복을 입은 남자가 나팔 연습하고 있었다. 서툴러 엉망진창인 나팔 연주 주위로 수학여행 온 학생들이 쏘아 올리는 폭죽 불꽃들 시시하고 아름다운 밤 공원에 바람은 언덕을 헤매어 난간의 철조망 흔들고 빨려 들어가다시피 바다와 하늘을 섞어낸 어둠처럼 표정을 잊은 얼굴들이 여기저기

침대 끝에 걸터앉아 스웨터를 벗는 사람이 있었다. 커튼 틈으로 창밖의 불빛 허리춤부터 양손으로 파란색 스웨터 뒤집으며 살색 살결 위로 속옷 자국 머리칼 붙은 목덜미 어깨선 날개 뼈 근처 미세한 두드러기 커피묻은 이불보 클랙슨 소리 뒤통수 지나가는 불 꺼진 침실의 그늘 양 손목에 스웨터 끼워둔 채 가느다란 숨소리 따라 흔들리는 어깨선 침대 끝에 걸터앉아 스웨터를 벗는 사람이 있었다. 허리춤부터 양손으로 파란색 스웨터 뒤집으며 살색 살결 위로 속옷 자국 어깨선 머리칼 붙은 목덜미 날개 뼈 근처 미세한 두드러기 커튼 틈으로 창밖의 불빛 묻은 이불보 클랙슨 소리 지나가는 불 꺼진 침실의 그늘 양 손목에 스웨터 끼워둔 채 가느다란 숨소리 따라 흔들리는 침대 끝에 걸터앉아 스웨터를 벗는 사람이 있었다. 커튼 틈으로 클랙슨 소리 허리춤부터 양손으로 파란색 스웨터 뒤집으며 머리칼 붙은 이불보 어깨선 목덜미 근처 미세한 두드러기 커피 묻은 살색 살결 위로 화상 자국 창밖의 비행기 불빛 지나가는 불 꺼진 침실 양 손목에 스웨터 끼워둔 채 가느다란 숨소리 따라 흔들리는 뒷모습으로 스웨터를 벗는 사람이 있었다. 허리춤부터 양손으로 파란색 스웨터 뒤집으며 바다 위로 배가 나아간 자국 머리칼 붙은 목덜미 어깨선 날개 뼈 근처 미세한 두드러기 커피 묻은 이불보 누군가 사라져 버리는 소리 불 꺼진 침실에서 침대 끝에 걸터앉아 양 손목에 스웨터 끼워둔 채

배와 버스가 지나가고

　여남은 어스름에 섞여 승객들과 승무원들 다 빠져나가고 여객선에서 마지막으로 내리며 하라는 갑판 둘러봤지만 아직 캄캄해 갑판 위로 켜놓은 불빛 청소복 입은 사람들 비추지 않았다. 수평선 너머로부터 서서히 구름을 물들여오는 새파란 빛살의 바람에 헝클어지는 머리 묶어내며 몰스킨코트 위에 배낭을 한쪽 어깨에만 걸치고서 길을 걷던 하라는 횡단보도 건너편에서 하라의 이름을 불러오는 동료들의 손짓을 눈치 채고는 그 자리에서 택시를 붙잡아 선착장을 떠났다. 재미도 재수도 없는 놈들에게 눈길도 주지 않으면서 도착하자마자 가장 먼저 내린 선장은 또 죄 없는 딸 이름을 주기도문처럼 외우며 카지노에서 돈 잃고 있겠지 자신이 이미 딸 인생에서 완전히 삭제된 줄도 모른 채 가족이든 친구든 누구든 주기적으로 전화를 받아 안부를 주고받으면서도 상대를 자기 삶에서 제외시키는 방법을 하라는 알고 있었다. 여전히 새파란 택시차창으로 졸고 있는 사람들이 가득한 버스가 지나가고 두터운 외투 속으로 눈감아 고개 숙여가는 노인들의 얼굴을 바라보다 미래에서 왔다던 사람의 얼굴이 떠오른 하라는 그 사람이 미래에서 왔다고 고백했을 때와 웃어 보이며 농담이라고 했을 때 들었던 기분을 곱씹어 보았다. 미안해요 그런 내용의 소설을 읽고 있었거든요 이어 실없는 농담들 나누는 새 잊어버리고 말았지만 어디서 왔든 그 사람은 내릴 수 있는 곳 없었다. 눈길이 닿을수록 아무 소리 들려오지 않는 버스 안의 할머니들을 눈감아내고 목욕탕에서 샤워 물 대충 끼얹고서 온탕에 들어가 누운 하라는 이마 위에 따뜻하게 적신 수건 올려둔 채 장 볼거리 생각했다. 감자 다져진 고기 태국고추 시금치 양파 카레 저지방우유 냉동피자 맥주 또 어떤 사람 얼굴이 잘 보이질 않는 희미한 어떤 사람 뿌옇다시피 막연한 몸짓과 목소리가 들리지 않는 어떤 사람 식당에서 바다를 바라보던 버스에 앉아 잠들어 있던 복도에서 길을 비켜주었던 사람들처럼 곧 다시 기억 저편으로 사라져 버려 장소와 함께 거의 영영 떠오르지 않을 어떤 사람 추위와 긴장으로 경직되었던 몸이 따뜻한 물

에 녹아내리며 물 아래로 아주 멀리 흘러내려가고 힘 풀린 눈꺼풀 위로 목욕탕 천장에 맺혀 있는 물방울 가리어져갔다. 눈이 내리고 있었다. 하라는 국수집에 앉아 있었다. 문을 등지고서 앉아 있는 하라보다 늦게 들어와 국수를 다 먹은 후 말없이 창밖을 지켜보던 손님 두 어 명이 가게를 나가고 나서도 하라는 팔짱끼듯 테이블에 양팔 얹어둔 채 앉아 있었다. 창 흔드는 바람소리가 한 팔을 비스듬히 세워 턱을 기대고 있던 하라 곁으로 야채 볶는 냄새와 함께 회오리 돌고 라디오에서 나오는 가요를 흘려들으며 어떤 음악은 정말로 좋은 음악은 듣기 너무 좋아서 죽고 싶어진다고 말하자 국수를 내온 하라의 어머니가 하라의 등짝을 때렸다. 말이 그렇다는 거지 진짜 죽는다는 게 아니라 음악이 이끌어낸 어느 다른 차원으로 도망 가버리고 싶어진다는 하라의 말을 더 듣지도 않고서 어머니는 골목으로 나가 길고양이들을 가게 안으로 들이고 하라는 바람을 호 불고서 그릇을 들어 국수의 국물부터 마셨다. 골목으로 날아오는 가벼운 눈발 가운데서 아직 못 들어온 새끼 길고양이들 품에 껴안아 들고 고양이 밥그릇 챙기는 어머니 옆얼굴 너머로 어렴풋이 바다가 보이고 동시에 유리창에 비춰진 자신의 모습을 본 하라는 마저 국수를 먹었다. 가게를 나서려는 하라의 가방에 기다란 꽃을 꽂아 넣으며 대신 집에 좀 갖다 놓아달라는 어머니의 부탁에 가방 밖으로까지 삐져나온 꽃을 본 하라는 이 꼴로 돌아다니다간 정말 너무 쪽팔려서 길 한복판에서 공황발작을 일으켜 기절하거나 졸도해서 넘어지다 뇌진탕으로 죽을 지도 모른다고 어머니는 고맙다며 발로 툭툭 치대어 고양이 울음소리 가득한 가게 밖으로 하라를 내보냈다.

　　버스 정류장에 도착하자 맑아진 구름 위로 땅거미가 슬그머니 길고 가느다란 빛을 드리우고 깨끗해진 얼굴의 사람들 발걸음 느긋해져 풍경이 고이듯이 흐르고 있는 것 같았다. 읽고 있는 소설에서 미래는 어떤데요? 정말 궁금해요? 어차피 다 가짜인데. 네 궁금해요. 미래라는 건 어차피 처음부터 가짜인 거잖아요. 재밌는 거 없어요? 미래에선 옛날 사람들의 기억

을 재생해요. 어떻게요? 죽은 사람들의 뇌에서 뽑아낸 이미지의 파형이 담긴 아주 조그마한 칩이 있어요. 그걸 이렇게 관자놀이에 갖다 붙이면 뇌파를 진동시켜서 머릿속에서 펼쳐지죠. 정말 생생해서 내가 그곳에서 그 사람으로 살고 있는 것만 같아요. 무슨 마약 같은 거예요? 비슷한 거 같아요. 사람들은 어딘가에 모여서 의자에 앉거나 땅에 누운 채로 짧게는 1초 길게는 40초 정도 되는 기억들을 몇 번이고 계속 재생하죠. 버스는 바다 위로 거대하게 뻗어 있는 고가도로로 진입해가고 왼쪽 차창으로 해변의 길쭉한 빌딩들이 줄지어 나타나 구름을 통과해온 햇살에 드러나듯 온몸을 반짝거리며 닿을 수 없이 유려한 해변과 그래픽 같은 빌딩들을 지나 바다 위로 휘어진 고가도로를 오르는 버스 창으로 바다와 하늘 사이 눈부시게 비어있어 바라볼수록 자기 자신도 그렇게 비워져 숨을 쉴 수도 없이 지금 이곳에서 완전히 없어져버리는 느낌 가운데 반대편 차창으로 주홍빛이 번져왔다. 고개 돌려보면 꽃이 담긴 가방. 온통 노을빛으로 물든 뒷모습의 승객들. 탄성처럼 빛이 폭파하는 버스 안에서 언제인가 본 것 같은데 이렇게 노을빛으로 물들어 여러 손짓으로 웃고 떠드는 사람들 그게 언제이고 그게 누구인지 눈을 감아도 퍼져 오르는 노을 속에서 유려한 해변과 그래픽 같은 빌딩들을 지나 고가도로를 오르는 버스 창으로 바다와 하늘 사이 가짜처럼 비어 있어 바라볼수록 자기 자신도 그렇게 비워져 숨도 쉴 수 없게끔 지금 이 순간 자체가 완전히 소멸되어버리는 느낌 가운데 반대편 차창으로 주홍빛이 번져왔다. 고개 돌려보면 꽃이 담긴 가방. 온통 노을빛으로 밝혀진 뒷모습의 사람들. 비명처럼 빛이 폭파하는 버스 안에서 언제인가 본 것 같은데 이렇게 선명하게 나타나도 지워지는 사람들 그게 언제이고 그게 누구인지 눈을 감아도 퍼져 오르는 노을 속에서 유려한 해변과

그래픽 같은 빌딩 지나 고가도로 오르는 버스 창으로 바다와 하늘 사이

As boats and buses go by

YI SangWoo

Elongated drainpipe rusted ladder surrounded by whirring box fans on the side of a tall shabby building casting oblique shadow at its own feet, walking past it back down the street that's gleaming with a sky and sea fused into a single block in the light seeping through two distant narrow walls, turn into another side street that gives onto the sloping uphill path and there, craning at building signs on either side of the incline, Thien would fall asleep on the stairs. You're always nodding off and in the same spot too, what's up with that, the aunties used to ask, Because sometimes it seems these mutterings and imaginations might be audible to everyone else, for there had been two aunties, twins, at the noodle shop where Thien once worked and where as steam wafted up from pots Thien would confuse the memory of the gentle breeze blowing through the small window overlooking the alley and glimmering under creased eyelids with the future which yes, to be encountered at some point in time but when was that point and where was it, Thien and the aunties who'd wipe the sweat away when Thien's own hands were occupied with soapy dishes meeting in the hall during breaks to watch TV or heading outside stretching limbs to share a smoke in the alley, the sight of several hands damp

and raw and bare from washing veggies in cold water gesturing, ring marks faded fingerprints softened nails dancing in the sun until the street brimmed with the light glancing off fingers images shimmering variously in front of the eyes right into the evening when shift over Thien wandered the neighbourhood alone. Walking past the low-roofed shoe repair shops where without fail old men sat stooped all the while holding onto the stories of And that's how Big Auntie's son wound up in prison or how Little Auntie the ballet dancer was trafficked at the age of twenty and had to live and work for two years abroad, as blue light soaked the edges of the dispersing dark of dawn and painted the windowpanes Thien would walk out to the harbor walk alongside the passenger ships that were departing or returning and on days when the view of the world passing by Thien's left cheek swirled with raindrops observe the people queued up outside the immigration office and imagine lining up behind them and filing and being interviewed for temporary residence. Papers at the ready and cracking jokes with the immigration officer a white man finishing his interview with an air of annoyance while around him faces tense people rehearse lines for their interview numbered tickets in hand these faces open up other faces locked away in memory faces that vanish the more one recalls them so get up resume walking lest they evaporate for good. What brings you here. I arrived to find myself here. Turning into the side street with the cheap motel run into white women on their way to work long legs intersecting eating doughnuts out of a box stand aside to let each other pass maybe share a word or a joke, at other times passing wordlessly by heads bowed as low as the depth of the pits gouged into their expressions and occasionally on days when Immigration's been hauling away anyone without a visa the retracing of steps to circle the park looping endlessly round the many bends that gird its unremarkable tower. Up the incline and down the decline the park full of forking paths looking behind the shoulder round and

As boats and buses go by

round over the same paths when here comes one's own self dressed as self in identical clothing and headed straight towards self only to awake and be met by sounds of slumbering from next room where some have vanished overnight and those that managed to stay put were snoring as best they could to erase the humiliation and seated at the desk Thien would light a dangling cigarette as the aunties used to.

From the radio on board the ship a light jazz music flowed a so-called bay area sound snatches of passengers remarking how all port cities have a music channel devoted to fusion jazz. After making the safety announcement Hara lowering the microphone passing the big window full of glittering sea would head downstairs to the break room for a round of cards or to catch a wink in the berth of a windowless cabin or to the mess just as lunch time's ending only to leave the bland plate of Japanese curry rice unfinished. Star-shaped sugar granules unfurled white against the smooth dark coffee pale curls gently tingeing to darker as they dissolved into the swirl of rippling black meanwhile two nuns in habit were seated across from each other at the next table looking out at the ocean blank spaces opened up now and then in the low thrum of their conversation as a long ray of sun having

As boats and buses go by

Lovers in matching denim jackets sit in an embrace whispering by the metro window head bowed the man opens and shuts his eyes from the depths of his lover's shoulder where his countenance remains buried murmurs gently as the woman's downcast gaze sidles over his eyelashes past the tails of his softly blinking eyes and behind her hair the orange glow of the tunnel as it collides with oncoming headlights fracturing their faces eyes noses lips dashed off visages to the empty silence of the next carriage susurrations scattering to the winds in the rumbling of the oncoming metro broken lights in its wake and now as eyes misplacing loneliness lift up from the floor dark spills in from the window and beneath it two people no longer in an embrace sit each alone

traversed the sea struck through a section of the mess blanching curry-stained white trays and coffee cups the darkened nodding profiles of passengers broken up into shards. Returning plate and tray Hara headed outside past the faces that meanwhile had turned away from the view towards each other, past the profiles of the two conversing nuns, and upon exiting the mess with brows knitted lips sealed tight barely able to fold away the specific emotion into some recess of the body, an emotion unexpectedly come to light in the sun's blaze, stumbled back to the radio room and resumed the announcements. Listing in the usual intonation and accent the dinner hours the on-board entertainment the event hours the remaining time to their destination until a calmness set in allowing Hara to smile in response to the antics of colleagues their attempts to make Hara burst out in laughter while on air, calm where there had been vertigo the mind free-falling in exact proportion to the exact reach of the sun's rays now all but forgotten. A small carton of milk a soboro bread to fuel the write-up of the work log before strolling the still-jazzy corridors humming to the music pausing to flatten body against the wall each time someone wearing a cleaning uniform passed by with a huge laundry cart. Afternoons mornings nights Hara would wander the corridors long after the cleaners had come and gone leaning against the wall with arms crossed or head bowed humming a tune from childhood. Singing snatches of the song pausing starting up again in an undertone pausing again. In pauses between the near-chanting and singing of the words, a silence of Hara's own making defied the void.

As boats and buses go by

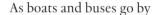

A handful of students in school uniforms were running along the beach. Bare feet encrusted in sand treading empty sky over rowdy footprints as shouts and laughter rang out leaping forward to envelop embrace the neck of the person up ahead hopping on each other's backs jumping in place long strands of hair aflutter wild spray of wa-

Taking the escalator from the top floor of the department store building where the floors by design form a single corridor that unfurls all the way down to the ground floor, watching people meander from

ter spiralling up their knees now scampering back face-to-face with the person behind dropping their mouths simultaneously to scream fingers gleaming at either end of their outstretched arms ties loosened around shirt collars glimpses of skin on bare necks and with skirt pleats flattened a handful of students in uniform were running along the beach. Bare feet encrusted in sand treading empty sky as shouts and laughter rang out over rowdy footprints jumping in place long strands of hair aflutter wild spray of water spiralling up their knees embracing necks hopping on each other's backs a handful of students were running along the beach. Jumping in place long stands of hair aflutter wild spray of water reaching up their knees scampering back face-to-face with the person behind fingers gleaming at either end of their outstretched arms ties loosened around shirt collars spray of water leaping forward to envelop embrace the neck of the person up ahead hopping on each other's backs dropping their mouths to scream scampering back face-to-face with the person behind fingers gleaming at either end of their simultaneously outstretched arms and swinging loosened ties a handful of students were running along the beach. Flattened skirt pleats bare feet encrusted in sand treading empty sky over rowdy footprints jumping in place long strands of hair aflutter as wild spray of shouts and laughter rang out spiralling up their knees leaping forward to envelop embrace the neck of the person up ahead hopping on each other's backs dropping their mouths to scream drops of water gleaming at either end of their outstretched arms now scampering back face-to-face with the person behind bare feet encrusted in sand treading empty sky over rowdy footprints leaping forward the bare neck of the person up ahead flattened skirt pleats

one shop to another. Across white marble floors punctuated by chattering groups and the occasional solitary stroller Thien would stare at any face that appeared forlorn even in company until, realising that what was being sought, waited for, was a familiar expression, at which point hurriedly turning away Thien would gaze up at the ceiling and there reflecting back from the silver mirror a face rent according to the shape and pattern of the mirror. The faceless rear-view of all who had been walking sitting standing still splintering then vanishing out of sight. A cloyingly sweet smell of flour hung in the chill air over the skating rink while Thien sat next to some kids eating corn dogs watching the Zamboni and the woman driving it wondered how long she's worked here what her name is what she thinks about as she smooths the sheet of ice whether she likes noodles whether Thien could get a job driving a Zamboni Are you waiting for someone, asks a child who's eaten the batter clean off the dog and left the sausage.

as Thien searched for words the Zamboni exited the rink and imagining the child who still hadn't finished the corn dog hurriedly waddling

Why aren't you in skates? I only mean to sit here My mum does that too Do you like to skate? Yeah I do but also I don't Sometimes I want to go home but I've no choice Why not? This is a secret but actually the world's about to dry up entirely you know and that means I'll be the last kid who's ever ice skated How did you figure that out? I had a dream where the sea had turned into desert and grown-ups were wandering the desert crying and crying At first I thought the grown-ups were just grown-ups but after I woke up I thought well that could be me It could right? Couldn't it? Aren't you cold? Do you want to eat my corn dog? No I'm fine you go ahead and enjoy it You smell of cigarettes I'm sorry Will I smoke too when I'm older? Well that depends on you So who are you waiting for? No one I'm here on my own Yeah I really need time to be on my own too Where d'you come from? From the roof garden No I meant which country are you from

behind the other kids Thien sat on by the side of the department store skating rink where no one ever struck up a conversation. Much like the view falling away even as Thien's eyes pass over it or from forlorn faces to ceiling mirror a brief sideways glance while leaning forehead on window glistening with rain picks out an employee reading beneath the sandwich shop's awning head covered in hairnet hand in uniform pocket, a scene that promptly melts away under gleam of bright lights rain spattering the bus as the vehicle leans into a curve Thien staring on at faces on buses passing to and fro in the next lanes eyes fixed on window pane until the faces slide down borne on rainwater suffused with the glow of streetlights traffic lights illuminated signage. Already past several sloping streets yet no matter where they happened to be passing and though it remained unseen the palpable sense of being enveloped by sea as though they were underwater and the bus entirely engulfed, as drops of rain borne aboard by passengers climbing on traced their paths along the floor with each turn or tremor of the bus a single flower protruding from the rucksack of a woman who's just boarded the stem longer than the length of the bag and Thien along with the rest of the passengers through light shining in past glass and words from the radio running up and down each together gazed upon the pink bloom hovering over a stranger's backpack.

Stirred awake while trying to free a crushed arm Hara tossed and turned in search of a comfortable position before climbing down the berth taking care not to disturb sleeping colleagues. Walking down corridor straight into the high wind blowing in off a sea glutted with night Hara looked up to see exhaled breath diffuse palely over vast expanse of nocturnal cold stars glinting and beneath it the deck empty deserted. Even the late-night bar shrouded in darkness and hovering by its bottle-lined windows a whiff of sick now mixing with the briny smell flowing over the deck lapped at Hara before subsiding. Clothes

flapping about in wrinkled patterns as dictated by gust turned to light a cigarette but the blast of air was overpowering and leaned against the rail Hara not out of interest in locating the origin of the waves but merely needing to gaze out at something to keep the mind blank followed the wave beyond the wave and the wave beyond the one beyond that one swell and grow on the edge of night until there was no smoke left to breathe out then stood flush against the wind as it swept past and through the body and back and only as a sensation of emptiness as if the heart cavity had been hollowed out took hold finally looked away. Tasting blood where lips had torn from cigarette stuck fast Hara's two hands flew up to cover the face and stood in this way until safe darkness had sufficiently spilled over the cupped hands and could sigh out expletives again. Wandering two floors of underground corridors in search of a lighter not a single soul to be encountered so down to the lower storage floor where Hara had never ventured before at this time of night and there at the end of the corridor a shard of light spilled out from beneath an open door.

Could I trouble you for a light? Yeah sure the person in cleaning uniform handed over a lighter and returned to their book. On night duty are you. No. This is the only time I can focus on reading. You mean you come here to read everyday at this hour? That's right. Good thing we arrive early tomorrow morning. Hmn. Not so sure. Not sure? Yes. I don't actually disembark. Why not? I don't have a visa. Handing back the lighter with a fresh cigarette to say thank you, waved away the smell of piss that had begun to waft over from the piles of wash-

Under a light bulb swaying to and fro in rhythm with the ship the storage room was piled high with laundry and in the midst of unwashed linen someone wearing a cleaning uniform was sat reading a book.

ing as cigarette unfurled, Is it good what you're reading? Yes it's good. What is it? Just a novel. I don't think I've read a book since I was twenty. Not like it's necessary. So why do you read? Dunno. Maybe I need new pasts. Why on earth would you need that? The past makes me sick to the stomach. I see. It's as if they're constantly readying to pull me under. I'd rather be curious about the future. I want to get there asap. The two of them sit on the piles of washing their knees not quite touching, What do you imagine you'll find there? The most amazing cocktails and beaches. Handsome puppies and amazing buildings too probably. After hours of swimming at the beach with the handsome dog we'd come back to find a wash and dry machine that automatically cleans us up and dries us off. Maybe there'll be a laser sword as well. What would you want that for? What do you mean what for, to cut out the dicks of any bastard that tries it on with me. After which I'll shove another guy's head into the hole. Like. Like a centaur? No like a human caterpillar. Never heard that one before. What about you? How do you imagine the future? Hmm. I've always found it strange, but the more I try to remember the more my memories seem to vanish. Like. Like they're empty? One thing at least is clear. What's that? That then or now I have nowhere to arrive. Don't be like that. It'll work out. I'm merely stating the truth. It's the only thing I remember clearly. We escaped from civil war and spent nearly two months roaming the desert before border patrol caught us and sent us here. To this ship you mean? No. To this era. I don't follow your meaning. I mean the closer I get to where I'm from memories of it naturally fade away. Where are you from? I'm from the future.

Frail and slant the stack of sunlight gliding down the entire length of the alleyway to lift off at the shore, and in the street a child. Meeting Thien's eyes the child turned away the bleached white ray obscuring her face from Thien to whom Big Auntie introduced the child as the

449

daughter of her jailed son. Keeping one eye on the child as she wandered the alley all three were busy cooking noodles while one or two customers doffed their fishing hats and sat down to gaze out the window and the sound of breathing flowed across all of their faces. Every free moment the aunties exchanged a few words over the window with the child would even go out into the alley to play then the silent child's voice ringing out in laughter at their goofiness in turn made Thien laugh but meeting the child's eyes unfailingly looked away. Once the customers who had sat dozing as though alive in a stupor their glasses of lukewarm beer forgotten on the table had stirred and gone the child installed on a vacated seat with an orange-flavoured ice lolly while they gathered round the plastic table in the alley How about an outing on our next day off Little Auntie saying I'll bring lunch Big Auntie saying Never mind that let's splurge on lunch for once Yes Let's Thien and Little Auntie clapping as twilight extended its branches between the narrow crevice of walls past the applause and the three faces to envelop the child unwittingly swinging her legs in the empty space between feet and floor. That night Thien wrote a letter. No soul to send it to more in hopes that the memory of writing it than its actual contents would remain and endure Thien jotted down the day's observations. The friend encountered on the way back to the motel. The difference in their gait. Always in a pair but today they'd been alone. How as the two of them stood aside to make room for the other time had quite definitely slithered past between them. The doodles left on the alleyway table outside the shop. The trainers the child Thien met for the first time had been wearing. Some other people had been thrown out of the motel again today the sounds of snoring had grown smaller.

As promised the aunties and Thien met outside the bookshop. The child wasn't there. The mother had come to fetch her. Wandering through streets lined with second-hand bookshops the aunties seem-

As boats and buses go by

ing to find the outing a nuisance now that they were there and tagging behind Thien saw how their backs were more face-like than their actual faces more telling and here there building sites blue canvas tents flapping like waves crashing along the shore a bakery on the ground floor of yet another tented building here they stopped for bread then passed the noises creeping from shuttered doorways three or four printing houses a hole-in-the-wall stationery shop the two still ahead scarves aflutter two women twins with dark long hair long coats walking down stone stairs. Barely looking at the other brushing aside coat fronts to thrust their hands in the pockets of high-waisted trousers or stroking the belt of their coat gaze light as a breeze on the street where gingko leaves startle underfoot legs crossed people sat along pavement tables drinking their teas coffees passed by looking off in different directions throwing out a handful of words as if answering without answering asking without asking while to one side the quiet sea gleamed from time to time before vanishing blazing back into view up the sloping path leading to an old wall cracked by time arms nearly brushing sidling collapsing connecting the distance between them to the wide-open space atop the hill catching breaths they leaned elbows against the fence of the observation point Thien noticing how their faces were the likeness of everyone beyond the railing over which they looked as the pair turned and headed back towards Thien their hair scattered white like the light of the sun. The three sat down on a bench to share the bread they'd bought, Shouldn't be picky about bread should try them all as they launch into tales of the latest letter to have arrived from the son in prison the choir class Little Auntie's been attending which of their regulars at the noodle place has been coming the longest dating way back to when they were refugees displaced by war and Thien listened concerned or laughing but not sharing own story with the two aunties who were tapping their sore knees with fisted hands. And though the granddaughter was not mentioned the

As boats and buses go by

two aunties followed any passing child intently with their eyes until the passing child had passed out of view and when it was time to go Big Auntie handed a book she'd bought earlier Small Auntie flowers as gifts for Thien.

In the gloaming boats ships afloat amid a patchwork of leaves and boughs and in a corner saturated the exact hue of blue as the waters below a man in Navy uniform practised his horn. Poorly a beginner notes all tangled as firecrackers shot up by students on a school trip lit up pale insipid around him and across the beautiful night-time park wind roved over hill shaking barbed wire fences sea and sky together fusing as by suction into a dark gloom settling over various faces their expressions mislaid

Person on the edge of a bed removing a sweater. Light through curtains entering window hands at waist peeled blue sweater up inside out over flesh-coloured flesh marked by outline of underwear hair clinging to nape of neck bare shoulder line faintest rash near shoulder blades coffee-stained sheets sound of car horns shadow passing over head in darkened bedroom wrists bound in sweater arms expelled a thin sigh as shoulders heaved person on the edge of a bed removing a sweater. Hands at waist peeled blue sweater up inside out over flesh-coloured flesh marked by outline of underwear bare shoulder line hair clinging to nape of the neck faintest rash near the shoulder blades through curtains light-stained sheets sound of car horns passing over darkened bedroom casting shadow wrists bound in sweater arms expelled a thin sigh as bed heaved person on the edge of a bed removing a sweater. Through curtains sound of car horns hands at waist peeled blue sweater up inside out over hair clinging to sheets bare shoulder line faintest rash near nape of neck coffee-stained flesh-coloured flesh marked by burns aeroplane lights entering window passing over darkened bedroom wrists bound in sweater arms expelled a thin sigh as back heaved person on the edge of a bed removing a sweater. Hands at waist peeled blue sweater up inside out over trails marked by ships sailing over seas hair clinging to nape of neck bare shoulder line faintest rash near shoulder blades coffee-stained sheets sound of someone disappearing in darkened bedroom person on the edge of a bed both wrists bound in sweater arms

As boats and buses go by

Mingling dusk a dozen people had spilled off the ship passengers crew alike Hara the last one to disembark looked round the deck but too dark yet for lights dotting the deck to show people in cleaning uniforms. Over the horizon clouds gradually tinting with bright blue rays of wind ruffled hair as Hara walked rucksack over one shoulder of moleskin coat tying back loose strands but noticing colleagues beckoning from across the street hailed a taxi and left the harbour. Not a glance towards their unpleasant joyless company doubtless Captain the first one off the boat making a beeline for the casino losing money while muttering his poor daughter's name in lieu of a prayer not realising for a second that he's long been erased from his daughter's life Hara receiving phone calls periodically from friends family to exchange news pleasantries knew how to exclude company from life. Still blue the taxi windows over which the reflection of a passing bus full of dozing people and closing eyes deep in the depths of the thick winter coat Hara peered at elderly faces their heads growing heavy only to see the face of the person who claimed to have come from the future, ruminated over the emotion that had arisen when after confessing to have come from the future they laughed it off as a joke. Sorry it's from the novel I'm reading now soon forgotten in silly banter but the truth remained that wherever the person was in fact from there was in truth nowhere they could set foot. Shutting out of sight the old women on the bus who grow ever more silent the more one's gaze rests on them Hara waded into the hot bath at the bathhouse after a perfunctory shower lay back with a warm wet towel draped over forehead thought instead of groceries. Potatoes minced meat Thai chillies spinach onions curry powder low-fat milk frozen pizza beer also a certain person whose face remained faint this opaque person whose vague gestures and voice couldn't be made out looking out at the sea from the noodle shop like the people asleep on the bus or for whom Hara had stood aside in corridors vanishing off as quickly as they had into distant memory and who together with the places would never again

resurface as body rigid from cold and nervous tension slowly thawed in the warm water melting down flowing away to some distant place while overhead above drooping eyelids drops of water on bathhouse ceiling grew shrouded from view. Snow was falling. Hara was sitting at the noodle shop. A couple of people who walked in as Hara sat with back to the door finished eating and remained awhile gazing silently out the window and even after they'd gone Hara sat one arm crossed over the other on the tabletop. The sound of wind rattling the windows eddied beside Hara together with the smell of frying vegetables as Hara sat chin in one propped-up hand letting pop music from the radio flow out the other ear saying how certain music that was genuinely good was so amazing to listen to it made one wish one was dead at which Hara's mother plopping down a bowl of noodles on the table slapped Hara on the back. It's a figure of speech I don't actually want to die I just want to run away to this other dimension the music creates but Hara's mother had walked out to the alley to let in the street cats and Hara blew on the bowl lifted it to drink the hot broth first. Standing in the light snow drifting in the alley hugging the small kittens that hadn't yet made it inside Hara's mother checked on the feeding bowls and beyond the profile of her face the ocean could be glimpsed alongside Hara's own face reflected on the pane at which Hara resumed eating. As Hara's about to leave Mother inserted a long-stemmed flower in the backpack asked Hara to bring it home but seeing how the flower jutted out past the flap it would be beyond embarrassing to walk around with that thing the shame of it bound to induce a panic attack rendering Hara unconscious or a swooning fall capped by fatal concussion but Mother simply said thank you and half-nudged, half-kicked Hara out of the shop alive with the yowling of cats.

Arriving at the bus station the clouds had brightened twilight casting a slender insidious light over them as faces likewise washed clear and footsteps grown leisurely made the passing view appear to form pockets even as it flowed past. In the book you're reading what is the

future like? Do you really want to know? It's all made-up anyway. Yes I want to know. Isn't the future itself made up in the first place? Anything interesting? Well, in the future they replay the memories of people from olden days. How? There's a tiny chip which holds waveforms of images extracted from the brains of dead people. You put that on the temple like so and it makes the brain waves vibrate and unfold the images in your head. They're so vivid it really feels as if I'm a person living there. Is it like doing drugs? You could say that. People come together to sit or lie down and replay the memories which are anything between a second and forty seconds long over and over again. The bus headed up the flyover spanning the immense width of the sea and out the windows to the left long buildings lined the fluent shore glittering from head to toe unveiled by sunlight that had tunnelled its way out of the clouds past the unattainable fluidity of the shoreline and the graphic-like buildings the bus climbed up the flyover arcing over the sea and out the window the space between sea and sky was dazzlingly empty the more one looked at it the more one felt emptied to the point of being without breath as if extinguished from the here now as orange light flooded in from opposite windows. Turning back flower poking out of bag. Backs of passengers steeped in glowing sunset. Inside bus where light exploded forth like a series of exclamations a sense of déjà vu people wrapped in setting sun like this laughing gesturing talking but when that was and who they were remained elusive even as the gloam continued to deepen beyond closed eyes past fluent shore graphic-like buildings the bus climbed up the flyover and through its windows the space between sea and sky artificially empty the more one looked the more one felt emptied to the point of being without breath as if extinguished from the here now as orange light flooded in from opposite windows. Turning back flower poking out of bag. Backs of passengers steeped in glowing sunset. Inside bus where light exploded forth like a series of exclamations a sense of déjà vu people who are soon erased no matter how vividly they may appear now but

As boats and buses go by

when that was and who they were remained elusive even as the gloam continued to deepen beyond closed eyes past fluent shore graphic-like buildings as the bus headed up the flyover out the window the space between sea and sky

As boats and buses go by

Translated from Korean
by Emily Yae WON

전시

2020부산비엔날레는 다음의 시각예술가, 음악가를 초청하여 열 장의 이야기 혹은 다섯 편의 시에 대한 응답으로 기존 작업의 일부를 선택하거나 새로운 작업을 제작하도록 하였다. 이 전시는 저자, 음악가, 시각예술가들로 구성되었으며, 작품들은 다음의 전시공간에서 전시되며 상호 연결된다.

배수아

전시공간
부산현대미술관
시각예술가
맨디 엘사예
강정석
쥬노 JE 킴·에바 에인호른
송기철
요제프 스트라우
마르니 웨버
음악가
오대리

박솔뫼

전시공간
원도심 일대
시각예술가
아지즈 하자라
허찬미
장민승
노원희
에메카 오그보
에르칸 오즈겐
반디 라타나
프란체스크 루이즈
음악가
세이수미

김혜순

전시공간
부산현대미술관
시각예술가
게리 비비
비앙카 봉디
산두 다리에
한묵
칼 홀름크비스트
구정아
이슬기
자이 탕 & 레이 하야마
음악가
김일두

김금희

전시공간
원도심 일대
시각예술가
압축과 팽창
음악가
최태현

Exhibition

Busan Biennale 2020 invited the following visual artists and musicians to respond to one of the featured stories or poems by making a new work or selecting an existing piece. Constituting this exhibition, the authors, musicians, and visual artists are connected and exhibited at the following venues:

BAE Suah

Venue
MOCA Busan
Artist
Mandy EL-SAYEGH
KANG Jungsuck
Jueno JE KIM & Ewa EINHORN
SONG Kicheol
Josef STRAU
Marnie WEBER
Musician
ODAERI

BAK Solmay

Venue
Old Town
Artist
Aziz HAZARA
HEO Chanmi
JANG Minoung
NHO Wonhee
Emeka OGBOH
Erkan ÖZGEN
VANDY Rattana
Francesc RUIZ
Musician
SAY SUE ME

KIM Hyesoon

Venue
MOCA Busan
Artist
Gerry BIBBY
Bianca BONDI
Sandú DARIÉ
HAN Mook
Karl HOLMQVIST
KOO Jeong A
LEE Seulgi
Zai TANG & Rei HAYAMA
Musician
KIM Ildu

KIM Keum Hee

Venue
Old Town
Artist
CO/EX
Musician
CHOI Taehyun

전시

김숨

전시공간
부산현대미술관
시각예술가
메르세데스 아스필리쿠에타
황 포치
정윤석
아라야 라스잠리안숙
서용선
투반 트란
음악가
엘리아스 벤더 로넨펠트

김언수

전시공간
영도
시각예술가
데이브 헐피시 베일리
다이가 그란티나
김희천
권용주
이요나
찰스 림 이 용
존 래프맨
아말리에 스미스
로버트 자오 런휘
음악가
제이통과 진자

편혜영

전시공간
부산현대미술관
시각예술가
요스 드 그뤼터 & 해럴드 타이스
사라 데라트
스테판 딜레무스
질 마기드
바르텔레미 토구오
음악가
쇠렌 키에르가르드

마크 본 슐레겔

전시공간
부산현대미술관
시각예술가
배지민
모니카 본비치니
제라르 빈
스탠 더글라스
루이즈 에르베 & 클로비스 마이에
라세 크로그 묄레르
박상호
음악가
아스트리드 존느

Exhibition

KIM Soom

Venue
MOCA Busan

Artist
Mercedes AZPILLICUETA
HUANG Po-Chih
JUNG Yoonsuk
Araya RASDJARMREARNSOOK
SUH Yongsun
Thu-Van TRAN

Musician
Elias Bender RØNNENFELT

KIM Un-su

Venue
Yeongdo Harbor

Artist
Dave Hullfish BAILEY
Daiga GRANTINA
KIM Heecheon
KWON Yongju
LEE Yona
Charles LIM Yi Yong
Jon RAFMAN
Amalie SMITH
Robert ZHAO Renhui

Musician
J-TONG and JINJAH

PYUN Hye-young

Venue
MOCA Busan

Artist
Jos DE GRUYTER & Harald THYS
Sara DERAEDT
Stephan DILLEMUTH
Jill MAGID
Barthélémy TOGUO

Musician
Søren KJÆRGAARD

Mark von SCHLEGELL

Venue
MOCA Busan

Artist
BAE Jimin
Monica BONVICINI
Gerard BYRNE
Stan DOUGLAS
Louise HERVÉ & Clovis MAILLET
Lasse Krogh MØLLER
PARK Sangho

Musician
Astrid SONNE

전시

아말리에 스미스

전시공간
부산현대미술관
시각예술가
까미유 앙로
바바라 카스텐
임호
리우 와
안젤리카 메시티
라즐로 모홀리 나기
장 카탐바이 무캔디
캐리 영
음악가
푸드맨

안드레스 솔라노

전시공간
원도심 일대
시각예술가
김아영
구동희
잉에르 볼 룬
나다니엘 멜로스
람한
음악가
무코! 무코!

이상우

전시공간
부산현대미술관
시각예술가
닐 벨루파
한나 블랙
니콜라 분
디네오 스샤 보파페
킴 고든
송민정
페터 베히틀러
음악가
킴 고든

470

Exhibition

Amalie SMITH

Venue
MOCA Busan
Artist
Camille HENROT
Barbara KASTEN
LIM Ho
LIU Wa
Angelica MESITI
László MOHOLY-NAGY
Jean Katambayi MUKENDI
Carey YOUNG
Musician
食品まつり a.k.a FOODMAN

Andrés Felipe SOLANO

Venue
Old Town
Artist
KIM Ayoung
KOO Donghee
Inger Wold LUND
Nathaniel MELLORS
RAM HAN
Musician
MEUKO! MEUKO!

YI SangWoo

Venue
MOCA Busan
Artist
Neïl BELOUFA
Hannah BLACK
Nicolas BOONE
Dineo Seshee BOPAPE
Kim GORDON
SONG Minjung
Peter WÄCHTLER
Musician
Kim GORDON

소개

배수아는 1965년 대한민국 서울에서 태어난 소설가이자 번역가이다. 1993년 첫 단편 이후로 지금까지 꾸준히 장편과 단편, 에세이 등을 발표해왔다. 2018년 단편집 『뱀과 물』을 출간한 이후로 자신의 작품을 직접 낭송극으로 만들어 수 차례 공연을 했다. 가장 최근 발표한 작품은 『멀리 있다 우루는 늦을 것이다』이며, 베르너 프리치 감독의 필름 포엠 〈FAUST SONNENGESANG〉 프로젝트의 III편(2018)과 IV편(2020)에 낭송배우로 출현했다.

박솔뫼는 1985년 대한민국 광주에서 태어난 소설가이다. 소설집 『그럼 무얼 부르지』, 『겨울의 눈빛』, 『사랑하는 개』를 비롯해 장편소설 『을』, 『백 행을 쓰고 싶다』, 『도시의 시간』, 『머리부터 천천히』, 『인터내셔널의 밤』 등을 썼다. 김승옥문학상과 문지문학상, 김현문학패를 수상하였다.

김혜순은 1955년 대한민국 경상북도 울진군에서 태어난 시인이다. 시집 『또 다른 별에서』, 『아버지가 세운 허수아비』, 『어느 별의 지옥』, 『우리들의 陰畵』, 『나의 우파니샤드, 서울』, 『불쌍한 사랑기계』, 『달력 공장 공장장님 보세요』, 『한 잔의 붉은 거울』, 『당신의 첫』, 『슬픔치약 거울크림』, 『피어라 돼지』, 『죽음의 자서전』, 『날개환상통』, 시론집 『여성이 글을 쓴다는 것은(연인, 환자, 시인, 그리고 나)』, 『여성, 시하다』, 『여자짐승 아시아하기』, 시산문집 『않아는 이렇게 말했다』 등을 출간했으며, 김수영문학상, 현대시작품상, 소월문학상, 올해의문학상, 미당문학상, 대산문학상, 이형기문학상, 그리핀 시 문학상을 수상했다.

김금희는 1979년 대한민국 부산에서 태어나 인천에서 성장한 소설가이다. 단편집 『센티멘털도 하루 이틀』, 『너무 한낮의 연애』, 『오직 한 사람의 차지』, 장편소설 『경애의 마음』, 중편소설 『나의 사랑, 매기』 등을 출간했다. 신동엽문학상, 젊은작가상 대상, 현대문학상, 우현예술상 등을 받았다.

Biography

KIM Hyesoon is a poet born in Uljin, Korea in 1955. Beginning as a poet in 1979 with the publication of *Poet Smoking a Cigarette* and four other poems in *Literature and Intellect*, she has published 10 poetry collections including, *From Another Star, Father's Scarecrow, The Hell of a Certain Star, Our Negative Picture, My Upanishad, Seoul, Poor Love Machine, To the Calendar Factory Supervisor, A Glass of Red Mirror, Your First*, and *Sorrowtoothpaste, Mirrorcream*. Her collections that are translated in English include: *Mommy Must be a Fountain of Feathers, All the Garbage of the World, Unite!, Blossom Pig, Autobiography of Death and Phantom Pain of Wings*. She has received multiple literary prizes including the Kim Su-Yong Literary Award, Sowol Poetry Literature Award, Midang Literature Award, Daesan Poetry Award, Lee Hyoung-Gi Literary Award, and Griffin Poetry Prize.

BAE Suah is a novelist and a translator born in 1965 in Seoul, Korea. In 1993, she published her first short story and has been presenting full-length novels, short stories, essays, etc. After publishing a short story collection, *Snake and Water* in 2018, she has been transferring her works into recitations which have been performed several times. One of her most recent work is 『멀리 있다 우루는 늦을 것이다』 and she has been working with the director Werner Fritsch on the film-poem project *FAUST SONNENGESANG* and participated as a reader in *FAUST SONNENGESANG* III (2018) and IV (2020).

KIM Keum Hee is a novelist born in Busan, Korea in 1979 and was raised in Incheon. She has published collections of short stories including, *Sentimentality Works Only for a Day or Two, Too Bright Outside for Love*, and *Only One Person's Share*, full-length novel, *Kyungae's Heart*, and mid-length novel, *Maggie, My Love*. She has won numerous awards including the Shin Dong-yup Prize for Literature, Munhakdongne Young Writers' Award, Hyundae Literary Award, and Woohyeon Art Award.

BAK Solmay is a novelist born in Gwangju, Korea in 1985. Besides the novel *Then What Shall We Sing?, The Eyes of Winter, The Dog I Love*, she wrote full-length novels including *Eul, I Want to Write a Hundred Lines, Time in the City, Slowly Head First*, and *International Night*. She has received the Kim Seung Ok Literary Award, Moonji Literary Award, and Kim Hyeon Prize.

소개

김숨은 1974년 대한민국 울산에서 태어난 소설가이다. 1997년 대전일보 신춘문예에 「느림에 대하여」가, 1998년 문학동네 신인상에 「중세의 시간」이 각각 당선되어 등단했다. 장편소설 『철』, 『노란 개를 버리러』, 『여인들과 진화하는 적들』, 『바느질하는 여자』, 『L의 운동화』, 『한 명』, 『흐르는 편지』, 『군인이 천사가 되기를 바란 적 있는가』, 『숭고함은 나를 들여다보는 거야』, 『너는 너로 살고 있니』, 소설집 『침대』, 『간과 쓸개』, 『국수』, 『당신의 신』, 『나는 염소가 처음이야』, 『나는 나무를 만질 수 있을까』 등이 있다. 동리문학상, 이상문학상, 현대문학상, 대산문학상, 허균문학작가상 등을 수상했다.

김언수는 1972년 대한민국 부산에서 태어난 소설가이다. 장편소설 『캐비닛』, 『설계자들』, 『뜨거운 피』와 소설집 『잽』이 있다. 작가의 작품들은 미국, 프랑스, 독일, 러시아, 일본 등 전 세계 20개국에 번역 출간되었다. 『뜨거운 피』가 한국에서 영화로 제작되었고 『설계자들』이 할리우드에서 영화 제작 중에 있다.

편혜영은 1972년 대한민국 서울에서 태어난 소설가이다. 소설집 『아오이가든』, 『사육장 쪽으로』, 『저녁의 구애』, 『밤이 지나간다』, 장편소설 『재와 빨강』, 『서쪽 숲에 갔다』, 『선의 법칙』, 『홀』, 『죽은 자로 하여금』 등이 있다. 한국일보문학상, 이효석문학상, 오늘의 젊은 예술가상, 젊은작가상, 동인문학상, 이상문학상, 현대문학상, 셜리 잭슨상을 수상했다.

마크 본 슐레겔은 1967년 미국 뉴욕에서 태어났으며, 현재 독일 쾰른에서 거주 중인 미국/아일랜드 국적의 소설가이다. 데뷔작 『Venusia』는 제임스 팁트리 주니어상에서 SF 부문 수상 후보에 올랐으며, 소설 『Dreaming the Mainstream: Tales of Yankee Power』, 『New Dystopia』, 『Mercury Station: a transit』, 『Sundogz』, 『High Wichita』 등이 있다. 지속적으로 실험적인 공상과학, 문학 이론, 예술에 대한 글을 독립 출판계에서 출간하고 있다.

Biography

KIM Soom is a novelist born in Ulsan, Korea in 1974. In 1997, she won the Daejeon Ilbo New Writers' Award for *On Slowness* and the Munhakdongne New Writer Award for *Time in the Middle Ages* in 1998. She has published full-length novels including, *Iron*, *To Abandon the Yellow Dong*, *Women and Their Evolving Enemies*, *Sewing Woman*, *L's Sneakers*, *One Left*, *Flowing Letter*, *When Has a Soldier Wanted to Be an Angel?*, *Sublime is Looking Inward* and *Are you living as you*, and short story collections including *Bed*, *Liver and Gallbladder*, *Your God*, *I've never seen a goat* and *Could I Ever Touch a Tree*. She received numerous awards including, the Dong Ri Literary Award, Yi Sang Literary Award, Hyundae Literary Award, Daesan Literary Award, and Heo Gyun Literary Writer Award.

KIM Un-su is a novelist born in Busan, Korea in 1972. He has published the full-length novels *The Cabinet*, *The Plotters*, and *Hot Blood* and a collection of short stories, *Jab*. His novels have been translated into several languages and published in 20 countries including, the United States, France, Germany, Russia, and Japan. *Hot Blood* has been made into a film and *The Plotters* is currently being made into a film in Korea and Hollywood.

PYUN Hye-young is a novelist born in Seoul in 1972. She has published novels, including *Aio Garden*, *To the Kennels*, *Evening Courtship*, and *As Night Was Passing*, and full-length novels, *Ashes and Red*, *To the Western Woods*, *The Law of Lines*, *The Hole* and *Let the Dead*. She has received the Hankook Ilbo Literary Award, Yi Hyo-Seok Literature Award, Today's Young Writer Award, Dong-in Literary Award, Yi Sang Literary Award, Hyundae Literary Award, and Shirley Jackson Award.

Mark von SCHLEGELL is a Science Fiction writer born in New York City in 1967. He is a dual American/Irish citizen, currently residing in Cologne, Germany. His first novel *Venusia* was honor s listed for the James Tiptree, Jr. award in science fiction and he has published *Dreaming the Mainstream: Tales of Yankee Power*, *New Dystopia*, *Mercury Station: a transit*, *Sundogz*, and *High Wichita*. His experimental science fiction, literary theory, and art writing appears regularly in the independent publishing underground.

소개

아말리에 스미스는 1985년 덴마크 코펜하겐에서 태어난 작가이자 시각예술가이다. 2010년부터 8권의 하이브리드-소설책을 출간했으며, 대표작으로는 『Marble』과 『Thread Ripper』를 꼽을 수 있다. 작가의 작품은 물질과 관념의 뒤얽힌 것들을 조사하며, 덴마크 섬에 있는 육식 식물, 디지털 구조로서의 직물, 인공적 삶의 선구자로서의 고대 테라코타 조각상 등과 같은 주제를 다룬다. 덴마크예술재단상 (2017-2019), 로얄 크라운 프린스 커플스의 떠오르는 스타상, 모르텐 닐센 기념상, 뭉크-크리스텐 문화상을 수상했으며 몬타나 문학상 후보에 올랐다.

안드레스 솔라노는 1977년 콜롬비아에서 태어난 소설가이다. 『나를 구해줘, 조 루이스』, 『쿠에르보 형제들』, 『네온의 묘지』를 출간했다. 또한 한국에서 6개월 간 일한 경험을 바탕으로 쓴 에세이 『최저 임금으로 살아가기』, 한국에서의 삶을 그린 논픽션 『외줄 위에서 본 한국』은 2016년 콜롬비아 도서상을 수상하였고, 2018년 『한국에 삽니다』로 번역되었다. 또한 영국 문학 잡지인 '그란타'의 스페인어권 최고의 젊은 작가 중 하나로 선정되었다.

이상우는 1988년 대한민국 인천에서 태어난 소설가이다. 『프리즘』, 『warp』, 『두 사람이 걸어가』를 출간했다.

Biography

Amalie SMITH is a writer and a visual artist born in 1985 in Copenhagen, Denmark. Since 2010 she has published eight hybrid fiction books, among them the novel *Marble* in 2014 and *Thread Ripper* in 2020. Her work investigates the intertwining of materiality and ideas, which has led her to work with topics such as the fabric of the digital and ancient terra cotta figurines as a precursor to artificial life. She received numerous awards, including three-year working grant from the Danish Arts Foundation from 2017 to 2019, the Royal Crown Prince Couple's Rising Star Award, Morten Nielsen's memorial grant and Munch-Christensen's cultural grant, and was nominated for the Montana Literary Award.

Andrés Felipe SOLANO is a novelist born in 1977 in Colombia. He is the author of the novels *Sálvame, Joe Louis; Los hermanos Cuervo* and *Cementerios de neón*. He also published *Salario mínimo*, an essay about his experience as a factory worker for six months. *Corea, apuntes desde la cuerda floja*, a non-fiction book about his life in South Korea, received the 2016 Premio Biblioteca de Narrativa Colombiana prize and was translated in 2018 into Korean under the title 『한국에 삽니다』. He was chosen as one of the Best Spanish-Language Young Writers by the UK literary magazine *Granta*.

YI SangWoo is a novelist born in 1988 in Incheon, Korea. He has published *Prism*, *warp*, and *two people walk*.

삽화
배지민

Illustration
BAE Jimin

[Cover, pp. 464–465] *Tears on the waves*, 2019,
SUMUK (water and ink) and white
powder on Hanji (Korean traditional
paper), 144 × 75 cm (detail)

[p. 11] *Everyday*, 2020, SUMUK and
white powder on Hanji, 50 × 34 cm

[p. 33] *Walking around the block*, 2020,
SUMUK and white powder
on Hanji, 103 × 72 cm

[p. 75] *Sunday*, 2020, SUMUK and
white powder on Hanji, 65 × 89 cm

[p. 101] *Going Together*, 2020, SUMUK
and white powder on Hanji, 53 × 72cm

[p. 169] *Return with full load of fish*, 2017,
SUMUK and white powder
on Hanji, 137 × 73 cm

[p. 201] *Dawn Busan*, 2020, SUMUK and
white powder on Hanji, 72 × 103 cm

[p. 263] *Me and Whirlpool*, 2020,
SUMUK on Hanji, 52 × 74 cm

[p. 287] *Lunch time*, 2020, SUMUK and
white powder on Hanji, 72 × 103 cm

[p. 331] *Electricity Speaks*, 2020,
SUMUK on Hanji, 94 × 49 cm

[p. 359] *Hill of sorrow*, 2016, SUMUK and
white powder on Hanji, 130 × 105 cm

[p. 403] *Go to work on rainy day*, 2020,
SUMUK and white powder
on Hanji, 73 × 116 cm

Words at an Exhibition

2020부산비엔날레 　　열 장의 이야기와 다섯 편의 시

Busan Biennale 2020　　an exhibition in ten chapters and five poems

[글] 배수아, 박솔뫼, 김혜순, 김금희, 김숨,
　　김언수, 편혜영, 마크 본 슐레겔, 아말리에
　　스미스, 안드레스 솔라노, 이상우
[번역] 소피 바우만, 조용경, 김소라, 여현정,
　　제니퍼 러셀, 데보라 스미스,
　　윌 벤더하이든, 이예원, 이수정, 윤정민
[삽화] 배지민

[초판 1쇄 발행] 2020년 7월 8일
[발행] (사)부산비엔날레조직위원회,
　　미디어버스
[기획·편집] 야콥 파브리시우스
[진행] 이나정
[교정] 미디어버스
[디자인] 신신
[인쇄·제책] 세걸음

(사)부산비엔날레조직위원회
부산광역시 연제구 월드컵대로 344
아시아드주경기장 38호 (47500)
051 503 6111 / busanbiennale.org
[집행위원장] 김성연
[전시지원팀] 홍지영, 이나정, 이지언
[전시팀] 이설희, 정푸르나, 정선경, 성지연,
　　우지현

미디어버스
서울시 종로구 자하문로 10길 22 2층 (03044)
070 8621 5676 / mediabus.org

해외유통
아이디어북스, 암스테르담
ideabooks.nl

[Texts] BAE Suah, BAK Solmay, KIM
　　Hyesoon, KIM Keum Hee, KIM Soom,
　　KIM Un-su, PYUN Hye-young, Mark
　　von SCHLEGELL, Amalie SMITH,
　　Andrés Felipe SOLANO, YI SangWoo
[Translation] Sophie BOWMAN, Helen
　　CHO, Sora KIM-RUSSELL, Sarah
　　LYO, Jennifer RUSSELL, Debora
　　SMITH, Will VANDERHYDEN,
　　Emily Yae WON, Cecilia Soojeong YI,
　　Emily Jungmin YOON
[Illustration] BAE Jimin

[First published on] July 8, 2020
[Published by] Busan Biennale
　　Organizing Committee, Mediabus
[Editorial Director] Jacob FABRICIUS
[Managing Editor] LEE NaJeong
[Proofreading] Mediabus
[Design] SHIN SHIN
[Printing & Binding] Seguleum

Busan Biennale Organizing Committee
(47500) 38, Busan Asiad Main Stadium,
344 Worldcup st. Yeonje-Gu, Busan, Korea
+82 51 503 6111 / busanbiennale.org
[Executive Director] KIM Seong-Youn
[Exhibition Support Team] HONG Jiyoung,
　　LEE Jieon, LEE NaJeong
[Exhibition Team] LEE Seolhui,
　　CHUNG Pooluna, JUNG Sunkyung,
　　SEONG JiYeon, WOO Jihyun

Mediabus
(03044) 22, Jahamun-ro 10-gil, Jongno-gu,
Seoul, Korea
+82 70 8621 5676 / mediabus.org

International Distribution
Idea Books, Amsterdam
ideabooks.nl

ISBN 979-11-90434-05-8 93600 / 값 20,000원